How To Select and Use
Nikon
SLR CAMERAS
by Carl Shipman

CONTENTS

1 THE NIKON SYSTEM 2
2 EXPOSURE—THE BASIC TECHNICAL PROBLEM 7
3 HOW A SINGLE-LENS-REFLEX CAMERA WORKS............ 14
4 LENSES 18
5 FILM HANDLING 56
6 CAMERA CONTROLS AND FEATURES 61
7 VIEWING AND FOCUSING......................... 65
8 EXPOSURE METERING 78
9 CLOSE-UP AND MACRO PHOTOGRAPHY 90
10 LIGHT, FILTERS AND FILMS 119
11 HOW TO USE FLASH 135
12 HOW TO CARE FOR YOUR CAMERA.................... 151
13 NIKON CAMERAS & ACCESSORIES 155

THIS IS AN INDEPENDENT PUBLICATION

Cooperation of Nikon, Inc., and Nippon Kogaku K.K. is gratefully acknowledged, however this publication is not sponsored in any way by the manufacturer or importer of Nikon cameras.

Information, procedures and data in this book are correct to the best knowledge of author and publisher. Because use of this information is beyond author's and publisher's control, all liability is expressly disclaimed.

Specifications, model numbers and operating procedures for the equipment described herein may be changed by the manufacturer at any time and may no longer agree with this book.

Publisher & Editor: Bill Fisher; Art Director: Don Burton
Book Assembly: Chris Crosson, Laura Hardock, Tom Jakeway, Pat O'Dell
Typography: Cindy Coatsworth, Connie Brown, Joanne Nociti

ISBN 0-912656-77-8
Library of Congress Catalog Card: 78-52274
©1980, 1979, 1978 Fisher Publishing, Inc., P.O. Box 5367, Tucson, AZ 85703 602-888-2150
Printed in U.S.A.

1
THE NIKON SYSTEM

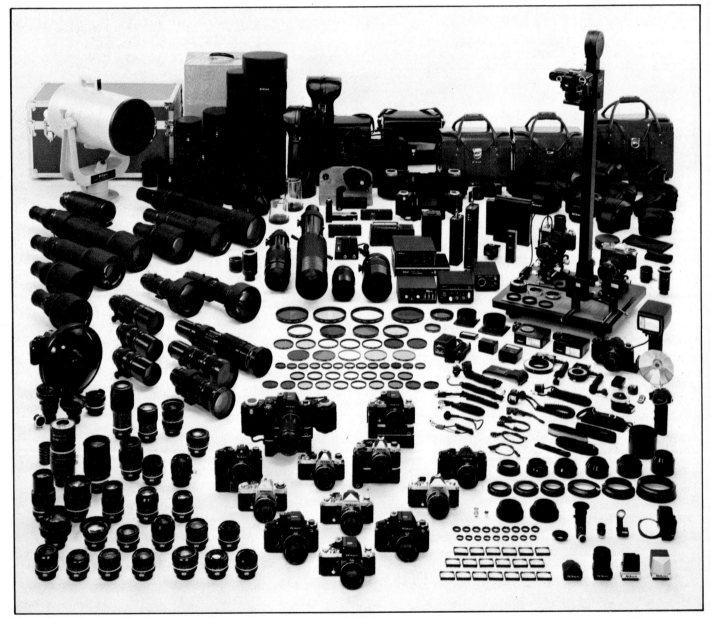

Nikon cameras are backed up by an array of system accessories to achieve virtually any photographic goal. This book helps you choose and use the equipment you need. Photo courtesy of Nikon, Inc.

The challenges of photography include the technical problems of equipment, films and exposure, along with artistic problems such as lighting and composition. Lots of things are wrong with the picture at left. Moving only a few steps off the path, I shot the picture at right, which I think is an improvement.

Nikon is well-known to photographers as the camera most often used by professionals. Reasons for this include Nikon's high quality, durability and ruggedness. Another important reason is the availability of a very large range of lenses and accessories which allow the user to set up a camera for nearly any conceivable photographic job.

As you will see in this book, the range of cameras and accessories is carefully and logically developed as a *system* of interchangeable parts centering around the basic camera body. Whatever you want to do in photography, you can select equipment from the Nikon system to meet your needs.

Some models have more features and can use more different kinds of accessories than others, which is a consideration in buying a camera.

Finding Your Way—Particularly if you are new to 35mm cameras with interchangeable lenses and accessories, a camera system looks impossibly complicated when viewed all at once. When the basic elements are

identified and the purpose of each is described, it becomes easy to find your way through the system and select the equipment items you need.

A major purpose of this book is to identify and describe camera models, lenses and accessories. I will explain how things work and how they fit together, without assuming much prior knowledge or experience on the reader's part. This book will discuss basic ideas where needed to explain how equipment works and why.

Another purpose is to serve as a buyer's guide with current data about available cameras and accessories.

This book begins with fundamentals applicable to all 35mm cameras, illustrated with photographs of Nikon cameras. This is to acquaint you with camera capabilities and how to use them, rather than specific camera models. To give you a preliminary introduction to current cameras, some are shown later in this chapter with brief descriptions.

At the end of this book, the emphasis changes. By then, you will know

how cameras, lenses and accessories work and you will have some familiarity with specific models. At that point, the book becomes specific about equipment. It gives descriptions, specifications and cross references to show which accessories can be used with which cameras. You can "go shopping" in the back of this book to select a new Nikon camera system, or add to a system you already own.

ELEMENTS OF THE SYSTEM

Most photographic equipment falls into fairly definite categories, each with specific functions. The most important categories are listed in this section. Besides these, there is a variety of miscellaneous items which will be discussed at appropriate places through the book.

Camera Body—The camera body has a lens mount which accepts a variety of interchangeable lenses. The body contains the film and the mechanism which transports film from a cartridge at one end to a takeup spool at the other. As the film moves through

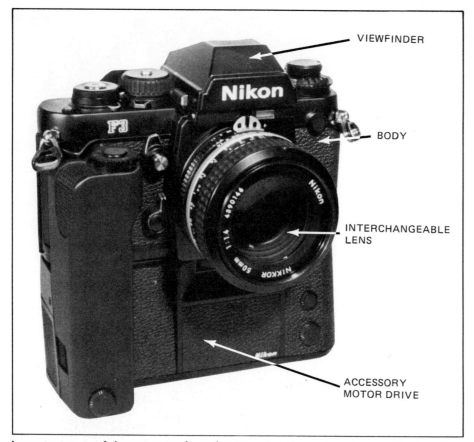

VIEWFINDER

BODY

INTERCHANGEABLE LENS

ACCESSORY MOTOR DRIVE

Important parts of the camera and a major accessory, the motor drive, are illustrated in this photo of a Nikon F3.

be used to take the picture. Therefore you see *exactly* what you are photographing.

Some models have removable viewfinders which can be interchanged with other finders of different types. Some have the viewfinder built in as a permanent part of the camera body.

Camera Body Accessories—Major accessories for the camera body are automatic film winders and motor drives. The film winder advances film after each exposure so you can shoot faster, without the trouble of advancing film manually. Motor drives also advance film automatically but at a faster rate than film winders. Motor drives are more sophisticated, offering features such as remote control and time-lapse photography.

Lens Accessories—These include lens hoods which keep stray light off the front surface of the lens, filters to change the color or amount of light entering the lens and a variety of accessories used to increase magnification or size of the image on film.

Viewfinder Accessories—Some of these accessories fit on the viewfinder window to magnify the image you see, so you can focus more precisely, or to allow you to view from a different position in respect to the camera. A very simple but important viewfinder accessory is a rubber eyecup to exclude stray light and make viewing more comfortable. Inside the viewing system is a viewing screen with a device to help you find best focus. On some models, the viewing screen is interchangeable so you can select and install the type that best suits your personal preference or best meets the requirements of the kind of photography you are doing. Interchangeable viewing screens are discussed in Chapter 7.

CAMERA MODELS

The following photos and brief descriptions of Nikon cameras will serve as an introduction to the models discussed in this book—just so you will recognize model numbers as they are mentioned in following chapters.

the camera, you can expose frames of film along its length. Also in the body is a shutter which opens up to allow light to strike the film and record a photographic image. Other features of the camera body will be described later.

Interchangeable Lenses—Nikon cameras have the same lens-mount design and all models can use interchangeable lenses. It's an advantage to switch lenses for different situations—using wide-angle lenses, telephoto, zoom lenses and special types

to make pictures that are not possible using a camera with a single, fixed lens.

Viewfinder—The viewfinder occupies a housing on top of the camera body. Part of the viewfinder is a window on the back which allows you to see the image that will be recorded on film when you operate the shutter button. This allows you to compose the photo and verify good focus. An important feature of this type of camera is that you get the same view through the lens that will

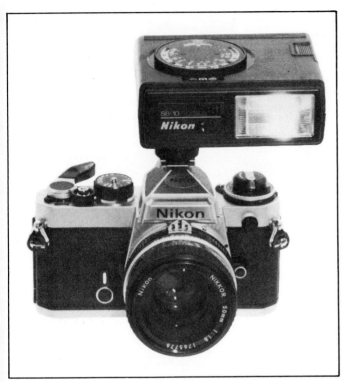

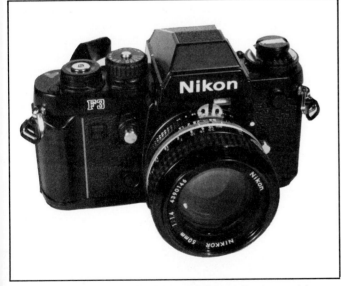

Nikon FE A compact, lightweight camera with both automatic and manual exposure control. Introduced in 1978 along with a special SB-10 electronic flash.

The Nikon F3 is a <u>top-of-the line professional camera</u> with a wide range of accessories. You can use it as an automatic-exposure camera or as a non-automatic manual camera.

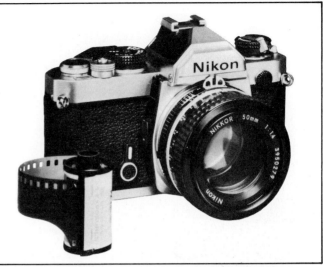

Nikon FM A compact camera, similar in size and appearance to the FE but not automatic. Introduced in 1977.

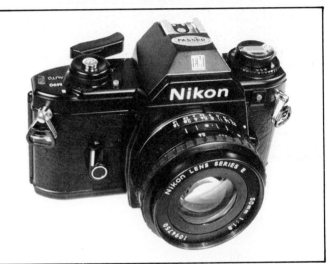

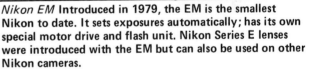

Nikon EM Introduced in 1979, the EM is the smallest Nikon to date. It sets exposures automatically; has its own special motor drive and flash unit. Nikon Series E lenses were introduced with the EM but can also be used on other Nikon cameras.

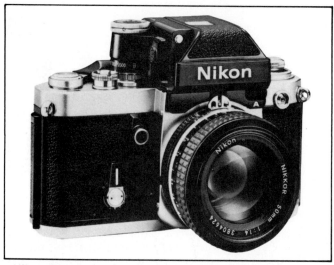

Nikon F2A One of several models based on the respected Nikon F2 body. The difference among models is the viewfinder—which is interchangeable. This model uses a moving needle in the viewfinder to show correct exposure.

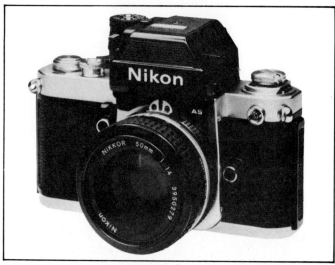

Nikon F2AS Similar to the F2A but uses LED indicator lamps in the viewfinder to show correct exposure.

Nikon F2 The basic F2 body spawned a series of cameras, each with different viewfinders. With a non-metering viewfinder as shown here, the camera is called an F2. This body is also available with special titanium parts for maximum strength and ruggedness. The titanium version is called F2T. The camera shown here is the F2T.

BLACK BODY OR CHROME?
Some camera models are available two ways: "Black body" means the camera body is black all over. "Chrome" means parts of the camera are metallic-silver in color. Black bodies cost a little more and are preferred by some photographers because they may be less conspicuous or because they have a more "professional" appearance. Except for the color difference, the cameras are the same.

2
EXPOSURE –
THE BASIC TECHNICAL PROBLEM

Everything about a camera serves in one way or another to get proper exposure of light onto the film. The camera body excludes stray light which can affect the film. The lens admits light from the subject being photographed.

Inside each lens is a *diaphragm,* made of metal leaves which form an approximately circular hole or *aperture.* By changing the position of the leaves, the hole in the center of the diaphragm can be made larger or smaller and thus transmit more or less light through the lens and into the camera where it exposes the film.

The control for aperture size is a serrated ring on the outside of the lens body. It is called the *aperture ring.* Click-stops, or detents, on the aperture ring cause it to move in definite steps as you rotate the control. Each major step is numbered, with each number representing a definite aperture size. These numbers are called *f-numbers.*

The aperture ring on each lens is marked in a series of *f*-numbers representing all steps between the largest possible setting and the smallest. The aperture ring can be set anywhere in its range of operation, whether exactly on an *f*-number or not.

Cameras are allowed in this cathedral, but no tripods or flash. I used a Nikon automatic camera, pushed it firmly against a stone column for stability, and let it decide the amount of exposure.

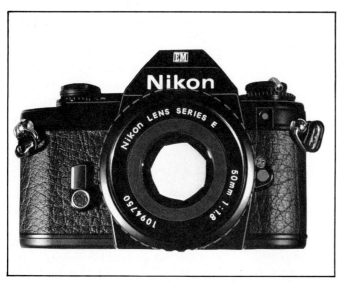

As lens aperture is opened, more light passes through the lens to expose film. Aperture is inside lens, formed by movable metal leaves which make straight edges around the hole.

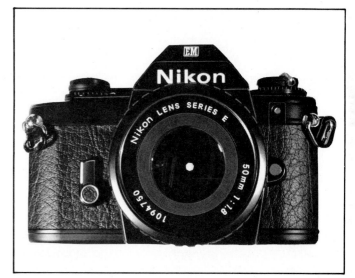

As lens aperture closes, less light passes through.

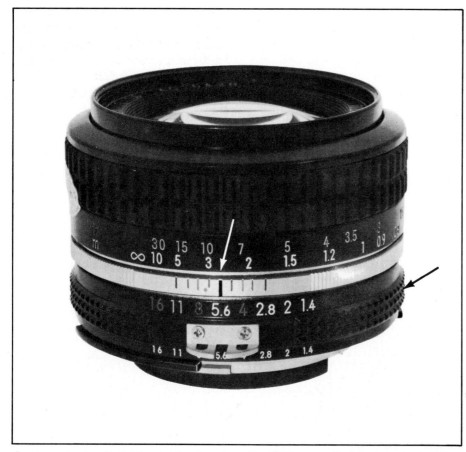

Aperture size is selected by turning Aperture Ring (black arrow). Aperture size is indicated by number opposite index mark (white arrow). This lens is set for f-5.6. Notice aperture scale of f-numbers is duplicated near back of lens. On some cameras, these aperture numbers are optically imaged inside the camera viewfinder so you can see the lens aperture size directly—called Aperture Direct Readout (ADR).

The f-numbers are important to photography with adjustable cameras and you will become very familiar with them. They are written in more than one way: f-2, f/2 and f:2. This book is part of the H.P. Books series on photography where the form f-2 has been standardized.

In the language of photography, when you set a lens to a particular f-number on the aperture ring, you have chosen an f-stop. If you then change to another f-number setting on the lens, you have selected a different f-stop.

THE f-NUMBER SERIES

It is useful and practically necessary to memorize the series of f-numbers engraved on the aperture ring. It helps you speak and think in the language of photography and it helps you make adjustments to your camera. It's easy to memorize.

All you have to do is remember two numbers: 1 and 1.4. Double them alternately as shown in the accompanying drawing. The f-number series continues both above and below the numbers shown but those are the common values.

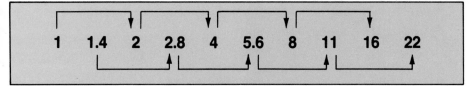

| 1 | 1.4 | 2 | 2.8 | 4 | 5.6 | 8 | 11 | 16 | 22 |

It's easy to write or remember the *f*-number series. Start with the numbers 1 and 1.4; then double them alternately, as shown here.

Notice there is an approximation between 5.6 and 11: *f*-11 is not exactly double *f*-5.6, but it is close enough and easier to remember.

This series of *f*-numbers is chosen so the *area* of the aperture is doubled with each full step toward larger aperture size. Going the other way, area is halved with each full step toward smaller aperture size. Because the amount of light that gets through a hole is determined by the area of the hole, each *f*-number step allows *twice* as much light, or *half* as much, as its immediate neighbors in the series.

Another thing you have to remember is that larger *f*-numbers mean smaller lens openings, and the reverse. If you have a lens set at *f*-8 and change it to *f*-11, the amount of light passing through the aperture will be reduced to half. If you change the aperture from *f*-2 to *f*-1.4, the amount of light reaching the film will be doubled.

In the early days of photography variable apertures had not been invented. Cameras used removable metal plates in the light path to the film. The metal plates were made with holes of different sizes and the thinking was that the plate would *stop* all the light except that which got through the hole. Changing these plates to allow more or less light on the film became known as changing *stops*.

The word remains with us; *f*-numbers are often called *f-stops*. Changing to smaller aperture is often called *stopping down*. Changing to larger aperture is usually called *opening up* although somebody may call it *stopping up* with equal logic. Changing aperture to one that is 3 sizes smaller is called *stopping down 3 stops*.

Earlier I defined doubling or halving the amount of light as an exposure change of *one step*. You can conclude that the words *stop* and *step* mean the same thing in photography. I prefer to use the word *step* to mean doubling or halving exposure which agrees with usage in the international standards for photography.

EFFECT OF LIGHT

The effect of light on negative film is to create a record of the light pattern in the light-sensitive layer, called *emulsion,* which is coated onto a clear base.

Exposure of film to cause an image after development is not just a matter of how bright the light on the film is.

Exposure is determined both by *how bright* the light is and *how long* it is allowed to fall on the film.

The length of time light is allowed to fall on the emulsion is measured in seconds or fractions of a second. It is controlled by a *shutter* inside the camera body, in front of the film.

THE SHUTTER-SPEED SERIES

Shutter speeds also change in steps so each longer time is double the preceding step. The standard series of shutter-open times in seconds is: 1 1/2 1/4 1/8 1/15 1/30 1/60 1/125 1/250 1/500 1/1000 1/2000.

Notice the approximation between 1/8 and 1/15; also between 1/60 and 1/125. The longer time is not exactly double the shorter time. The approximations are close enough and they make the shutter-speed series of numbers easier to remember and work with. You should learn the series.

For simplicity and ease of reading, the shutter-speed dial on a camera does not show the numerator of these fractions. Instead of 1/125, the shutter dial just shows 125. 500 means 1/500 second, and so forth.

The shutter-speed selector is usually on top of the camera. Shown here is the FE with shutter speeds from 8 seconds to 1/1000 second. Setting the shutter-speed dial to AUTO puts the camera on automatic operation so it chooses shutter speed automatically. Setting to B lets you make exposures longer than 8 seconds.

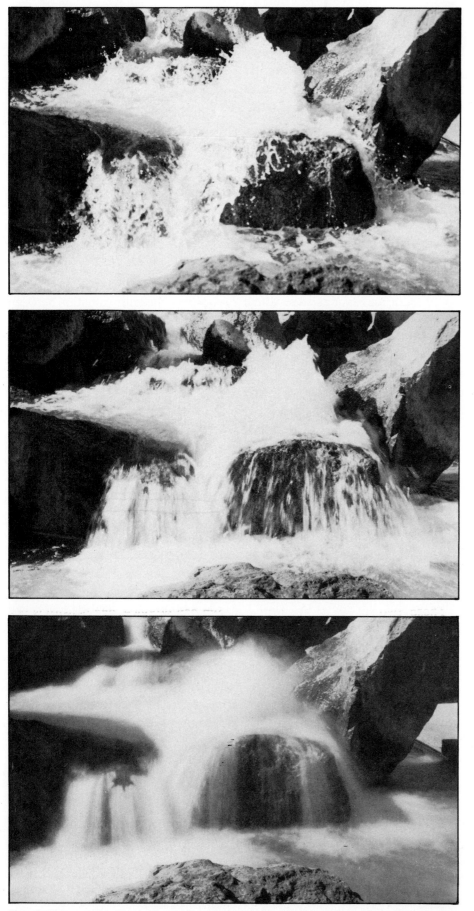

Fast shutter speeds stop motion; slow shutter speeds allow motion to blur in the picture. These photos were made at shutter speeds of 1/1000, 1/125 and 1 second.

RECIPROCITY LAW

The amount of exposure on film can be expressed by a simple formula which is a basic fact of photography:

Exposure = Illumination x Time

Illumination means the brightness of the light which falls on the film. *Time* is the length of time the shutter is open.

This formula is often written in the abbreviated form as: $E = I \times T$, where the letters stand for the words given in the preceding paragraph. This is called *reciprocity law.*

The important thing about the reciprocity law is this: To get a certain amount of exposure on the film, no particular amount of light is required and no particular length of time is required. The requirement is: The amount of light multiplied by the length of time must equal the desired exposure.

This means you can use less light and more time, or the reverse. When there is not much light, you expose for a longer time. When the light is very bright, you expose for a shorter time.

In practice, this is made very simple by the use of exposure steps on both aperture and shutter controls, as discussed earlier. If you double the intensity of light reaching the film, reduce exposure time to half. If you double exposure time, cut the amount of light in half. In other words, one step on the aperture scale in the direction of increased light is exactly balanced by one step on the shutter-speed scale in the direction of shorter time.

HOW FILM REACTS TO DIFFERENT AMOUNTS OF EXPOSURE

This discussion of how film responds to exposure applies to any kind of film; color or black and white (b&w). It is simpler to describe and understand when related to b&w film, but the same basic ideas apply also to color film.

If negative film is not exposed at all, but put through development anyway, it will be clear. Not perfectly clear, but practically clear.

Increasing exposure causes b&w film to become increasingly dark when it is developed. It will change from light gray to medium gray to black. There is a limit to how black it can get, just as there is a limit to how clear it can be.

For testing, it is convenient to change exposure in a series of definite steps and then observe the amount of darkening which results at each step. The technical word for darkening of the film is *density.* More density means it is blacker or more opaque and transmits less light when you look through it.

All human senses, including vision, operate in a way that's surprising when you first learn of it. Suppose you are looking at a source of light such as a light bulb. It is making a certain amount of light and it gives you a certain *sensation* or mental awareness of brightness.

Assume the *amount* of light coming from the source is *doubled.* It will look brighter to you. Not twice as bright, but you will notice a definite change.

To make another increase in brightness which you will interpret as the same amount of change, the amount of light must be *doubled again.* Successive increases in brightness which all appear to be *equal changes* must be obtained by doubling the actual amount of light to get the next higher step. This tells us what must be done on film to make steps of brightness which appear equal to an observer.

This is the reason standard step increases in exposure are in multiples of two.

Figure 2-1 is a test made by exposing each frame on a roll of film at a different exposure, doubling the exposure each time. The subject is a white piece of paper.

The result shows how film behaves over a wide range of different exposures which were made in orderly steps for convenience. You can see that the negative reaches a point where it doesn't get any blacker even with more exposure. It also reaches a point where it doesn't get more clear with less exposure.

Film cannot record details both in bright sunlight and in shadow. Notice shadow of wall across walkway.

These two limits of the film—maximum black and maximum clear—are practical limitations in photography. Normally you try to fit the different brightnesses or *tones* of a real-world scene into the range of densities the film can produce.

This is done by adjusting the camera controls with a rather simple idea in mind. In the range of densities the film can produce, one density is the middle one. The scene you are photographing also has a range of brightnesses or tones which are to be transformed into densities on the film. One tone *in the scene* is the middle one.

If you arrange exposure so the middle tone of an average scene is transformed into the middle density

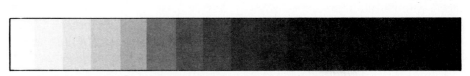

Figure 2-1/Different amounts of exposure result in different densities. Film testing is done by changing exposure in definite steps, making a *gray scale* as shown here.

In a real-world scene, you see many shades, or tones, ranging from white to black.

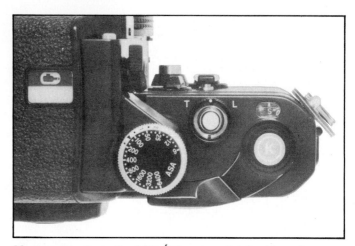

Most cameras have the ASA dial on top. Set the triangular index mark on the knurled ring opposite the desired film-speed number. This camera is set for ASA 125 film.

on the film, exposure is just right. When the negative is made into a print, lighter tones of the scene use lighter densities on the print—above the middle value. Darker tones of the scene use the darker densities of the print.

The only technical problem which can result from exposing film this way is if the brightness range of the scene exceeds the density range of the film. In that case, the film doesn't have enough different densities to match the different brightnesses of the scene. That can happen when part of the scene is in bright light or sunlight and another part is in shadow.

CONTROL OF EXPOSURE

Getting a desired exposure on the film depends basically on three things:

The amount of exposure the film *needs*—it varies from one type of film to another.

The amount of light reflected toward the camera by the scene or subject.

The setting of the camera exposure controls.

ASA Film Speed—Film manufacturers publish numbers called *ASA Film Speed*, a way of stating the amount of exposure *needed* by the film.

Film speed is a number such as 25 or 400. Higher speed numbers mean the film is more sensitive to light and requires less exposure. Doubling the

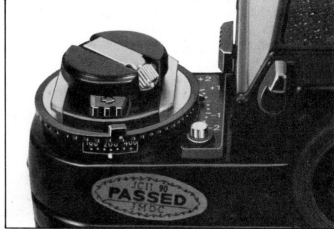

The Film-Speed Dial on the F3 surrounds the Rewind Knob. To set, lift up the outer rim of the dial and turn to place the desired film-speed number in the window. Release the control and turn slightly if necessary so it moves down to its normal position. This camera is set to ASA 200. Dots between the numbers on the scale are one-third steps. The F3 has an unusually wide range of ASA film speeds: from ASA 12 to ASA 6400.

film-speed number means it requires *half* as much exposure, and so forth.

The standard series of ASA Film-Speed numbers is 12, 25, 50, 100, 200, 400, and so on. It can be extended in either direction by doubling or halving the numbers.

Nikon-Nikkormat cameras have a film-speed dial which you use to set in the ASA speed number of the film you are using. This sets the camera to give correct exposure to that film.

Not all films have ASA speed ratings which fall in the series of num-

bers given earlier. For example, Kodak Panatomic X has an ASA speed of 32. Agfachrome 64 has a speed of 64.

Film manufacturers and camera makers have agreed to divide the ASA scale in thirds, so there are two additional numbers between each pair of the standard series. That is, two possible film speeds between ASA 25 and ASA 50, two between 50 and 100, and so forth. Films which don't have a speed number on the standard series are assigned one of the inter-

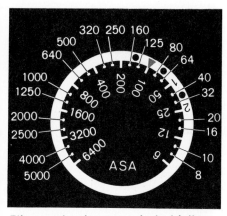

Film-speed scales are marked with lines and dots so each space is 1/3 of a step. Not all settings are numbered, because there isn't enough space. This illustration shows the ASA film-speed number for every mark on the dial, between ASA 6 and ASA 6400.

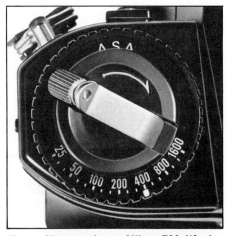

To set film speed on a Nikon EM, lift the outer rim and rotate until white index mark is opposite desired film speed. This camera is set for ASA 400.

mediate numbers, such as 32 or 80.

Cameras have a mark or dot on the film-speed scale for each standard speed number and for each of the intermediate numbers, but there isn't room to engrave all the numbers. Some are shown and some are just represented by a dot. The accompanying table shows ASA numbers for every setting on the film-speed dial.

Here's a little memory trick that can save you the problem of trying to remember what all the unlabeled dots mean. Just remember 8, 10 and 12. Repeatedly doubling any one of these three numbers gives one-third of all possible film-speed numbers. Do the same to the other two numbers and you generate all possible film speeds.

ASA or DIN—The ASA method of stating film speed was developed in the United States. The DIN system was developed in Germany. They are two different ways of giving the same information about film. In the ASA system, each step is *double* the next lower value. In the DIN system, the steps mean the same thing, but are obtained by *adding 3* units to get the next higher number.

The two speed-numbering systems agree at 12 and then follow their individual patterns for higher and lower speeds:

FILM SPEED RATING	
ASA	DIN
12	12
25	15
50	18
100	21
125	22
160	23
200	24
400	27
800	30
3200	36

With either system, higher speed numbers mean the film is more sensitive and therefore requires less exposure. We say film with higher speed numbers is *faster*.

Amount of Light From the Scene—After film speed is set into the camera, the next essential is to measure the amount of light reflected by the scene. Nikon and Nikkormat cameras do this automatically, assuming a light-measuring viewfinder is installed on Nikon cameras which use interchangeable finders.

Light measurement in the camera is done by an electronic sensor in the viewfinder housing. The sensor "sees" the image that will be used to make the picture, just as you do. The sensor measures the brightness of the scene to be photographed. This type of light measurement is sometimes called *through-the-lens* metering, or *behind-the-lens* metering because it measures the amount of light after it passes through the lens.

Through-the-lens metering is a great convenience. You don't have to carry along a separate light meter although some photographers do it anyway, out of habit or personal preference—or for the "insurance" of having two light meters in case one fails. If you use lens accessories, such as a color filter, the camera's built-in light meter automatically measures the change in light so you don't have to worry about it or do calculations to set exposure properly.

Exposure Control Settings—With film speed dialed into the camera metering system, and the amount of light coming through the lens measured inside the camera, the camera itself can figure the correct settings for the exposure controls. It indicates the correct settings on a display in the viewfinder, as you adjust the camera controls. Or, automatic cameras such as the Nikon FE and EL2 will set exposure for you.

The two exposure controls—aperture size and shutter speed—are used together to arrive at a pair of settings which produces the desired exposure as indicated by the viewfinder display. Several different pairs of settings can produce the same amount of exposure. You can change shutter-speed and make a balancing or compensating change in aperture size so you end up with the same amount of exposure—but you got it with a different *pair* of exposure-control settings—a practical application of the Reciprocity Law.

> **Beware of Slow Shutter Speeds**—More pictures are spoiled by camera motion during exposure than any other cause. With the normal 50mm camera lens, you can hand-hold at 1/60 or even 1/30 if you are careful but you should use firm support when you can find it. At shutter speeds of 1/30 or slower, use a tripod or some other way to hold the camera steady. With long-focal-length lenses, use faster shutter speeds when hand-holding the camera. See the note on page 64.

3

HOW A SINGLE-LENS-REFLEX CAMERA WORKS

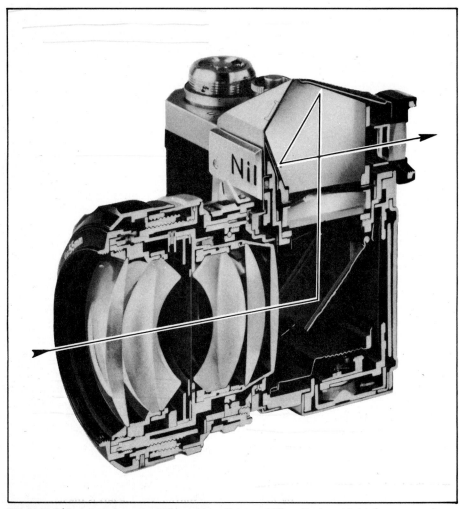

Figure 3-1/Cross-section of a Nikon shows light path for viewing. Light from scene is reflected off angled mirror so it travels upward and falls on focusing screen. Pentaprism, above focusing screen, causes you to see an upright and correctly oriented image on the screen. When mirror moves up to take the picture, shutter opens and the image falls on film in the back of the camera.

The main feature of a single-lens-reflex (SLR) camera which distinguishes it from other types is: You view and focus through the same lens used to cast the image onto the film. This has several important advantages and some relatively minor disadvantages.

The word *reflex* is a form of the word *reflection* and indicates that the image you see in the viewfinder is bounced off a mirror in the optical path between the lens and your eye.

Single-lens-reflex cameras are designed as shown in Figure 3-1. The lens receives light from the subject being photographed. A focusing control moves the lens closer to or farther away from the film.

To view, a mirror is moved to the "down" position to intercept light traveling from the lens toward the film. This intercepted light is bounced upward by the mirror to a *viewing screen*—also called *focusing screen*—and then through a special prism so it finally emerges at the viewing window where you can see what is coming in through the lens. You get the same view the film will get when you take the picture.

The focusing screen is just below the *pentaprism*. When the mirror is down, it reflects light from the lens onto the viewing screen where a focused image is formed. When you look through the viewing window on the back of the camera, you see the image on the screen.

The pentaprism not only reflects the light rays internally so they come out the viewing window, it also

With lens removed, you can see mirror in down position. Reflection in mirror is bottom of focusing screen, which is just above mirror, in the top part of the camera body.

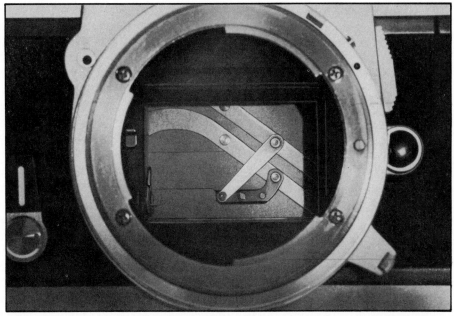

After the mirror moves up, the shutter opens. This is a vertically moving metal shutter, operated by those metal arms and levers.

causes the image you see to be correctly oriented—top to bottom and left to right. Like being wealthy, it's easy not to appreciate the benefit of correct viewing until you have to do without it.

The camera is built so the distance from lens to focusing screen by way of the mirror is the same as the distance from lens to the film in the back of the camera. Therefore, if the image is in focus as you see it on the screen, it will later be in focus on the film when the mirror is moved out of the way to take a picture.

A convenient way to think about it is this: You look through the pentaprism to examine the viewing screen which is showing you the image that will fall on the film when you trip the shutter. If you like what you see, squeeze the shutter button and several things happen very quickly.

The mirror moves up out of the way. As it swings up to its parking place, you lose your view of the image. When the mirror is out of

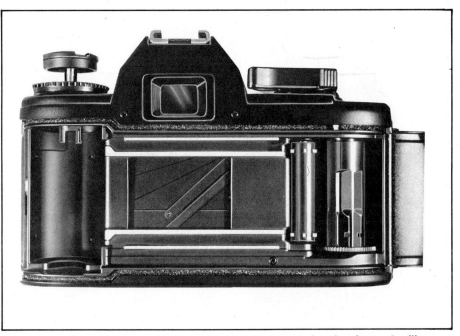

Open the back of a camera and you see the rectangular opening that forms the film frame, with the opening closed by the focal-plane shutter. On the left is the cavity for the film cartridge. Film take-up spool is on the right. This is a metal focal-plane shutter that moves vertically to open and close. Some camera models use horizontally moving shutters.

the way, the *focal-plane shutter* in front of the film is opened so light from the lens falls on the film.

In addition to mirror movement in synchronism with shutter operation,

the busy camera mechanism also lets you view the scene through the widest possible lens aperture for maximum scene brightness in the viewfinder.

HOW A FOCAL-PLANE SHUTTER WORKS

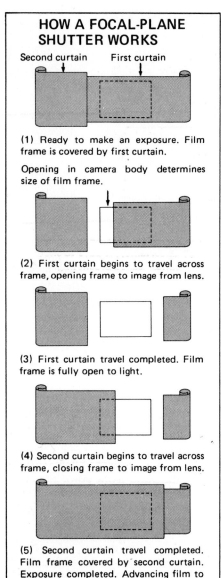

Second curtain First curtain

(1) Ready to make an exposure. Film frame is covered by first curtain.

Opening in camera body determines size of film frame.

(2) First curtain begins to travel across frame, opening frame to image from lens.

(3) First curtain travel completed. Film frame is fully open to light.

(4) Second curtain begins to travel across frame, closing frame to image from lens.

(5) Second curtain travel completed. Film frame covered by second curtain. Exposure completed. Advancing film to next frame resets shutter to (1) ready to make another exposure.

This drawing shows operation of a two-curtain focal-plane shutter which travels horizontally. When exposure time begins, the first curtain is released to start its travel. As it moves, the first curtain passes across the film frame, allowing light to fall on the film. When the first curtain has completed its travel, the frame is fully opened. When exposure time ends, the second curtain is released to begin its travel and close off light to the film.

Exposure time is measured from *release* of the first curtain to *release* of the second curtain. This drawing shows an exposure time long enough that the second curtain does not begin to move until after the first curtain has reached the end of its travel.

When you press the shutter button, the camera automatically closes lens aperture to whatever *f*-stop you selected at the lens. For example, if you selected *f*-11 with the aperture ring on the lens, the lens will automatically close down to *f*-11 after you depress the shutter button. This feature is called *automatic diaphragm,* or *automatic aperture.*

When the desired amount of time for exposure has passed, the shutter closes.

The mirror automatically swings back down to the viewing position, a feature commonly called *instant-return mirror.* Even though you lose sight of the scene while the film is being exposed, this time is usually brief and you quickly learn to ignore the "blackout." It's as if the camera "blinked."

With all that done and the image captured on one frame of the film, use the film-advance lever to move the next frame of film into position for the next picture. The lever also winds up the camera mechanism so it can operate mirror, lens aperture and shutter again for the next exposure.

VIEWFINDER DISPLAYS

SLR cameras show you a minimum of three things in the viewfinder: The scene you are photographing, a focusing aid in the center of the viewfinder screen, and an exposure display to help you set the controls.

The exposure display can be a moving needle, flashing indicator lights, or some other method depending on camera model. However it is done, when the exposure display indicates correct exposure, we say it is *balanced* or *satisfied.* This means you have set the camera so the film will receive the amount of exposure required by the ASA speed number of the film.

A common error is to assume that a balanced exposure display means you will get correct exposure for *anything* you happen to have in the viewfinder. This is not true. The entire exposure measuring system is based on photographing *average*

scenes. These are scenes most people like to shoot—travel photos are an example.

The exposure measuring system and the display in your camera will not give a correct indication when you are photographing non-average or unusual scenes, which often make the best pictures. This is so important that a whole chapter is devoted to *Exposure Metering*—Chapter 8.

Because there are two exposure controls, it is customary to set one first, then adjust the other to get correct exposure. It is possible to choose the first setting and then find it impossible to balance the camera exposure display. Suppose you decide to shoot at a very fast shutter speed—1/1000 second. Because exposure time is short, this will require a large lens opening. If the light is dim, the largest lens aperture may not be large enough. In that case, you will rotate the aperture ring on the lens to the largest available aperture setting and the exposure display still won't balance. That means you can't shoot at 1/1000 second in that light and you must use a slower shutter speed.

Setting aperture size first can get you into the same kind of situation, so it isn't a cure for the problem. For example, you may decide to use the

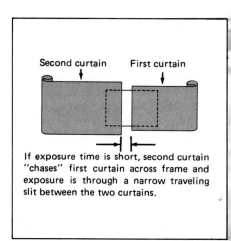

Second curtain First curtain

If exposure time is short, second curtain "chases" first curtain across frame and exposure is through a narrow traveling slit between the two curtains.

For short exposures such as 1/500 second, the second curtain follows so closely behind the first curtain that the entire frame is never open to light all at the same time. The frame is exposed by a traveling slit of light formed by the narrow gap between the two curtains.

What you see in the viewfinder varies among models. The Nikon FM shows you shutter speed at the left, ƒ-stop at the top, and correct exposure by a red LED indicator on the right. Circles in the center are focusing aids, discussed in Chapter 7.

Some scenes are difficult to meter and be sure of correct exposure. When there is any uncertainty, it pays to shoot at several different exposure settings—called *bracketing.*

largest aperture size of the lens and then find that you don't have a shutter speed that's fast enough to work with the large lens opening. This can happen when the light is very bright. If so, change to a smaller lens opening and you will have a shutter speed that works.

SHUTTER PRIORITY AND APERTURE PRIORITY

For reasons discussed later, there are times when shutter speed is the most important setting, so you choose it first and then use whatever aperture size is necessary to get correct exposure. When you choose shutter speed first, you are operating the camera with *shutter priority* or *shutter-preferred*.

If you choose an aperture setting first and accept whatever shutter speed is needed for that aperture size, you are operating with *aperture priority* or *aperture-preferred*.

Automatic SLR cameras measure the amount of light and set one of the two exposure controls automatically, *after* you have set the other one manually. If you set aperture and the camera sets shutter speed, the camera is operating with aperture priority. If you set shutter speed and the camera then chooses a suitable aper-

ture opening, the camera is operating with shutter priority.

There is sometimes a photographic reason to prefer aperture or shutter priority—and sometimes the photographer has a preference.

Depending on which camera model you use, Nikon equipment offers either method. For example, the F3, FE and EM operate with aperture priority when set to automatic. The F2AS camera uses an accessory which converts it to automatic operation with shutter priority. The accessory is called an *EE Aperture Attachment.*

The letters *EE* came into use a long time ago, when electronic light measurement was new. The light sensor was called an *Electric Eye.* Today, EE means any automatic control that is based on light measurement.

BRACKETING EXPOSURES

When there is any uncertainty about correct exposure, it's a good idea to *bracket* so you are sure of getting at least one good shot. Make an exposure at the setting you think may be right. Then make additional shots at other exposure settings, usually both more and less.

With color film, it's usually best to bracket in half-steps because changing exposure also changes the colors. Small color changes can be corrected when printing from color negatives, but can not be corrected on slide film. With b&w, bracketing in full steps is usually OK.

Experience is the best guide to bracketing. Try it and observe the results carefully. Professionals bracket a lot and say, *film is cheap.* If you have made a long trip, hired models and spent all day setting up for a shot, film is cheap compared to your other expenses. Besides that, the professional charges his client for the cost of film and other direct expenses in doing the job.

To many amateurs, film is not cheap and nobody else is paying for it. It still pays to bracket, but you can do it conservatively. If there is any uncertainty of any kind, bracket. If the shot is very important to you, bracket.

If you are shooting in your back yard, and can do it again if you need to, make one exposure using your best photographic judgment and see what happens. I think this is a good photographic exercise that will improve your skill and judgment.

4
LENSES

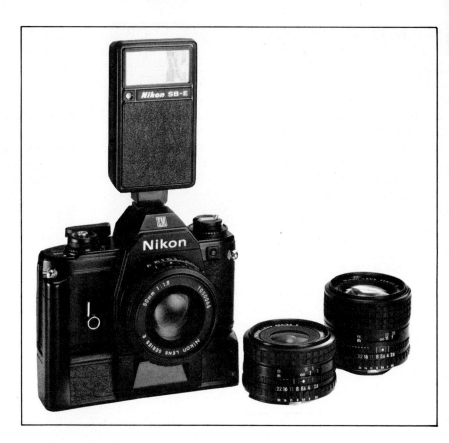

Nikon Series E lenses were introduced along with the EM camera, SB-E Flash and MD-E motor drive. Series E lenses are lighter and smaller than the *AI Nikkor* lenses shown below, and also cost less. Although Series E lenses were announced with the EM camera, they will fit other current Nikon models too.

The letters *AI* mean *Automatic Indexing*, which is explained in this chapter. AI Nikkors are top-quality standard lenses for all current Nikon cameras. A great variety of AI Nikkors is available so you can set up your camera to meet each photographic challenge.

THE NIKON LENS MOUNT

The first Nikon SLR camera, the Nikon F, was introduced in 1959. It used a bayonet lens mount which became known as the *Nikon F mount*. All Nikon and Nikkormat cameras made since then have used the same basic mount.

A lens mount must do several things. It must support and locate the lens precisely. This is done by the metal ring with the three projecting bayonet lugs which mate with three similar projections on the lens.

In addition, the lens mount must allow camera and lens to communicate with each other using levers on both lens and camera. Since 1959, this has been done in several ways. These levers provide two automatic operating features with most lenses: *automatic diaphragm* operation and *full-aperture metering*.

AUTOMATIC DIAPHRAGM

The aperture inside each lens is formed by a diaphragm with pivoted overlapping metal leaves which move in unison to change the size of the opening. When aperture is small, not much light gets inside the camera and the image you see in the viewfinder may be dim or even too dark to see properly. Therefore it is desirable to view at wide-open aperture and then take the picture at whatever smaller aperture size is needed for correct exposure.

In modern SLR cameras, this is done automatically by a mechanism inside the camera body which works with a lever on the back surface of the lens. The automatic aperture feature depends on *both* camera body and lens. All current Nikon and Nikkormat bodies are designed to provide automatic aperture operation with a suitable lens. Most Nikkor lenses have the automatic feature. Those that do not are special, for one reason or another.

STOP-DOWN METERING

Sometime before the moment of exposure, light coming through the lens must be measured by the camera's built-in exposure meter, so the exposure controls can be set correctly. Even though you are viewing at wide-open aperture with the brightest possible image on the viewfinder screen, the light-measuring system in the camera needs to know the amount of light that will come through the lens later—when the aperture is made smaller to take the picture.

One way is manually closing down the lens to the "shooting" or "taking" aperture so you can get a light reading and set exposure. When you measure light coming through a lens which is stopped down, rather than wide-open, it's called *stop-down metering*.

After viewing and focusing at open or full aperture, you operate camera controls to close aperture, reducing the amount of light. This reduced amount of light is measured inside the camera while you set the exposure controls for correct exposure.

FULL-APERTURE METERING

An improvement over stop-down metering allows measuring light *and* setting the exposure controls without stopping down the lens. It's called *full-aperture metering,* or *open-aperture metering*.

When setting exposure, you rotate the lens aperture control just as you would if metering stopped down. However, the lens aperture does not change when you rotate the aperture ring—it remains wide open.

A mechanical linkage between lens and camera body "tells" the camera what lens aperture you are selecting and therefore what the lens aperture will be *later* when it is stopped down automatically by the camera. The camera exposure meter figures exposure settings accordingly. When you adjust camera exposure controls so the viewfinder exposure display is satisfied, you have set exposure according to the amount of light that will come through the lens, even though you are viewing at full brightness through a wide-open lens.

MECHANICAL COUPLING BETWEEN LENS AND CAMERA

For stop-down metering, the basic lens mount is the only necessary mechanical connection. To measure the light, the lens aperture is actually stopped down so less light enters the camera. The camera's built-in meter "sees" the actual amount of light that will be used to expose film.

For full-aperture metering, additional mechanical connections are required between lens and camera.

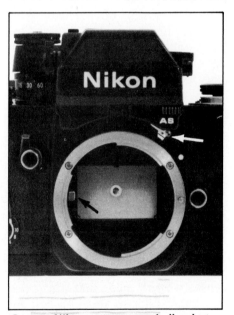

Current Nikon cameras are similar, but not identical. On this F2AS, the Automatic-Aperture Lever (black arrow) causes lens aperture to close to the selected value just before the shutter opens. The Meter-Coupling Lever (white arrow) receives information from the lens that tells the camera what aperture size you have selected during full-aperture metering.

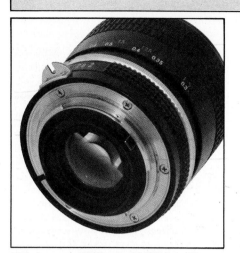

This is a pre-1977 non-AI Nikkor. The Meter-Coupling Prong has a U-shaped slot and there is no Meter-Coupling Ridge.

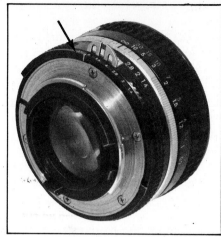

This AI Nikkor has a Meter-Coupling Ridge (arrow) to work with AI cameras. It also has a Meter-Coupling Prong with a slot and two holes for visual identification. The prong works with non-AI cameras.

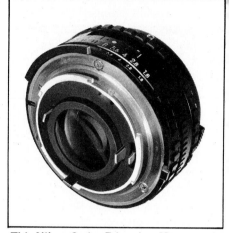

This Nikon Series E lens has Meter-Coupling Ridge only. It works with full automatic features on any AI camera. It also works with stop-down metering on non-AI cameras.

SEMI-AUTOMATIC INDEXING

Before 1977, Nikkor lenses communicated lens aperture settings to the camera body by a metal *Meter-Coupling Prong* on the lens. The cameras had a projecting metal *Meter-Coupling Pin*. When mounting a lens onto the camera, it was necessary to capture the pin in a slot on the lens meter-coupling prong—called *indexing*. Because you sometimes had to assist in coupling pin and prong together, this was called *semi-automatic* indexing.

Lenses of that design are called *Auto Nikkors* and many are still in use.

A later lens design—that I will show you next—is called *Automatic Indexing* which is abbreviated to AI. Because the earlier Nikkor lenses weren't made that way, people today refer to them as non-AI Nikkors to distinguish them from the current design. The cameras that worked with those non-AI lenses are now called non-AI cameras.

AUTOMATIC INDEXING

In 1977, AI lenses and AI cameras were announced. The AI feature on the lens was a projection on the back called *Meter-Coupling Ridge* which you can see in the accompanying photo. This ridge

works with a *Meter-Coupling Lever* on the camera body. These two parts contact each other *automatically,* so these lenses have automatic indexing.

AI Nikkor lenses *also* have a Meter-Coupling Prong so you can use the lens on non-AI cameras. The prong on new-style AI lenses has two holes, one on each side of the slot, so you can tell at a glance what kind of a lens it is.

AI Nikkor lenses work on both AI cameras and non-AI cameras because the lens has both a meter-coupling ridge and a meter-coupling prong. It's the meter-coupling ridge that makes it AI. The prong is just to fit old-style non-AI cameras.

NIKON SERIES E LENSES

In 1979, Nikon Series E lenses were announced. Notice that they are called *Nikon* rather than Nikkor.

These lenses are also AI types because they have the ridge. They don't have the prong and therefore don't "meter-couple" with non-AI cameras. They will mount on non-AI cameras but must be used with stop-down metering.

CONVERTING NON-AI NIKKORS TO AI CONFIGURATION

During the transition from non-AI to AI, owners of old-style cam-

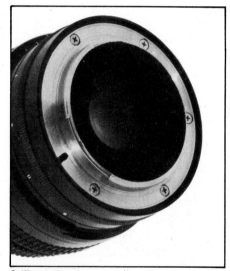

Still another lens type is called *manual*. It has no automatic features; no levers, prongs, ridges or anything except the basic bayonet mount. It is neither AI nor non-AI because it has no automatic features. It fits any Nikon camera and works with stop-down metering.

eras were not handicapped because AI lenses worked on older models. Many Nikon owners purchased new AI cameras and naturally wanted to continue using lenses they already owned. Nikon offers a conversion service through your dealer. Most non-AI Nikkors can be modified to the AI Nikkor configuration with one small exception which applies only to the EM. This is covered in the discussion of the EM camera in Chapter 13.

THREE CURRENT AI CAMERA TYPES

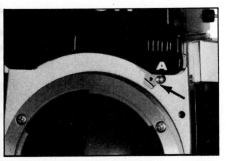

Nikon F2A and F2AS cameras have interchangeable viewfinders. The Meter-Coupling Lever (arrow) is part of the viewfinder.

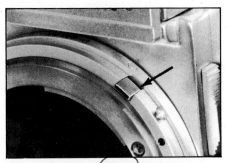

Nikon FE, FM and F3 have a Meter-Coupling Lever which is part of the lens mount. This lever can be flipped up out of the way, for stop-down metering, by depressing the adjacent pushbutton.

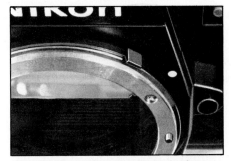

The EM Meter-Coupling Lever is also part of the camera lens mount but does not flip up because that is not necessary for stop-down metering with this camera.

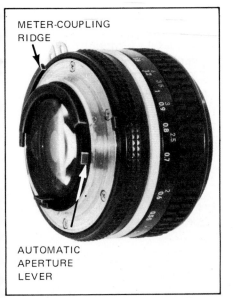

METER-COUPLING RIDGE

AUTOMATIC APERTURE LEVER

AI lenses all have a Meter-Coupling Ridge which works with the camera Meter-Coupling Lever to signal lens aperture settings. They also have an Automatic Aperture Lever which the camera uses to stop down the lens just before each exposure.

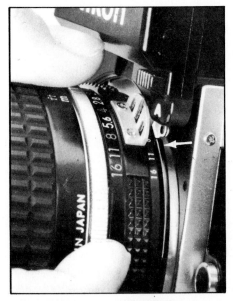

This AI Nikkor lens is installed on a Nikon F2A which is an AI camera. Notice that the Meter-Coupling Ridge on the lens is contacting the Meter-Coupling Lever on the camera. The *prong* on the lens isn't doing anything.

AI Nikkor lenses and non-AI Auto Nikkor lenses work the same way on non-AI cameras. The *prong* on the lens captures a *pin* on the camera. Non-AI cameras are not covered in this book.

All cameras described in this book are AI cameras, meaning they are designed to work with AI lenses. Some earlier models not described in this book are AI, some are non-AI.
AI Cameras: F3, EM, FE, FM, F2A, F2AS, EL2; Nikkormat FT3
Non-AI Cameras: F2 Photomic, F2SB Photomic; Nikkormat EL, ELW and FT2

METHODS OF APERTURE CONTROL

Historically, automatic lens features were developed over a period of years with a pause after each new development. During this pause, the latest development became standard and was given a name to distinguish it from earlier types.

In the Nikkor series of lenses, three of the stages of lens development are still represented.

Manual Lenses—These have no automatic features at all. To change the aperture setting, you reach around and do it by hand. Lens aperture size changes immediately when you rotate the control and the viewfinder image changes brightness.

Today, a few Nikkor lenses are the manual type even though thoroughly modern in every other aspect. Manual control of aperture is used when the design of the lens makes it impossible or impractical to use another form of aperture control.

Preset Lenses—In some cases, there there is an advantage in being able to focus at full aperture and then quickly change the lens to shooting aperture without removing your eye from the viewfinder. With a manual lens, this can't be done because you have to look at the lens aperture scale while you manually rotate the aperture ring to select the desired *f*-number.

An improvement of manual lenses was the addition of a *preset aperture ring* which works with the normal aperture ring as follows: Set the preset ring to the desired *f*-number. The preset ring does not control aperture size, it merely serves as a mechanical limit to rotation of the aperture ring. You can set the aperture ring to any larger aperture size than that selected by the preset ring, but not to any smaller aperture.

After shooting aperture is selected by the *preset ring,* use the adjacent *aperture ring* to open the lens aperture fully. This allows viewing at maximum brightness and focusing with maximum precision.

After viewing, composing and

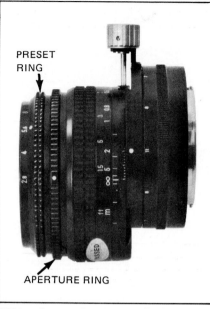

Nikkor Perspective Control (PC) lenses have a special adjustment that is useful in shooting architecture and similar applications as discussed later in this chapter. PC Nikkors are preset lenses with no automatic features. Preset Ring is set at a detent for desired shooting aperture. Then the Aperture Ring, which has no detents, can easily be rotated with one finger to open lens for viewing and then close lens to selected aperture size—all without looking at the lens.

focusing, turn the aperture ring toward smaller apertures without removing your eye from the viewfinder. The aperture ring will reach a mechanical limit at the *f*-number set on the preset ring. Then trip the shutter.

A few special lenses in the Nikkor line have preset aperture rings as noted in the lens tables at the end of Chapter 13.

Automatic Aperture—The logical development from preset aperture was to a mechanism that closes aperture for you automatically, after you have composed the picture and focused at full aperture. The lens stops down when you depress the shutter button. Nearly all Nikon and Nikkor lenses, including both AI and non-AI types, have automatic aperture.

Meter-Coupled—Lenses that allow full-aperture metering are sometimes called *meter-coupled.*

Even though a lens is equipped for full-aperture metering, you can't always use it that way. There are some lens accessories that fit between lens and camera but do not complete all of the mechanical linkages required for full-aperture metering. For example, a bellows mounts the lens on its forward end and attaches to the camera at the other end. The bellows does not mechanically transmit the mechanical signals between lens and camera, so full-aperture metering is not possible.

Every Nikon and Nikkormat camera has a simple stop-down metering procedure for use when you need it. You need it either when metering with non-automatic lenses or when metering with auto lenses but with accessories that prevent automatic lens operation.

After a bit of familiarization, you will meter stop-down or full-aperture, whichever is appropriate for the camera setup you are using.

THANKS

This book required a lot of assistance from some capable and generous people. Some helped get the project underway; some helped during preparation by providing information and also equipment for me to use and photograph; some helped by reading copy and correcting my errors. I want to say *thank you.*

Some of those who helped are listed below in no particular order. Because job titles and company affiliations change occasionally, I have omitted this information to keep it from being wrong sometime in the future.

Myron Charness Hiro Mizuno
Patricia Maye Joyce Campbell
Ray Vitiello Hideo Fukuchi
Al Parker Norio Miyauchi
Richard LoPinto Jeff Karp

HOW TO MOUNT NIKKOR LENSES

F2A, F2AS

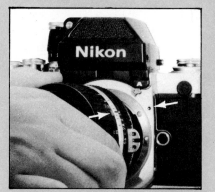

Align index mark on AI lens with dot on camera body. Grip knurled metal ring on lens body and turn counterclockwise until lens clicks into place.

To mount a non-AI lens, first set up the camera for stop-down metering as shown below.

F3, FE, FM

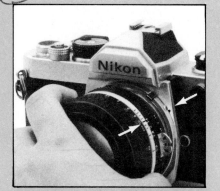

Align index mark on AI lens with dot on camera body. Grip knurled metal ring on lens body and turn counterclockwise until lens clicks into place.

To mount a non-AI lens, first set up the camera for stop-down metering as shown below.

EM

Align index dot on AI lens with dot on camera body. Grip knurled center part of lens body and turn counterclockwise until lens clicks into place.

Do not attempt to mount a non-AI lens on an EM camera. Damage to the camera will result.

HOW TO SET UP FOR STOP-DOWN METERING

F2A, F2AS

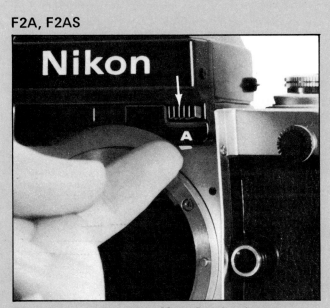

Before mounting lens, move Meter-Coupling Lever up to the right until it clicks. Mount lens and use camera exposure meter in the normal way. To restore full-aperture metering, remove lens, move Coupling Lever Release Button (arrow) to right until coupling lever drops down again.

F3, FE, FM

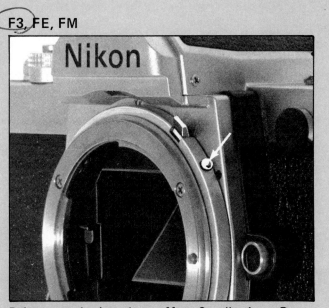

Before mounting lens, depress Meter-Coupling Lever Release Button (arrow) and flip Meter-Coupling Lever up as shown. Mount lens and use camera exposure meter in the normal way. To restore full-aperture metering, remove lens, flip Meter-Coupling Lever down again.

EM

When stop-down metering is necessary with the EM camera, the camera does it automatically without any special control settings on the camera.

HOW A LENS
MAKES AN IMAGE

Later in this book, I'm going to discuss close-up and macro photography and for that you need some basic information about how a lens makes an image, types of lenses, and what focal length means in the technical sense. This requires some formulas and simple math but it has a practical payoff in several ways. The most important is in photography with attachments to the camera.

LIGHT RAYS

We assume that light travels in straight lines called *rays*, and light rays do not deviate from straight-line paths unless they are acted on by something with optical properties such as a lens.

Light rays which originate from a source such as the sun, or which reflect from an object such as a mountain, appear to be parallel rays after they have traveled a considerable distance. In explaining how lenses work, the simplest case is when the light rays reaching a lens have traveled far enough to appear parallel, as in Figure 4-1.

CONVERGING LENSES

If you photograph a distant mountain, each point on the surface of the mountain reflects light rays as though it is a tiny source of light. The rays which enter the lens of your camera are effectively parallel. Rays from each point of the scene are scattered all over the surface of your lens but all those which came from one point of the scene are brought to focus at one point on the film as shown in Figure 4-2.

This drawing shows a simple single-element lens which is convex on both sides. This is called a *converging* lens because when light rays pass through, they converge and meet at a point behind the lens.

Focal length is defined as the distance behind the lens at which *parallel* light rays will be brought to focus by the lens. That implies a subject which is far enough away

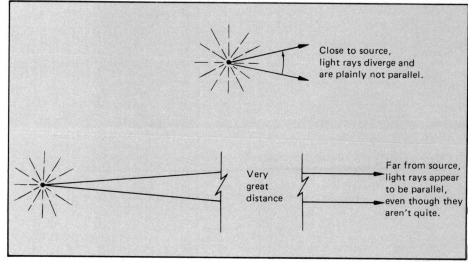

Figure 4-1/Light rays from a point source obviously diverge when you are close to the source. At a great distance, they still diverge, but *appear* to be parallel.

from the lens so the light rays appear to be parallel. We label that subject distance *infinity*—symbol ∞ —on the distance scale of a lens but it actually doesn't have to be very far away. Any subject beyond 100 feet or so appears to be so far away that the light rays from it are effectively parallel.

Figure 4-2 shows what happens to *parallel* rays when they are brought to focus by a converging lens. This lens will also image subjects closer than infinity, but it takes a greater distance between lens and film to bring nearby subjects into focus.

Figure 4-3 shows why. Light rays from a nearby subject diverge as they enter the lens. The lens will still change their paths so they come to focus, but because they were diverging rather than parallel when they came into the lens, it takes a greater distance behind the lens to bring them all together at a point.

Focusing a camera moves the lens toward or away from the film so there is the needed amount of distance between lens and film to bring light rays from the subject into focus.

Please notice that the *shortest*

distance ever required between lens and film occurs when the subject is at infinity and the light rays are parallel. All subjects nearer than infinity require a longer distance between lens and film. Therefore, to change focus from a distant subject to something nearby, you move the lens away from the film.

DIVERGING LENSES

Diverging lenses are shaped the opposite way and do the opposite thing. Parallel rays entering a diverging lens emerge on the other side as divergent rays—angled away from each other as shown in figure 4-4.

FOCUSING

Nikkor lenses focus by rotating a ring on the lens body, called the *focusing ring*. Mechanically, rotation of the focusing ring causes the glass elements in the lens barrel to move toward or away from the film, bringing objects at various distances into focus at the film plane. In most lenses, the glass elements move by traveling along a screw thread inside the lens, called a *helicoid*.

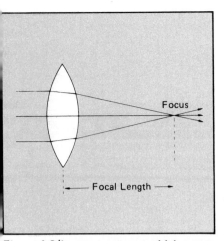

Figure 4-2/Lenses treat rays which appear parallel as though they are actually parallel. A converging lens brings parallel rays to focus at a distance behind the lens which is equal to the focal length of the lens.

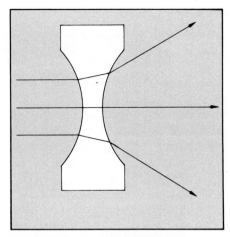

If light rays are parallel, from a distant source, lens brings them to focus at a distance equal to the focal length.

If light rays are diverging, from a nearby source, lens brings them to focus at a distance longer than the focal length.

Figure 4-3/Light rays from a nearby source are not parallel, so more distance behind the lens is needed to bring diverging light rays into focus.

Figure 4-4/A diverging lens causes rays to diverge as they pass through the lens.

When focused at infinity, the glass lens elements are positioned so the lens-to-film distance is equal to the lens focal length. To focus on nearer objects, the glass lens elements travel outward on the helicoid. When the end of the helicoid thread is reached, that's as close as the lens can focus without special accessories.

All Nikkor lenses will focus to infinity—some beyond infinity. The closest focusing distance varies as you can see in the lens tables beginning on page 202. Lenses with short focal lengths typically have minimum focusing distances that are also short—usually around 12 inches. Lenses with long focal lengths typically have minimum focusing distances that are correspondingly long—a few feet to over 100 feet.

A distance scale is engraved on the focusing ring so you can see where the lens is focused. The scale shows distance in both feet and meters and the scale is read by reference to an index mark on the lens body. The same index mark is also used to read f-numbers on the aperture ring.

This gives you two ways to determine where the plane of sharpest focus is. One way is to look through

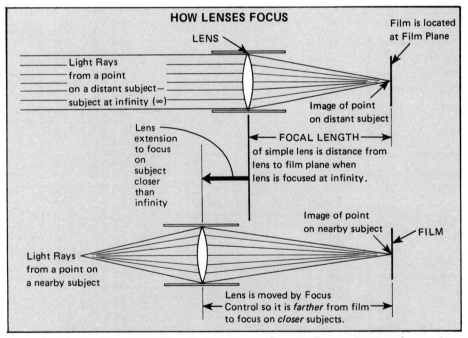

HOW LENSES FOCUS

LENS

Film is located at Film Plane

Light Rays from a point on a distant subject— subject at infinity (∞)

Image of point on distant subject

FOCAL LENGTH of simple lens is distance from lens to film plane when lens is focused at infinity.

Lens extension to focus on subject closer than infinity

Image of point on nearby subject

FILM

Light Rays from a point on a nearby subject

Lens is moved by Focus Control so it is *farther* from film to focus on *closer* subjects.

To make a focused image on film, the lens is moved so the distance between lens and film is correct.

the camera viewfinder and observe which part of the scene is in sharpest focus. The other is to look at the focused-distance scale on the lens. If you are focused sharply on an object 10 feet away, the focused-distance scale should indicate 10 feet. Focused distance is measured from the film

plane in the back of the camera.

Some camera models have a film-plane indicator mark engraved on the top of the camera. On models without the film-plane indicator, the film plane is at the forward edge of the camera serial number engraved on the camera top plate.

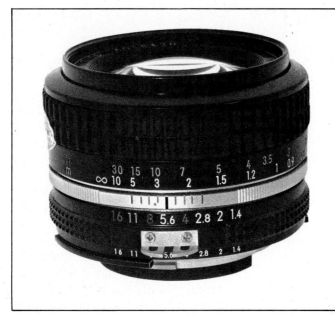

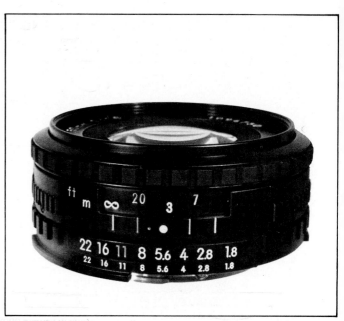

This is an AI Nikkor lens. The lens controls are the Focusing Ring, near the front, and the Aperture Ring, near the back. Focused distance scales are in feet and meters. This lens is focused at about 9 feet or about 2.7 meters, depending on which scale you prefer to read. Aperture setting is f-5.6. The smaller aperture scale at the back of the lens is the Aperture Direct Readout (ADR) scale which appears in the viewfinder of some camera models.

This Nikon Series E lens has the same controls and scales as an AI Nikkor although the appearance is a little different. Series E lenses are smaller and lighter than AI Nikkors of the same focal length.

LENS COMPATIBILITY

EM

Uses Nikon Series E and AI Nikkors with full-aperture metering and automatic diaphragm. Uses manual and preset Nikkors with stop-down metering and manual diaphragm control. *Do not attempt to mount a non-AI Auto Nikkor or lenses of other manufacture without the AI feature; damage to the camera will result.*

F3, FM, FE, F2A, F2AS

Use AI Nikkors or Nikon Series E lenses with full-aperture metering and automatic diaphragm. Use manual and preset Nikkors with stop-down metering and manual diaphragm control. Use non-AI Auto Nikkors with stop-down metering and automatic diaphragm.

F2

Uses any lens with Nikon F mount. Camera does not meter but will provide automatic aperture with non-AI Auto Nikkors, AI Nikkors and Series E lenses.

EARLIER NON-AI NIKON AND NIKKORMAT CAMERAS

Use non-AI Auto Nikkors or AI Nikkors with full-aperture metering and automatic diaphragm. Use manual and preset Nikkors with stop-down metering and manual diaphragm control. Use Nikon Series E lenses with stop-down metering and automatic diaphragm.

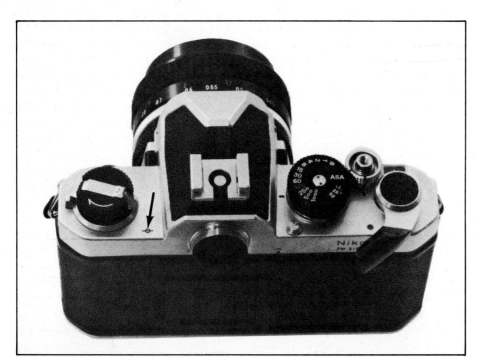

Focused distance is measured from film plane in camera. Camera will have film-plane indicator (arrow) on top of body, or serial number, or both. If film-plane indicator is not on camera, film plane coincides with forward edge of camera serial number.

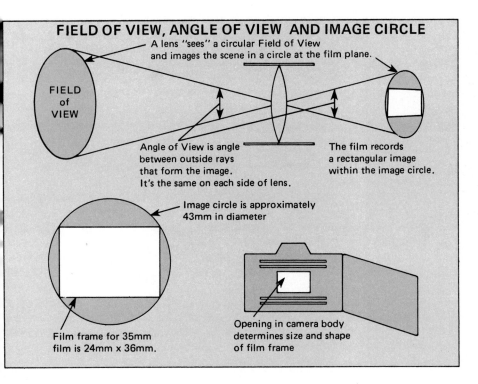

FIELD OF VIEW, ANGLE OF VIEW AND IMAGE CIRCLE

A lens "sees" a circular Field of View and images the scene in a circle at the film plane.

FIELD of VIEW

Angle of View is angle between outside rays that form the image. It's the same on each side of lens.

The film records a rectangular image within the image circle.

Image circle is approximately 43mm in diameter

Film frame for 35mm film is 24mm x 36mm.

Opening in camera body determines size and shape of film frame

FIELD OF VIEW

What the lens "sees" is called the *field of view.* If you point the lens so it sees only a flat wall, the field of view is a circle on the wall. If you point the lens at a landscape, the field of view is still circular at any point, but the circle has greater diameter at points farther from the camera. In other words, the lens sees everything in an expanding cone, with the tip of the cone at the lens.

THE IMAGE CIRCLE

A circular lens makes a circular image of a circular portion of the scene. In the camera a rectangular opening in front of the film allows only part of the circular image to fall on the film. This defines a rectangular *film frame.*

Dimensions of the film frame on 35mm film are 24mm by 36mm, which is about 1" by 1-1/2". This rectangular frame fits snugly inside the *image circle* which is about 43mm in diameter with all ordinary lenses.

Even though the camera viewing system shows a correctly oriented image, the image on film is upside down and reversed left-to-right.

FOCAL LENGTH

Focal length is expressed in *millimeters,* abbreviated *mm.* Technically, focal length is the distance between a certain location in the lens and the film in the camera when the lens is focused at infinity, as shown in Figure 4-2.

One practical value of focal length is a label or name for different types of lenses. The focal-length number tells you some important things about how the lens will "act" when installed on your camera.

Lenses are grouped by focal length into three classes: Short, medium and long, according to this table:

Short focal lengths—35mm and shorter
Medium focal lengths—45mm to 135mm
Long focal lengths—200mm and longer

The differences are *angle of view* and *magnification.* Short-focal-length lenses such as 20mm and 28mm have wide angles of view and low magnification.

Angle of view is the angle between the two edges of the field of view.

Because a lens sees a circular part of the scene and makes a circular image, its true angle of view is the same vertically, horizontally or at any angle in between.

Because the 35mm film format is a rectangle fitted closely into the image circle made by the lens, everything seen by the lens is not recorded in the film frame. This results in a slightly different definition: *the angle of view which is recorded on film.* In that sense, the 35mm camera lens has three angles of view: Horizontal, Vertical and Diagonal. Diagonal is the largest angle because it is corner-to-corner of the film frame. Horizontal is smaller; vertical is smallest because the film frame is not as tall as it is wide.

In photographic literature, when only one angle of view is given for a lens, it is the diagonal angle.

You can get a feel for angle of view by testing your own vision. With both eyes open, hold your arms straight out to the sides and then move them forward until you can just see your hands while looking straight ahead. Your angle of view will be a little less than 180 degrees.

Do it again with one eye closed. The angle will be a lot less. Clear vision for a single eye covers a total angle of around 50 degrees, depending on where you decide you can't see clearly enough to call it vision.

A 50mm lens has an angle of view of about 46 degrees. This is often called a normal lens for 35mm cameras and the reason given is that the angle of view is about the same as the human eye. Obviously this means *one* eye. Most people see with two eyes, so this definition of a normal lens doesn't make much sense.

Another way of defining a normal lens is to say it has a focal length approximately the same as the diagonal of the film frame. There's no basic wisdom in this—it's merely another way of stating the angle of view. In the 35mm film format, the diagonal measurement of the frame is about 43mm, so a normal lens should have a focal length of approximately 43mm.

28mm

50mm

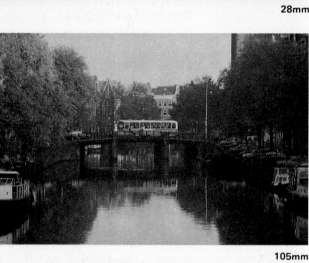

105mm

200mm

Photos made on a hazy afternoon in Amsterdam show how angle of view changes with focal length. Shot made with 28mm lens includes part of the canal bridge I was standing on. Shot made with 400mm lens has much narrower angle of view and much more magnification as you can see by size of bus. Because of higher magnification, lenses with long focal length will blur the picture if not held rock-steady. This 400mm shot shows the effect of traffic vibration of the bridge I was standing on.

400mm

For 35mm cameras, a 50mm or 55mm lens is considered normal or *standard,* because it is a good general-purpose lens and a compromise between wide and narrow angles of view. You can't do everything with a 50 or 55mm lens, but you can make a lot of fine pictures with it.

Use wide-angle short-focal-length lenses when you want to show a lot of the scene being photographed. They are handy in taking interiors when you want to get a lot of the room but the walls prevent you from backing up very far.

Long-focal-length lenses, such as 200mm and 300mm have narrow angles of view. A 200mm has an angle of about 12 degrees. A common type of lens with long focal length is called *telephoto.* Not all long lenses are of the telephoto de- sign but most are and the word has come to mean the same thing in popular terminology.

We think of a long lens as one that can "reach" out and fill the frame with a distant subject such as a mountain climber high up on a rock face. It excludes most of the mountain because of its narrow angle of view. What that really means is the lens has high *magnification.*

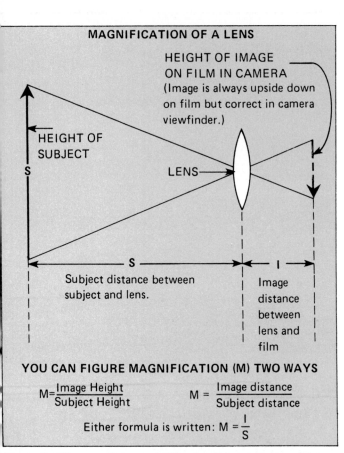

Figure 4-5/You can figure magnification by comparing subject and image heights, or subject and image distances from the lens.

Stamps are often photographed at higher-than-normal magnification, using special lenses and lens accessories described in Chapter 9.

MAGNIFICATION

Magnification is illustrated with the outside rays that pass through a lens, as in Figure 4-5. In this drawing, the subject is an arrow and the image is an upside-down arrow. In each case, the arrow extends all the way across the field of view. Magnification is a ratio or fraction: *The size of the image divided by the size of the subject.* In this case, the image is the one formed inside the camera, at the film plane. When making prints or enlargements, the image is usually magnified a second time. This discussion concerns only magnification in the camera.

Because the angle of view is the same on both sides of a lens, the sizes of image and subject are proportional to their distances from the lens. If image and subject are the same distance from the lens, they will be the same size.

This leads to two ways to think about magnification. You can compare sizes, or you can compare distances. Either way, you get the same result.

A simple formula to figure magnification is:

$$M = \frac{I}{S}$$

where I is either image size or image distance from the lens, and S is either subject size or subject distance.

Suppose the image on film in your camera is one-inch tall and the subject you are photographing is 50-inches tall. Figure magnification by comparing sizes:

$$M = \frac{\text{Image Size}}{\text{Subject Size}}$$
$$= \frac{1}{50}$$
$$= 0.02$$

Which you can also write as 2%.

The image is 2% as tall as the subject. Whenever magnification is a number less than one, the image is smaller than the subject.

Suppose the distance from lens to film is 2" and the distance from lens to subject is 100". You can figure magnification by comparing distances:

$$M = \frac{\text{Image Distance}}{\text{Subject Distance}}$$
$$= \frac{2''}{100''}$$
$$= 0.02$$

With lens accessories discussed in Chapter 9, you can make the image larger than the subject. Suppose the image is 1"tall and the subject is only 0.25" tall.

$$M = \frac{\text{Image Size}}{\text{Subject Size}}$$
$$= \frac{1}{0.25}$$
$$= 4$$

The image is 4 times as large as the subject and magnification is 4. Whenever magnification is a number larger than one, the image is larger than the subject. When magnification is exactly 1.0, image size and subject size are equal; image distance and subject distance are equal.

FLARE AND GHOST IMAGES

Light arriving at the front surface of a lens is partly reflected at the surface and partly transmitted through the glass in the direction we want it to travel. This happens at every air-glass boundary in a lens. Light rays which have passed through the front surface of a lens element are again reflected at the back surface of the piece of glass. Some light rays leave the glass and continue traveling toward the film. Some are reflected *internally* at the glass-air boundary and then bounce around inside the lens element.

Modern camera lenses are *compound,* meaning they have more than one lens element, so there are multiple reflections both within a single lens element and between elements.

In general, any light which is deflected or scattered from its intended path of travel will land somewhere it doesn't belong. This tends to put light on the film where there would otherwise be less light. The stray light has been "robbed" from areas where it should have been. Therefore light areas on the film are not as light as they should be and dark areas are not as dark. The result is a general reduction in contrast.

If the light which is scattered around by lens reflections forms no definite image on the film but is an overall fog and even a fog over a relatively large area of the picture, we call it *flare.*

Sometimes the reflections from lens surfaces happen in a way that causes a definite shape on the film—typically geometrical figures which are images of the lens aperture. Images of this sort are called *ghosts*.

The cure is to reduce light reflection at each glass-air surface. This is done by lens coating.

I used an old, poorly coated lens to make ghost images of the aperture by pointing the lens toward the sun and not using a lens hood.

LENS COATING

The first lens-coating method was a single very-thin layer of a transparent material such as magnesium fluoride. This made a great improvement in picture quality by reducing reflections from coated lens surfaces. However a single coating is not effective at all colors of light.

An improvement was obtained by using multiple coating layers of different thicknesses, so reflections are reduced at all colors of the spectrum. Most Nikkor lenses of recent manufacture have multiple-layer coating, identified as *NIC—Nikon Integrated Coating*—Nikon series E lenses also have NIC.

When a surface reflects less light, it transmits more light. Therefore multiple-layer coating has several beneficial effects. It reduces flare and ghosts which makes pictures sharper, with better contrast between adjacent light and dark areas. It also causes lenses to transmit more light, which makes the viewfinder image bright and puts more light on the film during exposure.

Nikon Integrated Coating also helps to color-match the light through Nikkor lenses so you don't see a color difference when the same subject is photographed through different lenses.

Complicated modern lenses, such as zoom lenses, use a lot of glass elements. Good quality in these lenses is possible because of modern multiple-layer lens coating.

LENS ABERRATIONS

To photographers, lens *aberrations* are like the boogie-man: mysterious, threatening and always lurking around trying to do something bad. Aberrations of a lens cause defects in the image.

There is a long shopping list of aberrations, including spherical aberration, chromatic aberration, coma and astigmatism. All lenses have all of these defects to some degree. Total elimination is probably impossible but partial *correction* is part of the design of each lens. For more money, you get more correction.

Correction of lens aberrations is done in several ways. Basic is the design of the lens itself, using multiple pieces of carefully shaped glass elements. This has always involved laborious mathematics. The process has been both speeded and improved by use of modern electronic computers to do the arithmetic.

To correct some of the lens aberrations, glass of differing chemical composition is used for the various elements in the lens. A limitation is the range of different types of glass. A special group of Nikkor telephoto lenses uses a special type of lens glass, called *Extra-low Dispersion,* for some of the lens elements. This results in a significant aberration reduction and corresponding improvement in image quality. These special lenses are identified by the symbol *ED* and are listed in the lens tables at the end of Chapter 13.

Because there are many different aberrations and the fact that correcting them is a series of compromises, the best guide to the lens user is simply the reputation of the lens maker.

Nikkor lenses have always been world leaders in quality, using the newest developments in materials and techniques. In fact, it was lens quality which first drew world attention to the Japanese Nikon cameras with Nikkor lenses.

Aside from purchasing lenses from a manufacturer with an established reputation for quality, there are only a few things the user can do to affect image quality. Keep the lens clean and protected from mechanical damage. Use a lens hood to keep stray light off the front surface of the lens. Focus carefully and don't move the camera during exposure.

Most aberrations have less effect on the image if the lens is used at medium apertures. Using ordinary films, it's hard or impossible to see any difference, but theoretically it is better to shoot at an aperture smaller than wide open.

A special-effects filter, the Samigon Kolor-Trix® circular diffraction filter, uses diffraction on purpose to spread the image of the early morning sun and break it up into color bands. *Unintended* diffraction through small lens apertures causes reduced contrast and loss of detail in your picture.

DIFFRACTION

When light rays make grazing contact with an opaque edge such as the edge of the lens aperture, they are *diffracted.* They are changed in direction slightly, bending toward the metal edge. If the region on the film where diffracted rays have landed is examined under a microscope, you can see alternating light and dark bands caused by diffraction.

Light rays from each point of the scene should be imaged at a point on the film. Due to diffraction, some rays are diverted and land at the wrong places. This reduces image contrast and image sharpness.

Only those rays which pass very close to the edge of the lens aperture are affected—those which go through the center of the opening are not diffracted.

Therefore the amount of image degradation due to diffraction depends on what proportion of the rays graze past the edge of the aperture and what proportion go through the center of the hole.

Depth of field is controlled by lens aperture. At left, I focused on the center screw but used small aperture so the other two are in fairly good focus. At right, I used large aperture so depth of field is narrow and only includes screw in center. Notice zone of good focus along ruler scale.

As an aperture is made smaller, there is more edge in proportion to the amount of hole, so the total percentage of rays which are diffracted is higher.

Theoretically, the image made by a lens at its smallest aperture will not be as good as one made at larger apertures, because of diffraction.

OPTIMUM APERTURE

If a lens is scientifically tested for image quality, starting at maximum aperture, the image will improve at successive *f*-stops as the lens aperture is closed because the effect of aberrations is reduced.

It varies among lenses, but typically at around *f*-8 the image is as sharp as it's going to get. Further reductions in aperture size cause diffraction effects to degrade the image.

Usually there are other compelling reasons which determine aperture size, but if you have none and you want the best image, set the lens at an *f*-stop near the center of its range.

DEPTH OF FIELD

Most photos include objects in the foreground, in the middle distance and far away. Typically, not all objects in the picture are in sharp focus. Usually there is a zone of good focus. Objects on the near side of this zone are out of focus, and objects on the far side are also out of focus.

The point of *best* focus—where you have actually focused the lens—is somewhere within the zone of good focus.

If a subject stands at the point of best focus and then starts walking toward the camera, focus will gradually get worse as the subject moves nearer. At some point focus will be just barely acceptable. That point defines the *near limit* of the zone of good or acceptable focus. Subjects closer to the camera have unacceptable focus. Similarly, there is a *far limit* to the zone of good focus.

Depth of field is a measure of the zone of acceptable focus. It is the distance from the nearest object in good focus to the farthest object in good focus. For example, if the near limit is 10 feet from the camera and the far limit is 30 feet from the camera, depth of field is 20 feet.

RULES ABOUT DEPTH OF FIELD

Several things affect depth of field.

Here are some practical rules or "ways to think" when taking a photo.

DEPTH OF FIELD IS INCREASED BY:
1) Shorter focal-length lens
2) Smaller lens aperture
3) Greater subject distance

DEPTH OF FIELD IS DECREASED BY:
1) Longer focal-length lens
2) Larger lens aperture
3) Shorter subject distance

These rules force you to this conclusion: If the image doesn't have enough depth of field, there are only two things you can do to improve it. A) You can use smaller aperture or B) make a smaller image in the camera. The smaller image comes from using a lens with shorter focal length or backing away from your subject, or both in combination.

VIEWING DEPTH OF FIELD

If you observe the scene through the viewfinder at wide-open aperture, and then the camera takes the picture at a smaller aperture, you did not see the same depth of field that was recorded on film because smaller apertures give more depth of field.

Viewing depth of field in the viewfinder is a thoroughly practical and simple way to see if there is enough

Depth of field is an artistic control, very important to your photographs. Using the Nikkor 135mm ƒ-2.8 lens at maximum aperture and focusing on objects at different distances from the camera, I could place the narrow depth of field where I wanted it. First, I focused on the fence post. Then on the bush beyond. Then on the distant boat. Returning focus to the bush, but with smaller aperture, gave increased depth of field so all three are in fairly good focus.

depth to satisfy your objective in making the photo. But to see depth of field as recorded on film, you must stop down the lens to the aperture that will be used to make the picture.

If you happen to be metering stopped-down, that's the time to view depth of field. If you are metering at full aperture, another step is required to see depth of field at shooting aperture. All Nikon cameras except the EM have a control that will stop down the lens to shooting aperture. First you balance the viewfinder exposure display by adjusting shutter speed and aperture size. Then you operate the Depth-of-Field Preview Button on the camera and the lens closes down to the aperture selected by the aperture ring on the lens.

You can see depth of field change as the lens stops down. Sometimes the effect is very pronounced and has a great impact on the image.

If the depth of field you see is not what you want, you are probably not stuck with it. Usually you can choose a different aperture size and compensate by using a different shutter speed. With an adjustable camera, you have control over depth of field.

If you have selected a small aperture size, perhaps to get lots of depth of field, the viewing screen will become noticeably darker when you operate the depth-of-field preview button. It may take a moment for your eye to become adapted to the lower light level.

READING DEPTH OF FIELD OFF THE LENS SCALE

Sometimes there isn't enough light to judge depth of field accurately—particularly if you are shooting in dim light anyway. Sometimes you need to plan a shot in advance and you need to know how much depth of field there will be before you actually view the scene through the viewfinder.

For situations like these, Nikkor lenses have a Depth-of-Field Scale engraved on the lens body. It works with the other scales on the lens— aperture size and focused distance— because depth of field is controlled by aperture size and focused distance. To use the depth-of-field scale, the lens must first be focused

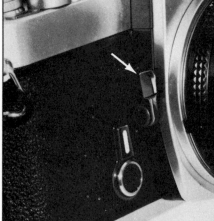

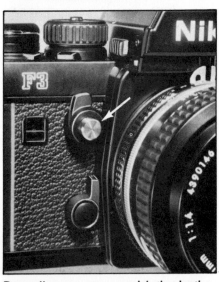

F-3

Depending on camera model, the depth-of-field preview button or lever is in one of these locations as shown by arrows in these photos. It is always easy to reach and operate with your right index finger.

on the subject of interest or pre-focused to the distance where you will later place the subject.

As shown in the accompanying picture, the depth-of-field scale is pairs of color-coded lines surrounding a center index mark. Each pair of lines of the same color indicates a span of distance on the focused-distance scale. For example, the red line on the left of the index mark "points" to a certain distance on the distance scale. The red line on the right side of the index points to another distance. There is a certain span of distance between the two red marks.

Similarly, there is a different span of distance between the other pairs of color-coded marks.

Here's how you know which color to use: Notice that the *f*-number scale on the lens is also color-coded to match the colors of the depth-of-field scale. Green, red, yellow and blue are used to identify certain *f*-numbers. If you set aperture to the *f*-number that is colored green, read depth of field between the two green lines on the depth-of-field scale, and so forth.

Not all *f*-numbers are color-coded. Each color-coded *f*-number on the

aperture scale requires a pair of color-coded lines of the same color on the depth-of-field scale. If every *f*-number were color-coded, there would be so many lines on the depth-of-field scale that it would be difficult to read. The *f*-numbers that are color-coded will give you a satisfactory indication of depth-of-field.

If you change focused distance while observing the depth-of-field indication on the distance scale, you will notice two things. Of course the near limit and the far limit of good focus will change because you are focusing the lens to a different distance. When you focus a lens, you can think of it as moving the *zone* of good focus farther away, or nearer. Also, you will get more actual depth of field when focused farther away.

DEPTH OF FIELD IS ARBITRARY

If you dig into the math behind depth of field, you'll find many if's, but's and maybe's. Depth of field is not an exact thing. It's an estimate. One problem is deciding where good focus stops. If your eyesight or desire for perfection differ from mine, we will not agree on good focus.

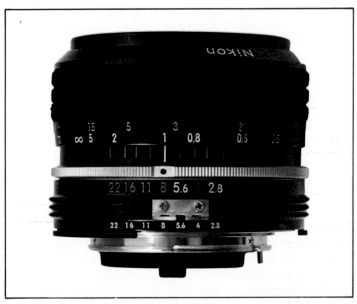

This lens is set at *f*-8, which is a pink color on the aperture scale. Depth of field is therefore between the two pink lines on the depth-of-field indicator. You read depth of field at two points on the focused distance scale, opposite the two indicator lines whose color is the same as the *f*-stop. In this example, depth of field is from about 0.8 meter to about 1.5 meters.

To establish some standard for good focus, lens designers reason as follows: Every tiny point on the subject should be a tiny point on the image. As focus gets worse, the tiny point on the image becomes a circle instead of a point. When the circle exceeds a certain diameter, focus is no longer acceptable.

The technical name for that blurred circle on the film is *circle of confusion*—a popular and sometimes apt name chosen for camera clubs.

The circle of confusion is defined in more than one way. Sometimes it's an absolute diameter such as 1/1000 inch. The reasoning is, a circle that small is indistinguishable from a point. Another way is to specify the circle of confusion as a certain fraction of the lens focal length, such as 1/1000. There is no solid agreement on any of these numbers.

For most Nikkor and Nikon Series E lenses, depth of field is calculated assuming the circle of confusion is 0.033mm which is very close to 1/1000 inch.

Please notice that changing the *definition* of depth of field will not change the actual image.

OTHER WAYS TO FIND DEPTH OF FIELD

Viewing depth of field through the camera, or reading it off the lens scale, will satisfy nearly all ordinary requirements. But there are other ways to find it.

You Can Calculate Depth of Field— These formulas will work:

$$\text{Near Limit} = \frac{F^2 S}{F^2 + SfC}$$

$$\text{Far Limit} = \frac{F^2 S}{F^2 - SfC}$$

Depth of Field
= (Far Limit) −
(Near Limit)

In these formulas,
C = diameter of circle of confusion in meters (0.033mm = 0.000033m)
f = lens aperture setting or f-number
S = distance to subject in meters
F = lens focal length in meters
Depth of Field is calculated in meters.

To get feet, multiply meters by 3.3.

These formulas work best for lenses with focal lengths near 50mm.

These formulas also work best for lenses used without accessories to increase image size or magnification. When you are using accessories to get a larger-than-normal image on film in the camera, depth of field is less than these formulas suggest. See Chapter 9.

You Can Look It Up—Depth-of-Field Tables are included with individual lenses. Save the data for those few occasions when you can't satisfy a depth-of-field requirement by any other method.

VIEWING AN ENLARGEMENT

The depth of field discussion, so far, relates to the image in your camera. Normally this image is made larger for viewing, either by making a print or projecting a slide.

After enlargement, the depth of field perceived in a picture depends on two additional things: how much the image is enlarged and how far the viewer stands from the print or the projection screen.

Often the photographer doesn't have control over viewing conditions. If they are not optimum for depth of field, you can't do much about it. If the image is enlarged more, or the viewer stands closer, apparent depth of field is reduced. If the image is enlarged less, or viewed from farther away, apparent depth of field is increased. This can be deduced by thinking about circles of confusion on the enlargement and whether the viewer can see them or not.

The practical approach is to make a picture that will have satisfactory depth of field in the viewfinder or as determined by any of the methods given earlier.

WITHIN THE DEPTH OF FIELD, WHERE IS BEST FOCUS?

Here's another handy rule of thumb. In ordinary photography with the subject at a medium distance, the plane of best focus is about 1/3 of the way into the depth of field.

If you are photographing a subject such as an automobile and you want the front edge of the subject to be focused as sharply as the back edge, focus 1/3 of the way into the subject. If you are standing toward the front of the car, pick something that is about 1/3 of the way between front and back—perhaps the front door handle. Focus carefully on the handle and you should get the same sharpness at both ends of the car.

DEPTH OF FOCUS

Depth of focus is sometimes confused with depth of field. It isn't the same thing. Depth of field relates to how far a subject can move either way from the point of best focus and still be in satisfactory focus. Depth of focus is the same idea, applied to the film plane. It is how far you could move the film and still get a satisfactory image, assuming the subject didn't move at all.

Depth of focus concerns lens and camera designers but does not concern the camera user. In a well-built camera, the film plane is fixed and immovable.

HYPERFOCAL DISTANCE

If you focus a lens at infinity, it has some depth of field in both directions from the focused distance. However, that part which extends *beyond* infinity is wasted because nobody lives there.

A way to use all of the depth of field without wasting any on the far side of infinity makes use of the lens designer's term *hyperfocal distance*.

If you focus a lens at its hyperfocal distance, depth of field extends from 1/2 the hyperfocal distance all the way to infinity. Suppose you know the hyperfocal distance is 20 meters. Set the focusing ring of the lens to 20 meters. Depth of field "automatically" starts at 10 meters from the camera and goes all the way to infinity.

When focused at the hyperfocal distance, the lens has more *total* depth of field than at any other setting of the focus control. Therefore it is a very good way to set the

To find hyperfocal distance, focus lens at infinity as at left. Lens aperture is set at *f*-11, so yellow lines on depth-of-field indicator show depth of field from a near limit of about 3 meters to infinity and an equal amount beyond infinity. Hyperfocal distance is 3 meters. Refocus lens to hyperfocal distance, as at right. Now depth of field extends from about 1.5 meters all the way to infinity, with none wasted beyond infinity. *Shortcut method:* Find near and far limits on depth-of-field indicator, for the aperture you are using. Then set infinity mark on focus distance scale so it is opposite the far limit—as in the photo at right.

lens when you are carrying the camera around. Then, if something happens suddenly and you want to shoot as fast as possible, you have a very good chance of getting the picture without fooling around with focus.

Finding the hyperfocal distance is easy because it is just the near limit of depth of field when the lens is set at infinity. It will vary with *f*-number, but the depth-of-field indicator takes care of that problem.

Set the lens to infinity and notice the near limit of depth of field, at the aperture you intend to use. Then refocus to that distance. ✔

Do that a few times for practice and you will soon start using the hyperfocal distance as a standby setting of the focus control.

✔ OR SET INFINITY MARK AT FAR LIMIT OF APERTURE TO BE USED

FLATNESS OF FIELD

In ordinary photography, the lens images a three-dimensional subject onto flat film and the photographer is concerned about depth of field.

There are some special cases where the subject is flat and has no depth at all—for example, photographing a printed page, copying a photograph or duplicating a slide. These applications are a severe test of the lens' ability to record details in sharp focus all the way to the edges of the frame. Some lenses are specially designed to photograph flat subjects and have special correction for *flatness of field*. In the Nikkor series, these are lenses intended for use at both normal and higher-than-normal magnifications—called *micro* lenses or *bellows* lenses.

In general, good flatness of field and large maximum aperture are incompatible in the design of a lens. Lenses with special correction for flatness of field typically have smaller maximum aperture than other lenses of similar focal length. For example, the 55mm Micro lens has a maximum aperture of *f*-3.5 but the 55mm normal Nikkor has a maximum aperture of *f*-1.2.

If you are copying or photographing flat subjects and corner-to-corner detail is important, use one of the

of the glass and the vel
e on both sides of the ir
light rays don't even kn

world, compound lens
together to reduce int
ementing, there are two
ter how tightly the dry
r. After cementing, the
re replaced by two air-c
ment is clear and the ve
ment is very close to tha

A severe test for flatness of field is to photograph a printed page. If flatness is OK, you don't notice it. If not, it looks like this—type is darker and sharper at center of frame.

micro or bellows lenses. If you use one of the normal lenses, the 50mm *f*-2 will give slightly better flatness of field than the *f*-1.4.

Whatever kind of lens you use, it's a good idea to stop down one or two stops from maximum aperture to be sure there is enough depth of field for "flat" subjects that are really not flat. Slides are usually curved rather than perfectly flat. Printed materials such as stamps usually have some curvature even though they look flat.

LENS NODES

As you remember, the technical definition of focal length is the distance from lens to film when the lens is focused at infinity.

All lenses mount on the camera the same way and at the same place, so you may wonder how a long-focal-length lens finds additional distance behind the lens to make the image.

Image distances are not tiny. As a rule of thumb, 25mm equals one inch. A 50mm lens requires about 2 inches between lens and film. A 200mm lens requires about 8 inches behind the lens to make a focused image.

Even though the mechanical distance between lens mount and film plane is fixed by the design of the camera body at about 2 inches, every lens has enough distance behind it to make a focused image, no matter what the focal length is. This is done optically, rather than mechanically.

Every lens has two points in the optical path from which distances are measured. The *front node* is used to determine lens-to-subject distance.

The *rear node* is used to determine lens-to-film distance. In lenses with focal lengths of 50mm or 55mm, the rear node is near the rear glass surface of the lens. It is *exactly* 50mm or 55mm from the film when the lens is focused at infinity.

Lenses with longer or shorter focal lengths require more or less distance between the rear lens node and the film plane. This is done by scientific trickery rather than mechanical spacing. The lens nodes can be moved in the optical path by the lens de-

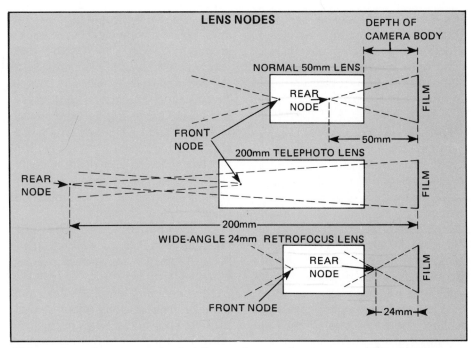

All lenses have the same *mechanical* distance between lens mount and film, but they need different *optical* distances for different lens focal lengths. This is possible because optical distance from lens to film is measured from the rear lens node. The lens node can be positioned where it needs to be, even in the air in front of, or behind the lens.

signer. To get a longer optical distance between node and film, the node is moved forward, away from the film. In some cases, the rear lens node is actually out in front of the lens. Lenses of differing focal lengths, designed so they all fit on the same camera body and all have the correct optical distance from rear node to film are called *parafocalized*.

You can't see a lens node and you can't find it to measure from, but it's there. You can always assume that the optical distance between rear lens node and film plane is equal to the focal length of the lens, when the lens is focused at infinity.

CATEGORIES OF LENSES

Following is a discussion of the categories of Nikkor and Nikon lenses with comments on the design of the lens types when that information is useful to the lens user. Also included are brief suggestions about selection and use of lenses.

For a list of specifications of available AI Nikkor and Nikon Series E lenses, see the lens table at the end of Chapter 13.

NORMAL LENSES

Lenses of 45mm to 55mm focal length are called *normal* lenses. They don't use optical trickery to move the lens nodes around—at least not very much. The angle of view is 46° for a 50mm lens. These are the lenses usually sold with cameras and they are a good general-purpose focal length.

Normal lenses make photos which we accept as realistic views of the scene, such as we would expect to see if standing at the camera location and viewing the scene directly. With a normal lens, there is no indication of an unusually wide angle of view or the very narrow angle of a telephoto lens and a viewer of the photo doesn't think about possible photographic trickery in making the shot.

If you are new at 35mm photography, start with the normal lens and let it teach you the basics of photo composition. Even if you own every lens in the Nikon catalog, take pictures with a normal lens unless

you have some reason to use a different focal length. Forcing a wide-angle or a telephoto angle of view onto a scene will not automatically turn your pictures into creative masterpieces.

WIDE-ANGLE

Focal lengths from 35mm to 13mm give angles of view from 62° to 118°. All of these are called *wide-angle,* however a 35mm lens is not noticeably so and serves many photographers as the standard shooting lens. When you get down to 24mm and shorter focal lengths, the picture makes it obvious that a wide-angle lens was used.

Wide-angle lenses are often used because the photographic situation requires it. If something prevents you from standing back far enough to get all of the desired view with a normal lens, put on a wide-angle. Shooting inside a room is a good example. Or, photographing a building from across the street, where other buildings limit how far back you can move to make the shot.

Besides these cases where the situation forces a wide-angle lens onto your camera, there are many opportunities to use a wide-angle for artistic reasons. These lenses allow you to focus closer than lenses with longer focal length, so you can emphasize the subject of interest and still include a wide view of the background. Or, you can capture that "wide world" feeling in a picture—if the scene is right.

Lenses with Floating Elements— Lenses are made of individual pieces of glass, called *elements,* which are clustered together in *groups* within the lens barrel. The positions and shapes of the lens elements and their grouping is part of the complicated science of lens design.

In conventional lenses, the focusing control moves the entire assembly of elements and groups as one unit.

Most ordinary lenses are designed to make the best image when used at medium subject distances or farther. Although the lens will focus closer than medium distances, image quality deteriorates slightly at short subject distances. Short-focal-length, wide-angle lenses suffer this problem more than long-focal-length lenses because they *allow* closer focusing and because long focal-length lenses typically are used for distant subjects.

However, you won't always have this problem with wide-angle lenses because you won't always use them for close focusing. For those cases where you do focus on very close subjects and still want the best possible image quality, certain Nikkor wide-angle lenses employ a special design. In these lenses, the groups of lens elements do not move in unison when you focus the lens. Not only does the entire assembly move forward or backward, but also the spacing between groups is changed according to focused distance. The rear group of lens elements changes its position in relation to the other lens groups, preserving image quality at short focused distances. Because the rear group appears to move independently, it is sometimes called *floating* and the design is called *floating element.* Nikon calls it *Close-Range Correction System.* Lenses with close-range correction are listed in the accompanying table.

NIKKOR LENSES WITH CLOSE-RANGE CORRECTION SYSTEM	
55mm	ƒ-2.8
35mm	ƒ-1.4
28mm	ƒ-2
24mm	ƒ-2.8
15mm	ƒ-5.6
13mm	ƒ-5.6

50mm ƒ-1.4 Nikkor is a normal lens with what we usually consider a normal angle of view.

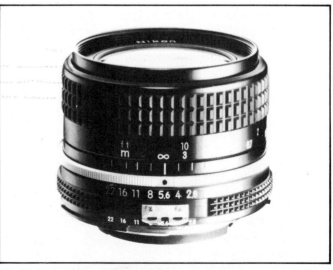

You'll find a 28mm very useful because it has an angle of view significantly wider than a 50mm or 55mm normal lens but the angle is not so wide that it calls attention to itself in your photos.

Circular fisheye lenses have valid scientific and industrial applications but are difficult to use effectively in ordinary photography. With the 8mm *f*-2.8 180° fisheye, I used the built-in yellow filter to strengthen color of afternoon sunlight. Notice photographer's shadow in picture. Observer thought she was out of the field of view.

Some fisheyes such as this 6mm *f*-5.6 extend so far back into the camera that they must be used with the mirror locked up.

FISHEYE NIKKORS

From the film's point of view, the lens *projects* an image onto the film. The light rays which form the image seem to originate at the rear node of the lens.

There are different ways to project the image. The one that "looks right" is called *rectilinear*. Straight lines appear straight in the picture and the viewer is not aware of any kind of distortion of the image. The relative sizes of objects appear natural and true-to-life except in unusual cases.

As focal length is made shorter, and angle of view becomes wider, it is more difficult to maintain rectilinear projection of the image and avoid obvious image distortion. Among current lens designs, the limit is an angle of view of about 118°. At wider angles, the lens designer switches to a different kind of image projection and different lens design, called *fisheye*. Obvious image distortion is permitted and unavoidable in the present science of lens design.

If you go underwater and look upward, you will see a surprisingly wide angle of view in the air above the water. For sure, this is an underwater people-eye view but we surmise that this is what the fish sees even though no fish has yet confirmed that speculation. Anyway, that's why lenses with unusually wide angles of view are called *fisheyes*.

Switching to the fisheye design and allowing fisheye distortion has a great effect on angle of view. The *shortest* focal length among the rectilinear Nikkors is the 13mm *f*-5.6 lens with an angle of view of 118°. The *longest* focal length among the fisheye Nikkors is the 16mm *f*-2.8, and it has an angle of view of 180°!

The 8mm and 10mm fisheyes have identical angles of view—180°. If you point an 8mm or 10mm fisheye straight up, it will record the sky all the way down to the horizon in all directions.

The 6mm fisheye has an astonishing 220° angle of view which means the lens "looks over its shoulders."

Because fisheye lenses can record a hemisphere or more on the flat surface of film, the image they make resembles a global map. In the image, straight lines which pass through the center remain straight. Straight lines which do not pass through the center of the image are bowed away from center. This fisheye distortion is obvious in photos of buildings and similar objects with straight lines or boundaries. It can be much less obvious in photos of nature and subjects without straight lines or straight edges.

When taking scenic views, a fisheye will curve the horizon line unless you compose the picture so the horizon passes through the center of the image.

As do all other circular lenses, fisheyes project a circular image. To make full use of the horizon-to-horizon viewing angle (or more) of most

The 6mm *f*-5.6 fisheye comes with front and rear lens caps, plus a separate viewer that you must use because the camera mirror is locked up and the camera viewfinder is blacked out. Separate viewer mounts directly on an F2-type hot shoe, mounts on any other hot shoe with accessory Flash Unit Coupler AS-2. Viewer also has lens cap.

The full-frame, rectangular image, meter-coupled 16mm *f*-2.8 Fisheye Nikkor is supplied with four bayonet-mount filters that mount on the rear of the lens. These are: L1BC, A2, B2 and O56. Filters are discussed in Chapter 10.

Nikkor fisheyes, those with angles of 180° or 220° record a circular image on film, *within* the normal rectangular film frame. The rest of the frame is unexposed and black in a print.

A circular image calls attention to the fact that it was made with a fisheye, which is not always desirable in general photography.

Another category of fisheye lenses, called *full-frame fisheye,* makes a circular image that is larger than the film frame. Recorded on film is a rectangular image taken from within the image circle—the same as shown earlier in the drawing on page 27. The full angle of view of the lens is used only from corner to corner of

the film frame because sides, top and bottom of the fisheye view are cut off by the edges of the film frame.

Non-Focusing Fisheye Nikkors—Because of the extremely short focal lengths of fisheye lenses, they have great depth of field. Two lenses, the 6mm *f*-5.6 and the 10mm *f*-5.6 take advantage of this fact and are fixed-focus, meaning they have no focus control. These lenses are focused a short distance in front of the lens, such that the depth of field extends to infinity even at wide-open aperture. The near limit of depth of field varies with aperture setting of course, but at these short focal lengths, you always get phenomenal depth of field. The worst case is with the lens wide open and even then the lens has good focus 0.484 meters from the camera—about 20 inches!

The non-focusing fisheyes are manual lenses without automatic aperture or meter coupling. They make a circular image within the film frame. The back of the lens extends so far into the camera body that the camera mirror must be raised and locked in its upward position before these lenses can be installed. The mirror remains locked up as long as the lens is on the camera. With the mirror up, the viewfinder is dark and there is no image on the focusing screen. The camera's light meter cannot measure image brightness.

To compose the image, viewing is done by an auxiliary viewfinder which clips onto the camera hot

shoe. The center of the image you see in the auxiliary viewfinder will not be exactly the center of the image on film but these lenses have such a wide angle of view that this usually doesn't matter.

Focusing Circular-Image Fisheye Nikkors—Two additional fisheye lenses are the 6mm *f*-2.8 and 8mm *f*-2.8 with angles of view of 220° and 180°. These also make a circular image within the film frame. They are more convenient to use than the non-focusing fisheyes for several reasons: The larger maximum aperture allows use in dim light without requiring extremely slow shutter speeds. The lenses do not require mirror lock-up, so you view the scene in the normal way through the camera viewfinder. They are automatic, with both automatic diaphragm and full-aperture metering. They have a focus control for more precise focusing and are used the same way as other automatic Nikkors.

Focusing Full-Frame Fisheyes—The 16mm *f*-3.5 is an automatic lens with a 170° field of view. diagonally. The 16mm *f*-2.8 is also automatic but has a diagonal angle of view of 180°. Both lenses make rectangular images that fill the frame, so it is less obvious that the photo was made with a fisheye. For general pictorial use, one of these is probably the best choice among fisheyes.

Image Projection of Fisheye Lenses—Two methods are used to project a hemisphere onto the flat film: *equidistant* and *orthographic* projection. Because of the similarity to map-making, these terms are taken from cartography and are explained in books about making maps. The 10mm *f*-5.6 OP Fisheye Nikkor uses orthographic projection. The other fisheyes use equidistant. These differences are of interest mainly to those who use fisheyes for technical photography.

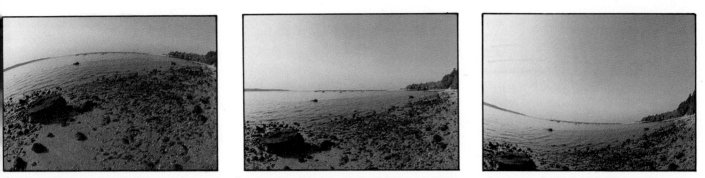

In some photographic situations it's very hard to see the distortion of a fisheye—as in the center photo where the horizon passes through the center of the lens. Tip the lens up or down and the horizon does unusual things. Shot with a Fisheye Nikkor, 16mm f-3.5.

A 200mm telephoto is very useful. Not too large and heavy and the focal length often allows hand-holding which is convenient for sports and some travel photos.

Filters for Fisheye Lenses—Because of their wide angles of view, fisheye lenses cannot use lens hoods or filters mounted in front of the lens. The forward extension of front-mounted lens accessories would intrude into the field of view, darkening the picture around the edges—called *vignetting*.

Fisheye Nikkors use built-in filters selectable by a control on the lens body or filters that attach to the rear of the lens. These filters are described in Chapter 10.

TELEPHOTO NIKKORS ✓

The basic requirement to make a long-focal-length lens is to have a relatively long optical distance between the rear node and the film. This can be done in a clever way by using a diverging lens element in the lens as shown in Figure 4-6.

The first lens element converges the rays so they would come in focus as shown by the dotted lines. Before reaching the film, the converging rays are intercepted by the diverging lens element which causes them to come into focus at a greater distance as shown by the solid lines.

Lenses built this way are called *telephoto*, although the word has come to mean any long lens in popular language. The telephoto principle has two advantages. A lens can be physically shorter than it would be without the diverging element. The rear node can be located where it needs to be so the focused image lands on the film plane in the camera body.

Telephoto Ratio—A measure of the reduced length of a lens because of the telephoto design is called *telephoto ratio*. It is the distance from the front lens surface back to the film plane, divided by the lens focal length. Telephoto lenses which are more compact have smaller telephoto ratios. Most have telephoto ratios less than 1.

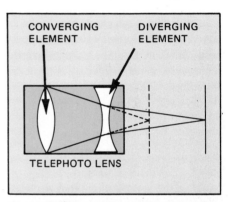

Figure 4-6/The telephoto principle shown simplified with a converging element and a diverging element. Dotted lines show where the converging element would normally make an image. Because the rays are intercepted and diverged by the diverging element, focal length is increased as shown by the solid lines.

Telephoto Focal Lengths—Telephoto Nikkors have focal lengths ranging from 85mm to 1200mm. Corresponding angles of view range from 28.5° to a very narrow 2°.
Single-Unit Telephotos—Lenses with focal lengths from 85mm to 1200mm are available in conventional form: one unit that you attach to the camera body and use in the regular way. These lenses are automatic, with full-aperture metering.

41

As a rule of thumb, anybody can hand-hold a 200mm lens if it is done carefully and if shutter speed is not too slow. Most people can hand-hold a 300mm lens if they are thoughtful about doing it and can learn to hold it steady. Few people can hand-hold a 400mm lens except at the fastest shutter speeds. Nevertheless, you can use a 400mm lens without a tripod if you find some other steady support for the lens such as a fence railing or the limb of a tree.

Longer-focal-length lenses become physically longer and heavier even though of telephoto design and with a low telephoto ratio. Recognizing that you will use a tripod at least part of the time with longer telephotos, certain Nikkor lenses have a tripod socket in a rotatable collar on the lens itself. This allows mounting the combination of lens and camera more nearly at the balance point, using the tripod mount on the lens rather than the one on the camera. This gives much better stability.

Because the lens can be rotated in its tripod mount, it is very easy to position the camera for either a horizontal-format or a vertical-format—meaning the long dimension of the film frame can be either horizontal or vertical.

Two-Part Telephoto Lenses—A group of two-part telephoto Nikkors with focal lengths from 800mm to 1200mm is intended for use with a tripod or other firm support.

An interchangeable focusing unit is used with all of these lenses. The focusing unit mounts on the camera and contains an automatic diaphragm and a focusing mechanism. Each of these lenses mounts on the same focusing unit. Each has a tripod mount on the lens itself. As you can see in the accompanying photo, the camera seems almost incidental compared to the lens and focusing unit.

With all of these lenses except the 1200mm, the focusing unit automatic diaphragm is used, allowing full-aperture viewing when used with the AU-1 focusing unit. To use the 1200mm, the aperture ring on the focusing unit is set to *f*-4.5 and left there. Aperture size is then controlled by a separate aperture ring on the lens itself. The combination then works as a manual lens with stop-down metering.

Two focusing units are available. The AU-1 uses 52mm filters which are inserted into the focusing unit. The advantage is that this size filter fits most Nikkor lenses in the center of the focal-length range and is the size most owners are likely to have. The standard focusing unit does not use filters inserted into the focusing unit. 122mm filters are screwed into the front of each lens.

ED Nikkors—These lenses are made with a special optical glass to give better picture quality. The special lens glass is called *extra-low dispersion,* indicated by the letters *ED* in the lens nomenclature.

Lens glass with extra-low dispersion allows lens designers to produce a more perfect registration of the red, green and blue components of an image. Thus, the image is sharper, either on color film or black-and-white. Because the lens designer can do more correction of aberrations with this special glass, fewer lens elements are required in some ED lenses and they are more compact than other lenses of the same focal length and maximum aperture.

The fault in lenses that prevents perfect superimposition of the image is called *chromatic aberration.* Ordinary lenses, called *achromatic,* have this fault corrected as much as the type of lens glass will allow. Two colors, usually red and blue, are brought to focus at the same plane (the film). Wavelengths between red and blue are not brought to focus exactly at the film plane and therefore are not sharply focused on the film. The portion of an image that is made by wavelengths not sharply in focus is blurred. Additionally, infrared (IR) wavelengths longer than visible red and ultraviolet (UV) wave-

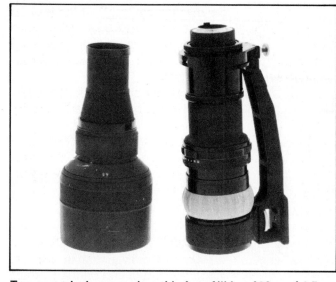

Two-part telephotos, such as this Auto-Nikkor 400mm *f*-4.5, use a common Focusing Mount Adapter shown at right.

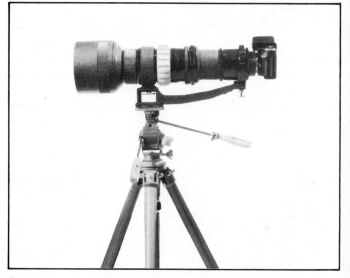

Size of two-part telephoto lens is not apparent in a photo of the lens—until you show it with camera attached. Camera mounts on lens, lens mounts on tripod. Entire lens rotates in its mount so you can turn the camera for a vertical frame.

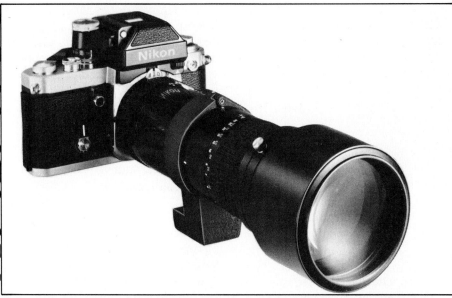

The AI Nikkor 400mm ƒ-5.6 IF-ED lens has internal focusing, so the overall length does not change, and uses Nikon extra-low dispersion glass for improved image quality. When mounting on a tripod, use the mount on the lens rather than the tripod socket on the camera.

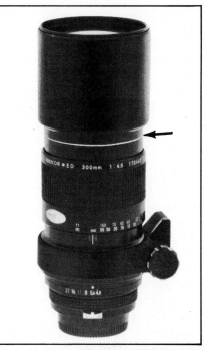

Quick visual identification of ED Nikkor lenses is assured by bright-gold metal band around forward part of lens. This is the 300mm ƒ-4.5 lens. Lens mounts on tripod; camera mounts on lens. Clamp on tripod mount allows rotating lens and camera for a vertical frame. Built-in lens hood telescopes outward.

lengths shorter than visible blue are not brought to focus at the film plane.

The parts of the image which are not sharply focused because of their color or wavelength are referred to as the *secondary spectrum*. ED optical glass used for some of the lens elements allows more complete correction of chromatic aberration and allows significant reduction of the secondary spectrum. Light of all colors is brought to better focus on the film. This technique is so effective that ED lenses not only sharply focus visible colors, they also bring IR wavelengths into focus at the film plane.

Telephoto Lens Pupils—Telephoto lenses can be identified by looking into the front and back of the lens while holding it away from your eye and pointing it toward a window. At each end of the lens you will see a spot of light, called a *pupil*, which is actually the lens aperture seen through that end of the lens.

With a normal lens, the two pupils will be the same size or nearly so. With a telephoto lens, the pupil seen looking in the front will be plainly larger than the pupil seen looking in the back.

If you change aperture size while looking at a pupil, you will see the size of the pupil change because it's an image of the aperture.

Internal-Focusing Lenses—Drawing from zoom lens technology, Nikon has developed a group of lenses that do not use screw-thread helicoids to move lens elements for focusing. The cam-type mechanical design allows for faster focusing—meaning less rotation of the focus control to change from closest to farthest focus—and focusing is done without changing the mechanical length of the lens. In some cases, this design gives other benefits such as larger maximum aperture and closer minimum focusing distance.

In lens nomenclature, the internal-focusing feature is indicated by the letters IF.

IF-ED Lenses—Some lenses have internal focusing and also use extra-low dispersion glass. These are indicated in the lens table as IF-ED lenses.

RETROFOCUS LENSES

The telephoto design is used to move the rear node forward so there is enough distance between node and film plane to accommodate a long focal length.

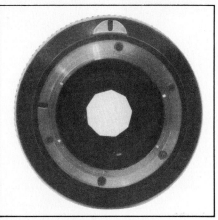

By looking at the entrance and exit pupils of a lens, you know if it's a telephoto or not. Telephotos have larger entrance pupils.

The 1000mm *f*-11 Reflex Nikkor uses 39mm filters that mount on the rear of the lens. Available filters are shown in the table on the facing page. Because mirror lenses don't have adjustable apertures, correct ex-exposure sometimes requires use of neutral-density filters, as discussed in Chapter 10.

The problem is reversed with wide-angle lenses because they have focal lengths that are shorter than the depth of the camera body. It is always necessary that the distance between the rear lens node and the film be equal to lens focal length when focused at infinity. Therefore the rear lens node must be positioned in the air, behind the lens, inside the camera body, by optical trickery.

For example, a 24mm lens has a focal length of about one inch. The distance between the lens mounting surface and the film plane on SLR cameras is about 2 inches. Therefore

a conventionally designed 24mm lens would make a focused image about one inch in front of the film plane in the camera.

To solve this problem, the telephoto design is reversed. The diverging lens element is at the front and the converging lens element is at the back. This has the effect of locating the rear lens node in the airspace between lens and film, and the designer can put the node exactly where it needs to be.

These lenses are called *reversed-telephoto* or *retrofocus.* All Nikkor lenses with focal lengths shorter than

45mm are retrofocus lenses.

With a retrofocus lens, the pupils are not the same size either—the rear pupil is larger than the front pupil.

REFLEX NIKKORS

The word *reflex* is a form of the word *reflect.* In cameras and lenses, it means the light rays are reflected by a mirror somewhere along the optical path. As you know, this happens in the viewing system of an SLR camera.

Some lenses use front-surfaced mirrors to reflect light. The mirror surface is curved to produce an expanding or converging beam, so mirrors can do the same things as lenses except that light rays don't go through any glass when reflected off a *front-surfaced* mirror. Some lens aberrations caused by light rays going through glass are eliminated when image formation is done by a mirror. Mirrors don't have chromatic aberration, for example.

Practical lens designs for cameras use doughnut-shaped mirrors and glass elements as shown in the accompanying drawing. This construction is usually called *catadioptric,* implying use of both mirrors and glass lens elements. In the Nikkor series, it is called *reflex,* signifying the presence of mirrors in the lens.

The way to get a big sun or moon in your picture is to use a long-focal-length lens. These mirror-lens photos by Bill Keller were made with 500mm and 1000mm focal lengths.

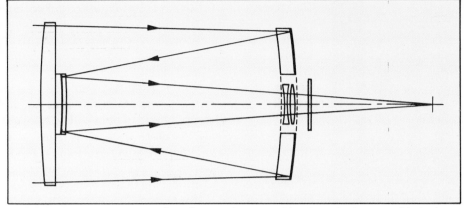

Reflex-Nikkor lenses are *catadioptric,* meaning a combination of mirrors and lens elements. Light from the scene is reflected twice on mirror elements, as shown.

AVAILABLE 39mm FILTERS	
Yellow	(Y-52)
Orange	(O-56)
U.V. Haze	(L-37C)
Skylight	(L1BC)
Red	(R-60)
Neutral Density	(ND-2)
Neutral Density	(ND-4)
Neutral Density	(ND-5)
Neutral Denisty	(ND-8)
81A	(A-2)
85	(A-12)
82A	(B-2)
80C	(B-8)
80B	(B-12)
Filter Pouch	(CA-2)

These 39mm filters are used with 1000mm and 500mm Reflex Nikkors and the following ED-IF lenses: 300mm *f*-2.8, 400mm, *f*-3.5, 600mm, *f*-4, 600mm *f*-5.6, 800mm *f*-f-8, 1200mm *f*-11.

The mirrors in Reflex Nikkor lenses reflect the light rays twice, thereby "folding" the light path and producing a lens that is much shorter than its own focal length; shorter and lighter than conventional lenses of the same focal lengths. As with ED lenses, the advantage is mainly at longer focal lengths, so Reflex Nikkors are available at 500mm, 1000mm and 2000mm.

These lenses don't have apertures that are variable in size to control the amount of light. Exposure is adjusted by varying shutter speed or by use of gray-colored neutral-density filters whose purpose is to reduce the amount of light without changing the color of the image. Neutral-density filters are discussed in Chapter 10.

Because they don't have variable apertures, these lenses are non-automatic and require stop-down metering.

The 500mm and recently manufactured 1000mm lenses use screw-type filters, 39mm in diameter, which attach to the back side of the lens. Early 1000mm and current 2000mm lenses have a revolving turret near the back of the lens which holds 4 interchangeable filters. By rotating the turret, one filter is moved in the optical path. The filters can be changed by removing the turret cover. Available filter types are listed in the accompanying table and described in Chapter 10.

Angle of view of the 2000mm lens is only 1° 10' which includes such a small portion of the overall scene that it could be difficult to "get your bearings" when setting up for a shot. This potential problem is solved by a peepsight in the lens carrying handle which helps point the lens to the desired point. The 2000mm lens also has a special tripod mount on the lens which allows swiveling the lens vertically.

Catadioptric lenses have one characteristic that is visible in the picture and calls attention to the lens type. Out-of-focus points in the scene record as small doughnuts in the picture, because of the doughnut-shaped mirrors in the lens. This is more noticeable if the points are bright, such as reflections from dewdrops.

USING LONG-FOCAL-LENGTH LENSES

There are photographic situations where it is impossible or not practical to get the picture you want without using a long lens. If you are sitting in the stands and want a close view of the pitcher's windup at a major-league baseball game, you can't get it with a normal lens. The pitcher will be a very small part of a larger view. Use a lens with a long focal length and the angle of view narrows to include just the pitcher.

In addition to "reaching out" to capture a distant image, long lenses offer you selectivity. You can single out one face in a crowd; one building on a hillside.

When shooting over very long distances, the air between you and the scene may degrade the image. "Heat waves" in the air path will blur the image. Light scattering by particles in the air reduces image contrast and sharpness.

Long-focal-length lenses require very firm and steady supports because the least amount of vibration or lens movement blurs the picture.

ZOOM LENSES

A zoom lens can be focused on a subject and then, by a zoom control on the lens, the focal length can be changed to alter the image on film.

If you will please refer back to Figure 4-6, which shows how a diverging lens alters the focal length of a converging lens, it will be apparent that the distance between the converging and diverging lens controls the focal length of the combination.

Zoom lenses are complex, using many glass elements in a mechanical assembly which requires high precision and extremely close manufacturing tolerances. They work by moving all of the lens elements to focus and some of the lens elements independently to change focal length.

In an ideal zoom lens, nothing changes except focal length when zooming the lens. Focus on the film should remain sharp while image size changes, the *f*-number of the lens

NOT TRUE OF TOKINA 50-250 mm Zoom F4/F5.6 (OR OF TOKINA 28-85)

should remain constant; and aberrations should not increase.

In practice this is difficult to accomplish. A lens design can preserve good focus at one or more points along the zoom range, but it is difficult to keep sharpest focus at all focal lengths.

With high-quality zoom lenses of modern design, such as current Zoom Nikkors, these reservations about image quality are more theoretical than actual. In normal viewing, including projection on a screen, it is difficult or impossible to see any quality difference between an image made with a zoom lens and one made with a conventional lens of similar focal length.

When using a zoom lens, focus with the lens set to its longest focal length. Depth of field will be smallest and therefore your focus adjustment will be more accurate. Then zoom to shorter focal lengths if picture composition benefits.

If you do it the other way, imprecise focusing can be masked by the

The Zoom-Nikkor 80-200mm lens is super-handy for sports and travel photos, however the relatively small maximum aperture size of f-4.5 is sometimes a handicap. Zoom by sliding knurled ring along length of lens; focus by rotating same ring. A scale on lens body shows focal length—set here for 80mm. Because depth of field changes with focal length, depth-of-field indicator lines are curved to show more depth at shorter focal lengths.

Another useful Zoom-Nikkor is the 43-86mm f-3.5.

Although large and best used on a tripod, the 50-300mm Zoom-Nikkor really gets in there. Top photo is with lens at 50mm. Bottom photo, at 300mm focal length, singles out young cowboy from the row of fence sitters.

greater depth of field at short focal length settings. Then when you zoom to a longer focal length, your subject may be outside the zone of good focus. The main advantage of a zoom lens is the obvious one—it allows you to change focal length in a hurry, without changing the lens. This is essential in some kinds of photography such as sports. It is convenient, in other kinds of photography, to be able to adjust focal length and magnification to suit your purpose when composing a photograph.

SPECIAL LENSES

The Nikkor series includes a variety of special purpose lenses. Some are discussed in this chapter; some merely mentioned here and discussed later, at a more appropriate place in this book.

PC LENSES

PC means *perspective control.*

These lenses have a *shift* feature, similar to a technical or view camera. You can shift the lens so the center of the lens is no longer at the center of the film frame. The lens remains parallel to the film; it merely shifts vertically, horizontally, or at any angle in between.

A very common problem in photographing architecture is: The corners of a room or building look closer together near the top of the photo,

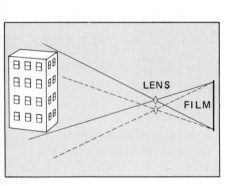

Simplified drawing shows how shifting the lens parallel to the film changes the part of the scene which falls within the film frame.

USING A PERSPECTIVE CONTROL LENS (PC)

PC-Nikkor lens rotates on its mount so you can shift in any direction, reading the amount of shift from scale on lens. Small numbers nearest camera show maximum shift for different rotational positions of lens. If you shift more than maximum indicated amount, you are likely to darken one corner of the frame.

Here's one way to use a shift lens. When you point the camera upward to include the entire building in the frame, the building seems to lean over backwards because the face of the building is not parallel to the film plane in the camera. In the camera viewfinder, you can see that the sides of the building are not parallel to the sides of the frame.

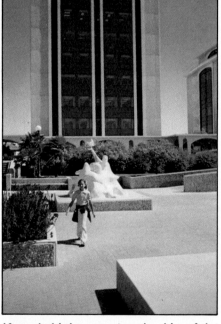

If you hold the camera so the sides of the building are parallel to the sides of the frame, an ordinary lens won't include all of the building in the picture.

Shift lens solves the problem. Continue holding camera so building looks vertical; shift lens upward until entire building is in frame. This time it's not leaning.

which makes it appear that the structure is leaning over backwards. This sometimes surprises the unwary but it shouldn't because you can see it in the viewfinder before you take the picture. It can be avoided by holding the camera so vertical lines of a structure, such as corners, are parallel to the sides of the viewfinder.

Often you can't get the picture you want when holding the camera that way. When shooting a tall building, you get a lot of parking lot and not enough building to show the top. Tip the camera upward to include all of the building and it seems to fall over backwards.

By rotating a control on the lens, the optics can be shifted up to 11 millimeters off center. This distance is measured on the film frame.

Shifting solves photo problems as shown in the drawing and photos on the preceding page. If you like to photograph buildings and interiors, you'll find a PC lens is nearly essential. There are two PC lenses: a 28mm f-4 and a 35mm f-2.8. Because of the shift feature and the fact that a PC lens can be rotated 360° to allow shifting in any direction, the lens has no automatic features. It's a preset type, used with stop-down metering.

POINT OF VIEW, LENS CHOICE, AND FORMAT

Usually you have some choices when making a picture. After you have decided to photograph a scene or subject, you must then decide on point of view, the lens you will use, and the format—whether you will hold the camera for a vertical or horizontal frame.

When I made these pictures, access to the site was limited by a fence. This is as close as I could get.

Using a 50mm lens and the vertical format, I made a scenic view. The vertical format emphasizes the height of the tall smokestacks and the old equipment takes its place as part of the scene.

Switching to a 200mm lens, which seems to change the point of view, I made a horizontal format shot of the disabled boiler surrounded by junk. The mood and impact of this photo is distinctly different from the other.

LENSES FOR HIGH MAGNIFICATION

When magnification is 1.0, the image on film is the same size as the subject. At higher magnifications, the image is larger than the subject. Magnifications up to about 8 are practical with camera lenses and special accessories that fit between lens and camera, such as a bellows. This range of magnification is usually called *macro* photography.

Most camera makers offer special lenses for higher-than-normal magnification and these lenses are usually called *macro lenses*. In the Nikkor series, these are called *Micro Nikkors*, discussed in Chapter 9.

Another special lens for higher magnifications is the 200mm *f*-5.6 Medical Nikkor, originally designed for medical and dental close-up photography. It's a complete lens and illumination system in a package, designed for simplified operation with magnifications up to 3. This lens is also described in Chapter 9.

RELATIVE MAGNIFICATION

Actual magnification, as defined earlier, is the height of the image on film divided by the height of the subject. Lens descriptions sometimes compare the magnification of one lens to that of a 50mm used as a reference. This should be called *relative magnification* because it compares the size of the image made by a lens of any focal length to that made by a 50mm lens under the same conditions.

Relative magnification among lenses is simply the focal length of the lens being discussed, divided by the focal length of a 50mm lens. For example, the relative magnification of a 2000mm lens is 2000/50=40. This is sometimes stated as 40X where the symbol X means *times*.

FOCUSING WITH INFRA-RED FILM

When light rays pass through a converging glass lens, they are bent

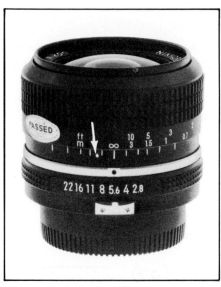

When using Infra-Red film, use the red dot (arrow) as the index mark for focused distance, rather than the normal index.

or *refracted* so they come to focus at a point. This is theory. In practice, the bending power of lens glass is not the same for all colors or wavelengths of light. Blue wavelengths come to focus closest to the lens, red wavelengths focus farther away and IR focuses still farther away, due to chromatic aberration.

Achromatic lenses, as mentioned earlier, are optically corrected so blue and red light comes to focus at the same point—the film plane. In between, the secondary spectrum is slightly out of focus. IR light rays longer than visible red are not corrected and come to focus *behind* the film plane if visible light rays are in focus at the film plane. This is sometimes a problem when photographing with special IR film.

There are two kinds of IR film. One makes a color image using three colors, only one of which represents the IR image. This is properly called *false-color film*. Because most of the image is formed with visible light rays, viewing and focusing are performed just as with any other film.

Black-and-white IR film is manufactured so it is sensitive to IR wavelengths. To make an IR image, a filter is used to cover the camera lens which blocks all or most visible light rays. This causes a problem with both viewing and focusing. The viewing problem is solved by focusing and composing the image before attaching the filter that blocks visible light. After that, mainly IR wavelengths come through to expose the film.

If you don't change the focus setting on the lens, the IR image will not be in focus with ordinary achromatic lenses because these lenses bring IR to focus behind the film plane.

To bring the IR image into focus, you must move the lens away from the film so the focused IR image lands exactly on the film plane. This means you must change the focus setting so it appears to be set for a shorter distance.

Most Nikkor lenses have a small red dot or line just to the left of the focusing index mark. The dot is mingled with the depth-of-field scale on the lens but is not part of that scale. It's an IR focusing index.

Here's how to use it: After focusing with visible light and installing the IR filter over the lens, notice the distance setting you arrived at with visible light. Suppose it is 10 feet. Move the focus control so that same distance is opposite the IR focusing index mark. Set 10 feet opposite the red mark instead of the normal focusing index. Basically, it's just a matter of switching indexes when using IR film.

Exceptions—There are some interesting cases where the lens doesn't have an IR focusing index, or you don't have to use it.

As you remember from the earlier discussion, ED lenses use special glass and have superior correction of the secondary spectrum. This works so well that not only are wavelengths between blue and red brought into focus at the film plane, IR wavelengths are also. Therefore some ED lenses don't have an IR focusing mark.

Reflex Nikkors use some mirror surfaces and some glass lens elements. Because mirror surfaces don't

TC-14 teleconverter multiplies lens focal length by 1.4.

TC-200 teleconverter doubles lens focal length.

TC-300 teleconverter doubles lens focal length and is designed for use with lenses specified in table on page 51.

have chromatic aberration, the combination of mirrors and lens elements is relatively free of the problem. Therefore Reflex Nikkors don't have separate IR focusing marks either.

Because short-focal-length lenses have large depth of field, when these lenses are used at small aperture, refocusing for IR photography may not be necessary even though these lenses have IR focusing indexes. As a rule of thumb, when lenses of 50mm or shorter are used at apertures of f-8 or smaller, refocusing for IR is not necessary. It won't harm anything if you do it anyway.

Most Nikkor lenses are identified on the front as shown here. Some special lenses are identified in other locations on the lens.

LENS IDENTIFICATION

Information engraved on a lens tells you its essential specifications and other data. On the front of most lenses, engraved on the metal ring surrounding the glass, is the lens identification.

Following the lens name—Nikkor—is a series of numbers. The first of these, such as 35mm, states the focal length. The next number, such as 1:1.4, states the maximum aperture. Disregard the first part and read the part following the colon, 1.4 in this example. That means the lens has a maximum aperture size of f-1.4.

The next number is the lens serial number. You should record the serial numbers of all camera equipment, descriptions, date of purchase and purchase price.

Also on Nikkor lenses is the word *Nikon* which identifies the lens as part of the Nikon-Nikkormat system.

Another way to find maximum aperture of a lens is to look at the aperture ring of the lens barrel. All f-number settings are engraved on the ring, and the smallest f-number you see represents the largest possible aperture setting for that lens.

TELE-EXTENDERS

Accessories called *tele-extenders* or *teleconverters* fit between a camera lens and the camera body. These

are diverging lenses placed in the optical path to give the same effect as the diverging lens in a telephoto design. Typically, tele-extenders multiply focal length of the basic camera lens by a factor of 2 or 3, so tele-extenders are marked 2X or 3X to show their effect on lens focal length.

If you use a 50mm lens with a 2X tele-extender the focal length of the combination becomes 100mm.

The minimum focusing distance of the camera lens is unaffected by the presence of a tele-extender. If this distance is 18" without the tele-extender, it is 18" with the tele-extender. This is sometimes an advantage because it allows larger images on the film.

Not only do tele-extenders multiply focal length, they also multiply the f-number of the lens. If a lens is set at f-4 and a 2X tele-extender is installed, the lens acts like the aperture had been changed to f-8. Because larger f-numbers mean less light gets through the lens, using tele-extenders may force you to use shutter speeds that are slower than you prefer.

Accessory lens manufacturers offer tele-extenders with mounts for most popular brands of camera. If you buy one, buy from a reputable manufacturer and don't buy the cheapest.

Some tele-extenders preserve the automatic features of the lens; some don't. Be sure you know what you are buying.

Although unusual, it is possible for equipment of a different brand to cause problems when installed on your camera. Of course the camera manufacturer is not responsible for problems caused by accessories of a different brand. Good protection against problems of this sort is to buy the equipment from a reliable camera shop and thoroughly discuss both the equipment you intend to buy and what you plan to do with it.

Nikon Teleconverters—There are three special Nikon teleconverters. Each is designed for use with a specified group of lenses and each is optically corrected for high image quality when used with the specified lenses shown in the accompanying table.

TC-14 is a very unusual teleconverter. It multiplies both focal length and *f*-number by 1.4. When used with a 600mm lens, for example, the focal length of the combination is 840mm. It reduces the light by one exposure step. For example, *f*-4 multiplied by 1.4 becomes *f*-5.6. Multiplying any *f*-number by 1.4 gives the next larger standard *f*-number.

TC-200 and TC-300 both have the same basic specification: They both multiply lens focal length and *f*-number by 2. TC-200 is for use with one group of lenses—those without deeply recessed rear elements. TC-300 is for use with a different group of lenses—those with recessed rear elements.

LENSES TO BE USED WITH NIKON TELECONVERTERS	
Use With TC-200	**Use With TC-300**
AI NIKKOR LENSES	105mm *f*-4 Micro
6mm *f*-2.8 Fisheye	200mm *f*-4 Micro
8mm *f*-2.8 Fisheye	300mm *f*-4.5 (1)
13mm *f*-3.5 Fisheye	300mm *f*-4.5 ED (1,3)
13mm *f*-5.6	300mm *f*-4.5 IF-ED
15mm *f*-5.6	400mm *f*-5.6 ED
18mm *f*-4	400mm *f*-5.6 IF-ED
20mm *f*-4	400mm *f*-3.5 IF-ED
24mm *f*-2.8	600mm *f*-5.6 IF-ED
28mm *f*-2	800mm *f*-8 IF-ED
28mm *f*-2.8	1200mm *f*-11 IF-ED
28mm *f*-3.5	
35mm *f*-1.4 (1)	**Use With TC-14**
35mm *f*-2	AI NIKKOR LENSES
35mm *f*-2.8	135mm *f*-3.5
50mm *f*-1.4	180mm *f*-2.8
50mm *f*-2	200mm *f*-2 IF-ED
50mm *f*-1.2 (1)	300mm *f*-4.5 ED
85mm *f*-2	300mm *f*-4.5 IF-ED
105mm *f*-2.5	400mm *f*-5.6 ED
135mm *f*-2 (1)	400mm *f*-3.5 IF-ED
135mm *f*-2.8	500mm *f*-8 reflex
135mm *f*-3.5	(without filter)
180mm *f*-2.8 (1)	600mm *f*-4 IF-ED
200mm *f*-4	600mm *f*-5.6 IF-ED
58mm *f*-1.2 NOCT (1)	1000mm *f*-11 reflex
55mm *f*-3.5 Micro	(without filter)
20—50mm *f*-4 Zoom	50—300mm *f*-4.5 Zoom
28—45mm *f*-4.5 Zoom	
43—86mm *f*-3.5 Zoom	**EXPLANATION OF SYMBOLS**
80—200mm *f*-4.5 Zoom	(1) Exposure may not be uniform across frame if used at lens apertures smaller than *f*-11.
80—200mm *f*-2.8 Zoom	
50—300mm *f*-4.5 Zoom (2)	(2) May cause vignetting of image.
105mm *f*-4 Micro (2)	(3) Remove rubber protector at tip of teleconverter before mounting on lens.
200mm *f*-4 IF Micro	
300mm *f*-4.5 (1,2)	**NOTES:**
300mm *f*-4.5 IF-ED (2)	Mount lens on teleconverter, then mount lens/teleconverter assembly on camera. Disassemble in reverse order. Certain combinations of lens, teleconverter and focusing screen may require additional exposure compensation. See literature packaged with teleconverters.
400mm *f*-5.6 IF-ED (2)	
400mm *f*-3.5 IF-ED (2)	
600mm *f*-5.6 IF-ED (2)	
500mm *f*-8 Reflex	
NIKON SERIES E	
35mm *f*-2.5	
50mm *f*-1.8	
100mm *f*-2.8	

COMPATIBILITY OF TC-14, TC-200 & TC-300 TELECONVERTERS			
Type of Camera	Type of Lens	Indexing	Metering
AI	AI	Automatic	Full Aperture
AI	Non-AI	(Lens cannot be mounted)	
Non-AI	AI	Not applicable	Stop-Down
Non-AI	Non-AI	(Lens cannot be mounted)	

When using Nikon teleconverters, do not set lens aperture larger than f-2. Use exposure compensation shown here for maximum aperture of lens, no matter where aperture is set. Best way to make these corrections is change film speed setting. With some combinations of teleconverter, lens and focusing screen additional compensation is required. See teleconverter instruction booklet.

EXPOSURE COMPENSATION WITH NIKON TELECONVERTERS	
LENS MAXIMUM APERTURE	EXPOSURE COMPENSATION (STEP)
f-1.2	−1
f-1.4	−2/3
f-1.8	−1/3

SAME PROBLEM WITH USE of TOKINA DOUBLER — BUT AGAIN NO RELEVANCE unless MAX. aperture of lens is F.12 → F18

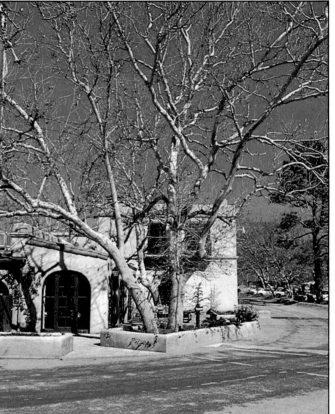

Cameras always make correct perspective as seen from the camera location. When you view the resulting picture, you will see correct perspective only if you view the print from the correct distance.

Because 2X teleconverters reduce aperture size by two steps, the effective aperture of a lens and teleconverter combination is always two steps smaller than indicated on the lens aperture scale. If you have the lens set to f-2, effective aperture will be f-4.

If the TC-200 is used with a lens capable of settings larger than f-2, the lens should never be set larger than f-2 for two reasons: The teleconverter limits maximum effective aperture to f-4 even if lens aperture is larger than f-2, so no additional light passes through, and image quality will be reduced when the camera lens is set larger than f-2.

Exposure metering with the camera meter is normal, as if no teleconverter were in use, except when using lenses with maximum aperture settings larger than f-2. Even though you do not set the lens larger than f-2, exposure compensation is necessary, as shown on the accompanying table.

PERSPECTIVE

The word *perspective* literally means *to see through*. If you are looking at a photo or painting and the perspective is correct, what you see is indistinguishable from the original scene. You can't be too picky when

applying this definition because it applies to the big parts of the picture—its geometry.

If perspective is correct, the shapes you photograph and their relationships to each other will look like the real world. Streets will become narrower as they recede into the distance. The side of a building seems to become less tall at greater distance from the viewer. Distant people and automobiles are smaller than those nearby. As far as lines, angles and relative sizes of things are concerned, it's as though you are not looking at a photograph, you are *seeing through* it to the actual scene.

A strict statement of perspective must include the viewing distance at which it is correct. Usually the photographer has no control over the distance from which people look at pictures.

If you make a slide using your 50mm lens, the correct viewing distance of the slide itself is 50mm—about 2 inches. Don't bother to try it because your eye can't focus that close. When the image is made larger, correct viewing distance increases in proportion.

Suppose you have a print made from your slide so everything on the print is ten times as tall. Viewing distance becomes ten times as great—500mm or about 20 inches. This formula—focal length multiplied by enlargement of the image—gives correct viewing distance for any photo taken with any lens, but most people don't pay any attention to it.

Because all of us have grown up looking at photos from the right distances and the wrong distances, we are very tolerant of incorrect perspective unless the effect is extreme. We often notice incorrect perspective in shots made with very long or very short focal lengths.

This is never the fault of camera or lens. It always results from viewing the photo at the wrong distance.

As photographers, we can *cause* these perspective effects to happen by choosing lenses which make it impossible or unlikely that the viewer will use the correct viewing distance for proper perspective.

Zoom-Nikkor 25-50mm *f*-4 is a handful of short to normal focal lengths in one package.

Zoom-Nikkor 80-200mm *f*-2.8 ED. An 80-200mm zoom is very useful in many kinds of photography—portraits, sports, action photos and travel, for examples. The particular advantage of this lens is its relatively large maximum aperture of *f*-2.8.

Fisheye-Nikkor 16mm *f*-2.8 is supplied with four special filters that attach to a special bayonet mount on the rear of the lens. They are: L1 BC, 056, A2 and B2, described in chapter 10.

Nikkor 300mm *f*-4.5 IF-ED. Use the tripod mount on the lens rather than the socket in the camera.

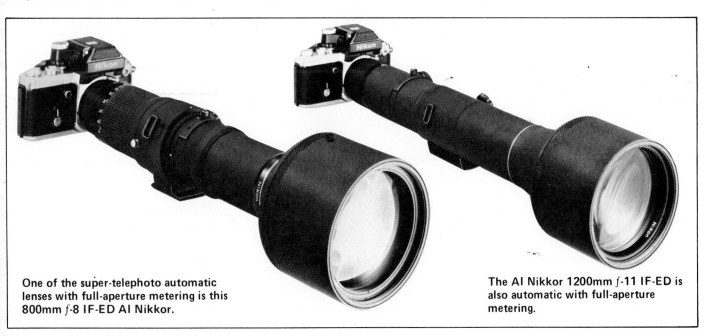

One of the super-telephoto automatic lenses with full-aperture metering is this 800mm *f*-8 IF-ED AI Nikkor.

The AI Nikkor 1200mm *f*-11 IF-ED is also automatic with full-aperture metering.

28 mm

From the same camera location, all views have the same perspective. Wide-angle view taken with 28mm lens was enlarged 3.75 times compared to view taken with 105mm lens. Notice that perspective of 105mm view is identical to center part of 28mm view. The only difference is image size on the negative.

105 MM

PERSPECTIVE WITH LONG LENSES

When two similar objects are nearby, we judge the distance between them by their relative sizes. You may have to look outdoors to confirm this: A car at the end of the block is tiny compared to a car in your driveway. Your mind doesn't say it's tiny, your mind says it's a block away from the nearest car.

Now we play a photographic trick on the viewer. Photograph the two cars from a quarter-mile away, using a long-focal-length lens such as 500mm. The cars are still a block apart, but they look about the same size on film. Enlarge the negative so the cars are ten times as tall on the print. The correct viewing distance for proper perspective is then 500mm—about 200 inches or nearly 17 feet.

Nobody will view your print from that distance. It will be viewed from a few feet or maybe even held in the viewer's hand. This tricks the viewer's mind into thinking it is seeing two cars that are nearby. Because they are about the same size, the mind says that they are very close to each other. Of course they aren't, but the picture sure looks that way.

The technique is often used in photographing race cars to make them look close together. It is often used as a trick in newspapers and magazines to make houses or traffic signs appear jammed up against each other when in reality they are not. There are a lot of ways you can use this trick and all are OK except one. Don't use it by accident. You should know when you are doing it.

PERSPECTIVE WITH SHORT LENSES

Put your eye about 8 inches from somebody's nose and notice *exactly* what you see. You see a very large nose with smaller facial features and ears receding into the distance. Find somebody with his feet on the desk and put your eye about 12 inches from the sole of his shoe. You see a very large shoe connected to a person with a tiny head.

Put your camera lens at either of these viewpoints and you'll get the same view on film. However, most lenses of 50mm focal length or longer won't focus that close. Lenses of shorter focal length allow close focusing, therefore they allow the short-lens perspective trick.

Shot of cars two blocks away, taken with 400mm lens, makes them appear jammed together amid a jungle of signs and light poles. If you stand at the camera location, you get this same view but with a lot of cars and street *between* you and this distant scene. When you can see the entire scene, this illusion disappears.

Assume you used a 20mm lens and enlarged the negative so everything is ten times as tall on the print. Correct viewing distance of the print is 200mm—about 8 inches. Put your eye 8 inches from the print and you get exactly the same view you would in real life. But most people don't know that's what they actually see in the real world. At any other viewing distance, the picture doesn't look right. They think your picture has the wrong perspective and is very funny.

The camera *never* gives wrong perspective. It's always the viewer's fault.

Perspective in Portraiture—Because we don't often look at other people with our eyes eight inches from the nose, we quickly notice the short-lens perspective effect in a portrait. The long-lens effect can also occur—it tends to reduce the apparent distance between nose and ears, giving a face-flattening effect—we are a little more tolerant of that because we see it often.

Some combinations of focal length, distance between camera and subject, subsequent enlargement and viewing distance result in portraits with short-lens effect even when taken with the standard lens that came with your camera—50mm or 55mm. It's usually not obvious, but experienced photographers can see it readily or your subject may see it without being aware of it and reject the portrait as a "bad picture."

That's why most photographers using 35mm film prefer lenses of 85mm up to 135mm for portrait work. If you use a lens much longer than 135mm, you risk the long-lens effect.

With lenses in the 85mm to 135mm range, you can fill the frame with your subject's head without getting the camera up close. This not only makes a portrait without short-lens effect, it makes the subject more comfortable and relaxed because the camera is farther away.

Do Lenses Get Different Perspective?—From the same camera loca-

28mm 55mm

105mm 200mm

When the camera location is changed, perspective changes. Using lenses of different focal lengths, I moved the camera to keep model's head about the same size in the frame. Notice the apparent change in distance between model and clock tower. Also notice the depth-of-field problem with the 200mm lens. I set focus between model and tower, but gave priority to good focus on clock face.

tion, all lenses get the same perspective. A long-focal-length lens gets a small section of the overall view; a short lens gets a larger section; but both get the same perspective when viewed from the correct distance. You could cut out part of the wide-angle view, enlarge it, and the result would be indistinguishable from the view with the longer lens as far as perspective is concerned.

Change camera location and you change perspective no matter what lens you are using. Every different camera location gets a different perspective view of the scene.

5
FILM HANDLING

Occasionally, someone will invest a lot of time and effort into shooting a roll of film and then get unsatisfactory results because of mishandling the film in one way or another. There are lots of opportunities to do it wrong, starting from the day you purchase film in the box at your dealer and ending when you finally get positive images safely in hand.

This chapter discusses film storage; loading and unloading the camera; and how the camera handles film when you wind it manually. Choosing a type of film for a specific purpose is discussed in Chapter 10, *Light, Filters and Films* and you'll find a list of some currently available film types at the back of that chapter.

THE FILM EMULSION

The light-sensitive material in a photographic emulsion is a compound of silver of the general name *silver halide.* This is used in both b&w and conventional color films although the structure and processing of color film is different to produce a color image.

The characteristics of photographic emulsion change slowly after manufacture in two principal ways. After development, old film shows an overall density, called *fog,* which cannot be accounted for by exposure to light. It is a deterioration of the silver halide in the emulsion.

The density range which the film can produce is limited by this because areas on the film which should be clear are fogged instead. Also, the difference in tone between two objects in the picture will be less on old film than fresh film. The difference is

called *contrast* and lack of it causes prints to look "flat." They have an overall gray appearance instead of strong blacks and vivid whites with definite visible differences between the image tones.

With color film, the image recorded by silver halide in the emulsion is converted during processing to appear in color. Changes in the photographic emulsion due to aging affect the colors in the final transparency or color print in ways difficult or impossible to correct.

EXPIRATION DATING

Films carry a date on the carton referred to as the *expiration date* even though nothing drastic actually happens at that instant. Although film should be exposed and processed before that date, the film will probably be about as good during the month after its expiration as during the month before. The date means the film should perform satisfactorily up to that time under normal conditions.

Expiration dating of films intended for amateur use is based on storage

Film manufacturers print several important items of information on film packages. Film speed is usually given two ways: ASA and DIN. An expiration or "develop before" date shows when you should have used and processed the film. A batch number is often shown, so the film can be traced back to the date and place of manufacture if there is a problem.

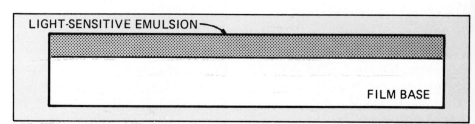

Basically, film is a light-sensitive layer of emulsion supported by a film base. Most films are more complex than this. Color film, for instance, has three layers of emulsion—each sensitive to a different color.

at room temperatures: 70 degrees Fahrenheit (20°C.) and around 50% relative humidity.

High temperature and high humidity accelerate the aging process and humidity is the worst culprit. Most film is sealed in a pouch or can to protect the film from external humidity changes. If the emulsion dries out excessively, that's not good either.

FILM STORAGE

Storing film at reduced temperatures—such as in your refrigerator—slows down the aging process, and is recommended both before and after exposure if you keep the film a long time before shooting or a long time after shooting and before development.

An exception is color films intended for professional use and some special b&w films. These should *always* be stored at reduced temperature—follow the manufacturer's instructions.

Film should be in sealed factory containers when stored, and allowed to return to room temperature before breaking the seal, otherwise moisture may condense in the package and the film may be ruined. If you buy film in quantity, storing it in the refrigerator is a good idea provided you observe this precaution. After development, room-temperature storage of photographic materials is normally OK.

LOADING FILM INTO THE CAMERA

Before opening the camera to load film, it's a good idea to check to be sure the camera doesn't already have film in it. Turn the rewind knob in the direction of the arrow on the knob. If there is no film in the camera, the knob will turn freely. If you feel resistance, there is film inside which light will damage if you open the camera without first rewinding the film. When film is safely rewound into the cartridge, the rewind knob turns freely, indicating that it is safe to open the camera to remove the exposed cartridge of film.

After verifying that there is no film in the camera, open the camera back so you can load a fresh cartridge of 35mm film. Opening the camera is done in more than one way, depending on camera model, as shown in the illustrations on page 63.

With the camera back open, inspect the interior. Look for visible dirt, residue such as a piece of film broken off the preceding roll, or anything that looks wrong. Occasionally it's a good idea to brush out the interior carefully with a *clean* soft brush, a puff of air from a rubber squeeze bulb or a pressurized can of dust remover.

1/With camera back open, lift rewind knob to insert film cartridge, then push knob fully against camera body to hold cartridge in place, turning knob if necessary. Pull film end across back of camera and insert into slot in take-up spool. Use film-advance lever to advance film until sprocket holes on *both* sides of film engage sprocket teeth. In this photo, sprocket hole at top is about to engage a sprocket tooth.

2/As you close camera back, make a special point of looking at the film cartridge to be sure you have loaded the right film. Check the ASA film speed as you'll need it in the next step. In this case it is ASA 125.

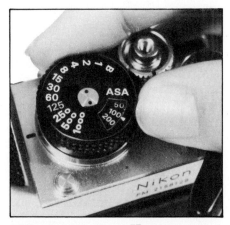

3/When camera back is closed, *immediately* set the film speed dial to agree with the film you loaded into the camera. This FM camera is set for ASA 125.

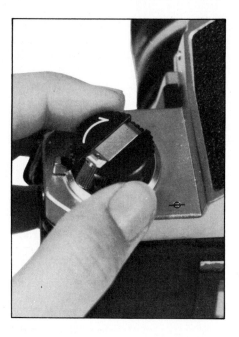

4/Then turn rewind knob clockwise gently until you feel slight tension. This takes slack out of the film so the rewind knob will turn when you advance film.

5/Using the film-advance lever and shutter button, shoot blank frames with lens cap on until the frame counter advances past zero to 1. Watch rewind knob to be sure it turns while you are advancing film. If so, camera is ready to shoot when you have advanced to frame 1.

When cleaning the interior of the camera, remember the focal-plane shutter mechanism is delicate and treat it accordingly. Avoid touching it or blasting it directly with air.

Drop the film cartridge into the chamber on the left and follow the steps shown in the accompanying photographs.

When the film is caught in the take-up spool and you have advanced it far enough so sprocket holes on *both* sides of the film are engaging teeth on the sprocket, close the camera. Set the film-speed dial.

With the back closed, very gently rotate the rewind knob clockwise as though you are rewinding until you feel a slight resistance. That takes up any slack film inside the cartridge.

The frame counter on top of the camera automatically resets each time the back is opened, setting itself to *minus* 2 frames, which is indicated by the symbol S on the frame-counter dial.

Advancing film with the back open does not advance the frame counter, so when you close the back, it still shows S. All of the film between cartridge and take-up spool was exposed to light just before you closed the back, so none of it can be used to make pictures. It is necessary to advance the film three frames, after the camera back is closed so the light-struck film will be wound onto the

take-up spool and unexposed film will be in position behind the lens.

By operating the film-advance lever and the shutter button, fire 3 *blank shots* with the lens cap in place, while advancing film from S to the first dot on the other side of 0, which is frame 1. You can expose this frame to make the first picture on the roll.

While advancing the film to frame 1, watch the rewind knob on top of the camera. It should revolve counter-clockwise each time you advance film. This shows that the spool inside the film cartridge is actually turning and you are actually advancing film through the camera—which means you have it loaded properly and nothing is wrong.

If it does not turn, you'd better open the back of the camera to make sure the film leader is firmly engaged in the takeup spool.

It is important to understand that the frame counter does not actually count frames of film as they go through the camera. It only counts the number of times you have operated the film-advance lever. If the film leader is caught in the take-up mechanism and film is advancing each time you operate the lever, the frame counter will be telling the truth. If the film leader is not grasped by the take-up, it will not move through camera as you work the advance lever, and the frame counter gives a false count.

Loading and unloading a camera should always be done in subdued light. If you have to do it outdoors, shade the camera with your body to avoid direct sunlight on the film cartridge. The film slot in the cartridge is lined with a soft black material which contacts the surface of the film on both sides to exclude light and prevent fogging film inside the cartridge. This is a practical but not perfect device and you can help it protect your film by minimizing both the

Holders for the film-carton end don't seem very important until you forget what film you have in the camera. Without a reminder, it's easy to become confused —especially if you own more than one camera.

amount of light on the cartridge while loading and unloading and also the length of time the cartridge is in any light.

The cartridge should be left in the package until you are ready to use it and returned to the package or some other light-tight container as soon as you remove it from the camera.

It's a good idea to keep a lens cap over the lens when not shooting and leave it in place while loading film and advancing film.

There is no harm in firing blank shots with the lens uncovered except it gets confusing later. You can end up with well-exposed negatives or slides which show somebody's feet or handsome navel.

FILM GUIDING AND FLATNESS

There are four polished metal rails, two above and two below the focal-plane shutter opening in the back of the camera. The film rides on the two inside rails. They are separated enough not to be in the picture area. In fact, they are directly underneath the sprocket holes. The outer two rails are edge guides. They stand slightly higher than the inner rails so the edges of the film are guided in a straight path from cartridge to take-up.

Because film is wound up inside the cartridge, it tends to curl in the long direction as it is pulled out and across the camera. Because the film is layers of different materials—the base and the emulsion—it may tend to curl crossways also, depending on humidity.

A spring-loaded pressure plate is on the inside of the rear cover of the camera. When the cover is closed, this flat smooth plate gently presses against the two outer guide rails and contacts the back of the film. The two outer guide rails hold the pressure plate away from the two inner rails a small amount to allow for the film thickness. This creates a channel closely confining the film to keep it traveling straight across the camera and hold it flat while being exposed.

The film is in contact with camera parts everywhere it can safely be touched without scratching the emulsion. The inner guide rails touch the emulsion side of the film in the sprocket-hole area. The outer rails touch the edges of the film. The pressure plate touches the back side of the film—the base. If the pressure plate scratches the back side of the film, those scratches will show in a slide or print. Dirt on the pressure plate or gouges due to extreme abuse can scratch the film.

REWINDING FILM

When you have exposed the last frame in the cartridge, the film-advance lever will become difficult to move. *Don't force it!* If the lever completed a full stroke, the camera is cocked and there is a fresh frame in position. You can shoot that frame. If the lever only moved part of a stroke, rewind the film immediately.

Don't try to force the lever hoping to get one more exposure on the roll. If you do, the film may tear out the sprocket holes or pull off the spool inside the cartridge—it's only held with tape! If it pulls off the spool, you will not be able to rewind the film. If this happens by accident, the film must be removed from the camera in a darkroom or you will have to improvise a dark container for your hands and the camera.

There are light-tight cloth bags for this purpose, called *changing bags*. I have read about clever people using a coat for the purpose, gathering the folds of the coat tightly around the camera and inserting their arms backwards in the sleeves. I have never tried it, because I never had to. Don't try it outdoors, because you'll surely fog the film.

Film wound on the take-up side of the camera is not protected from light. If you don't rewind immediately and later forget that you didn't, you can ruin the entire roll by opening up the back of the camera.

Much of good camera-handling technique is based on well-formed habits. If you get in the habit of rewinding immediately when you have exposed the last frame, you will never ruin a roll of exposed film by opening the camera.

On the bottom plate of the camera, directly below the film-advance lever is a small button called the Film Rewind Button, which must be depressed to rewind.

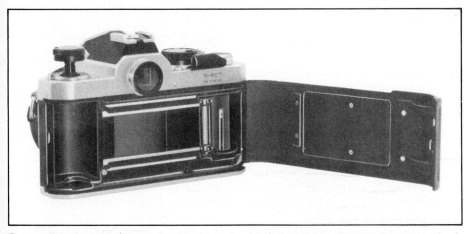

Four polished metal rails work with the spring-loaded pressure plate on the camera back to form a channel for the film. This holds the film flat while each frame is being exposed.

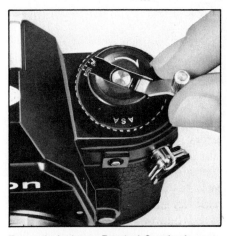

To rewind, tip up Rewind Crank, depress Rewind Button on bottom of camera and turn crank slowly clockwise.

When rewinding, don't turn the crank fast, particularly if the humidity is low. You may get static electricity discharges inside the camera which makes "lightning" tracks like these.

Because both your hands will be busy rewinding rather than supporting the camera, I think it's a good idea to have the neck strap around your neck when rewinding. It helps to support the camera and eliminates any chance of dropping it.

I use my left hand to hold the camera and depress the rewind button. Tilt up the Rewind Crank on the Rewind Knob and turn it with your right hand in the direction of the arrow—clockwise.

Rewind slowly, particularly if the humidity is low. Static electricity can build up on the film and discharge during rewinding. This is a flash of light, like a miniature lightning bolt inside the camera. It can cause strange tracks on the film. Slow rewinding reduces the chance of this happening.

By rewinding slowly and paying attention to the feel of the rewind crank, you will be able to tell when the film end pulls clear of the takeup mechanism. When that happens, there will be about as much leader extending from the cartridge as there was when you loaded the camera.

It's a good idea to stop rewinding at that point, leaving some leader sticking out of the cartridge. The light trap where the film comes out of the cartridge works best when the opening is filled with film. If you wind it all the way into the cartridge you increase the chance of a light leak into the cartridge which can fog the exposed film. On the other hand, if you wind the film all the way into the cartridge, you will never expose the same roll twice.

One side of the film leader is cut off in a standard pattern, making it narrower for the first couple of inches. The light seal of the cartridge works best when the full width of the film is in the trap. If you rewind too far but there's some film sticking out, pull a little bit out of the cartridge so the full width is in the trap.

Rewinding this way makes an exposed cartridge look exactly like an unexposed one. If you think there is any chance of getting confused and putting the same roll back into the camera, you can use a pencil to mark the leader on the emulsion side. Write the letter E for *exposed.* If you've never looked closely at film, the base side is shiny and the emulsion side is a dull gray or brownish color before processing.

You shouldn't ever get confused about whether a roll of film has been exposed or not if you form the habit of never opening the factory package until just before loading the cartridge into the camera.

Another good habit to form is *look at the cartridge* just before you close the camera back cover. If you carry more than one type of film and you are busy shooting action or something that takes a lot of concentration, it's easy to grab and load the wrong kind of film while your mind is busy with something else.

Sometime during the loading procedure, you should have an automatic check point to verify what's in the camera. I formed the habit of doing this just before closing the camera back. It's not too late to take the cartridge out if you have loaded the wrong kind of film, and it is reassuring to *know* you have the right film in the camera.

Read two things on the film cartridge: The film type, such as Agfachrome 64 and the film-speed number, such as 64.

On closing the camera back, *immediately* check the film-speed dial on the camera to be sure it is set at the right number. If the setting does not agree with the film speed of the film you just loaded, change the dial setting Do that even before advancing film to frame 1.

SCRATCHES ON THE FILM

You may get lengthwise scratches on the film. This can happen in the camera, in film developing machines, in printing, or in machines at commercial labs that cut and mount slide film into slide holders.

If it is happening inside your camera, the location of the scratches on film can give you a clue where to look. Check for a piece of dirt, a bit of broken film or scratches on the pressure plate in the camera back cover.

If you don't find anything in your camera, suspect the lab. Complain loudly and emphatically. They may give you a new roll of film but that doesn't help much when you drove two days and climbed a mountain to shoot the roll that was scratched. If it happens twice, find a new lab.

CAMERA CONTROLS & FEATURES

This chapter discusses camera-body controls and features. The camera shown in the photo is a Nikon F3. Other Nikons are similar, including older models. Differences among models are specifically identified in Chapter 13. This discussion is intended to make you generally familiar with camera controls and their locations. With this information, you can adapt quickly to any Nikon.

Power Switch—This is the main switch for the camera.

Film-Advance Lever—This lever is used when loading the camera, to wind film onto the take-up spool and bring frame 1 into position for exposure. After frame 1 is exposed, use the Film-Advance Lever to advance the film so frame 2 can be exposed, and so forth to the end of the roll.

It has two rest positions. When pushed fully against the camera body, in the closed position, it is out of the way. Use this setting to store the camera and when you are using a film winder or motor drive to advance the film, instead of the Film-Advance Lever. The other setting is partially rotated, to the stand-off position, so it is convenient to hook it with your thumb to advance film manually. After you have advanced film, the lever returns to the stand-off setting and is ready to be used again.

To advance film, hook the lever with your right thumb, move it through a full stroke, and allow it to return to the stand-off position. On some models, including the F3, an alternate way of advancing film is to move the lever through a series of short strokes, allowing it to return to

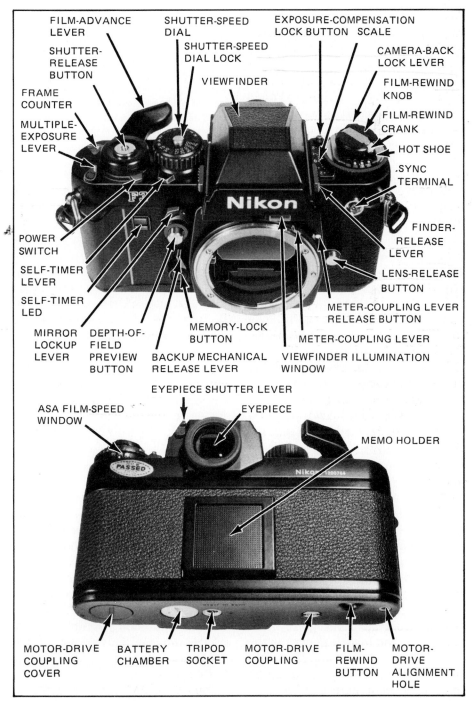

FILM-ADVANCE LEVER
SHUTTER-RELEASE BUTTON
FRAME COUNTER
MULTIPLE-EXPOSURE LEVER
POWER SWITCH
SELF-TIMER LEVER
SELF-TIMER LED
MIRROR LOCKUP LEVER
DEPTH-OF-FIELD PREVIEW BUTTON
SHUTTER-SPEED DIAL
SHUTTER-SPEED DIAL LOCK
VIEWFINDER
EXPOSURE-COMPENSATION LOCK BUTTON SCALE
CAMERA-BACK LOCK LEVER
FILM-REWIND KNOB
FILM-REWIND CRANK
HOT SHOE
SYNC TERMINAL
FINDER-RELEASE LEVER
LENS-RELEASE BUTTON
METER-COUPLING LEVER RELEASE BUTTON
METER-COUPLING LEVER
MEMORY-LOCK BUTTON
BACKUP MECHANICAL RELEASE LEVER
VIEWFINDER ILLUMINATION WINDOW

EYEPIECE SHUTTER LEVER
ASA FILM-SPEED WINDOW
EYEPIECE
MEMO HOLDER

MOTOR-DRIVE COUPLING COVER
BATTERY CHAMBER
TRIPOD SOCKET
MOTOR-DRIVE COUPLING
FILM-REWIND BUTTON
MOTOR-DRIVE ALIGNMENT HOLE

the stand-off position after each short stroke. In the Camera Specifications table of Chapter 13, these two methods of advancing film are referred to as single stroke and multiple stroke.

For most people, the difference between multiple and single stroke advance mechanisms is trivial. For a person with some impairment of movement of the right thumb, the difference may be important.

Shutter-Release Button—When an unexposed frame of film is in place behind the lens, *squeeze* the shutter button to make an exposure.

Multiple-Exposure Lever—To make multiple exposures on the same frame, turn this lever fully counterclockwise for each exposure after the first. Then operate the Film-Advance Lever normally through one full stroke. When advancing film manually, the lever must be reset for each exposure. This lever can also be used to make multiple exposures with motor drive by holding the lever counterclockwise.

Self-Timer Lever—To set the self-timer, move this lever to the left to expose the red dot on the camera body. To start the timer, depress the camera Shutter-Release Button. On the F3, a red Self-Timer LED on the front blinks to indicate that the timer is counting down. During the last two seconds of the ten-second delay period, the LED blinks at a faster rate.

Shutter-Speed Dial—Turn to select numbered shutter speeds, A for automatic operation, X or T.

Shutter-Speed Dial Lock—You must depress this button to turn the Shutter-Speed Dial *away from* the X or A settings.

Film-Plane Indicator—Shows the location of the film plane.

Viewfinder Illuminator Button—In dim light, depress this button to illuminate the shutter-speed and aperture readouts and the over- or underexposure indicators in the viewfinder.

Depth-of-Field Preview Button—When depressed, this closes lens aperture to the *f*-stop selected on the lens Aperture Ring. This allows you to see depth of field at shooting aperture, rather than wide open.

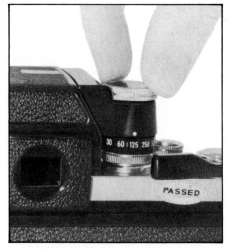

On F2-type cameras, the same knurled ring sets both shutter speed and film speed. To set film speed, lift the ring while turning. Read film-speed scale in center of ring. To set shutter speed, turn without lifting. Read shutter speed scale against white index dot on viewfinder body. This camera is set to 1/125 second.

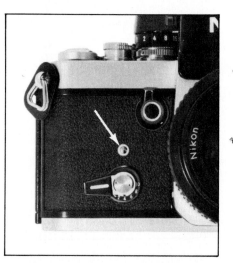

On F2-type cameras, the self-timer start button (arrow) is concealed under the self-timer lever until you move the lever to set the timer for operation. Delay time is read off scale against index mark on hub of lever. This timer is set for 4 seconds delay.

Mirror Lockup Lever—To lock up the mirror, first depress the Depth-of-Field Preview Button. While holding it depressed, rotate the Mirror Lockup Lever away from the lens until it latches. This holds the mirror up and the lens stopped down. To restore normal operation, rotate the lever toward the lens. This allows the mirror to move down to its normal viewing position and the lens to open again.

Backup Mechanical Release Lever—Allows operation of the camera at a mechanical shutter speed of 1/60 second. Pull the lever away from the lens and then press it down to release the shutter. Also functions at T setting of Shutter-Speed Dial.

Exposure Memory Lock Button—With the camera on automatic exposure, this allows metering on one surface and holding the exposure setting while photographing a different scene—called substitute metering.

Finder-Release Levers—Slide these backward to release the viewfinder so it can be interchanged with another type, or to replace the focusing screen.

Exposure-Compensation Control—Causes the camera to give more or less exposure, on automatic than it otherwise would use. Control range is plus-or-minus two exposure steps.

Exposure-Compensation Lock Button—Must be depressed to turn Exposure Compensation Control.

Film-Rewind Crank—To rewind manually, tip this crank out of the Film-Rewind Knob and use it to rewind.

Film-Rewind Knob—Turn clockwise to tension film. This knob rotates counterclockwise when film is being advanced in the camera. To open camera back, lift upward on this knob.

Camera-Back Lock Lever—To prevent opening the camera back accidentally, this lever must be moved counterclockwise before the Rewind Knob can be lifted up.

Film-Speed Control—Lift and turn the outer rim of this control to set film speed.

ASA Film-Speed Scale—Shows the film-speed setting through a rectangular window.

Hot Shoe—Provides mount and electrical connections for SB-12 Flash. Adaptors are available so F3 can use other flash units.

Sync Terminal—Accepts Nikon screw-in or standard push-in sync cords to connect camera body to flash unit that is not mounted in the Hot Shoe.

Lens-Release Button—Depress to remove lens.

HOW TO OPEN THE BACK COVER

To open the back of an F2-type camera, lift the handle of the O/C Key out of the recess, then turn it toward O as indicated by the arrow engraved on the camera bottom plate. Back will pop open. Leave set to O while loading film. Snap back closed, then return key to C position and fold handle down into recess.

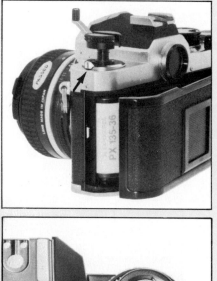

F3

Some models are opened by first moving the Safety Lock (arrow) toward back of camera with one finger while lifting up on the Rewind Knob. It doesn't matter if the Rewind Crank is tipped up or not. Release Rewind Knob before snapping back closed again.

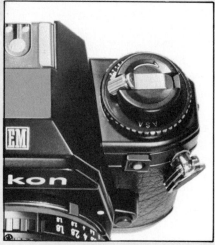

Other models, such as this EM, don't have a safety lock on the Rewind Knob. To open the camera back cover, just pull up on the Rewind Knob. If you find the knob difficult to grasp, tip up the Rewind Crank and pull upward on the crank until you can grasp the knob.

Choosing Shutter Speed for Hand-Holding—When you can't get a long focal-length lens onto a firm support, set shutter-speed to the same number as lens focal length, or to a higher number. If you are hand-holding a 200mm lens, don't use a shutter speed slower than 1/200. Because you can't set to 1/200, set to 1/250 instead.

Eyepiece Shutter Lever—Closes internal shutter to prevent light from entering viewfinder when your eye is not at the eyepiece. This prevents incorrect exposures on automatic.

Motor-Drive Coupling—A mechanical coupling between motor drive and the camera.

Film-Rewind Button—Disconnects film-advance mechanism in camera so you can rewind the film.

Memo Holder—Holds end of film box or any other reminder.

Tripod Socket—Mounts camera on tripod or copy stand. Has standard American ¼-20 threads.

Motor Drive Electrical Contacts—Provides electrical control circuits between camera and motor drive. Also makes connections so batteries in motor drive supply electrical power to the camera.

Battery Chamber—Remove cover to install or replace camera batteries.

Meter-Coupling Lever—Operated by Meter-Coupling Ridge on AI Nikkor lenses to signal setting of lens Aperture Ring.

Meter-Coupling Lever Release Button—Allows Meter-Coupling Lever to be tipped up for stop-down metering.

Viewfinder Illumination Window—Allows ambient light to enter viewfinder to illuminate shutter-speed display. Also allows light from viewfinder illuminator lamp to illuminate lens ADR scale for better visibility in dim light.

Viewfinder Eyepiece—Look in here to see viewfinder displays and image on focusing screen.

NIKON EDUCATIONAL SERVICES

A pleasant and worthwhile tradition in the United States is the traveling Nikon School—actually Schools. The Nikon school will be conducted in most major cities in the U.S.A.

An institution since 1970, more than 200,000 people have taken this opportunity to learn more about photography, face-to-face with friendly and knowledgeable instructors. Even though the schools are sponsored by Nikon and Nikon equipment is used and demonstrated, you don't have to own Nikon equipment to attend and benefit from the information.

The school is given by two instructors during a ten-hour period that passes very quickly. You get a Friday evening of instruction and all day Saturday—or all day Sunday followed by three hours on Monday evening. During the all-day sessions, lunch is included so you meet other people who share your interests.

Ask your local Nikon dealer for schedule information about Nikon Schools coming to your part of the country. You can register in advance, by mail, so you are assured of a seat.

Familiarity with the controls of your camera pays off when you want to shoot at a precise moment. If the camera isn't ready and properly set up, you miss the shot. At Sea World, if you want this shot and miss it, you wait for the next show.

7
VIEWING & FOCUSING

Usually it's good practice to cradle the lens in your left hand. Operate lens controls with your left hand; camera-body controls with your right hand. Take a braced stance, pull in your elbows, and don't breathe at the moment of exposure.

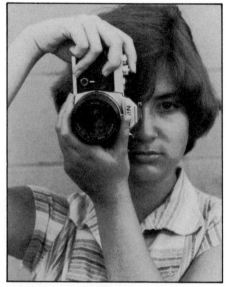

When the long dimension of the frame is vertical, we call it a vertical-format picture. I prefer to hold the camera as shown here.

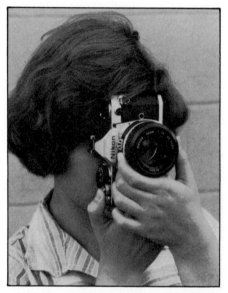

Some photographers prefer this method of holding the camera for a vertical frame, operating the shutter button with the right thumb. However you do it, hold the camera snugly against your face and brace your arms against your body so camera movement is minimized.

A major advantage of an SLR camera is that you see the image through the same lens that is used to take the picture.

Light rays reflecting off the mirror fall on a ground-glass *focusing screen.*

The irregular face of the ground-glass is called a *matte* surface. Each small point on the screen receives light from the lens and becomes luminous. Each small point retransmits light rays toward the eye of the camera operator. What you see is the image on the screen whether it is in focus or not.

The camera is designed so the distance from the lens mounting surface to the film plane is the same as the distance to the focusing screen by way of the mirror. Therefore, if the image is in focus on the screen it will also be in focus on the film when the mirror is moved out of the way to make the exposure. When you make focus adjustments, you are using the screen as a *substitute* for the surface of the film.

Some Nikons use interchangeable focusing screens. These are three types of screens: one type for the F3, another for the FE, and still another

type for the F2 series. Other Nikon cameras used fixed, non-interchangeable screens.

FOCUSING SCREEN BRIGHTNESS

A matte screen tends to be brighter in the center than the edges unless the brightness difference is corrected by a special lens.

As shown in Figure 7-1, each point of a matte screen, when acting as a light source, sends light rays forward in all possible directions.

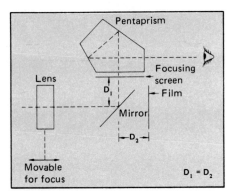

The distance from lens to focusing screen by way of the mirror is identical to the distance from lens to film when the mirror is raised. Judging focus by looking at the screen is equivalent to viewing the image at the film plane.

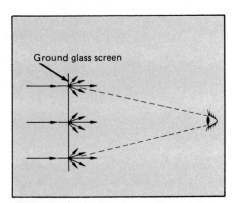

Figure 7-1/Most focusing screens use an irregular *matte* surface such as ground glass. Without correction, much of the light around the edges of the screen goes out of the observer's line of vision. The screen appears dark around the edges even though the image is actually uniformly bright.

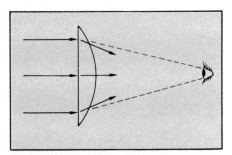

Figure 7-2/Correction of uneven illumination of a focusing screen is made by a *field lens* which bends the outside light rays toward the viewer's eye.

Away from the center of the screen, the brightest rays are not directed toward the observer's eye, so the screen appears dark around the edges.

More uniform focusing-screen brightness is obtained by use of a converging *field lens* which bends the rays from the edges of the screen toward the center, as in Figure 7-2.

A conventional field lens made of glass is thick and heavy. The parts of a lens which change the direction of light rays are the front and back surfaces—the material inside the lens does nothing. Therefore it is possible, for special applications, to remove material from the inside of a lens without changing the contour or shape of the front and back surfaces. Visualize the result, *a Fresnel lens,* by looking at Figure 7-3.

A Fresnel lens is made into a series of concentric rings by circular slices through the lens. Each concentric ring is made thinner by removing material from the inside without changing the shape of either top or bottom surface. Each concentric ring continues to affect light rays just the same as though it had not been "collapsed." However, the rings are separated from each other by vertical faces which sometimes appear as faint circles in the image. For viewfinding, the circles due to a Fresnel lens are not objectionable.

In Nikon cameras, a Fresnel field lens is used in the viewing system to save both weight and space. For further weight saving, these lenses are precision-molded of acrylic resin.

The focusing screen is a "sandwich" with the matte surface in the middle. The glass surface on top is shaped to act as a field lens, giving partial correction of screen brightness. The bottom surface of the viewing-screen assembly is the acrylic Fresnel lens which provides additional brightness correction. If your camera uses interchangeable focusing screens, protect the bottom surface when changing screens so it doesn't get scratched.

Because the screen-brightness problem is only at the edges, most Nikon focusing screens use the Fresnel field lens only at the edges of the viewing area, leaving a circular area in the center without the concentric Fresnel rings. This center area is 12mm in diameter and you can see it in the viewfinder because it looks a little different than the Fresnel lens that surrounds it. This center area without Fresnel rings is usually called a *fine-ground matte focusing spot.* You can judge focus a little better in this area because the image does not include the Fresnel rings.

This 12mm circle is also helpful because it defines the area of maximum sensitivity of the light-metering system in the camera.

THE AERIAL IMAGE

It's easy to understand how we can see an image that has been brought to focus on a matte surface. If the matte surface were not there, the image would be brought to focus anyway but the light rays would not be intercepted by the matte surface. An image of that sort exists "in the air" instead of on a screen and is called an *aerial* image.

Some Nikon focusing screens have no matte surface in all or part of the screen area. In this part of the screen, you see the aerial image because the light rays which were in focus at the aerial image point are again brought to focus at your eye by optics in the viewing system and the optics in your eye.

An aerial image is brighter than one formed on a matte surface because a matte surface absorbs some of the light and does not retransmit all of it toward your eye. A disadvantage of viewing the aerial image is that it doesn't show you depth of field, so aerial-image focusing screens are recommended for special purposes rather than general photography.

Even if the entire viewing area is aerial image, the uneven brightness problem exists unless corrected, so aerial-image focusing screens use a Fresnel field lens but don't have a matte surface.

Figure 7-3/To save weight and space, a converging lens can be "flattened" by dividing it into concentric rings and then making each ring thinner. Viewed from the front, you can see faint circles at the steps in the contour of the lens. This is a Fresnel lens.

Figure 7-4/A biprism is two wedges of glass, tapering in opposite directions. The outer edge is normally made into a circle so it fits a circular area in the center of the focusing screen.

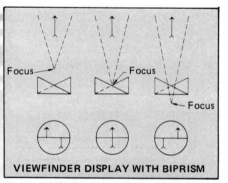

VIEWFINDER DISPLAY WITH BIPRISM

Figure 7-5/A biprism visually separates lines into two displaced segments when the image is not in focus.

Figure 7-6/A microprism is an array of small pyramids whose intersections work like little biprisms. Microprisms work well to show good focus on any subject with surface details.

FOCUSING AIDS

Judging focus by looking at the image on a matte screen depends a lot on how good your eyesight is. Even with good vision it is inferior to other methods of indicating good focus. Other methods, called *focusing aids,* are used. They are located in the center of the focusing screen. **Split Image**—A split-image focusing aid is two small prisms with their faces angled in opposite directions as shown in Figure 7-4. This is called a *biprism.*

Each of the two prisms *refracts* or bends light rays which pass through it. If the image from the lens is brought to focus *in front of the focusing screen,* rather than at the screen, the two halves of the image appear misaligned as shown in Figure 7-5.

If the image comes to focus *on the viewer's side of the screen,* the effect is reversed and the image is misaligned in the opposite direction. At the point of best focus, the two halves of the image are not displaced in respect to each other.

The human eye is better at judging alignment of lines or edges in an image than judging focus by general appearance so a split-image focusing aid is a good way to find focus.

For most effectiveness with vertical lines in the scene, the display should move the top half of a vertical line to the right or left and the bottom half in the opposite direction.

If the prisms are positioned in the camera to split vertical lines and the image consists mainly of horizontal lines, it will be difficult to see any indication of focus.

Some split-image viewfinders are angled at 45 degrees to give some focus indication on both vertical and horizontal lines. If the split-image focusing aid is not oriented correctly to split the lines of whatever you are shooting, rotate the camera until it does. Focus, return the camera to the best orientation for the scene, and make the picture.

Focusing Aid Blackout—Imagine that your eye is looking out at the scene through the biprism and the lens. Your line of sight will be displaced in one direction by one prism and in the other direction by the other prism.

Even though the prism angles are small enough to allow you to look through the lens at full aperture, a smaller aperture may block your line of sight so you end up looking at the back side of the aperture diaphragm rather than out to the world beyond. This is common for focusing aids of this type and the biprism will *black out* on one side or the other.

The side that goes black depends on where your eye is. Move your head one way or the other and the opposite side of the biprism will go black. By changing the position of your eye, you alter your line of vision to favor one prism or the other.

This problem puts the camera designer into a technical conflict. Large prism angles cause large image displacements when the image is not in focus and therefore give a very good indication of focus. But large prism angles are more likely to black out under certain conditions.

In general, smaller aperture size requires smaller prism angles. Assuming you are focusing at maximum aperture, a lens with a maximum aperture of *f*-5.6 will require a smaller prism angle than a lens with maximum aperture of *f*-1.4.

If you are focusing with a split-image focusing aid that is satisfactory for the lens you are using, it may black out if you stop down the lens to view depth of field or do stop-down metering. This isn't a problem because you should already have focused with the lens at maximum aperture where the focusing aid works well.

A biprism which splits lines doesn't work well when there aren't any lines in the picture. The worst case is either a plain surface or a mottled surface such as a mass of foliage. **Microprism**—Another type of focusing aid which is more useful on scenes without strong geometric lines is a *microprism,* shown in Figure 7-6.

It is an array of many small pyramids whose intersections work in a

way similar to the biprism. Visually, the microprism displaces small segments of the image causing it to "break up" and have an overall fuzzy appearance. When focus is reached, the image seems to "snap" into focus.

A microprism is even more helpful when hand-holding the camera. If you jiggle the camera—on purpose or because you can't help it—the image will seem to scintillate when it is out of focus.

Because operation of the microprism is similar to the biprism, it has the same problem of black-out with long focal lengths and small apertures.

Combination Screens—Some focusing screens use a biprism in the center, surrounded by a microprism ring. This is very handy in general photography because you can use the focusing aid that works best for the scene or subject. Nikon focusing screen type K is an example.

Parallax Focusing—Some special-purpose Nikon focusing screens show you an aerial image in the same plane as a pane of clear glass which is used for a focusing screen. A sharply-etched cross is engraved on the clear glass.

With this focusing aid, you judge focus by moving your eye from side to side, or up and down, while looking through the viewfinder. If the aerial image is in focus at the same plane as the engraved lines, nothing will change when you move your eye. If the aerial image is in focus in front of, or behind, the engraved lines, the lines will seem to move across the image when you move your eye. This is called *parallax* focusing. Examples are Nikon focusing screen types C and M.

INTERCHANGEABLE FOCUSING SCREENS

Interchangeable focusing screens for the F3 camera are listed and described with the F3 in Chapter 13. A different set of screens is available to fit the F2A, F2AS and earlier F-series cameras. These are shown with the F2 cameras in Chapter 13. Interchangeable screens for the FE are shown here.

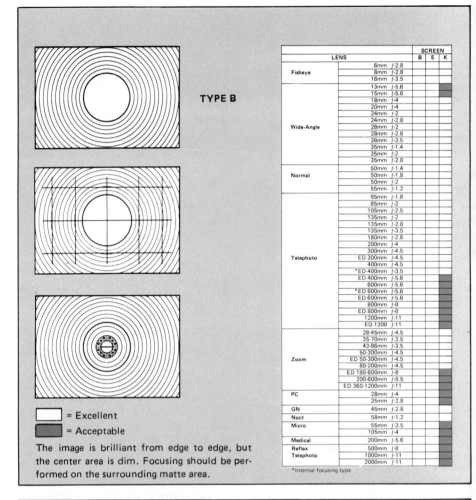

TYPE B

LENS		SCREEN		
		B	E	K
Fisheye	6mm f-2.8			
	8mm f-2.8			
	16mm f-3.5			
Wide-Angle	13mm f-5.6			▨
	15mm f-5.6			▨
	18mm f-4			
	20mm f-4			
	24mm f-2			
	24mm f-2.8			
	28mm f-2			
	28mm f-2.8			
	28mm f-3.5			
	35mm f-1.4			
	35mm f-2			
	35mm f-2.8			
Normal	50mm f-1.4			
	50mm f-1.8			
	50mm f-2			
	55mm f-1.2			
Telephoto	85mm f-1.8			
	85mm f-2			
	105mm f-2.5			
	135mm f-2			
	135mm f-2.8			
	135mm f-3.5			
	180mm f-2.8			
	200mm f-4			
	300mm f-4.5			
	ED 300mm f-4.5			
	400mm f-4.5			
	*ED 400mm f-3.5			▨
	ED 400mm f-5.6			▨
	600mm f-5.6			▨
	*ED 600mm f-5.6			▨
	ED 600mm f-5.6			▨
	800mm f-8			▨
	ED 800mm f-8			▨
	1200mm f-11			▨
	ED 1200 f-11			▨
Zoom	28-45mm f-4.5			
	35-70mm f-3.5			
	43-86mm f-3.5			
	50-300mm f-4.5			
	ED 50-300mm f-4.5			
	80-200mm f-4.5			
	ED 180-600mm f-8			▨
	200-600mm f-9.5			▨
	ED 360-1200mm f-11			▨
PC	28mm f-4			
	35mm f-2.8			
GN	45mm f-2.8			
Noct	58mm f-1.2			
Micro	55mm f-3.5			
	105mm f-4			
Medical	200mm f-5.6			
Reflex Telephoto	500mm f-8			▨
	1000mm f-11			▨
	2000mm f-11			▨

*Internal focusing type

☐ = Excellent
▨ = Acceptable

The image is brilliant from edge to edge, but the center area is dim. Focusing should be performed on the surrounding matte area.

HOW TO INTERCHANGE FOCUSING SCREENS

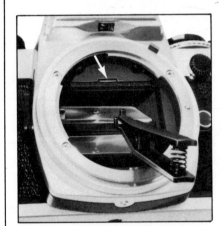

To remove focusing screen from FE, remove lens. Using fingernail, pull out Focusing Screen Holder Release (arrow). Focusing screen will drop down as shown. Using tweezers that come with replacement screens, grasp tab on screen and lift up and out. Use tweezers to place new screen on holder with rear part *on top of curved metal springs at back of holder.* Use projection at tip of tweezers to push upward on screen holder until it clicks into place.

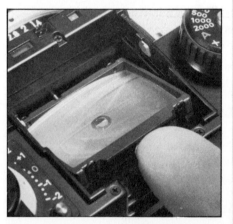

To remove the focusing screen from an F3, first remove the viewfinder by sliding the Finder-Release Levers back and lifting up the finder. One Finder-Release Lever is on each side of the finder. The focusing screen fits snugly into a cavity below the viewfinder. Use your fingernail to lift up the tab on the back of the screen until you can grasp the tab and remove the screen. To install a screen, put the front edge into the cavity first, then lower the back edge, pushing down gently to be sure it is seated.

Type K focusing screen has biprism in center surrounded by microprism ring. Notice that biprism splits out-of-focus image of line but microprism makes it fuzzy. Also notice circle showing boundary of maximum-sensitivity metering area.

CHOOSING A FOCUSING AID

If you use any of the Nikon cameras with interchangeable focusing screens, you can choose screens according to your personal preference or the photographic circumstances.

If you have a camera with a screen that cannot be changed by the user, then of course you use the screen that is in the camera. Current fixed-screen models such as the Nikon EM and the Nikon FM use K-type screens with both split-image and micro-prism focusing aids on the same screen.

The K-type screen can be *used* with all lenses in the Nikkor series however the focusing aids start to black out at apertures of *f*-5.6 and do not function at smaller aperture sizes. When the focusing aid is blacked out, use the matte part of the screen to judge focus.

When mounting Nikon and Nikkormat cameras on a tripod, do not tighten the tripod screw into the camera with great force. Damage to the camera baseplate may result. Just tighten until the mount is firm, without perceptible movement or wobble.

DISPLAY OF APERTURE AND SHUTTER-SPEED SETTINGS

All current Nikon cameras display shutter speed in the viewfinder. Some cameras use a moving needle to show you the shutter speed the camera selects when you choose aperture size. The other camera models display a numeral indicating the selected shutter speed.

Some models also display the *f*-number setting of the lens so you can see it in the viewfinder.

Aperture Direct Readout—AI lenses have two aperture scales on the lens. The one toward the front of the lens is larger and is the one you use when setting aperture while looking directly at the lens.

The smaller aperture scale, toward the back of the lens, is positioned so it can be viewed through a small lens in the viewfinder housing of certain camera models. An image of the selected *f*-number is projected optically into the viewfinder display. You see an actual image of the small *f*-number scale on AI lenses. Because you see it directly, this is called *Aperture Direct Readout* (ADR).

INTERCHANGEABLE VIEWFINDERS

Above the focusing screen in all SLR cameras is the viewfinder housing which provides some optical arrangement for you to view the screen. Nikon F2 and F3 cameras have interchangeable focusing screens and removable viewfinders. This allows both changing the viewing screen and using different types of viewfinders on the same camera body, as shown in Chapter 13.

The F3 displays are all at the top, above the image area. At left, an LED display shows shutter speed with + and − signs to indicate overexposure and underexposure. In the center is the lens aperture setting. At right is a red LED indicator, not visible in this drawing. With the special SB-11 and SB-12 flash units, this red LED signals flash-ready and if there was enough light for correct exposure.

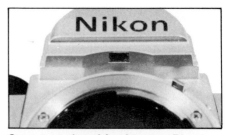

Cameras equipped for Aperture Direct Readout have a small window in the camera body, just above the ADR scale on an AI lens. When looking at the viewfinder display of aperture size, you are actually seeing an image of the ADR scale on the lens itself.

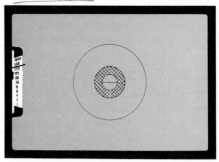

The viewfinder display of the EM has focusing aids in the center and a moving-needle at the left which indicates shutter speed selected automatically by the camera.

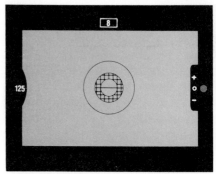

FM display shows aperture at the top, imaging the lens ADR scale. Shutter speed appears at left. Red LED at right indicates correct exposure.

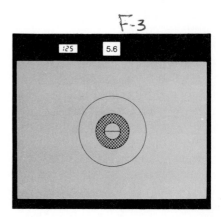

VIEWING AIDS

A set of viewing aids is available to make viewing and focusing easier or more precise. These viewing aids all screw into the eyepiece frame of the finder.

To use Nikon viewfinder accessories on an EM camera, you must obtain a special EM Eyepiece Adapter which is available from your dealer. Slide the adapter over the EM viewfinder eyepiece; then attach viewfinder accessories to the adapter.

Eyepiece Correction Lenses—Correction lenses allow you to put your eyeglass prescription into the viewing system so you can shoot without wearing glasses. Many photographers find eyeglasses inconvenient for several reasons. They touch the camera eyepiece occasionally, which is disconcerting when you are concentrating on focusing and composing the image. Eyeglasses also hold the eye away from the finder and make it difficult to see the entire frame. However, using a correction lens on the camera and shooting without your glasses is a mixed blessing if you need glasses for other purposes—such as not walking in front of a truck or off a cliff because you're blind without your specs. I find it annoying to take my glasses off to shoot a picture and put them back on again to read the frame counter or set the camera controls, but that's what I do.

Available correction lenses are listed in the accompanying table, which gives diopter ratings. These designations are intended to state the diopter rating of the entire viewing system, including the lens.

Theoretically, you can choose an eyepiece correction lens to match your eyeglass prescription, which is also stated in diopters. If your eyeglasses are +3 diopters and you install a +3 correction lens on the camera, theoretically you should be able to view and focus without your glasses. In practice, it depends on whether your eyeglass correction is for near vision, middle distance, or far vision. The viewfinder image is effectively at about arms length and

Eyepiece Correction Lenses screw into camera eyepiece and correct the viewing system for your vision.

EYEPIECE CORRECTION LENSES	
Description	Corrects For
−5 Diopter	Nearsightedness
−4 Diopter	Nearsightedness
−3 Diopter	Nearsightedness
−2 Diopter	Nearsightedness
0 Diopter	Farsightedness
+0.5 Diopter	Farsightedness
+1 Diopter	Farsightedness
+2 Diopter	Farsightedness
+3 Diopter	Farsightedness

All diopter ratings give net effect when installed. With no correction lens installed, viewfinder is −1 diopter.

some glasses—bifocals for example—don't correct well at that distance. The best way to choose is by trying different lenses.

Right-Angle Viewing Attachment—The normal viewing arrangement through the eyepiece on the back of the camera is called eye-level viewing and is convenient for most shooting. If you use the camera on a tripod or stand with the lens pointed downward to photograph something directly below the camera, or if you have the camera at ground level, it may be inconvenient to get your eye where it needs to be to look through the finder window.

The Right-Angle Viewing Attachment screws into the viewfinder eyepiece and changes the optical path for viewing by 90 degrees. The attachment rotates on its own mount so you can view from above, below or at any angle in between. With older models, you see the entire viewfinder frame but the image is reversed left-to-right.

Right-Angle Viewing Attachment rotates so you can view from above, as shown here, or from any other angle. When purchasing, specify camera model it is to fit.

The apparent size of the viewfinder image is reduced to about 60% of what you see without the right-angle attachment. A newer version, the DR-3 Right-Angle Viewing attachment provides a correctly oriented and normal-size image of the focusing screen.

Adjust the accessory to your eyesight by rotating the eyepiece of the attachment. When first installed, you may mistake poor lens focus for misadjustment of the attachment, and the reverse. Focus the right-angle attachment and lens alternately until the image is sharpest. Then you know the attachment is adjusted for your eye and you need only focus the lens for additional shots. The viewfinder split-image or microprism focusing aid will give an indication of correct lens focus even if you have the right-angle attachment slightly misadjusted for your eyesight.

Rubber Eyecup—This is a very convenient accessory with or without eyeglasses. It excludes stray light coming from the gap between your face and the finder. This helps reduce reflections from the glass surface of the viewfinder eyepiece which can be distracting and prevent a good view of the screen. It also helps prevent stray light from entering the eyepiece and finding its way to the camera light-measuring system which could affect exposure readings.

VIEWFINDER DISPLAY ILLUMINATION			
CAMERA MODEL (AND VIEWFINDER)	EXPOSURE INDICATOR	SHUTTER-SPEED DISPLAY	APERTURE-SIZE DISPLAY
F3	Built-in Illuminator ✓	Built-in Illuminator ✓	Built-in Illuminator ✓
F2A Photomic (DP-11)	Ambient light or Photomic Illuminator	Ambient light or Photomic Illuminator	Ambient light on lens ADR scale
F2AS Photomic (DP-12)	Self-illuminated LED	Ambient light or Built-in Illuminator	Ambient light on lens ADR scale
Nikon FE	Light coming through lens	Light coming through lens	Ambient light on lens ADR scale
Nikon FM	Self-illuminated LED	Light coming through lens	Ambient light on lens ADR scale
Nikon EM	Light coming through lens	Light coming through lens	No display

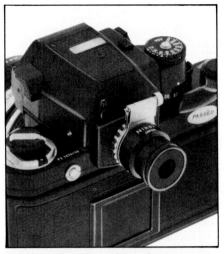

Eyepiece Magnifier is hinged so you can flip it up out of the way when you want to see the entire focusing screen.

Eyepiece Magnifier—Critical focusing is aided by use of a magnifier to examine the image on the focusing screen. The Eyepiece Magnifier screws into the viewfinder eyepiece and magnifies the center part of the image by a factor of 2. You do not see the entire viewfinder frame—only the center part. The image has correct orientation. The magnifier is adjusted for your eyesight by rotating the magnifier eyepiece.

When setting up to use the magnifier, disregard the focusing aid on the focusing screen because the focusing indication is affected by both lens focus and magnifier adjustment when rotating the magnifier eyepiece.

Focus lens and magnifier alternately until the image on the matte surface is sharpest. Then you know the magnifier is set for your eyesight and you need only focus the lens for additional shots. Do this very carefully because misadjustment of the magnifier *changes* the focus indication of split-image and microprism focusing aids.

VIEWFINDER IMAGE AREA

Another variable among camera models is the area or dimensions of the image in the viewfinder compared to the actual size of the film frame. This is usually stated as a percentage. If the viewfinder shows less than 100% of the film frame, the part you don't see is approximately the same as the part of the frame that is covered by a slide mount.

If you shoot negative film, using a viewfinder that doesn't show you the edges of the frame, a print will show things around its edges that you didn't see when you took the picture. Usually this doesn't matter because the unseen border is very small. If it does matter, or if there is something undesirable on the edge of the negative, it can be cropped when printing.

The viewfinder frame coverage is listed for each model in the camera specifications table of Chapter 13.

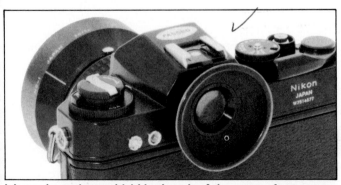

It's good practice to shield both ends of the camera from stray light. Use lens hood and rubber eyecup. Lens hoods are labeled to show which lens they should be used with. They attach in a variety of ways: screw-in, snap-on, slip-in and built-in which means permanently attached to the lens.

8
EXPOSURE METERING

Often there is no single "correct" exposure for a scene. You get different results with different exposure settings and all are acceptable—they create a different mood or feeling about the picture. Photo by Bill Keller.

Measuring the light after it has gone through the lens and any accessories such as filters is an advantage because what the internal light meter "sees" is the light that will expose the film.

Nikon cameras use three types of light sensors:

Cadmium Sulfide (CdS) was standard for many years. CdS responds more slowly than the other two sensor types discussed here, particularly in very dim light. If the reading changes slowly, wait for it to stabilize. In very dim light this can take 30 seconds or more. CdS sensors also require a short time to adjust to large changes in light intensity. If you measure a very bright scene and then immediately measure a very dark scene, the meter reading will be too high. If a minute or so elapses between such major changes in light intensity, the CdS cell works OK. Both of these disadvantages are minor and do not affect normal use of the camera.

The newer Silicon Photo Diode (SPD) requires more electronics in the camera but responds virtually instantaneously and its accuracy is not affected by sudden large changes in illumination. *(F-3)*

A still newer light sensor is the Gallium Photo Diode (GPD). The operational characteristics of GPD sensors are very similar to silicon cells with one significant difference. Silicon cells respond to infra-red light, GPD cells do not. Thus, GPD may give a more accurate reading in some circumstances.

The output of the light sensor in the camera is fed into a built-in calculator along with ASA film speed, shutter speed and aperture. The built-in exposure calculator operates the exposure display in the viewfinder to help you set correct exposure.

Except for automatic operation of automatic cameras, you have manual control and should normally adjust *f*-stop and shutter speed so the display indicates proper exposure.

Because the image reflected onto the focusing screen is the same as the image that will later fall on the film,

This drawing is to give you the idea of center-weighted metering. In the center, the meter "sees" all the light and has maximum sensitivity. Outside of the center area, meter sensitivity gradually decreases toward the edges of the frame.

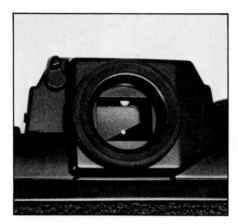

Automatic cameras measure the light and set exposure automatically. If your eye is not at the viewfinder eyepiece, light can enter the eyepiece and cause an incorrect exposure reading—particularly if the camera is in bright light but the subject is in dim light. Some cameras have an eyepiece shutter to close the opening when your eye is not there to block light. In this photo of an F3, the shutter is partially closed. It is operated by the Eyepiece Shutter Lever on the left side of the eyepiece.

the focusing screen can be used as a substitute location for measuring light just as it is a substitute location for judging focus and composition of the picture.

Most Nikon 35mm cameras locate the light sensor in the pentaprism housing, near the viewing eyepiece, so the sensor can "see" the focusing screen and measure the amount of light. The F3 is an exception. *It measures light OTF.*

METERING PATTERN

In many shooting situations, the subject of interest is near the center of the frame and more importance can be given to light from that part of the scene. Nikon light sensors are designed with a sensitivity pattern such that the sensor responds more to light near the center of the viewing screen and less to light nearer the edges. This type of metering is called *center-weighted* because more "weight" or significance is attached to light at the center of the image.

Nikon light sensors make more

than half of the total light reading based on brightness of a 12mm circle in the center of the screen. The circle is visible on many viewfinder screens. The remaining portion of the light reading is based on light outside of the 12mm circle, with decreasing sensitivity toward the edges of the frame.

If you imagine a bright light in the viewfinder, moving from the edge to the center, it will have minimum effect on the exposure meter when the light is at the edge of the frame. As the light moves toward the center of the frame, it will have progressively more effect on the reading.

Center-weighting is a good, practical metering pattern that requires minimum thought and attention when photographing most scenes. As an example, suppose you are photographing a subject on a bright day at the beach. The subject is surrounded by bright sky above and on each side and white sand below. Typically both sky and sand are brighter than the subject's face, so if exposure were set by measuring sky brightness or sand

If your subject fills the central metering area in the viewfinder, and you balance the camera exposure display, you should get a good exposure unless the subject itself requires some special exposure compensation.

Most scenes in nature have average reflectance unless you point the camera at a bright sky or white sand or something unusually light or dark. Man-made objects that are not unusually light or dark can be included and the scene still has average reflectance.

brightness it would be wrong for the portrait. A center-weighted meter automatically "ignores" sky and a bright foreground to take the exposure measurement from your subject. In this situation, a center-weighted metering pattern will give good exposure without any thought from you.

That doesn't mean you shouldn't think about what is being measured and what is inside that 12mm circle. There are situations where any exposure meter can recommend camera settings that will not give the exposure you want. This is discussed in more detail later in this chapter.

i.e. if subject is fully occupying the 12 mm circle

AN AVERAGE SCENE

In the discussion of over- and underexposure, I pointed out that film has a limited range of density between fully clear and fully black. An important idea of exposure is to cause the various light values from a scene to produce densities within the range of the film. The safest thing to do is put the middle light value of the scene right on the middle of the film density scale. Then, higher and lower light values from the scene "have a place to go" on the film.

By measurement of many typical scenes, it has been found that most outdoor scenes and many shots in a man-made environment have the same average amount of light coming from the entire scene. Some parts are brighter and some are darker but they average out, or *integrate,* to the amount of light that would come from a certain shade of gray. This shade is called 18% gray because it reflects 18% of the light that falls on it. I think we are indebted to Eastman Kodak for this discovery. Anyway, Kodak publishes cards which are 18% gray on one side and 90% white on the other. These cards are bound into some Kodak reference books and sold separately at camera shops. Inside covers of H.P. Books' *SLR Photographers Handbook* are printed approximately 18% gray so you can use them as metering aids.

The idea is that you can meter on an average scene or meter on an 18% gray card in the same light and the exposure meter in your camera will give the same settings. Another remarkable property of the 18% gray card is that it works with either b&w or color film. In an average scene, all of the colors integrate to gray when combined, so the gray card represents not only the average reflectance but also the average color. Commer

74

cial high-volume print-making machines produce color prints on the assumption that they should average out to 18% gray.

Not only is 18% gray the average reflectance of an average scene, it is also the *middle* shade or tone in the scene. In an average scene, there are as many shades or tones that are brighter than 18% gray as there are tones darker than 18% gray.

HOW TO INTERPRET EXPOSURE READINGS

If you decide to go around photographing 18% gray cards, I guarantee every exposure will be a whopping success. It's built into the system. The exposure called for by ASA film-speed ratings will put an 18% gray card right in the middle of the density scale of the film.

When you are looking through your camera at a scene and trying to decide if it is average, you must keep in mind the sensitivity pattern of the center-weighted exposure meter. It doesn't see the same way your eye does. You must consider mainly that part of the scene that is near the center of the viewfinder. If it is all a medium tone that reflects approximately 18% of the light, the camera meter will conclude it is average and recommend correct control settings. If the scene *in the measuring area* is partly light and partly dark, but *averages out* to a middle tone, the exposure reading will be OK.

The exposure meter, unless you override it with your own good judgement, will place the *average* brightness in the metering area at the middle density of the film. If the scene in the metering area is mainly sky, sky will become 18% gray on the print and faces in your picture will be too dark.

Every exposure meter "thinks" it is measuring an 18% gray card in some amount of light. It recommends an exposure that will make whatever it sees turn out to be 18% gray in the photo.

If you show the meter a white piece of paper, it doesn't think the paper is white. It thinks it is gray and

This scene was metered exactly as photographed. The central area includes some light, some dark, and the two average out to a middle tone for the scene.

reflects 18% of the light. Therefore the meter thinks the light is very bright and recommends less exposure. Do what the meter says and the reduced exposure will make white paper look exactly 18% gray in the picture. *and gray would be black.*

Show the meter a dark surface and it says, "Aha, the light just became very dim on this gray card. Open up the lens to let in more light!" Wrong again. In the print, the dark surface becomes middle gray. People's faces are seriously overexposed.

You must *interpret* every reading according to what is in the metering area of the viewfinder. If it is a middle tone, you can believe the meter. If not, don't believe it!

If you shoot a small bird on a snow bank, the meter will suggest an exposure that makes white snow look gray, if a significant amount of the white snow is in the metering area. If you are metering mainly bird in the central part of the viewfinder, then a snow background won't have much effect on the meter because of the center-weighted metering pattern.

A clue is the amount and brightness of background included in the central measuring area. If the subject

is small and the background large, worry. If the background is significantly brighter than middle gray, give more exposure than your camera meter suggests.

If the background in the metering area is significantly darker than middle gray, give less exposure than the meter suggests, to avoid overexposing the subject of interest.

Because meter sensitivity gradually diminishes toward the edges of the frame, there is no definite metering area to consider. It is mainly the 12mm circle, but a very bright spot just outside the circle will also affect the meter.

Using a center-weighted metering pattern—or any other kind—requires two things. You must know what the metering pattern is so you can use it intelligently, and then you must practice until you learn how it works. Center-weighting is a "natural" pattern for most photographers and learning to use it is very easy.

A camera that sets exposure automatically measures exposure the same way, with center-weighting. The exposure meter can be fooled the same way but if the camera is setting exposures automatically it

When metering on a gray card, be sure the card fills the central metering area in the viewfinder.

Light skin reflects about one step more light than 18% gray. Take the reading, then open up one step.

will make wrong exposures unless you prevent it. I'll tell you in a minute how to take charge of an automatic camera so you can prevent it from making a mistake.

SUBSTITUTE METERING

This is a way to solve some difficult exposure problems. Suppose you are shooting a scene with no middle tone. Everything is very bright or very dark. If areas of bright and dark are about equal and the metering area includes an equal amount of each, the meter itself will average light and dark and give an exposure as though it was examining the middle tone of the scene. For example, a checkerboard with black and white squares will affect a meter as though it was a uniform gray color, if several squares of each tone are in the metering area.

This requires some judgment on your part as to how bright and how dark the two extremes are and whether they appear in equal amounts to the meter.

You can sidestep the problem by placing an 18% gray card in the scene so it receives the same amount of light as the rest of the scene. Meter on the card and shoot at the exposure setting which results. If you shoot that picture, it will show the gray card as a middle tone with the bright and dark areas appropriately lighter and darker than middle gray.

A more artistic effect results from removing the gray card after taking the reading but before exposing the film. The picture will be the same as before except the card won't be there. Bright and dark areas will reproduce properly.

If it is not convenient to place the 18% gray card at the scene—perhaps because the scene is on the other side of a chasm or river—you can meter on the card anywhere as long as it is in the *same light* as the scene. If you are shooting in sunlight for example, you can assume it has the same brightness everywhere. Hold the gray card near the camera in the same light as the scene and meter on the gray card.

Angle the card so it faces a point between camera and light source *and* so the camera does not see glare reflected from the surface of the card.

Metering on a substitute surface instead of the scene itself is called *substitute metering.* Many photographers carry an 18% gray card for this purpose.

In dim light, a gray card may not reflect enough light to allow metering. Some gray cards are 90% white on the reverse side and white paper is about the same. If you meter on 90% white instead of 18% gray, the white card will reflect *five times* as much light into the exposure meter as a gray card, because 90% ÷ 18% = 5.

Because the exposure meter assumes everything out there is 18% gray, it attributes the high value of light to brighter illumination rather than more reflectance of the surface. Therefore it will recommend an exposure only 1/5 as much as it would if you were actually metering on 18% gray. Because you know that, you compensate by *increasing* exposure by 5 times over the exposure meter reading.

To make the correction, multiply the indicated shutter-open time by 5 and select the nearest standard number. If the exposure meter says shoot at 1/60 second you will want to shoot at 5/60 second which reduces to 1/12 second. The nearest standard speed is 1/15 second.

You can also correct by changing aperture. Opening up by 2 steps is an increase of 4 times, which is often close enough. Opening up aperture by 2-1/2 steps increases exposure 5.6 times, which is closer. There is no exact setting of the diaphragm ring which gives a 5-times exposure increase.

A very handy substitute metering surface is the palm of your hand. You should check your own palm but light skin typically reflects about one step more light than an 18% gray card. If so, you can hold your palm in front of the camera—in the same light as the subject or scene—meter on your palm and then open up one step. If your palm reflects only a half step more, obviously that's how much to open before shooting.

You will find that dirt, grass, weeds, foliage and other common things have a surprisingly uniform reflectance and often it is nearly the same as an 18% gray card. Spend some time measuring common surfaces and you can learn to use them in a hurry as substitute metering surfaces to set your camera for a quick shot of some unusual scene such as a flying saucer passing by. Another advantage of using your exposure meter to measure the reflectance of common objects is that it helps you learn to distinguish non-average scenes from average scenes.

You can use substitute metering with any camera with manual control

Many things around you have reflectances that are suprisingly close to 18%. With your camera exposure meter and a gray card for reference, you'll discover you can use grass, old paving, brown dirt, foliage, and lots of other things as a substitute metering surface.

of exposure settings.

When using an automatic camera, such as the FE and F3, that has a Memory Lock control, you can use the memory lock to perform substitute metering as described a little later. With an EM, which doesn't have a memory lock, you can do it by changing the film-speed setting—also described later.

METERING TECHNIQUES

If the subject of interest fills the central third of the viewfinder area, you can assume the meter reading is taken only from that subject.

If the subject is small compared to the metering area, adjust the exposure as follows: Use 2 steps more exposure if the background is white as paper. Use 2 steps less exposure if the background is black. For intermediate backgrounds, adjust exposure accordingly.

When background in the metering area is a problem, here's an old trick that sometimes helps. Move close enough so the subject fills the metering area. Meter and set exposure controls. Then back up and shoot the picture you want, without changing the controls.

An alternate to marching forward with your camera is to substitute a

long-focal-length lens and get a bigger image of the subject for metering. Then put another lens on and shoot using the same settings you found with the long lens. OR Zoom Back

When metering on light skin, an exposure meter usually recommends settings that will make the skin middle gray. Light skin typically reflects about one step more light than 18%. Better exposure usually results from using one step more exposure than the camera meter suggests. Sometimes, a half-step.

KEEP OUT STRAY LIGHT

Light entering the viewfinder through the viewing eyepiece may affect the meter reading under some conditions. To preserve metering accuracy, observe these precautions.

Hold your eye close to the eyepiece when metering.

Use a rubber eyecup.

When using an automatic camera and operating the shutter with a cable release or self-timer, if your eye is not at the viewfinder eyepiece, prevent stray light from entering the eyepiece. Some camera models have a viewfinder eyepiece shutter you can close to block light. Otherwise, cover the eyepiece with your hand or black tape to keep out light.

AVERAGING f-NUMBERS

Here's another way of solving some difficult exposure problems. Suppose the scene has bright areas and dark areas, both of interest. Move your camera close enough to get an exposure reading on the bright area and notice the recommended setting. Say it's f-8 at 1/125. Then meter on the dark area and again note the recommended setting. Say it's f-2 at 1/125.

You average these two exposure recommendations and shoot at that average setting. It doesn't matter if the scene has any middle tones or not.

How do you average f-numbers? Do it by counting exposure steps. The average of f-2 and f-8 is f-4, two steps from each end. If you want to do it by mathematics, you can't take a common arithmetic average because it

gives the wrong answer. For example, the *wrong* answer is $(2 + 8) \div 2 = 5$.

To average f-numbers, you have to find the *geometric* average of two numbers. Multiply them together and then take the square root of the result—easy to do if you carry a scientific pocket calculator with you on photo trips. Anyway,

$$\sqrt{2 \times 8} = \sqrt{16} = 4$$

Another benefit of measuring the brightest and darkest areas of the scene is that it tells you the overall brightness range of the scene. If this exceeds the capability of the film, you can't get all of the scene on film.

FILM SPEED AS AN EXPOSURE CONTROL

ASA film speed is a message from the film manufacturer to the exposure calculator in your camera, requesting a certain amount of exposure. With a non-automatic camera, the film receives that amount of exposure if you balance the viewfinder display. With an automatic camera, the film gets that exposure if you stand back and let the camera do it.

As you remember, *doubling* ASA film speed means the film needs *half* as much exposure, and the reverse.

You don't have to use the ASA speed number as an input to the camera—you can use whatever you choose. If you dial in a higher or lower speed number, then you are not using the ASA number but you are using your own *Exposure Index (EI)* to guide the camera.

If you have selected 32 at the camera when the film is ASA 64, the camera is set to give one step more exposure than it would if you dialed in 64—provided you balance the exposure display at the speed setting of 32.

This is not necessarily a wrong exposure. Suppose you have performed substitute metering using your precision palm which reflects 36% of the light. To use your palm instead of a gray card, you meter on it and open up one step.

If you decide to change the film-speed dial from 64 to 32 as a way of

adding one step, what happens inside the camera? It depends on the camera. Among the non-automatic cameras, when you change the film-speed setting from 64 to 32, the exposure display in the viewfinder becomes unbalanced by one exposure step. That didn't change the exposure yet because you haven't yet changed *f*-stop or shutter speed. You have to balance the display once again by changing either aperture or shutter speed. When you do that, exposure will increase by one step.

Let's try it with the camera on automatic. It actually makes the exposure requested by the film-speed setting without any help from you. If you set an automatic camera at 32 instead of 64 and meter on the scene it will adjust itself for an exposure one step more than if you had done it with 64 dialed into the camera.

Film speed is an exposure *control* only if the camera exposure is set according to the film speed you have dialed in. An automatic camera responds automatically to a changed film speed, so it is a control. A manual camera responds to a changed film speed only if you then balance the exposure display on the new film speed.

Another use of film speed is to deliberately underexpose or overexpose an entire roll. It is common to shoot with a film speed set into the camera which is higher than the manufacturer recommends. This amounts to deliberate underexposure but many photographers don't think of it that way. They say, "I am rating this film at a higher speed, so I can use it in dim light." Even so, it's still underexposed and requires special development, called *push processing*.

When you shoot any part of a roll with a higher speed number so it requires special processing, you should expose the entire roll that way. It is convenient to change the film-speed rating and leave it for the entire roll. That way you use the camera normally and you don't have to remember not to. You also need to remember to mark that cartridge so it won't get normal development.

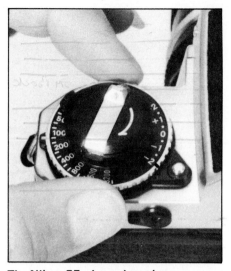

The Nikon FE, shown here, has a special exposure compensation control. To cause the camera to give more or less exposure than it normally would on automatic, lift and turn the knurled ring, placing the index mark on the ring opposite the amount of exposure compensation you want. This control is set for -2 steps. Don't forget to reset to 0 when special compensation is no longer needed.

HOW TO TAKE CHARGE OF AN AUTOMATIC CAMERA

A Nikon automatic camera sets shutter speed automatically based on light from the scene, film-speed and aperture setting. It can be fooled by non-average scenes just like any other meter and camera can be fooled. There are several ways to prevent exposure errors.

Change Film-Speed Setting—For any scene, you can change the amount of exposure the automatic camera will give by changing the setting on the film-speed dial.

If you want the camera to give more exposure, set the film-speed dial to a lower number. Now the exposure calculator thinks the film needs more exposure, so it gives more, automatically. If you want less exposure, dial in a higher film speed number. Remember to change film speed back to the correct setting after the shot or you will get incorrect exposures for the remainder of the roll.

A backlit portrait with the subject against bright sky or a window requires additional exposure because

the bright background "fools" the exposure meter. You should give one to two steps more exposure, depending on how bright the background is and how much of it is in view. This can be done by changing the film-speed setting to a lower number.

With an automatic camera, you can do substitute metering using the film-speed control. Meter on the substitute surface and notice the shutter-speed indication in the viewfinder. Then meter on the subject you intend to photograph. While doing that, change the camera film-speed setting until the shutter-speed indication is the same as that obtained earlier from the substitute metering surface.

EXPOSURE COMPENSATION

Changing the film-speed setting on the camera is a perfectly acceptable way of giving more exposure for a subject against a bright background, or less exposure for a subject against a very dark background—provided you remember to return the control to the correct setting afterwards.

FE and F3—The FE and F3 have a special Exposure Compensation control which you can use to give more or less exposure without actually changing the film-speed setting—although the control has the same end result.

The Exposure Compensation control surrounds the Rewind Knob on these cameras and is mechanically connected to the film-speed control which is at the same location. To give more or less exposure than the camera would otherwise use on automatic, lift the ring and turn until the desired amount of exposure compensation is indicated by a small red index mark adjacent to the scale. The scale is from -2 exposure steps to +2 steps, in increments of 1/2 step.

What this actually does, inside the camera, is change the film-speed setting. When you are not using exposure compensation, be sure to return the dial to zero.

EM—The EM has an Exposure Compensation Button near the lens

mount that you can operate with the index finger of your left hand. When pushed in, it gives about two steps more exposure—suitable for a small subject against a bright background. You must hold the button in while making the exposure. The increased exposure is shown in the viewfinder —the meter needle indicates a shutter speed that is about two steps slower.

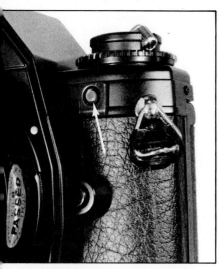

The EM has an Exposure Compensation Button (arrow) which you use when photographing backlit subjects. It gives approximately two steps more exposure. You must hold the button down while making the exposure.

Memory Lock—Another way to take charge of an automatic camera without taking it off automatic is to use the memory lock. On the FE and EL2 camera, this is a second function of the camera self-timer. The control is called Self-Timer/Memory Lock. Move the lever away from the lens and it serves as a self-timer. Move it towards the lens and it becomes a memory lock.

It allows substitute metering with an automatic camera. Point the camera at the substitute metering surface. Be sure the substitute surface fills the metering area—the central third of the viewfinder area, approximately. Let the automatic camera set the exposure for the substitute surface. Operate the Memory Lock by pushing the lever toward the lens and shutter speed is locked even though the needle continues to move with light changes. Then point the camera

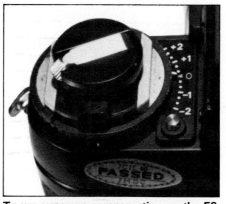

To use exposure compensation on the F3, depress the small chromed Exposure Compensation Locking Button while turning the outer rim of the adjacent ASA Film Speed/Exposure Compensation Dial. Select the amount of compensation by turning the control so the white index mark points to the desired amount of compensation. Range is from +2 to −2 exposure steps, in 1/3 steps.

at the scene you intend to photograph and depress the shutter button while continuing to hold in the lever.

Another use is to place your subject off-center in the frame. Suppose you are making a portrait against sky background but you don't want the subject at the center of the frame. Meter with the subject in the center; operate the Memory Lock; move the camera to place the subject anywhere in the frame; operate the shutter while holding in the lever.

Take It Off Automatic—You can observe the exposure settings before

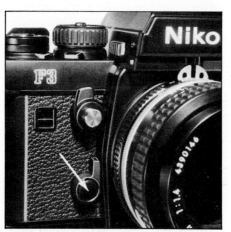

A handy way to do substitute metering with some models is to use the Memory Lock. Meter on the substitute surface. While metering, push in the Memory Lock button or lever. Hold the memory locked while pointing the camera at the scene you intend to shoot and making the exposure. This is an F3 camera.

releasing the shutter. If you don't want to use those settings and the camera can be operated manually, take the camera off automatic by turning the shutter-speed dial to the shutter speed you want to use. Change *f*-stop and shutter speed as needed to increase or decrease exposure compared to the amount that the camera would have used automatically.

HOW MANY EXPOSURE STEPS CAN A CAMERA MAKE?

That's an interesting question. The FM camera has shutter speeds from 1/1,000 to 1 second. If you use the 50mm *f*-1.4 lens, it can close aperture down to *f*-16.

Suppose we set the lens to its smallest aperture and the shutter to its fastest speed. Then move the shutter to slower speeds until we use them all up. Then, at the slowest shutter speed, continue to increase exposure a step at a time by opening the lens until it is fully open. Count the steps. Each *space* between lines in the following table is an exposure step.

f-number	shutter speed	EV number
16	1,000	18
16	500	17
16	250	16
16	125	15
16	60	14
16	30	13
16	15	12
16	8	11
16	4	10
16	2	9
16	1 second	8
11	1 second	7
8	1 second	6
5.6	1 second	5
4	1 second	4
2.8	1 second	3
2	1 second	2
1.4	1 second	1

I make it 17 steps, total. Some Nikons have more.

The number of exposure steps has practical significance. You should recognize that each of the exposure settings in the preceding list is a

0.2 the actual main subject filling the view finder metering area

definite amount of exposure—different by a factor of two from the one above or below.

EV NUMBERS

To simplify identification of these exposure settings, let's assign a number to each one as shown in the right-hand column. Those identification numbers are *exposure-value (EV)* numbers. For some purposes they are more convenient to use because each exposure is represented only by a single EV number rather than the whole assortment of combinations of *f*-stop and shutter speed that will yield the same amount of exposure.

Nikon specifies the working range of the exposure-measuring system in EV numbers.

We encounter a minor complication here. When EV numbers are used to specify the range of an exposure meter, some film speed must be assumed.

Another complication when using EV numbers to specify the operating range of an exposure-measuring system is that the camera meter cannot measure light which can't get through the lens. If you have an *f*-4 lens installed on the camera, the most light the meter can see is what comes through at *f*-4. If you then change to an *f*-1.4 lens, the light meter can work at a lower EV number simply because the lens opens up more.

Therefore the EV range of Nikon exposure meters is specified for a certain film speed *and* a certain lens aperture: ASA 100 and *f*-1.4.

Let's keep separate the exposure steps you can make by different camera-control settings and the EV range of the exposure-metering system because they are not necessarily the same. If the exposure meter can measure 16 steps, but the camera can make 17, the exposure meter cannot work at all camera settings.

It is unusual but not impossible for film to *need* an exposure that the camera cannot provide. This will never happen due to decreased light

EV NUMBERS & EQUIVALENT EXPOSURE SETTINGS																				
EV	4 min.	2 min.	1 min.	30 sec.	15	8	4	2	1	1/2	1/4	1/8	1/15	1/30	1/60	1/125	1/250	1/500	1/1000	1/2000
-8	f-1																			
-7	1.4	f-1																		
-6	2	1.4	f-1																	
-5	2.8	2	1.4	f-1																
-4	4	2.8	2	1.4	f-1															
-3	5.6	4	2.8	2	1.4	f-1														
-2	8	5.6	4	2.8	2	1.4	f-1													
-1	11	8	5.6	4	2.8	2	1.4	f-1												
0	16	11	8	5.6	4	2.8	2	1.4	f-1											
1	22	16	11	8	5.6	4	2.8	2	1.4	f-1										
2	32	22	16	11	8	5.6	4	2.8	2	1.4	f-1									
3	45	32	22	16	11	8	5.6	4	2.8	2	1.4	f-1								
4	64	45	32	22	16	11	8	5.6	4	2.8	2	1.4	f-1							
5		64	45	32	22	16	11	8	5.6	4	2.8	2	1.4	f-1						
6			64	45	32	22	16	11	8	5.6	4	2.8	2	1.4	f-1					
7				64	45	32	22	16	11	8	5.6	4	2.8	2	1.4	f-1				
8					64	45	32	22	16	11	8	5.6	4	2.8	2	1.4	f-1			
9						64	45	32	22	16	11	8	5.6	4	2.8	2	1.4	f-1		
10							64	45	32	22	16	11	8	5.6	4	2.8	2	1.4	f-1	
11								64	45	32	22	16	11	8	5.6	4	2.8	2	1.4	f-1
12									64	45	32	22	16	11	8	5.6	4	2.8	2	1.4
13										64	45	32	22	16	11	8	5.6	4	2.8	2
14											64	45	32	22	16	11	8	5.6	4	2.8
15												64	45	32	22	16	11	8	5.6	4
16													64	45	32	22	16	11	8	5.6
17														64	45	32	22	16	11	8
18															64	45	32	22	16	11
19																64	45	32	22	16
20																	64	45	32	22
21																		64	45	32

Column group header: SHUTTER SPEED (spanning columns 4 min. through 1/2000)

because you can always set the camera on B and expose for two or three weeks if necessary.

It may happen when using fast film in a bright light. The film may need *f*-64 at 1/4,000 but the camera can't do that. You will look for a way to reduce the amount of light coming in the lens. When you find it, it will be called a *neutral-density filter.* Its use is discussed in Chapter 10.

THE BASIS OF EV NUMBERS

Fundamentally, EV numbers have nothing to do with exposure. They only relate to shutter-speed and aperture settings on the camera.

To make it easy, EV 0 is *f*-1 at 1 second, or any other combination of control settings that gives the same exposure.

On the accompanying EV Table, notice that a camera set for EV 1 will give *less* exposure than EV 0. If the film speed is not changed, and if we *assume* the exposure is correct at each EV setting, then EV 1 must have been used because the light was brighter. When EV numbers are used to specify exposure-meter range with an assumed film speed, higher EV numbers mean the light is brighter. When exposure-meter limits are stated in EV numbers, the higher number is the *bright-light* limit; the lower EV number is the *dim-light* limit.

MEASURING RANGE OF THE EXPOSURE METER

This gets complicated, but all you really need to grab is the general idea.

The basic limits in an exposure-measuring system are: When setting exposure or telling you how to do it, the system cannot use any settings that aren't possible. For example, *f*-64 and 1/4,000. Also, the light-measuring sensor cannot be expected to read light levels beyond its range. There is a limit in both directions. The light can be too dim for an accurate reading, or it can be too bright.

The limits are easy to express in EV numbers.

You should understand that the EV range of a camera exposure-measuring system is only the limiting range of metering accuracy. If you work in light that is too bright or too dim for metering accuracy, you should disregard the meter indication and find some other way to figure exposure.

The limit of metering is not a limit on use of the camera. The camera always gives whatever exposure you have the controls set for, no matter if it is in or out of the metering-system range.

HOW MUCH RANGE DO YOU NEED?

A rule of thumb worth remembering is: For scenes illuminated by direct sunlight, correct exposure is *f*-16 and a shutter-dial setting equal to the film speed. For example, if you use ASA 125 film, set shutter-speed to 125 and aperture at *f*-16.

Referring to the EV Table, *f*-16 at 1/125 second is EV 15. All Nikon light-measuring systems work to EV numbers higher than 15, so in general you don't have to worry about the bright-light metering limit of the camera. If you can get the exposure display balanced, the light is not too bright for the meter.

Depending on what kind of photos you take, you may encounter the dim-light limit of the metering system occasionally or frequently. If you shoot at night, you may work beyond the metering limit of the camera. Accessories that produce high image magnification, such as a bellows, reduce the amount of light drastically, often exceeding the measuring limits of the camera's built-in meter.

The metering range varies among camera models as shown in the accompanying table.

To give you an idea of what you can shoot at low light levels, with ASA 100 film, you can shoot faces in candlelight at about EV 4.

METERING RANGE OF AUTOMATIC CAMERAS

Because the FE, EM and F3 meter up to EV 18, you are very unlikely to encounter the bright-light limit of metering accuracy and I suggest you don't worry about it.

If you shoot in dim light or with accessories to get high magnification, these cameras may give you an incorrect meter reading unless you are aware of the metering-accuracy limit. When operating below the accuracy limit, disregard the meter indication and find some other way to measure exposure. A separate accessory light meter may do it. If you are shooting at high magnification, Chapter 9 tells you how to cope with exposure problems.

Operating on Automatic—The simplest way to know if you are operating the camera below the dim-light metering limit is to consult the table on the following page to find the dim-light EV limit for whatever film speed you are using. Then consult the EV Table.

If the camera is set to operate on automatic, it nevertheless does its metering at full aperture, so you are only concerned with full aperture. At the EV-limit number, find shutter speed for the maximum aperture of the lens. Then don't believe the meter reading if the light becomes so dim as to require longer shutter speeds. Not only that, *don't operate the camera on automatic* under those conditions because the camera is automatically choosing shutter speed based on the

MEASURING RANGE OF EXPOSURE METER (*f*-1.4 and ASA 100)		
Camera (Viewfinder)	Measuring Range	Sensor
F3	EV1 to EV 18	SPD
F2A Photomic (DP-11)	EV1 to EV 17	CdS
F2AS Photomic (DP-12)	EV −2 to EV 17	SPD
Nikon FE	EV 1 to EV 18	SPD
Nikon FM	EV 1 to EV 18	GPD
Nikon EM	EV 2 to EV 18	SPD

meter reading. If the meter reading is inaccurate, shutter speed will be wrong and you will not get correct exposure.

Here's an example: Suppose you have ASA 400 film in an FE camera. The dim-light metering-accuracy limit is EV 3. You are using a 200mm f-lens. Consulting the EV table, EV 3 at f-4 is a shutter speed of 2 seconds. In this situation, if the display shows a shutter speed slower than 2 seconds, don't make the exposure. I'll give you another suggestion in a minute.

Bear in mind that *this only applies when you are shooting in very dim light.* In normal light levels you can use Nikon automatic cameras with no worry about exceeding the dim-light metering limit.

A simplified approach is in the table below.

SLOWEST SHUTTER SPEED FOR METERING ACCURACY		
ASA	FE, F3 with f-1.4	EM with f-1.4
6400	1/60 *	
3200	1/30	
1600	1/15	1/30
800	1/8	1/15
400	1/4	1/8
200 (160)	1/2	1/4
100 (80)	1	1/2
50	2	1
25	4	1
12	8	

* (F3 only)

The penalty for using the simplified table is loss of metering ability at low light levels because the table denies you some shutter speeds that you could use with a lens of maximum aperture smaller than f-1.4.

Operating on Manual—If you take the camera off automatic operation so you set both aperture and shutter speed yourself, the dim-light limit doesn't change. When metering at full aperture with meter-coupled lenses, follow the procedure described in the preceding section.

HOW TO OPERATE BELOW THE METERING LIMIT

This is done in two parts. One is

DIM-LIGHT LIMIT OF METERING ACCURACY (EV)		
ASA FILM SPEED	FE, F3 with f-1.4	EM with f-1.8
12	−2	
25	−1	0
32	−1	0
40	0	1
50	0	1
64	0	1
80	1	2
100	1	2
125	1	2
160	2	3
200	2	3
250	2	3
320	3	4
400	3	4
500	3	4
640	4	5
800	4	5
1000	4	5
1250	5	6
1600	5	6
2000	5	
2500	6	
3200	6	
6400	7 *	

* (F3 only)

simply to meter the scene or otherwise get an exposure based on the film's ASA speed. The second part is correction for *reciprocity failure* of the film—discussed in Chapter 10.

You can sometimes measure lower light levels by changing to a lens with larger maximum aperture. The basic limitation is the amount of light actually reaching the sensor in the viewfinder housing. If you are measuring with an f-4 lens and can't get a reading within the metering range, maybe you can with an f-1.4 lens because you can open it wider and let in more light. Then make compensating changes in shutter speed to figure the setting for the f-4 lens you actually use.

Example: Suppose you are using a Nikon FM camera with an f-4 lens. You can't get the display to indicate correct exposure with any setting of shutter speed or aperture, so you know the light is outside of the metering range—with that lens. Switch to an f-1.4 lens and you will get an exposure reading of f1.4 at 1 second.

Because the lens is meter-coupled and actually remains at full aperture, you can change the aperture control to f-4 and the display shows a shutter speed of 8 seconds. Put the f-4 lens back on the camera, check the film data sheet or Chapter 10 for reciprocity failure information and then make the exposure. It will be considerably longer than the 8 seconds you measured, because of reciprocity failure. You may make the resulting time exposure with a locking cable release.

Another way to get an exposure reading is to use an accessory light meter, separate from the camera. Some of these have a very wide metering range with accuracy down to very low light levels. If the accessory light meter will read at an EV level lower than the camera can, use the accessory meter and then transfer the settings to the camera controls. Don't forget to check the film data for the possibility of reciprocity failure.

Another trick is to meter on white paper in the same light as the subject. This reflects more light into the lens than an average subject and may bring the light level within measuring range of the meter. If so, multiply the indicated exposure by 5 as described earlier. Also, don't forget to check for reciprocity failure of the film.

READING THE EXPOSURE DISPLAY

If you are choosing a camera model, consider the type of exposure display and your personal preferences. Three types of exposure displays used in Nikon cameras are shown on the next page.

NIKON EXPOSURE DISPLAYS

MOVING NEEDLE	LED INDICATORS	LIQUID CRYSTAL

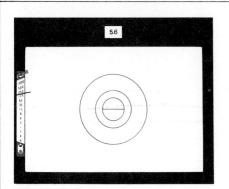

The Nikon FE shows lens aperture setting in a window above the focusing screen by the ADR method which displays an actual image of an *f*-number scale on the lens. At the left of the focusing screen is a moving needle display with two needles.

Automatic operation is selected by turning the shutter-speed dial to AUTO. The green needle moves to the top and indicates A as a reminder. The black needle moves along the scale of shutter speeds to indicate the shutter speed selected automatically by the camera to make the next exposure. If you don't want to use that shutter speed, change lens aperture and the camera will select a different shutter speed to give correct exposure.

On manual, both needles move along the scale of shutter speeds. The green needle shows the setting of the shutter-speed dial. The black needle shows the shutter speed recommended by the camera metering system. For an average scene, correct exposure will result when both needles indicate the same shutter speed—which you cause by changing aperture and shutter speed as needed. This is called "match needle" metering. To give more or less exposure than the meter recommends, don't match the needles.

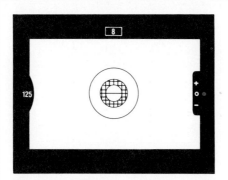

The Nikon FM is a manual camera which gives you control of exposure at all times. The lens aperture setting is displayed in a window above the focusing screen by the ADR method. The setting of the shutter-speed dial is shown at the left and a set of three LED exposure indicators is on the right, adjacent to the symbols +, O, and −.

When O is indicated by a glowing LED, exposure is correct within 1/5 step, for an average scene. To give more or less exposure, adjust aperture or shutter speed as you choose.

+ ○ −	Overexposure by more than 1 *f*-stop
+ ○ −	Overexposure by 1/5 to 1 *f*-stop
+ ○ −	Correct Exposure
+ ○ −	Underexposure by 1/5 to 1 *f*-stop
+ ○ −	Underexposure by more than 1 *f*-stop

The three LED indicators combine to give five indications as shown in this table. If it is not possible to get an indication of correct exposure, the light is too bright or too dim. Change the light if possible. Change film speed, lens maximum aperture, or consider using a neutral density filter, as appropriate.

The F3 uses a Liquid Crystal Display (LCD) which is not self-illuminated. They are opaque numerals which must be illuminated by another source of light. The light source is either ambient light or a lamp in the viewfinder that you can turn on.

At top center, lens aperture setting is shown using the ADR method. At left, shutter speed is shown by an LCD display. At top right is a red LED which is used with some Nikon flash units.

Automatic operation is selected by turning the shutter-speed dial to A. The LCD display then shows shutter speed selected by the camera for correct exposure of an average scene. If the light is brighter or dimmer than the metering range of the camera, the display shows a + or − symbol.

⁻M 500	Underexposure
₊M 125	Overexposure
⁻₊M 250	Correct exposure

On manual operation, the LCD shows the setting of the shutter-speed dial and an M with + and − symbols. These indicate overexposure, underexposure or correct exposure of an average scene as shown in this table. To give more or less exposure than the meter recommends, adjust aperture or shutter speed as you choose.

INTERMEDIATE CONTROL SETTINGS

You can always set any lens to an intermediate setting between marked *f*-stops. Nikkor lenses usually don't have detents between marked *f*-stops, so it's easy to position the aperture ring anywhere between clicks.

Intermediate shutter speeds are allowed on some cameras, in *some part* of the shutter speed range, as shown in the accompanying table. If you make an intermediate setting between marked shutter speeds on a camera that doesn't allow it, the camera still works but at one of the marked shutter speeds.

EXPOSURE ADJUSTMENTS FOR REPRO-COPYING AND SLIDE COPYING

Nikon uses *repro-copying* to mean copying non-transparent materials such as photographic prints, printed pages, stamps and the like. Slide copying is done in a special slide holder and requires more than normal image magnification in the camera. Slide copying is discussed in detail in Chapter 9.

Nikon and Nikkormat instruction booklets typically include advice or a data table as shown here to cover situations where the background may influence the meter reading enough to give incorrect exposure.

EXPOSURE BRACKETING

Bracketing exposures means to make one exposure at camera settings you think may be correct and then make additional shots with more and less exposure. Bracketing can be done in half-steps or full steps on the exposure controls.

Bracketing is recommended when there is any doubt about correct exposure; when there is the possibility that a different exposure may give a more satisfactory result; or when there is the possibility that the different exposures of the same scene may give more than one useful photo.

INTERMEDIATE SHUTTER-SPEED SETTINGS	
CAMERA	INTERMEDIATE SETTINGS ON SHUTTER-SPEED DIAL
All F2 models	Intermediate settings OK from 1/80 to 1/2000. Below 1/80, set dial exactly on a marked shutter speed.
FE on manual and FM	No intermediate settings. Always set exactly on a marked shutter speed.
F3 on manual	No intermediate settings. Always set exactly on a marked shutter speed.
EM	No shutter-speed dial

REPRO-COPYING & SLIDE COPYING				
SUBJECT	B&W or Color Photo	Letters on Light Background	Letters on Dark Background	Photo-micrography
COMPEN-SATION	Expose as though shooting original scene	+1-1/2 steps	−1/2 step	+1 step

Nikon recommends these exposure adjustments when using ordinary color or b&w films. *Photomicrography* means photographing through a microscope. Exposure adjustments are approximate and bracketing is a good idea.

Multiple exposures are fun to make and a challenge to your creativity. This is a small waterfall exposed three times: through a red filter, then green, then blue. I moved the camera between exposures so the images don't overlap exactly. Yellow color is caused by overlap of red and green.

MULTIPLE EXPOSURES

Nikon cameras are designed so you can't expose the same frame more than once—*inadvertently*. Making double or multiple exposures *on purpose* is easy, fun, and sometimes artistically rewarding. It's done in different ways, depending on the camera model.

CAMERA	METHOD
F3, FE, FM	Control on body
EM	No control
F2 cameras	Use Rewind Button

For the EM and earlier cameras without an official method, here's an unofficial procedure:

1. Before the first exposure, take slack out of the film path by turning the rewind knob in the rewind direction until *slight* resistance is felt. Hold the knob in that position for the rest of this operation.

2. Depress the film-rewind button on the bottom of the camera and hold it down with another finger.

3. While holding everything that way, move the film-advance lever through one full stroke.

4. Make the next exposure on the same frame.

If you want to make three or more exposures, repeat this procedure.

When you use this method with cameras having no "official" muliple-exposure procedure, the film may shift a small amount during the multiple exposure. Often this doesn't harm the photo because exact registration of the multiple images is not necessary.

To expose the next frame after the multiple exposure, operate the film-advance lever without holding in the rewind button. Just as you begin to move the lever, the rewind button will pop out and the lever will actually advance film. Put a lens cap on and expose one blank frame.

You can always tell if film is moving or not moving. Watch the film-rewind knob. When film is moving, the knob turns.

Cameras with a Special Multiple-Exposure Control—The FM camera has a Multi-Exposure Button on the top plate next to the shutter-speed dial. Using your left thumb or forefinger, slide the button toward the viewfinder housing after making the first exposure. Hold it that way while operating the film-advance lever; then release the button. Repeat for as many multiple exposures as desired. When the last multiple exposure has been made, operate the film-advance lever without operating the multi-exposure button. This will advance the next frame of unexposed film into shooting position. A blank frame after the multiple exposure is not necessary.

The FE is basically the same, except the control is easier to use. It's a lever that you can move with the index finger of your right hand while operating the film-advance lever with your right thumb. After you have moved the film-advance lever a short distance, you can release the Multi-Exposure Lever.

The F3 is similar. The Multiple-Exposure Lever is on top, in the right front corner. Flip it out for each multiple exposure. It returns to the normal setting after each exposure unless you hold it out.

F2 cameras have a multiple-exposure procedure using the Rewind Button on the bottom of the camera. This is described in Chapter 13.

Keeping Count—The frame counter counts strokes of the film-advance lever rather than actual frames of film as they go by. However, what the frame counter does during multiple exposures varies according to the camera model.

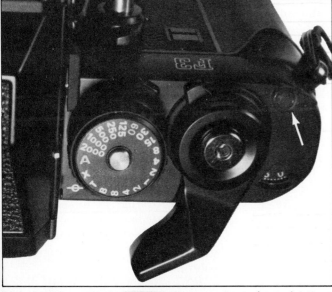

With the F3, rotate the Multiple-Exposure Lever (arrow) fully counterclockwise after the first exposure. It will lock in that position. Then operate the Film-Advance Lever through a full stroke. The Multiple-Exposure Lever will return to its normal setting during the stroke as shown here. Make the next exposure.

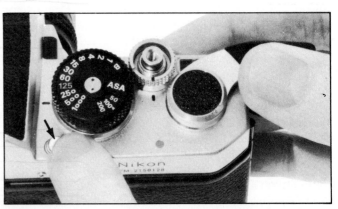

With the FM, move special Multi-Exposure Button (arrow) toward viewfinder, hold while operating the Film-Advance Lever, release and make the next exposure on the same frame.

The Nikon EM frame counter continues to count lever strokes during multiple exposures. If you make three exposures on frame 8, the counter will display the numbers 8, 9, and 10 while you are making the multiple exposure. Then, when you actually advance the next frame of film, the counter reads 11 but you are actually on frame 9. The count remains in error until you reach the end of the roll.

The frame counter runs to its highest number and then stops counting while you finish the roll. You can advance the film and make exposures in the normal way with everything working except the frame counter. When you reach the end of the roll, you know it because the lever resists further advancing. Don't force it!

The F2 models, FE, FM and F3 give you a correct frame count all the way to the end of the roll no matter how many multiple exposures you make along the way.

Setting Exposure—Correct exposure for multiple exposures depends on several things. If a subject is photographed with normal exposure against a dark background, the film frame can then be considered as two separate areas. The area of the subject is fully exposed by the subject. The dark background receives very little exposure because only a small amount of light is reflected by the dark background.

You can make a second exposure against the dark background and give the second subject normal exposure also because the background area on the film is essentially not yet exposed, assuming the two subjects *do not overlap* on the film.

Now the film frame can be considered as three areas. One for each subject with normal exposure and some background that is still not fully exposed. Obviously, a third subject could be placed in the unused dark background area of the frame and normal exposure given to the third subject.

The rule for multiple exposures against a dark background when the subjects *do not overlap* is to give nor-

With a scene under uniform illumination, such as all sunlight or all in shade; there is usually no problem in deciding on exposure.

mal exposure to each shot.

When the subjects do overlap, the situation is different. Normal exposure of two subjects occupying the *same* area on film amounts to twice as much exposure as that area needs—one step too much. Three overlapping normal exposures give three times as much total exposure as the film needs and so forth.

With overlapping subjects, the rule is to give the correct *total* amount of exposure to the film, allowing each individual shot to contribute only a part of the total. If there are two overlapping images, each should receive one-half of its normal exposure. Three overlapping images should each receive one-third the normal exposure.

This is done by dividing the normal amount of exposure for *each* shot by the total number of exposures to be made. Please notice: This *does not* require each exposure to be the same. Measure for each exposure, divide by the number of exposures to be made, and give the resulting amount—whether or not it is the same as some other subject requires.

This procedure tends to give normal exposure to the *combined* image on the film, but each individual image is less bright according to how many shots there are. If you make more

than three exposures, each individual image becomes pretty dim, but the effect is sometimes pleasing anyway. Also, even though the background is dark, it will get lighter and lighter with successive exposures.

A handy way to adjust exposure is: Multiply film speed by the planned number of shots and set the nearest available speed on the camera dial. Then use the camera normally for each shot.

You can also adjust exposure by changing shutter speed or aperture.

With a camera set for automatic, you can use the Exposure Compensation control. Don't forget to reset for normal exposure after the multiple-exposure sequence.

WHEN TO WORRY ABOUT SCENE BRIGHTNESS RANGE

First, let me tell you when *not* to worry. All film manufactured for general use will record any scene under uniform illumination—unless the scene itself includes bright light sources.

When the scene is uniformly illuminated, light reflected toward the camera is governed only by the reflectance of the different surfaces in the scene. A very light object may reflect about

When lighting across the scene varies, such as part sunlight and part shade, you can choose exposure for either part. Exposing for sunlight causes silhouette of sparrow in shadow. Exposing for shadow detail would overexpose sunlight part.

90% of the light; a very dark object may reflect 3% or 4% of the light; but this is a brightness range of only about 5 exposure steps. All films can handle that. Just put the middle tone of the scene on the middle density of the film and you will get a satisfactory picture.

The brightness-range problem occurs when part of the scene is in light and part in shade. If you go exploring outdoors with the light meter in your camera, you'll find lots of shaded areas where the amount of light is 3 or 4 steps less than direct sunlight.

If the light across a scene changes by 4 steps because part of it is in shadow, you can normally figure that the scene-brightness range is increased by that number of exposure steps.

No commonly available film can do that. You may decide either to sacrifice picture detail in highlights or shadows because you can't get both.

If you want to preserve detail in the highlights, meter on a medium tone in the brightly lit part of the scene. If necessary, put a substitute-metering surface in that light. This gives a full range of tones in the brightly lit part of the scene and the lighter tones in shadow.

If you want to preserve a detail in the shadows, meter on a medium tone in the shade. If necessary, put a substitute-metering surface in shadow. This gives a full range of tones in shadow and the darker tones that are in full light.

If you want to make a compromise between losing detail in highlight and shadows, average the highlight and shadow readings as described earlier.

With experience, you learn to judge scenes for brightness range, according to the film you are using. Sometimes you can get fooled. If you use your camera meter to measure the brightest part and the darkest part where you want to record surface texture or details, you won't be fooled. Count the number of steps difference between these two exposure readings and that's the brightness range you must cope with.

Here's a rule of thumb about what films can do:

B&W film can record 7 exposure steps.

Color-slide film can record 6 steps.

Color-negative film can record 5 steps.

When using this rule, it's important to remember to measure only surfaces where detail is important to the picture. If a white shirt or a white wall is in the picture, surface details may not be necessary in these.

LOCATION OF THE LIGHT SENSOR

All information so far in this book applies to all Nikons, no matter where the light sensor for the exposure-measuring system is located. Two locations are used, depending on camera model, and this will make a difference in some discussions later in this book.

In all Nikons except the F3, the light sensor is in the viewfinder housing. It measures light by looking at the top of the focusing screen, just as you do when you examine the image.

What the sensor actually measures is the amount of light transmitted *through* the focusing screen.

Cameras based on the F2 body, such as the F2A and F2AS, use both interchangeable viewfinders and interchangeable focusing screens. A light sensor is in certain of the interchangeable viewfinders, but not all. Therefore these cameras meter when you are using some viewfinders and do not meter when you are using other finders.

For cameras that meter and use interchangeable screens, placing the sensor in the viewfinder housing creates a potential problem. Among a large assortment of interchangeable screens, such as those available for the F2A and F2AS, the amount of light transmitted through the focusing screen varies depending on which screen you have installed. For example, some screens have a matte surface and some are clear; some have a focusing aid in the center and some don't.

For the F2 group of cameras, the exposure reading is corrected by an adjustment you must dial into the metering viewfinder. This correction depends on both screen and lens as you will see in the F2 descriptions in Chapter 13.

For the FE camera, the problem is avoided by limiting the number of

interchangeable screens that can be used. The available screens transmit approximately the same amount of light to the sensor in the viewfinder housing, so no adjustment is required.

For the F3 camera, the problem is eliminated by not placing the light sensor above the focusing screen. It's in the bottom of the camera, below the mirror, as shown in Figure 8-1. This has several important advantages.

The F3 Metering System—The light path for viewing is the same as other SLR cameras and is shown by the upper light path in Figure 8-1. For clarity, the metering path for ordinary photography is shown by the lower ray.

The mirror is manufactured so there are many tiny holes in the center region. About 8% of the light striking the mirror in this region passes through the holes. The remaining 92% is reflected upward for viewing.

Light that passes through the mirror is reflected downward by a small *secondary* mirror behind the main mirror. Light reflected by the secondary mirror enters an SPD light-measuring sensor, which is mounted in the bottom of the camera looking backward toward the film plane. The light-measuring pattern is center weighted.

When you press the shutter button, the exposure measurement is memorized by the camera and the main mirror swings up. Simultaneously, the secondary mirror folds up against the back of the main mirror so it is out of the light path to the film. For ordinary photography, light metering *ends* when the main mirror swings up.

This system has several advantages. The F3 also uses interchangeable viewfinders and a large assortment of interchangeable focusing screens. Because metering is in the camera body rather than in one of the viewfinders, the camera meters with any of the available finders installed. Because the light being measured does not pass through a focusing screen, no correction is necessary for different screens. This greatly simpli-

Scenes that are partly in sunlight and partly in shadow present an exposure problem.

fies camera operation.

With certain Nikon electronic flash units, the light sensor in the camera body is used to control exposure by the flash. The light path for this application is also shown in Figure 8-1.

Metering begins after the mirrors are up, after the first curtain of the focal-plane shutter is fully open and at the instant the flash fires. At that instant, the light sensor in the camera is looking at the front surface of the film, measuring the light that is actu-

ally being used to expose the emulsion. When enough light has been measured for correct exposure, the sensor turns off the flash. This is discussed with more detail in Chapter 11. *what about free flash?*

Still another advantage of the F3 metering system is automatic exposure control when photographing at high magnification through a bellows or extension tubes, and when copying slides. This is discussed in the following chapter.

LIGHT MEASUREMENT IN THE F3

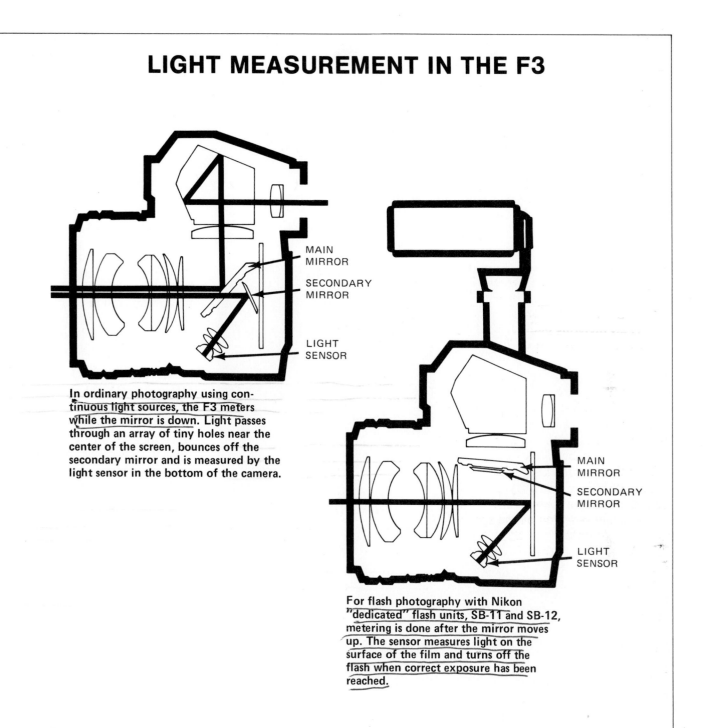

MAIN
MIRROR

SECONDARY
MIRROR

LIGHT
SENSOR

In ordinary photography using continuous light sources, the F3 meters while the mirror is down. Light passes through an array of tiny holes near the center of the screen, bounces off the secondary mirror and is measured by the light sensor in the bottom of the camera.

MAIN
MIRROR

SECONDARY
MIRROR

LIGHT
SENSOR

For flash photography with Nikon "dedicated" flash units, SB-11 and SB-12, metering is done after the mirror moves up. The sensor measures light on the surface of the film and turns off the flash when correct exposure has been reached.

Figure 8-1

CAMERAS, VIEWFINDERS AND SCREENS					
CAMERAS WITH INTERCHANGEABLE FOCUSING SCREENS AND VIEWFINDERS	FACTORY-INSTALLED CAMERA VIEWFINDER	CAMERAS WITH NON-INTERCHANGEABLE FOCUSING SCREENS AND VIEWFINDERS		FOCUSING SCREEN USED	CAMERAS WITH FIXED VIEWFINDERS BUT INTERCHANGEABLE FOCUSING SCREENS
Nikon F3	DE-2				
Nikon F2	DE-1	Nikon FM	Nikkormat FT3	K-type	Nikon FE
F2A Photomic	DP-11	EL2			
F2AS Photomic	DP-12				

89

9
CLOSE-UP & MACRO PHOTOGRAPHY

You'll enjoy exploring the world of close-up and macro photography.

Two different types of accessory items are used in close-up and macro photography. They will be discussed separately with the simple theory of how each of these devices works. After that, application is easy.

MAGNIFICATION OF A NORMAL LENS

A 50mm lens used by itself on the camera has greatest magnification when focused on the closest possible subject. The closest focusing distance of a 50mm lens is a little less than 0.45 meters—the closest marked distance on the focusing ring. This distance is measured from the film plane inside the camera body.

To focus at the closest distance, rotating the focus control moves the 50mm lens away from the film by about 7.5mm, so the distance from lens node to film becomes about 57.5mm.

Under these conditions, magnification is approximately 0.15—the image on the negative is about 15% as tall as the subject.

WAYS TO SPECIFY MAGNIFICATION

In this book, image size and subject size are compared to each other in only one way: Image size divided by Subject size equals Magnification. Magnification can also be calculated by comparing distances: Image distance divided by Subject distance equals Magnification. Both are written by the same formula. To find Magnification (M),

$$M = \frac{I}{S}$$

...nage
... size
... you
...stance
... them

...he same
...d result
...cation is
...eans the
...than the
...is less than
...than subject

...re uses other
... thing. *Repro-*
...magnification
...u see the term
..., it also means
magnification, figured by the formula just given.

Some Nikon literature uses the symbol X to indicate magnification. 2X means a magnification of 2. 1/5X means the image is 1 unit tall and the subject is 5 units tall. In this book, I will complete the indicated division. 1/5 = 0.2. A magnification of 1/5 is the same as a magnification of 0.2.

CLOSE-UP PHOTOGRAPHY

Close-up photography begins at about the same place normal lenses leave off. *Close-up* photography starts at a magnification of about 0.1 and extends up to a magnification of 1.0 or life-size. *Macro* takes over from there and gives larger-than-life images on the negative.

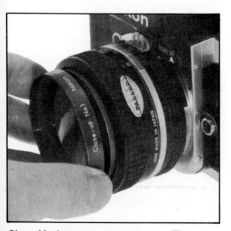

Close-Up lenses are easy to use. They just screw into the accessory threads on the front of the camera lens.

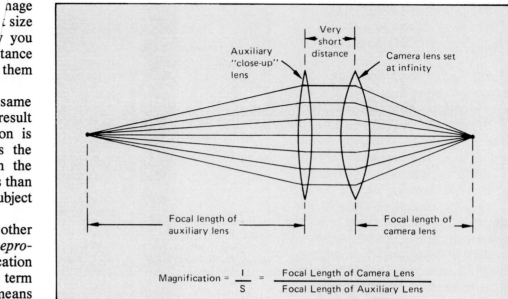

Figure 9-1/With close-up lenses, magnification is easy to calculate.

$$\text{Magnification} = \frac{I}{S} = \frac{\text{Focal Length of Camera Lens}}{\text{Focal Length of Auxiliary Lens}}$$

Close-Up Lenses—Clear-glass accessory lenses used to increase magnification attach by screwing into the front of the lens. They are called *supplementary* lenses, *close-up* lenses and sometimes *portrait attachments*. Nikon refers to them as *close-up lenses*.

They work by playing an optical trick on the camera lens.

To use a close-up lens, it is screwed into the filter-mounting threads on the front of the camera lens—sometimes called the *prime lens*. This results in a very short distance between close-up and prime lens, as shown in Figure 9-1.

The subject is placed at the focal point of the close-up lens. If the close-up lens has a focal length of 500mm, the subject is placed 500mm in front of the lens. Light rays from every point of the subject enter the close-up lens and emerge on the back side as parallel rays. The parallel rays immediately enter the front of the camera lens.

The simplest example is when the camera lens is focused at infinity. It is "expecting" parallel rays from a distant subject but it actually receives parallel rays from a nearby subject due to the action of the close-up lens. The prime lens doesn't care—when it receives parallel rays, it brings them to focus behind the lens at a distance equal to its focal length. If the camera lens has a focal length of 50mm, it will bring parallel rays to focus at a distance of 50mm behind the lens—actually behind the optical point called the lens *node*.

In this situation, when the camera lens is focused at infinity, magnification is very easy to figure.

$$M = \frac{\text{Image distance}}{\text{Subject distance}}$$

Image distance is the focal length of the camera lens; subject distance is the focal length of the close-up lens. I'll show an example of this calculation in a minute.

Because close-up lenses attach by screwing into the filter threads, they are virtually universal in application. All you have to do is buy close-up lenses with the correct thread diameter to fit your lens. If your lens uses filters with a 52mm thread diameter, get close-up lenses with the same diameter. Several accessory manufacturers offer sets of close-up

lenses in various thread diameters. These are available at most camera shops, in commonly used sizes.

Focal Length and Diopters—

Accessory close-up lenses often come in sets of three, identified as 1, 2 and 3. Some makers offer a 10 lens also. The focal length of the lens is disguised in its identification number.

These numbers are properly called *diopters,* a measure of lens *power.* Eyeglass prescriptions are written in diopters. The diopter rating of a lens is the reciprocal of its focal length—1 divided by focal length—when focal length is *expressed in meters* rather than millimeters or any other unit. To find the diopter rating of a 500mm lens, notice that 500mm is 0.5 meter.

$$\frac{1}{0.5 \text{ meters}} = 2 \text{ diopters}$$

That's a 2 close-up lens.

An easier way to do it is divide 1,000 by the lens focal length *in millimeters:*

$$\frac{1,000}{500 \text{mm}} = 2 \text{ diopters}$$

To figure magnification with an accessory close-up lens rated in diopters, you need to work that problem backwards. You *know* the diopter rating, it's engraved on the close-up lens—you need to know focal length.

Here's the formula you actually need:

$$\text{Focal Length (mm)} = \frac{1000}{\text{Diopters}}$$

If you have a 2 diopter close-up lens,

$$\text{Focal Length (mm)} = \frac{1000}{2}$$

$$= 500 \text{mm}$$

If you are using the 2 close-up lens with a 50mm camera lens set at infinity, now you can figure magnification.

Camera Lens	Close-Up Lens	Maximum Subject Distance		Minimum Subject Distance		Magnification	
		mm	inches	mm	inches	min	max
50mm	1	1000	40	333	13	0.05	0.17
	2	500	20	250	10	0.10	0.22
	3	333	13	200	7.9	0.15	0.28
	3 + 1	250	10	167	6.2	0.20	0.33
	3 + 2	200	7.9	143	5.6	0.25	0.39
	3 + 2 + 1	167	6.2	125	4.9	0.30	0.45
	10	100	3.9	83	3.3	0.5	0.67

Figure 9-2/This shows magnifications with accessory close-up lenses and a 50mm camera lens. Magnification changes according to camera lens focal length. If you double focal length, to 100mm, minimum magnification will also double. Maximum magnification will increase but will not be exactly double.

$$M = \frac{\text{Image distance}}{\text{Subject distance}}$$

$$= \frac{\text{Focal length of close-up lens}}{\text{Focal length of camera lens}}$$

$$= \frac{50 \text{mm}}{500 \text{mm}}$$

$$= 0.1$$

In this example, the image in the camera will be 0.1 (one-tenth) as tall as the subject. That is true *only* when the camera lens is focused at infinity. Focus closer and two things happen.

Image distance gets longer because the focusing mount moves the lens farther from the film. Subject distance gets shorter.

Therefore when you focus the camera lens closer than infinity with a close-up lens attached, magnification increases. Greatest magnification occurs with the camera lens focused at its shortest distance, but it isn't simple to calculate.

Figure 9-2 does the arithmetic for you if you are using accessory close-up lenses rated in diopters.

NIKON CLOSE-UP LENSES

The standard set of Nikon close-up lenses does not have the same diopter ratings as typical accessory sets. The Nikon units are labeled 0, 1 and 2 with diopter ratings of 0.7, 1.5 and 3, respectively. Figure 9-3 shows the magnification ranges you can get with combinations of Nikon close-ups.

Nikon close-ups fit lenses with 52mm filter-thread diameter which means they will fit at least one Nikkor lens in most focal lengths from 20mm to 200mm. Use of close-up attachments with lenses longer than 200mm is not recommended on account of poor image quality—and 200mm is marginal for some applications.

DOING IT WITH ARITHMETIC

First, calculate the magnification you need, based on subject size and the desired image size. Usually people figure on nearly filling the frame with the image. Decide which camera lens you will use, remembering that longer focal lengths give more magnification.

Then figure the focal length of the close-up lens using this formula:

$$F_{cu} = \frac{\text{Focal length of camera lens}}{\text{Desired Magnification}}$$

Knowing focal length of the close-up lens, consult one of the accompanying tables to see which close-up lenses have that focal length. Use the close-up attachment with the nearest *larger* focal length.

If you prefer, convert close-up lens focal length into a diopter rating with this formula:

$$\text{Diopters} = \frac{1000}{\text{Focal Length (mm)}}$$

	Lens			
CLOSE-UP LENS 1	50mm f-2		13.2–30.4	0.23–0.08
	55mm f-1.2		14.2–30.7	0.22–0.08
	85mm f-1.8		18.8–31.2	0.26–0.13
	105mm f-2.5		20.9–31.5	0.29–0.16
	135mm f-2.8		24.3–32.6	0.33–0.20
	135mm f-3.5		23.9–32.1	0.33–0.20
	200mm f-4		27.2–33.4	0.50–0.30
	Zoom 43–86mm f-3.5	F=43mm	22.5–31.5	0.11–0.07
		50mm	22.5–31.5	0.13–0.08
		60mm	22.5–31.5	0.16–0.09
		70mm	22.5–31.5	0.19–0.11
		86mm	22.5–31.5	0.23–0.13
CLOSE-UP LENS 2	50mm f-1.4		11.1–17.5	0.29–0.15
	55mm f-1.2		11.6–17.5	0.29–0.16
	85mm f-1.8		14.1–17.9	0.38–0.25
	105mm f-2.5		15.2–18.3	0.45–0.31
	135mm f-2.8		17.3–19.4	0.56–0.40
	135mm f-3.5		16.8–18.9	0.56–0.40
	200mm f-4		19.1–20.1	0.83–0.59
	Zoom 43–86mm f-3.5	F=43mm	16.2–18.9	0.18–0.13
		50mm	16.2–18.9	0.20–0.15
		60mm	16.2–18.9	0.25–0.18
		70mm	16.2–18.9	0.30–0.21
		86mm	16.2–18.9	0.37–0.25
LENS 1 +2	50mm f-1.4		9.9–13.2	0.37–0.23
	50mm f-2		9.7–12.9	0.37–0.23
	55mm f-1.2		10.2–13.3	0.37–0.24

	f-4.5			
3T + 4T	85mm f-2		11.5–13.2	0.53–0.37
	105mm f-2.5		12.5–13.8	0.63–0.45
	135mm f-2.8, f-3.5		13.7–14.4	0.83–0.59
	200mm f-4		15.7–15.7	1.2–0.91
	Zoom 80–200mm f-4.5	F=80mm	16.4–17.1	0.43–0.36
		200mm	16.4–17.1	1.1–0.91

Figure 9-3/This table shows magnification with selected camera lenses for the standard set of close-up lenses and two close-up lenses—3T and 4T—intended for use on telephoto lenses with 52mm filter rings. 3T and 4T are two-element lenses to reduce aberrations and have Nikon Integrated Coating. When using close-up lenses, verify focus by checking matte area of focusing screen. When stacking close-up lenses, watch for image cut-off at corners of the frame. Although allowed in this table, use of close-up lenses 1 or 2 with the 200mm f-4 may result in visible loss of image quality.

Then choose the close-up lens or combination of lenses with the nearest *smaller* diopter rating. Either way, this gives you a magnification that is a little less than you need with the lens set at infinity. Changing lens focus to a shorter distance then gives more magnification.

If you can't get the needed magnification with a close-up lens you

FOCAL LENGTH OF NIKON CLOSE-UP LENSES		
LENS	DIOPTERS	FOCAL LENGTH (mm)
0	0.7	1430
1	1.5	667
2	3	333
1 + 0	2.2	455
2 + 0	3.7	270
1 + 2	4.5	222
1 + 2 + 0	5.2	192

Cloth photographed at a magnification of about 4, enlarged more to make this print. Depth of field is always a problem at high magnifications. Cloth is raised up due to needle puncture and band of acceptable focus is clearly visible.

Close-up lenses are handy and convenient for photographing objects in nature. When shooting flowers, try backlighting.

have, go back to the beginning and start over with a camera lens of different focal length, longer for more magnification, shorter for less.

SETTING EXPOSURE WITH CLOSE-UP LENSES

Close-up lenses don't change exposure enough to worry about. At higher magnifications, they make a very small change that you can ignore. Usually you will be using the camera's built-in exposure meter anyway, so it measures the effect of the close-up accessory and you set exposure accordingly.

USING CLOSE-UP LENSES

Because close-ups are simple single-element lenses, they have uncorrected optical aberrations which become more apparent at higher magnifications. In general, you'll get satisfactory image quality if you use close-up lenses at magnifications of 0.5 or less. You can stack close-up lenses by screwing one into the other and then screwing the combination into the lens filter threads. If so, put the

close-up with the highest diopter rating nearest the camera. Nikon recommends stacking no more than two.

When close-up lenses are stacked, the diopter rating of the combination is the sum of the individual ratings.

If you use magnifications greater than 0.5, or stack more than two close-ups, you'll get visible degradation of image quality but the result may still be satisfactory for your purpose.

With the same close-up lens, camera lenses of longer focal length give more magnification. Subject distance is *always* the focal length of the close-up lens. Image distance is the focal length of the camera lens—when focused at infinity. If you change from a 50mm camera lens to a 200mm, you'll get 4 times as much magnification with the same close-up lens.

As with any other high-magnification photography, the camera should be on a tripod or solid mount. If you are a solid mount, you can try handholding. Use a lens hood to exclude stray light.

If you are using a tripod or copy

stand, lock the camera mirror up to reduce vibration. These lenses do not interfere with camera automation, so you can meter and set exposure as you normally do.

Depth of field is usually a major problem in close-up and macro photography because it is seldom enough. About the only thing you can do is close down the lens. In the high-magnification domain, closing aperture is not as effective as in normal photography, but it will help some.

You may end up looking for more light and shooting at long exposure times so you can use a small aperture.

Don't use two or three close-up lenses stacked if you can avoid it because every surface reflects light. I think it's better to use only one close-up lens with longer camera lenses to get more magnification.

Changing focus with any lens changes magnification, but when subject distance and image distance are about the same, focusing the lens causes large magnification changes. When you are trying to control image size in the frame and also find focus,

t can be frustrating. A technique you will quickly discover is to set the focus control for magnification, then move the entire camera back and forth to find focus.

A good way to get acquainted with a new set of close-up lenses is to try different combinations while focusing on a yardstick.

MACROPHOTOGRAPHY

The word *macro* is often used rather loosely in photographic literature and products. The most strict definition is magnifications greater than 1.0.

As you know, rotating the focusing ring on a lens moves the glass elements of the lens farther from the film, to focus on closer subjects. The lens elements travel along an internal thread in the lens barrel, called a *helicoid*. As the lens is extended along the helicoid, magnification increases. The limit is the end of the helicoid because you can't move the lens any farther by twisting the focus control. This is the *near* limit of focus and the *maximum* magnification of any lens without using additional devices to increase magnification still more.

Nikon offers several ways to move the lens still farther from the film to get more magnification. They are all attachments which fit between lens and camera body to increase lens-to-film distance or *extension*. When using these, you face exactly the same proposition as when using close-up lenses. You can have more magnification than the standard lens and camera combinations will give, but the price is reduced image quality.

Because there are AI and non-AI lens mounts, there are extenders and related items for each.

Magnification by Lens Extension— When you increase image distance by moving the lens farther from the film, two things happen. Magnification increases and subject distance automatically decreases. This means the point of focus is moved closer to the lens by increasing extension and there's nothing you can do about it.

One handy way to increase lens extension is the use of spacers called *extension rings* or *extension tubes* which fit between lens and camera body. It can also be done by a bellows between lens and body, which has the advantage of continuous lens positioning at any distance between the maximum and minimum extension or *draw* of the bellows.

Magnification obtained by increasing the distance between lens and camera is calculated approximately by the formula:

$$M = X/F$$

where M is magnification, X is the *added* distance or extension of the lens, and F is the focal length of the lens being used. When X and F are equal, magnification is 1.0, as would be the case with a 50mm lens and 50mm of added extension *with the lens set at infinity.*

From the amount of magnification just calculated, magnification can be increased by focusing the lens to shorter distances than infinity because that decreases subject distance and simultaneously adds image distance.

You can rearrange the formula to figure the amount of lens extension needed for a desired amount of magnification:

$$X = F \times M$$

where the symbols mean the same as before. Suppose you are using a 50mm lens and need a magnification of 0.8:

$$50mm \times 0.8 = 40mm$$

Using bellows or extension tubes, move the lens that far from its normal position and the magnification will be approximately 0.8 with the lens set at infinity.

How Far is the Lens Actually Extended?—Magnification of any lens is determined simply by the ratio of image distance and subject distance.

The focusing helicoid in the lens can move the glass lens elements farther from the film by an amount equal to the length of the helicoid. This varies among lenses, but let's assume it's 7.5mm.

With a 50mm lens on a camera, the *total* distance from lens to film can range from 50mm to 57.5mm, depending on where you set the focus control. When focused on the closest subject possible, the image distance is 57.5mm.

If a separate lens extender is inserted between lens and film, its thickness adds to the distance already there. Using 20mm for the extension device, image distance now ranges from:

$$50mm + 20mm = 70mm$$

up to

$$50mm + 7.5mm + 20mm = 77.5mm$$

In both cases, total distance between lens and film includes the lens focal length of 50mm plus the added extension of 20mm that you inserted between lens and camera. The remaining 7.5mm depends on where you set the lens focusing control.

When you add extension between lens and film by any kind of an extension device, the distance scale on the lens focus control no longer means anything. When you have it set for infinity, the lens is actually focused much closer than infinity. At every setting of the lens focus control, the actual focused distance is much less than the scale shows. With added extension, think of the focus control as a way of changing the total distance between lens and film rather than a way of adjusting where the lens is focused.

Effect of Lens Nodes—In discussing close-up lenses and extension, I've been saying that the simple formulas used here will give *approximate* magnification. The reason is those locations in the optical system that lens designers call *nodes*.

Because node location varies among lens types and nodes typically are separated from each other by an amount that you and I can't discover, calculation of magnification may be inexact. The formulas given here will usually be close enough but if you find a case where they aren't, just

blame it on the nodes and find the magnification you need by experiment.

NIKON EXTENSION RINGS

Extension tubes or rings are the simplest, handiest and least expensive way to put distance between lens and camera. They also weigh the least and take up the smallest amount of space.

Extension rings are available in a variety of types and sizes. Extension rings that fit between lens and camera but preserve all automatic features including full-aperture metering are identified with the letter P, as in PK or PN. There is one series of these extension rings for non-AI cameras and lenses and a different series

for AI cameras and lenses.

Extension rings which preserve n automatic features are identified wit the letter K, as in K-1 and K-2. Thes fit both AI and non-AI cameras an lenses. They require stop-dow metering and manual control of len aperture.

Special-purpose extension ring will be discussed individually in th chapter, along with their purpose and related equipment.

AUTOMATIC EXTENSION RINGS

These come in two sets which ar identical except that one set is for A cameras and lenses and the other se is for non-AI equipment.

EXTENSION RING	LENGTH (mm)	TYPE
PK-11	8	AI
PK-12	14	AI
PK-13	27.5	AI
PK-1	8	non-AI
PK-2	14	non-AI
PK-3	27.5	non-AI

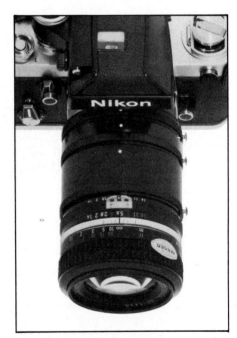

Extension rings fit between camera and lens to give more magnification of the image.

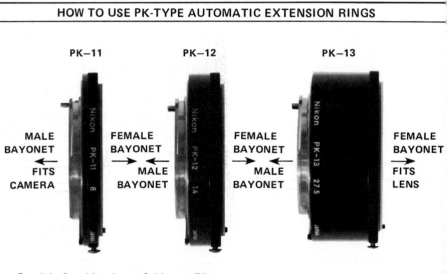

HOW TO USE PK-TYPE AUTOMATIC EXTENSION RINGS

Possible Combinations of AI-type Rings

Rings	Extension (mm)
PK—11	8
PK—12	14
PK—11 + PK—12	22
PK—13	27.5
PK—11 + PK—13	35.5
PK—12 + PK—13	41.5
PK—11 + PK—12 + PK—13	49.5

There are intervals between the fixed amounts of extension you get with rings. With a 50mm lens, you can get every possible magnification between 0 and 1.0, or a little more, with only very small gaps where the focusing movement of the lens doesn't completely "fill in" the interval between fixed extensions.

The range of magnification you can get with a set of PK rings is not the same with lenses of different focal lengths. Let's calculate maximum magnification using a stack of all three PK rings with three different lenses, each lens set at infinity.

$$M = \frac{X}{F}$$
$$= \frac{49.5mm}{200mm}$$
$$= 0.25$$

$$M = \frac{49.5mm}{50mm}$$
$$= 0.99$$

$$M = \frac{49.5mm}{28mm}$$
$$= 1.8$$

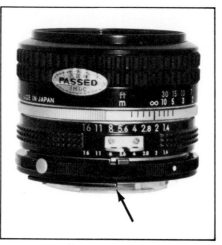

When you install an AI-type extension ring on the AI lens, the combination works with full-aperture metering only on AI cameras because the AI extension ring does not have the meter-coupling prong. It has only a meter-coupling ridge as shown by the arrow. This ridge repeats movement of the ridge on the lens and thus preserves the full-aperture metering feature. Extension ring shown here is a PK-11. This combination of lens and extension ring can be used on non-AI cameras, but with stop-down metering.

To do calculations involving focusing movement, you need to know how much movement there is for various lenses. The accompanying table lists focusing-movement range for lenses you are likely to use with added extension.

LENS FOCUSING MOVEMENT	
LENS	MAXIMUM FOCUSING EXTENSION (mm)
*28mm f-2	4.0
28mm f-2.8	3.8
28mm f-3.5	3.8
*35mm f-1.4	6.7
35mm f-2	6.4
35mm f-2.8	6.4
45mm f-2.8 GN	3.1
50mm f-1.4	7.6
50mm f-2	7.7
55mm f-1.2	7.6
55mm f-3.5 Micro	27.5
58mm f-1.2 NOCT	8.6
85mm f-1.8	10.6
85mm f-2	10.5
105mm f-2.5	13.7
105mm f-4 Micro	52.5
135mm f-2	18.1
135mm f-2.8	18.0
135mm f-3.5	18.1
180mm f-2.8	22.4
200mm f-4	27.0

This table gives focusing movement for some Nikkor lenses that you are likely to use with extension.

*These lenses have floating elements. Extension shown is movement of rear elements. Movement of front elements and change in length of lens will be different. Use extension shown in this table to compute magnification range.

INTERCHANGEABILITY OF AUTOMATIC EXTENSION RINGS					
CAMERA TYPE	EXTENSION RING TYPE	LENS TYPE	MAXIMUM-APERTURE INDEXING	METERING	NOTE
AI	AI	AI	Automatic	Full Aperture	
AI	non-AI	AI	no	Stopped Down	
AI	AI	non-AI	→	→	Lens cannot be mounted
AI	non-AI	non-AI	no	Stopped Down	
non-AI	AI	AI	no	Stopped Down	
non-AI	non-AI	AI	Semi-Automatic	Full Aperture	
non-AI	AI	non-AI	→	→	Lens cannot be mounted
non-AI	non-AI	non-AI	Semi-Automatic	Full Aperture	

NOTE: When a non-AI lens or accessory is to be mounted on most AI cameras, you must first push up the camera's meter-coupling lever to prevent it from becoming damaged. This also prepares the camera for stop-down metering as described in Chapter 8. **DO NOT ATTEMPT TO MOUNT NON-AI EQUIPMENT ON AN EM CAMERA—DAMAGE TO THE CAMERA WILL RESULT.**

NON-AUTOMATIC EXTENSION RINGS

Extension Ring Set K consists of 5 rings which can be purchased separately or a complete set in a case. Because they are non-automatic, they don't have any levers to preserve automatic features of lens and camera. Therefore they work equally well with AI or non-AI equipment. In all cases, these rings require manual operation of lens aperture and stop-down metering.

This set of rings seems complicated at first because some have bayonet mounts; some have screw threads on the ends; some will fit together and some won't. If you spend a minute with the accompanying chart, you'll see the possibilities with K rings.

POSSIBLE COMBINATIONS OF K RINGS	
RINGS	**EXTENSION (mm)**
K–1	5.8
K–2 + K–3	10.8
K–1 + K–2 + K–3	16.6
K–2 + K–4 + K–3	20.8
K–1 + K–2 + K–4 + K–3	26.6
K–2 + K–5 + K–3	30.8
K–1 + K–2 + K–5 + K–3	36.6
K–2 + K–4 + K–5 + K–3	40.8
K–1 + K–2 + K–4 + K–5 + K–3	46.6

REVERSING THE LENS

Lenses for general use are designed with the expectation that subject distance will be considerably longer than image distance—the subject a few feet from the camera and the lens only a few inches from the film, for example. If the lens is not used as the designer expected, lens corrections don't work as well and image quality is degraded.

If magnification is increased by lens extension until the image on film is larger than the subject in real life, then the image distance must be longer than subject distance. For magnifications larger than 1.0, lenses make a better image if they are reversed so the longer optical path is still on the side of the lens that the designer intended—even though it becomes image distance rather than subject distance.

Macro Adapter Ring BR-2—Mounting a lens reversed is done by a gadget commonly called a *reversing ring*. Nikon calls it Macro Adapter Ring BR-2. The adapter screws into the filter-mounting threads on the front of the lens. The other end of the adapter fits the camera mount. The reverse adapter can mount directly on a camera body or, of course, on the forward end of extension rings or bellows.

The BR-2/BR-3 Trick—If you own both a BR-2 and a BR-3, if you can screw them together to make an extension ring with extension of 20.3mm.

Macro Adapter Ring BR-2 is used to mount a lens backwards. The threaded end of the BR-2 screws into the 52mm filter-mounting threads on the front of the lens. Then the bayonet end of the BR-2 is used to attach the reversed lens to a bellows, extension rings, or the camera body.

When a lens is reversed, a BR-3 can be mounted on the forward (bayonet) end of the lens to act as a lens shade, mount filters, and attach a slide duplicator. In this view, the top of the BR-3 is the bayonet end. Lever at side is the release so assembly can be taken apart. Bottom side has internal threads that fit 52mm filters.

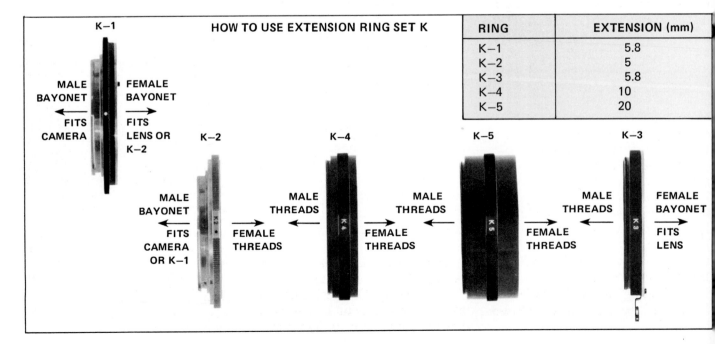

HOW TO USE EXTENSION RING SET K

RING	EXTENSION (mm)
K–1	5.8
K–2	5
K–3	5.8
K–4	10
K–5	20

K–1
MALE BAYONET ← FITS CAMERA
FEMALE BAYONET → FITS LENS OR K–2

K–2
MALE BAYONET ← FITS CAMERA OR K–1
FEMALE THREADS

K–4
MALE THREADS ←
FEMALE THREADS

K–5
MALE THREADS ←
FEMALE THREADS

K–3
MALE THREADS →
FEMALE BAYONET → FITS LENS

EFFECT OF REVERSING ON EXTENSION

Reversing a lens changes the amount of extension. Some is due to the reverse adapter itself. The BR-2 adds about 4.3mm to the distance between lens and film.

Some extension is due to the recess at the front of a lens, between the filter threads and the first glass surface. When a lens is turned around, this recess becomes extension. The amount isn't a lot on most lenses, but there are a few deeply recessed lenses, where it becomes a major factor.

In addition to the mechanical extension provided by the reversing ring and the recess at the front, the optical distance between lens node and film changes when you reverse the lens.

The accompanying table shows approximate lens extension due to reversing the lens. It includes mechanical extension due to the recess between the first glass surface and the filter threads and it also includes extension due to using what is normally the front node in place of the rear node. It *does not* include the thickness of the reverse adapter or whatever method you may use to reverse the lens.

With typical short-focal-length lenses, both nodes are near the film. When such lenses are reversed, both nodes move away from the film by a distance greater than the physical length of the lens body. Thus extension is greatly increased by reversing a short lens and magnification goes up accordingly.

With typical long-focal-length lenses, both nodes are far from the film, near the front glass surface of the lens. When reversed, both nodes become closer to the film and extension is actually *less* than before the lens was reversed. This shows up in the table by *negative* numbers in the lens extension column. For example, if you reverse the 135mm f-3.5 lens, total extension becomes about 100mm less than if you hadn't reversed it. Magnification drops dramatically. Reversing long lenses is an exercise in futility.

APPROXIMATE EXTENSION DUE TO REVERSING LENS	
LENS	EXTENSION DUE TO REVERSING (mm)*
24mm f-2.8	56
28mm f-2, f-3.5	55
35mm f-1.4, f-2, f-2.8	55
50mm f-1.4	51
50mm f-2	34
55mm f-1.2	51
55mm f-3.5 Micro	46
85mm f-1.8	-5
105mm f-2.5	-17
105mm f-4 Micro	-15
135mm f-2.8	-77
135mm f-3.5	-100

*Extension does not include reversing ring. If BR-2 is used, add 4.3mm.

BELLOWS

If you do a lot of high magnification photography, you'll find a bellows more convenient than extension tubes because it requires less fiddling and changing. Also, the amount of extension available with a bellows is considerably more than with a set of extension tubes, so maximum magnification is greater.

Nikon bellows are the PB-4, PB-5 and PB-6. Each consists of two movable metal standards connected to each other by an accordian-pleated bellows. The standards move along the bellows rails by adjustment knobs which operate internal gears. On the opposite side from the knob that moves the standard is a locking knob to hold the adjustment.

The rear standard has a bayonet mount to fit the camera body. Depress a pushbutton on the rear standard and the camera can be rotated to shoot either a horizontal or vertical frame format. The front standard has a bayonet mount to fit a Nikkor lens. Extension rings can be used between the front standard and the lens.

One of the rails on each bellows has a millimeter scale to read bellows extension. This scale does not tell you the amount of extension directly, but you can easily figure it.

These photos of a paperclip show the range of magnifications that are useful and easy to do with a bellows. Magnifications are: 1, 2, 4, and 6. With short-focal-length lenses reversed on the bellows, you can get higher magnifications —up to 10 or 12—but not many common subjects require that much magnification and there are problems with depth of field, lighting and image quality. These photos made with flash.

HOW TO READ THE BELLOWS SCALE

The position of each standard can be read on the scale. On the rear standard, read the scale position of the *rear* face of the standard at the point where it touches the scale. When this standard is moved fully to the rear of the bellows, its rear face aligns with 0 on the scale.

On the front standard, read the scale at the front face. On the rear standard, read the scale at the rear face. Subtract the smaller reading from the larger to get the *scale reading*. This is not actual bellows extension because the distance between front and rear faces of the bellows standards is not the same as the length of the bellows between the camera mount at one end and the lens mount at the other.

To find actual *bellows extension*:

For PB-4 and PB-5, subtract 8mm from the scale reading.

For PB-6, subtract 22mm from the scale reading.

All magnification formulas are based on actual bellows extension.

All formulas for magnification by extension apply to the bellows, so it is easy to figure the amount of extension needed, or it is easy to figure the amount of magnification for a certain extension with a certain lens.

BELLOWS PB-4

This bellows has some worthwhile features not described in the preceding general discussion. It has two sets of rails. The front and rear standards move along the upper pair of rails. A tripod mount moves along the lower pair of rails. In some applications, a movable tripod mount is a significant advantage. When shooting with high magnification, it is virtually necessary to set extension for the desired

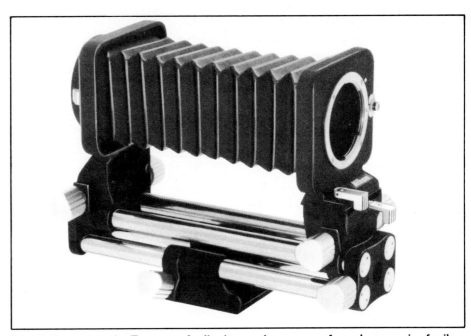

PB-4 Bellows controls: Two sets of rails give maximum ease of use. Lower pair of rails has a movable tripod mount so you can move entire bellows forward or back. Front and rear bellows standards travel independently on upper pair of rails. Each of these adjustments is done by a knob; locked by the knob on opposite side. Front of bellows (at right) has mount for lens and lens-release button. Below lens mount are tilt and shift levers. Camera end of bellows has button to allow rotating the camera for a vertical frame mount.

amount of magnification and then move the *entire* setup—camera, extension device and lens—toward or away from the subject to find best focus. A movable tripod mount on the bellows lets you do this very conveniently.

A movable tripod mount also allows you to support the camera setup close to the balance point of the apparatus.

Always support the bellows by the tripod mount on the bellows. *Never* support the setup using the tripod mount on the camera base.

The Tilt and Shift Feature—Another valuable feature of the PB-4 bellows is *movements* of the front standard. These are similar to the movements of a view camera.

When the bellows is extended, the *tilt* feature allows you to rotate the front standard so the lens is no longer

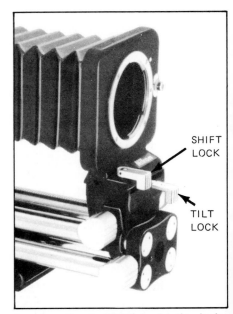

SHIFT LOCK

TILT LOCK

Levers on front of PB-4 are friction locks. Release the top lever and you can shift the front standard sideways. Release the lower lever and you can tilt, sometimes called *swing*, the front standard so it is no longer parallel to film.

parallel to the film plane. Viewed from the top, this rotation is to the left or right—about 30° in either direction.

Tilting a lens angles the plane of best focus in the same direction that you tilt the lens. When shooting at high magnification, depth of field is very small anyway and sometimes it is very helpful to angle it so you can control which parts of the subject are in best focus. Tilting a lens is done according to the Scheimpflug principle as shown in the drawing on this page.

The PB-4 also *shifts* the front standard so it moves left or right along a path parallel to the film plane. If the lens is not tilted, it shifts sideways but remains parallel to the film. If the lens is tilted, it shifts sideways but remains tilted at the same angle.

The main advantage of shifting when shooting at high magnification with a bellows is to compensate for the apparent subject movement when you tilt. If you tilt the lens to the left, it "sees" a different part of the scene than it did before you tilted it.

PB-5 bellows is simpler; has fewer adjustments. Tripod mounts are fixed, at either end.

BELLOWS PB-5

This is a simplified version of the PB-4. It does not have the lower set of rails with the movable tripod mount. Instead, there is a tripod socket at each end of the bellows, in the bottom of the casting which joins the rails together at their ends.

Instead of moving the entire camera setup with the movable tripod mount, as with the PB-4, you have to do it some other way. If you are using a copy stand, some are equipped with an adjustment knob to move camera and bellows up and down together and, of course, this serves as well to find focus.

The PB-5 also doesn't have the tilt and shift capability at the front standard. If you are copying flat subjects such as slides or stamps, there is no need to tilt the plane of best focus.

In general, the PB-5 should be used for copying flat subjects, and for situations where you don't mind spending a little more time getting the shot set up.

BELLOWS PB-6

Newest in the line of Nikon bellows, the PB-6 is a bellows system with some additional accessory components.

The PB-6 uses one rail with "vees" shaped similar to a machinist's lathe. The front and rear bellows standards travel along the top of the rail, each with its own adjustment and lock. A

tripod mount or focusing adjuster travels along the bottom of the rail, with its own positioning control and lock.

A feature not shared with the other bellows is a reversible front standard which makes it very simple to reverse the lens. This is discussed further a little later.

Levers on each side of the front standard can be used to stop down the lens to see depth of field or to make a stop-down meter reading. The camera can be rotated on the rear standard to make horizontal or vertical shots.

For very high magnifications—up to 8.5 with a 50mm *f*-2 lens, a special bellows extension accessory, the PB-6E is available. This attaches to the front of the PB-6 bellows rail and has its own bellows which couples to the PB-6 bellows so the overall combination is much longer.

Without the accessory, the PB-6 bellows has a maximum bellows extension of 208mm. With the PB-6E attached, maximum extension of the combination becomes 438mm.

Also available for use with the PB-6 is Macro Copy Stand PB-6M which serves as a base so the bellows will stand vertically on a tabletop. The PB-6M attaches to the front end of the bellows rail. It has a circular opening which holds two round discs that are supplied with the unit. The discs serve as a background for the subject you are shooting. One is metal, painted 18% gray so you can also use it to make exposure settings. The other is a translucent white acrylic disc which can be used with a light source beneath it if desired. Spring clips on the PB-6M hold the discs in place and can also be used to hold slides or other specimens in place when needed.

The PB-6M can also be used as a slide holder for slide copying, illuminating the slide from behind with the translucent disc installed in the PB-6M. For this application it will be convenient to mount the bellows horizontally on a tripod or vertically on a copy stand and then arrange a light source on the back side of the translucent disc.

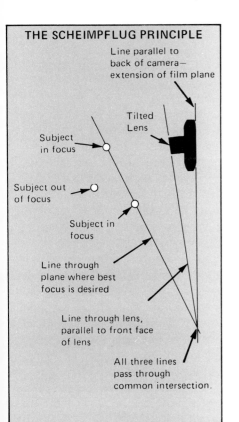

THE SCHEIMPFLUG PRINCIPLE

Line parallel to back of camera— extension of film plane

Tilted Lens

Subject in focus

Subject out of focus

Subject in focus

Line through plane where best focus is desired

Line through lens, parallel to front face of lens

All three lines pass through common intersection.

PB-6 bellows with accessory PB-6M base.

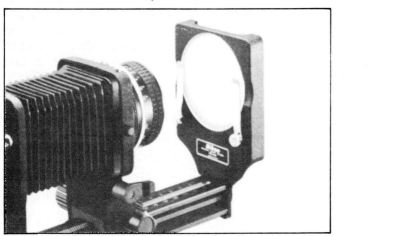

PB-6M base can also be used as a slide holder for slide copying.

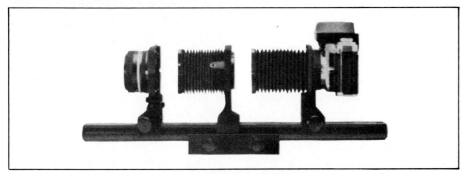

For more magnification, install extension bellows PB-6E between the PB-6 and lens.

REVERSING THE LENS ON A BELLOWS

With either bellows, you should reverse the lens when working at magnification greater than 1.0. With the PB-6 you can do it by removing the front standard, reversing it on the rail, and attaching the front of the bellows fabric to the lens rather than the front standard. This changes bellows extension because the lens is now *between* the two standards. Reading the bellows scale and then adjusting the reading as described earlier will give an approximate but not exact value.

With any Nikon bellows you can reverse the lens without reversing the front standard. Install BR-2 Adapter Ring on the front standard, then install the reversed lens on the BR-2.

With the lens reversed, use the BR-3 ring to protect the forward end of the lens, to act as a lens shade, and to screw in 52mm filters as needed.

PRESERVING AUTOMATIC APERTURE WITH A BELLOWS

Lenses mounted on the forward end of a bellows lose all automatic features and require manual aperture control and stop-down metering. You can restore automatic aperture operation on lenses designed for auto aperture by using Auto Ring BR-4 with Double Cable Release AR-4.

Auto Ring BR-4 is a 9mm extension ring with male and female bayonet fittings on the ends and some special features. On the side of the BR-4 is a Depth-of-Field Preview Lever which serves the same purpose as the equivalent camera control when a lens is mounted directly on the camera. Operate the lever and the lens is stopped down to whatever aperture size is selected on the lens aperture ring. If you want to hold that aperture size, push the lever inward toward the BR-4 ring and it locks in position. The lens remains stopped down until you release the lever by pulling it out again.

In addition to lens aperture control by manual operation of the BR-4 preview lever, a fitting on the ring

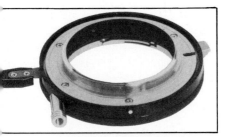

BR-4 Auto Ring can be operated two ways: Operate black handle manually to close down aperture. At the end of lever movement, lever can be locked by pushing in on handle. The other method of operation is with AR-4 Cable Release screwed into cable-release socket adjacent to black handle. To lock aperture in stop-down position with cable release, use Plunger Locking Ring at handle end of cable release. Light-colored lever at opposite side of BR-4 is lens-release lever.

accepts one branch of Double Cable Release AR-4.

This cable release has a single handle with a single pushbutton but the cable itself branches into two parts. One end has the special Nikon cable-release fitting with the threaded collar that fits Nikon and Nikkormat shutter buttons. The other branch of the double cable has a convention-

Double Cable Release AR-4 used with Auto Ring BR-4 gives automatic diaphragm operation with a bellows. One branch of the double cable closes lens aperture to the selected value just before the other branch operates the camera shutter button. Lens is stopped down by Auto Ring BR-4 mounted on the bayonet end of the lens. Here, lens is reversed so BR-4 is at front.

One branch of the AR-4 has the same end fitting as the Nikon-type cable release and fits the camera shutter button. The other end has a conventional ISO-type cable-release end fitting and connects to the BR-4 Auto Ring.

al tapered-thread end-fitting of the type used on many camera brands other than Nikon and Nikkormat. The tapered-thread end-fitting fits a threaded socket on the side of the BR-4 Auto Ring so you can stop down the lens aperture remotely and in synchronism with the camera shutter.

Assuming you have measured or calculated exposure so the lens aperture ring is properly set, you make the exposure by depressing the pushbutton in the handle of the double cable release. Two things happen: First, the lens aperture is stopped down by the branch of the cable that connects to the BR-4. Then the shutter button on the camera is depressed by the other branch of the double cable release and the camera shutter mechanism operates to make an exposure.

For time exposures, a locking ring surrounds the BR-4 pushbutton. To use the Plunger Lock Ring, unscrew it so it moves away from the base and is free to move up and down along the Release Plunger. Set the camera shutter dial to B. Depress the plunger and it will automatically lock in the fully depressed position. To end the exposure, push down on the edge of the lock ring, anywhere around its circumference. It will slide downward and release the plunger.

On the other end of the cable branch that operates the BR-4 ring are two knurled adjustment collars.

These are used to set the stroke length of the pin that projects from that end of the cable release.

If the BR-4 Auto Ring is used between lens and bellows, it gives 9mm of extension which you should include in calculating magnification. If you reverse the lens, you can still attach the BR-4 to the bayonet end of the lens even though it is the front. The BR-4 will still operate the lens aperture as just described, serve as a lens shade and also give mechanical protection to the forward end of the lens.

SETTING UP FOR THE MAGNIFICATION YOU NEED

The Lens Extension Graph on the following page shows the range of magnifications you can get with various lenses mounted normally or reversed where appropriate. Actual extension for the high and low limits of magnification is read off the scale at the top of the graph.

Along the bars representing magnification range, certain specific magnifications are shown by marked lines and adjacent numbers. To set up for that amount of magnification, read the lens extension on the scale directly above the marked point on the bar graph. The number shown by each mark is the magnification at that extension. The following number in parentheses is the approximate distance in centimeters from the front edge of the lens barrel to the plane of best focus. This is not subject distance because it is not measured from the invisible lens node. It is a *practical setup distance* that you can measure and use.

For the lens you intend to use, get approximate lens extension from the graph and set up bellows or extension rings to give that amount of extension. The extension shown on the graph should be the total extension of the lens, including Macro Adapter Ring BR-2 and Auto Ring BR-4, if used, plus any other lens extension being used. The graph itself takes into account any lens extension due to reversing the lens. All you have to do is add up all extensions that you can see and measure.

LENS EXTENSION GRAPH

ACTUAL LENS EXTENSION (mm) — scale at top: 50 60 70 80 90 100 110 120 130 140 150 160 170 180 190

LENS	POSITION	Magnification (free working distance in cm), read left → right across extension scale
20mm f-4	Normal	2.1 (0.2) 2.5 (0)
20mm f-4	Reverse	5 (3.9) 6 (3.8) 7 (3.7) 8 (3.7) 9 (3.7) 10 (3.7) 11 (3.6) 12 (3.6)
24mm f-2.8	Reverse	4.5 (4) 5 (3.9) 6 (3.8) 7 (3.8) 8 (3.7) 9 (3.7) 10 (3.7)
28mm f-2 / 28mm f-2.8 / 28mm f-3.5 / 28mm f-4 PC	Normal	1.5 (0.6) 2 (0.1)
28mm f-2 / 28mm f-2.8 / 28mm f-3.5 / 28mm f-4 PC	Reverse	4 (4.9) 4.5 (4.8) 5 (4.8) 5.5 (4.7) 6 (4.7) 6.5 (4.6) 7 (4.6) 7.5 (4.6) 8 (4.6) 8.5 (4.5)
35mm f-2.8 / 35mm f-2 / 35mm f-2.8 PC	Normal	1.2 (2.2) 1.5 (1.6) 2 (1) 2.5 (0.6) 3 (0.4) 3.5 (0.2) 4 (0.1) 4.5 (0)
35mm f-2.8 / 35mm f-2 / 35mm f-2.8 PC	Reverse	3 (4.9) 3.5 (4.7) 4 (4.6) 4.5 (4.5) 5 (4.4) 5.5 (4.4) 6 (4.3) 6.5 (4.3)
35mm f-1.4	Normal	1.5 (1.2) 2 (0.6) 2.5 (0.2) 3 (0)
35mm f-1.4	Reverse	3 (5.4) 3.5 (5.2) 4 (5.1) 4.5 (5.0) 5 (4.9) 5.5 (4.9) 6 (4.8) 6.5 (4.8)
45mm f-2.8 GN	Normal	1 (7.4) 1.5 (5.9) 2 (5.1) 2.5 (4.6) 3 (4.3) 3.5 (4.1)
45mm f-2.8 GN	Reverse	1.5 (6.7) 2 (5.9) 2.5 (5.4) 3 (5.1) 3.5 (4.9) 4 (4.7)
50mm f-2	Normal	1 (6.4) 1.5 (4.7) 2 (3.8) 2.5 (3.3) 3 (3) 3.5 (2.7)
50mm f-2	Reverse	1.6 (6.9) 2 (6.3) 2.5 (5.8) 3 (5.4) 3.5 (5.2) 4 (5.1) 4.3 (4.9)
50mm f-1.4	Normal	1 (4.6) 1.5 (2.9) 2 (2) 2.5 (1.5) 3 (1.2) 3.5 (0.9)
50mm f-1.4	Reverse	2 (6.3) 2.5 (5.8) 3 (5.4) 3.5 (5.2) 4 (5) 4.5 (4.8)
55mm f-1.2 / 55mm f-3.5 Micro	Normal	1 (5.1) 1.5 (3.2) 2 (2.3) 2.5 (1.8) 3 (1.4) 3.3 (1.2)
55mm f-1.2 / 55mm f-3.5 Micro	Reverse	2 (6.4) 2.5 (5.8) 3 (5.5) 3.5 (5.3) 4 (5)
85mm f-1.8	Normal	0.6 (18) 0.8 (16) 1 (14) 1.2 (12) 1.4 (11) 1.6 (10) 1.8 (9.8) 2 (9.3)
85mm f-1.8	Reverse	0.6 (16) 0.8 (14) 1 (12) 1.2 (11) 1.4 (10) 1.6 (9.2) 1.8 (8.6) 2 (8.1)
105mm f-2.5 / 105mm f-4 Micro	Normal	0.4 (36) 0.6 (28) 0.8 (24) 1 (21) 1.2 (19) 1.4 (18) 1.6 (17)
105mm f-2.5 / 105mm f-4 Micro	Reverse	0.2 (57) 0.4 (31) 0.6 (22) 0.8 (18) 1 (15) 1.2 (14)
105mm f-4 Bellows	Normal	0.2 (60) 0.4 (33) 0.6 (25) 0.8 (20) 1 (18) 1.2 (16) 1.3 (15)
135mm f-3.5 / 135mm f-2.8	Normal	0.4 (46) 0.6 (35) 0.8 (29) 1 (26) 1.2 (24) 1.3 (23)
135mm f-3.5 / 135mm f-2.8	Reverse	0.2 (74) 0.4 (41) 0.6 (29) 0.8 (24)
180mm f-2.8	Normal	0.3 (75) 0.4 (57) 0.5 (51) 0.6 (45) 0.7 (41) 0.8 (38) 0.9 (35) 1 (33)
200mm f-4	Normal	0.3 (101) 0.4 (84) 0.5 (74) 0.6 (68) 0.7 (63) 0.8 (60) 0.9 (57)
300mm f-4.5	Normal	0.15 (254) 0.2 (204) 0.3 (154) 0.4 (129) 0.5 (114) 0.6 (104)

Scale at top is approximate actual lens extension, not bellows scale reading. Horizontal lines show range of magnifications available for listed lenses. Other lenses of similar focal length will have similar magnifications. Arrows show specific magnifications at the extension read from scale at top. Numbers in parentheses are free working distance in *centimeters* between front of lens barrel and subject plane, at indicated magnification. Example: The 24mm f-2.8 lens, mounted in reverse, has a magnification of 7 when extended approximately 102mm. At that magnification, working distance between lens and subject is about **3.8** *centimeters*.

NOTES ON USING LENSES WITH EXTENSION

Lens	Position	Notes	Lens	Position	Notes
20mm f-4	Normal	The further the lens is stopped down, the better the image quality. Unsuitable for copying.	50mm f-1.4	Normal	The further the lens is stopped down, the better the image quality. Unsuitable for copying.
	Reverse	Image quality is best at f-8 and deteriorates at smaller apertures.		Reverse	Corner image quality deteriorates at low magnification.
24mm f-2.8	Reverse	Image quality is best at f-8 and deteriorates at smaller apertures. Cannot be used in normal position.	55mm f-1.2	Normal	Suitable for normal close-ups but unsuitable for copying. Because corner image quality is poor, it is advisable to stop down the lens as far as possible.
28mm f-2 28mm f-3.5 28mm f-2.8 28mm f-4 PC	Normal	The further the lens is stopped down, the better the image quality. Unsuitable for copying.		Reverse	Corner image quality deteriorates at low magnification.
	Reverse	Image quality is best at apertures from f-8 to f-11, and deteriorates at smaller apertures.	55mm f-3.5 Micro	Normal / Reverse	Image quality is best at f-8 and deteriorates at smaller apertures.
35mm f-2.8 35mm f-2	Normal	The further the lens is stopped down, the better the quality.	85mm f-1.8	Normal	The further the lens is stopped down, the better the image quality.
	Reverse	Image quality is best at f-8 and deteriorates at smaller apertures.		Reverse	Corner image quality deteriorates at low magnification.
35mm f-1.4	Normal	The further the lens is stopped down, the better the image quality.	105mm f-2.5	Normal	The further the lens is stopped down, the better the image quality.
	Reverse	Image quality is best at f-11 and deteriorates at smaller apertures.		Reverse	Image quality is good at high magnification. Corner image quality deteriorates at low magnification.
35mm f-2.8 PC	Normal	Corner image quality deteriorates at low magnification. Unsuitable for copying.	105mm f-4 Bellows	Normal	The further the lens is stopped down, the better the image quality.
	Reverse	Image quality is best at f-8 and deteriorates at smaller apertures.	135mm f-3.5 135mm f-2.8	Normal	The further the lens is stopped down, the better the image quality.
45mm f-2.8 GN	Normal	Image quality is best at apertures from f-8 to f-11 and deteriorates when the lens is stopped down further than f-11.		Reverse	Image quality is good at high magnification. Corner image quality deteriorates at low magnification.
	Reverse	Image quality is best at f-8 and deteriorates at smaller apertures.	180mm f-2.8	Normal	The futher the lens is stopped down, the better the image quality.
50mm f-2	Normal	The further the lens is stopped down the better the image quality.	200mm f-4	Normal	The further the lens is stopped down, the better the image quality.
	Reverse	At high magnification corner image quality deteriorates somewhat when the lens is stopped down further than f-8.	300mm f-4.5	Normal	The further the lens is stopped down, the better the image quality.

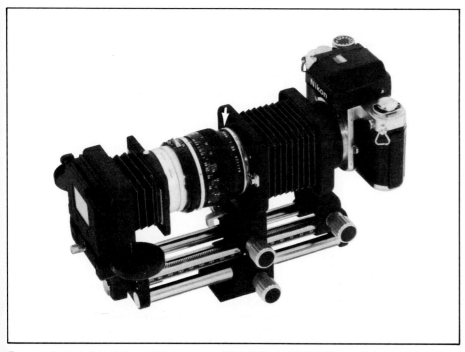

From right to left, equipment is: camera, PB-4 Bellows, BR-2 Macro Adapter Ring (arrow) used to reverse the lens, 55mm Micro-Nikkor lens, BR-3 Adapter Ring between lens and slide copier, and PS-4 Slide Copying Adapter.

With lens extension set, then move the entire bellows and lens assembly forward or backward to get the correct distance between the front end of the lens and the subject plane. You'll know when this distance is correct because the image will be in sharp focus. At all other distances, the image will be fuzzy and magnifications will be wrong.

SLIDE COPYING ADAPTERS

A slide copier fits on the end of a bellows and lets you do a lot of interesting things. You can copy slides, seeking to make exact duplicates. You can copy slides while making deliberate changes such as cropping the original image or using filters to change the color of the original. You can make slide "sandwiches" of two slides so the copy combines the two

To attach PS-4 to front of lens, or to BR-3 Adapter Ring on reversed lens, squeeze buttons on PS-4 to reduce diameter of threaded ring, slide threaded ring into lens or BR-3 Adapter where it is held by threads of lens or adapter.

A very useful feature of the PS-4 copier is a movable slide holder. Release set screw (arrow) and you can move holder vertically and horizontally as needed to crop slides you are copying. When cropping, magnification must be greater than 1.

images. You can add a textured background, put the moon or sun where they never were in reality, and other tricks.

Among all of those possibilities, and whatever else you may think of, the one I don't recommend is making exact duplicates. If that's what you want, you'll be better off making several identical exposures at the time you shoot the picture, or else having duplicate slides made for you by a commercial lab.

I enthusiastically recommend slide copying to alter or improve the end result. For use with either of the bellows units just described, there are two slide copiers, one with more features than the other. Both slide copiers are attached to the end of a horizontal mounting rod. Both attach to the front end of a bellows by sliding the mounting rod into a hole in the bellows front casting, and securing the rod in place by a set screw on the bellows. By loosening the bellows set screw, the slide copier can be moved forward or backward to adjust the distance between slide and lens.

The slide copiers have a built-in bellows which makes a light tunnel between slide and lens so no stray light falls on the lens front surface.

The lens-attachment plate on the slide copier is held to the copier body by two magnets—one on each side. Pull the lens-attachment plate away from the magnets and it extends the small bellows built into the copier.

The lens-attachment plate attaches to the filter-mounting threads on the front of the lens as follows: A flexible threaded ring projects from the copier. This ring is partially cut away as you can see in the accompanying photo. Chrome pushbuttons on top and bottom of the lens-attachment plate compress the threaded ring so it slides inside the front of the lens body. Release the pushbuttons and the threaded ring expands to mesh on the filter-mounting threads on the lens or BR-3 Adapter Ring.

On the front of the copier is a slot to insert mounted slides and a channel through which you can pass roll film. Access to the roll-film channel is by a hinged plate with a frosted-glass pane in the center so diffused light can pass through to illuminate the transparency you are copying.

Slide Copying Adapter PS-4—Fits either bellows PB-4 or PB-5. Ac-

cepts slides in 2" x 2" square mounts, either vertical or horizontal frame format. Has two roll-film holders on either side of the front plate so you can conveniently feed rolls of 35mm film through the copier.

A feature of this copier is a movable slide-holder assembly on the front of the unit. Release the set screw and you can move the slide holder or roll-film holder a total of 12mm vertically or 18mm horizontally, or any combination of the two movements. This allows cropping the slide you are copying by using a magnification greater than 1.0 and then shifting the original so you copy only the part you want.

Slide Copying Adapter PS-5—Fits either bellows PB-4 or PB-5 and is basically the same as the PS-4 except it has no provision to move the film holder. You can do a small amount of cropping by moving the slide sideways in the holder, but not much. If you are using the PB-4 bellows, you can do some cropping by shifting the lens sideways, flexing both the PB-4 bellows and the bellows of the copier. Both bellows should be extended an inch or more so they are not stressed unduly.

Slide Copying Adapter PS-5 is simpler than the PS-4, without the movable slide holder or the trays on each side to hold roll film. It fits PB-4 or PB-5.

With any slide copier, you can do some cropping by pulling the slide partially out of the slot in the holder. You must use magnification greater than 1.0, so the lens "sees" only the center part of the slide being copied before the slide is moved horizontally or vertically.

HOW TO SET MAGNIFICATION

With the slide copier mounted and its bellows attached to the front of the lens, you have two adjustments for the desired magnification: image distance and subject distance.

Setting Up for a Magnification of 1.0—Here's a handy rule of thumb that gets you close: For a magnification of 1.0, the *total* distance between film and subject is approximately 4 times lens focal length. With a simple lens, the distance is exactly 4 times focal length, but with most real-world lenses it isn't. It's usually a little longer or a little shorter because of those pesky lens nodes.

Also, when magnification is 1.0, subject distance and image distance are equal to each other and each is equal to twice the lens focal length.

If you are using a 55mm lens, for example, make the initial equipment setup so the distance from the film-plane indicator on top of the camera to the slide being copied is about 220mm. Use a metric scale to measure this distance along the top of the bellows. Don't worry about where the bellows front standard is while doing that.

Then set bellows extension to twice the lens focal length by moving the front standard. This puts the front standard in approximately the right location. Put in a slide and get enough light behind it so you can see the image. Adjust for best focus by making small adjustments of either bellows standard.

You don't want magnification less than 1.0 because the image won't fill the frame in the camera. I usually use a magnification of a little more than 1.0 just to be sure the edges of the slide mount on the original don't show in the copy. Sometimes I use considerably more magnification than 1.0 so I can do some artistic cropping of the image.

To increase magnification slightly, move the front standard forward a very small amount—about 1mm. Then move the rear standard backward until the image comes back into sharp focus. Repeat if desired.

If you intend to use magnification significantly greater than 1.0, you should reverse the lens. Use Macro Adapter Ring BR-2 between bellows and the reversed lens. Use Adapter Ring BR-3 on the forward side of the reversed lens. The threads on the BR-3 will allow attachment of the copier bellows just the same as if it were being attached to the front of a lens. If you use a color filter to change color of the copy, screw the filter into the forward end of the BR-3; then attach the copier bellows to the threaded front side of the filter frame.

When using a lens reversed, the basic idea is the same but the extension is different for the reasons discussed earlier.

Use the Lens Extension Graph—With the lens mounted normally or reversed, you can get approximate setup distances from the graph on page 115. Read lens extension from the scale along the top of the graph and set that amount of total extension between camera body and lens, taking into account any lens reversing hardware, and extension of the BR-4 if used. The graph itself takes into account any extension due to reversing the lens so you don't have to worry about that. All you have to do is add up all extensions that you can see and measure.

Then find the setup distance in centimeters between the forward end of the lens and the subject plane—given in parentheses on the Lens Extension Graph. Set this distance between the forward end of the lens and the slot in the slide copier where you insert the slide. Do it by moving the slide copier. From that point, find exact focus by small adjustments of either bellows standard.

If you need a magnification not marked exactly on the bar chart, you can estimate setup distances by reference to marked magnifications that are larger and smaller than the amount you need. Then find exact magnification and focus by experiment.

How to Calculate Setup Distances—If all else fails, you can always do it by simple arithmetic as follows:

1. Estimate the amount of magnification you need.

2. Find added extension (X): $X = M \times F$.

3. Adjust the PB-4 or PB-5 bellows to get the correct amount of lens extension, taking reversing hardware *and* reversing the lens into account.

4. Find Image distance (I): $I = X + F$.

5. Find Subject distance (S): $S = I/M$.

6. Find film-to-subject distance by adding image distance to subject distance.

$I + S = $ Film-to-Subject Distance

7. Leaving the bellows extension as already set, move the slide copier until the total film-to-subject distance is correct. Then move the slide copier in or out until the image is in focus.

Copying slides while *changing something* is fun and worthwhile. Originals on left, copies on right. In top photos, I used magnification greater than 1 so I could crop in closer on sailboat. Lower left picture was underexposed at night with daylight film and tungsten illumination from open door of nearby garage. In slide copier, I used enough exposure to bring out image. Remaining problem is color correction which can be done with filters over camera lens. I like this effect.

8. Find best focus by making small adjustments of either bellows standard.

Guessing at It—I recommend you use one of the methods already given to make an equipment setup with the distances approximately correct. Particularly when working at high magnifications, good focus at the right magnification can be maddeningly elusive if you are trying to find it by experiment. Everything you move changes something else and it's easy to get lost in the adjustments. I have seen people give up in disgust when a minute or so in advance planning would have avoided all the frustration and made the shot possible. Consulting the graph or doing the arithmetic is the *easy* way!

ILLUMINATING THE SLIDE

On the front of the slide copier is a frosted-glass pane to admit light and diffuse it some so the slide is uniformly illuminated. As magnification increases, the light reaching the film decreases and the viewfinder image becomes darker. Unless you are using extremely high magnification, you can see well enough to make the setup just by pointing the slide copier at any reasonably bright light such as a window in daylight.

To make the exposure, it's best to get enough light for a shutter speed of 1/15 or faster so you avoid the possibility of reciprocity failure and the need for additional exposure to correct that problem. If you stay away from reciprocity failure, you can usually follow the camera exposure recommendation, making adjust-

ments only for unusual subject matter.

There are three commonly used way to illuminate the slide. You can use a flash unit pointed toward the frosted-glass window in the copier. This requires experimentation to find correct exposure setting. The setting will change if you change magnification. You can use a tungsten light source, such as a floodlamp or even household lamps. Or you can use daylight. I find it convenient and satisfactory to point the slide-copier toward white paper which is illuminated by daylight—both direct sunlight and light from the sky.

CHOOSING A FILM

If you use black-and-white film, the color of the light used to illuminate the slide doesn't matter much.

If you use color film in the camera,

you should match it to the type of light being used. Use *Tungsten* film for tungsten (incandescent) light. Use *Daylight* film for daylight or electronic flash. These film types are discussed in the following chapter.

With ordinary color films in the camera, you will notice an increase in image contrast of the copy and probably a small change in overall color. You can control color by testing with suitable filters over the camera lens—also discussed in the following chapter. With ordinary films, an increase in contrast is unavoidable, but often this is acceptable and sometimes it even improves the result.

To reduce contrast gain in copying slides, use Kodak Ektachrome Slide-Duplicating film. This is available in 35mm film cartridges and is specially designed for copying color transparencies with minimum increase in contrast.

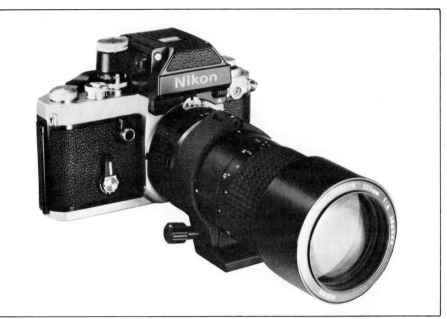

Recently announced as an addition to Nikon micro lenses is the Micro-Nikkor 200mm *f*-4 IF lens. Without accessories, the magnification range is up to 0.5. Used with the Nikon TC-300 Tele Converter, the lens has an effective focal length of 400mm and magnifications up to 1. In both applications, this lens has more free working distance between the front of the lens and the subject than other micro lenses. Internal Focusing is used and the lens has Nikon Multi-Layer Integrated Coating.

LENSES FOR HIGH MAGNIFICATION

There are three Nikkor lenses specially designed for use at magnifications of 1.0 or higher. They are the 55mm *f*-3.5 Micro-Nikkor, the 105mm *f*-4 Micro-Nikkor and the 200mm *f*-4 Micro-Nikkor.

All of these lenses have high-quality optics, with special correction for flatness of field, which is very important at high magnifications. These three lenses are called *Micro* even though most other lens makers use the term *Macro* for similar lenses. Use of *Micro* is an entrenched tradition at Nikon.

Large maximum aperture and maximum correction for flatness of field are imcompatible in lens design, which is the reason these lenses hve relatively large apertures. The 55mm and 105mm lens bodies project forward beyond the glass elements so these lenses do not require hoods. When these lenses are reversed, the recess between the forward end of the body and the first glass element becomes part of the lens extension.

Because depth of field is always a major problem at higher magnifications, these micro lenses have mini-

Note: A recently announced 55mm *f*-2.8 Micro-Nikkor is similar to the 55mm *f*-3.5 except for two improvements: Maximum aperture is *f*-2.8 and the new lens has a Close-Range Correction System as described on page 38.

mum aperture of *f*-32. Usually, insufficient depth of field is worse than any lens aberration or the effect of diffraction at small aperture. If you need *f*-32, use it.

THE 55mm *f*-3.5 MICRO-NIKKOR

The helicoid in this lens has an unusually long range of movement—27.5mm, which is half the lens focal length. When focused on the nearest possible subject, magnification is 0.5 with no extension other than that provided by the built-in helicoid of the lens. The closest marked focusing distance is 0.241 meters or 9.5". Closer focusing and still higher magnification can be achieved with added lens extension using a bellows or extension tubes.

Auto Extension Ring PK-13—Designed specifically for the AI 55mm Micro-Nikkor, but usable with any AI lens, this is an extension ring which preserves both automatic aperture and full-aperture metering. It provides an extension of 27.5mm. When used with the 55mm Micro-Nikkor, the available range of magnifications starts at 0.5 when none of the lens helicoid movement is used and goes up to 1.0 when all of the lens helicoid movement is used.

When used at a magnification of 1.0, the total distance between lens and film is two focal lengths: One focal length is built into the lens and

When PK-13 extension ring is used between lens and camera, its fixed extension of 27.5mm changes magnification range of the 55mm Micro-Nikkor. Magnification range becomes 0.5 to 1.

camera body, one-half of a focal length is the PK-13 extension ring and the remaining half of a focal length is due to full forward movement of the focusing helicoid. In this case, lens-to-subject distance is also two focal lengths, but some of this distance is used up inside the lens.

The practical usable distance, often called *free working distance* or *working distance*, is from the front edge of the lens barrel to the plane of best focus. At a magnification of 1.0, the working distance is about 57mm.

Auto Extension Ring PK-3—For non-AI lenses, the PK-3 ring serves exactly the same purpose as described for the PK-13. Both rings preserve automatic aperture and full-aperture metering when used with the appropriate lens and camera combination.

Reading the Lens Focusing Scale— The focusing ring on the 55mm Micro has four scales: Two distance scales showing feet and meters, the same as

other lenses. Also there are two magnification scales—one for the lens alone and one for the lens when used with a 27.5mm extension ring.

The magnification scales actually show fractions which Nikon calls *reproduction ratio*. The scale for use with lens alone begins at a focused distance of about 0.7 meter, where reproduction ratio is shown to be 1:10 which means 1/10. To obtain *magnification* as used in this book from a reproduction ratio expressed as a fraction, perform the indicated division: $1/10 = 0.10$.

After the first scale marking, the next is 9 which means 1/9. This and all following scale marks are the denominators of fractions whose numerators are 1, but the numerator is not shown.

I find it difficult to use reproduction ratios when planning a shot, and prefer to divide all fractions to get magnification expressed as a decimal number. The accompanying table does that for Micro-Nikkor lenses. You can usually estimate settings between marked points on the scale.

Suppose you want to nearly fill the narrow dimension of the frame with a small flower that is 1-1/4" in diameter. Assume you want the image to be 3/4" tall on the film so there is background all around the flower. Figure the needed magnification:

$$M = \frac{I}{S}$$
$$= \frac{3/4''}{1\text{-}1/4''}$$
$$= \frac{0.75}{1.25}$$
$$= 0.6$$

Consulting the table showing magnification versus scale readings of Micro-Nikkor lenses, a scale reading of 1.7 gives a magnification of 0.588 which is very close to the needed amount.

THE 105mm *f*-4 MICRO-NIKKOR

The basic idea of the 105mm micro

MAGNIFICATION OF 55mm AND 105mm MICRO-NIKKOR LENSES		
SCALE READING		**MAGNIFICATION**
Without Extension Ring	1:10	0.100
	9	0.111
	8	0.125
	7	0.143
	6	0.167
	5	0.200
	4	0.250
	3	0.333
	2.5	0.400
	2	0.500
With 1:1 Extension Ring	1.9	0.526
	1.8	0.556
	1.7	0.588
	1.6	0.625
	1.5	0.667
	1.4	0.714
	1.3	0.769
	1.2	0.833
	1.1	0.909
	1	1.000

lens is the same as the 55mm micro. I has magnifications up to 0.5 withou any accessories and uses a specia extension ring that gives magnifica tions from 0.5 to 1.0. The free work ing distance between the front of th lens barrel and the subject is longe with the 105mm, as you can see in th Lens Extension Graph. This some times makes the 105mm lens mor convenient to use because you ca get light on the subject more easil when there is greater distance be tween lens and subject.

A disadvantage is that you nee nearly twice as much extension to ge the same magnification with th 105mm lens, compared to the 55mn micro. With the lenses not reversed and installed on a bellows, ful bellows extension with the 105mn lens gives magnification of abou 1.75 whereas full bellows extensio with the 55mm micro gives magnifi cation of about 3.4.

Auto Extension Ring PN-11—De signed specifically for the AI 105mn Micro-Nikkor, but usable with any AI lens, this has an extension o 52.5mm. It preserves automatic aper

ure and full-aperture metering capability. When used with the 105mm micro lens, the range of magnifications available by adjustment of the lens focusing control is 0.5 to 1.0.

This extension ring has a tripod socket built into a collar around the ring. By using the tripod socket on the extension ring instead of the one on the camera base, you can get a more balanced arrangement on a tripod and not stress the camera tripod mount. The collar rotates on the extension ring, with detents every 90°. It has a locking adjustment to hold any rotation so you can position the camera for a vertical shot, horizontal, or any angle.

Auto Extension Ring PN-1—Identical to the PN-11 in function, this ring fits non-AI lenses and preserves both automatic aperture and full-aperture metering.

THE 200mm *f*-4 MICRO-NIKKOR IF LENS

A 200mm micro lens is unusual, but Nikon offers one. It was shown earlier in this chapter and has several advantages. It's about the same size as other 200mm lenses but, because it has Internal Focusing, the length doesn't change as you focus the lens which makes it easier to handle.

The main advantage is that it provides more working distance between lens and subject than shorter lenses. This makes some things possible that may be difficult or impossible with shorter lenses. With longer working distance, you may be able to photograph small animals or insects without causing them to run away. With longer working distance, it is easier to get light on the subject.

This lens provides magnifications up to 0.5 without accessories. Using PK-type automatic extension tubes, you can increase magnification up to about 0.75.

The TC-300 teleconverter is recommended for this lens but you can also use the TC-200. These teleconverters double focal length and *f*-number but don't change the minimum focusing distance with one of

105mm Micro-Nikkor gives magnifications up to 0.5 without extension ring; magnifications from 0.5 to 1 with 52.5mm extension ring. This is non-AI lens and PN-1 ring. AI lens uses PN-11 ring. Because lens and extension ring combination is long, ring has tripod mount for better balance.

the teleconverters. Thus, the lens acts like a 400mm *f*-8, and has a magnification range up to 1.0.

In addition, you can use the lens for general photography. A 200mm lens is very useful for many purposes and the addition of macro capability makes this lens even more useful.

THE *f*-5.6 200mm MEDICAL-NIKKOR

Originally designed as a simple easy-to-use high magnification lens with built-in lighting, the Medical-Nikkor finds many uses beyond medical photography. With its 200mm focal length, working distance between lens and subject is relatively long—an advantage in many photographic situations.

The lens has a built-in flash in the form of a ringlight surrounding the front end of the lens. This gives even illumination without strong shadows

Medical Nikkor has built-in flash, uses interchangeable close-up lenses to change magnification.

and eliminates the problem of using a separate light source in close quarters. The flash duration is approximately 1/1000 second which is fast enough to stop motion and allow hand-holding the camera even at high magnifications. The flash is suitable for daylight color films. A separate AC-operated power supply or a battery pack supplies power to operate the ringlight.

In addition to the built-in flash, there are incandescent modeling lights which give enough illumination to make a setup and find focus.

Magnification is changed by selecting from a group of six supplementary close-up lenses which screw into the front of the lens body. Without any supplementary lenses, magnification ranges up to 0.067. With supplementary lenses, magnification ranges from 0.125 to 3.0. Even selecting supplementary lenses is easy—instructions are engraved on the lens

body, to show which to use for a desired magnification.

There is no focus control. You find focus by positioning lens at the correct distance from the subject.

When used with its built-in flash, setting exposure is simple and done without any calculations. Film speed and magnification are dialed into the lens with special controls. The combination of these two settings automatically sets aperture size to give correct exposure with flash. All that's left is to set camera shutter speed to the marked flash-sync position on the dial—discussed in Chapter 11. The camera's built-in exposure meter is not used with flash.

Still another control on the lens allows you to record numerals on the lower right corner of the frame to show magnification used or a number from 1 to 39 for whatever purpose you may find. This can only be done when using the electronic flash because part of the light generated by the flash is used to record the numerals.

The flash can be disconnected for use in a bright light or with daylight. In this case, the camera's built-in meter can be used.

DETERMINING MAGNIFICATION

With any lens and any equipment setup, you can closely estimate the amount of magnification used by imaging a millimeter scale across the long dimension of the viewfinder. In a viewfinder that shows the entire frame, you should see 36mm of a scale you are focusing on *if* the magnification is 1.0; less of the scale if magnification is greater than 1.0; and more of the scale if magnification is less.

Based on seeing the *entire* frame in the viewfinder, magnification (M) is equal to the frame *width* (W) divided by the *amount* (A) of scale you can see:

$$M = \frac{W}{A}$$

If you place the scale so you read across the narrow dimension or *height* (H) of the frame, change the formula to:

$$M = \frac{H}{A}$$

Example: After making the setup and getting the subject in focus, substitute a millimeter scale for the subject. Across the width of the frame, you can see 28mm of the scale. Magnification is 36/28 = 1.3, *if you are seeing all of the frame.*

Not all cameras show you the entire frame. If you don't see the entire width of the frame, you see fewer millimeters on the scale than you should. When you calculate magnification, you get a larger number than you should. Correct for this by multiplying magnification as calculated by a factor which is determined by how much of the frame you actually see. If you see 92% of the frame, for example, multiply magnification as calculated by 0.92 to get the correct value.

In the preceding example, the correction is 1.3 x 0.92 = 1.2 which should be very close to the exact magnification you are using.

The accompanying table lists correction factors for viewfinder coverage which you should use with various Nikon and Nikkormat models.

TOTAL MAGNIFICATION

Occasionally you may need to know the total amount of magnification used to make a print or reproduce a photo in a publication. Total magnification is the magnification in the camera multiplied by any subsequent magnification. For example, if you shoot at a magnification of 1.2 and the image is later magnified by 3, total magnification is 3 x 1.2 = 3.6.

LIGHT PROBLEMS WITH LENS EXTENSION

From the film's point of view, light comes from the back end of the lens as an expanding cone making a circle at the film plane.

APPROXIMATE VIEWFINDER PERCENTAGE OF ACTUAL FRAME		
Camera	Viewfinder Image	
	Long Dimension	Short Dimension
F3	100%	100%
F2 Series	100%	100%
EL, EM	92%	92%
FE, FM	92%	94%

If you estimate magnification by focusing on a millimeter scale and using the formulas in the column at left, the result will be accurate if you are seeing all the film frame in the viewfinder. If you see less than the full frame, correct the magnification as follows: First, convert percentages in this table to decimals. (94% = 0.94) Then multiply estimated magnification by the decimal number to improve your estimate.

Light sources which produce diverging rays are subject to the *inverse-square law.* The law says the amount of light changes inversely with the distance from the light source.

When the inverse-square law applies, light decreases according to distance squared. If distance is doubled light does not decrease to 1/2 its former value, it decreases to 1/4. Making the distance 3 times as large decreases the amount of light by 3 times 3 which is 9, and so forth.

The inverse-square law is always applicable inside the camera, between the lens and the film. Both magnification and the amount of light on the film change due to focusing.

The amount of movement in the normal focusing range of the lens is so small that the amount of light on the film doesn't change very much. If you set exposure controls *after* focusing, it doesn't matter because you set exposure for whatever light there is.

When you use extension tubes or

a bellows to put extra distance between lens and film the distance may change enough to have a major effect on the amount of light at the film plane. An easy example is: A 50mm lens with 50mm of added extension makes a life-size image on film.

However, inserting 50mm of extension *doubled* the image distance—from 50mm without the extension to 100mm with extension. By the inverse-square law, doubling distance reduces illumination to 1/4, which is two exposure steps. The image is less bright on film and also in the viewfinder. As magnification is increased above 1.0 the light falls off very rapidly and the viewing screen becomes very dark.

As long as you are using the built-in camera meter and it is reading within its range of accuracy, the camera measures the actual amount of light that will expose film, so the camera-recommended exposure settinmgs should be satisfactory. The possibility of reciprocity failure should be considered for longer-than-normal exposure times, as discussed in the following chapter.

It's easy to get into situations where a direct through-the-lens light measurement with the camera's built-in meter is not possible because the light is so dim. There are ways around the problem, some based on a simple calculation of the amount of light lost due to lens extension.

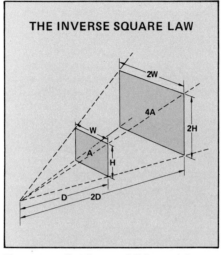

THE INVERSE SQUARE LAW

If an expanding beam of light travels *twice* as far, it illuminates a surface that is *four* times as large. Brightness of the illuminated surface falls to 1/4 as much. That's the inverse-square law about light.

EXPOSURE CORRECTION FOR A NORMAL LENS

This discussion and the sections immediately following will clarify why I have emphasized the differences between telephoto, retrofocus and normal lenses. With normal lenses, entrance and exit pupils are the same size, or very nearly so. When making exposure correction for light loss due to lens extension, the type of lens you are using makes a difference in the amount of correction you need.

The general procedure is this: When you can't get a reading with the camera meter, determine exposure for the subject in some other way, assuming you are not using any lens extension. Then correct that exposure for the amount of lens extension you are actually using. Then correct again for reciprocity failure if needed.

When you can't get a reading through the camera, you can often get it with a separate accessory light meter. This reading, of course, does not consider lens extension. If you don't own a separate light meter, remove the lens extension device from the camera while making an

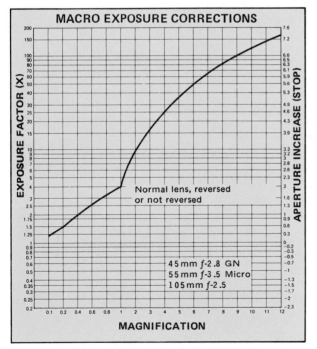

Normal lens has two meanings. It sometimes means the *standard* 50mm or 55mm lens that comes with the camera. Here, *normal* means a lens that is neither telephoto or retrofocus. Exposure correction for a normal lens is the same whether the lens is reversed or not.

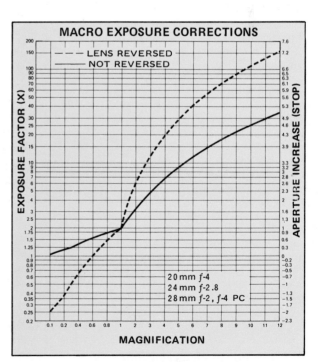

When used at higher magnifications, the correction for a telephoto or retrofocus lens depends on whether the lens is reversed or not, except at a magnification of 1. This graph and those on following pages are for tele and retro lenses.

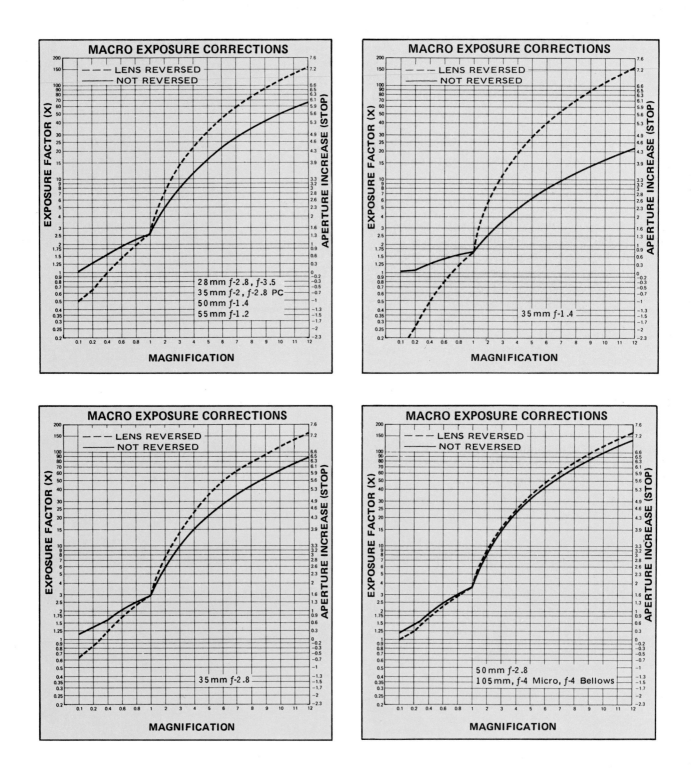

exposure reading of the subject. This reading also does not consider the effect of lens extension.

If you are using flash, you can calculate camera exposure settings using the flash guide number as described in Chapter 11. This, also, does not take added extension into account.

However you do it, you have a camera exposure setting that would work fine with no extension but will not give enough exposure when using lens extension. To correct for this, multiply the amount of exposure for no lens extension by an *Exposure Factor*, sometimes called *Exposure Correction Factor* which is determined by the amount of magnification you are using.

For normal lenses you can figure the Exposure Factor (EF) as follows:

$$EF = (M + 1)^2$$

Nikon publishes curves showing exposure factors for lenses you are likely to use with magnification. These spare you the necessity of doing arithmetic and also show how to take the correction in either shutter speed or aperture.

For normal Nikkor lenses, consult the left graph on the preceding page. Notice that there are only three normal lenses in the series of Nikkors.

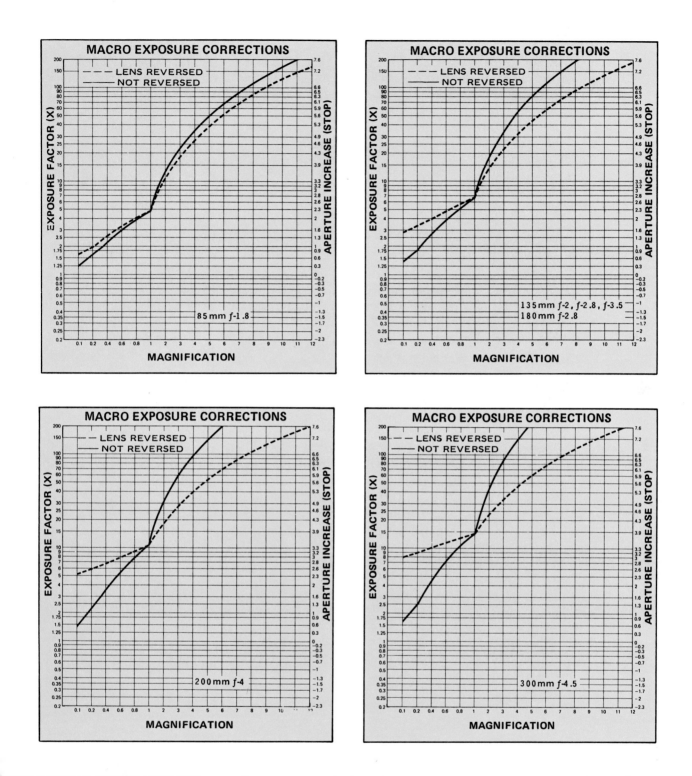

MACRO EXPOSURE CORRECTIONS (85mm ƒ-1.8)

MACRO EXPOSURE CORRECTIONS (135mm ƒ-2, ƒ-2.8, ƒ-3.5 / 180mm ƒ-2.8)

MACRO EXPOSURE CORRECTIONS (200mm ƒ-4)

MACRO EXPOSURE CORRECTIONS (300mm ƒ-4.5)

EXPOSURE CORRECTION FOR TELEPHOTO AND RETROFOCUS LENSES

If you are using other Nikkor lenses with extension, consult the Exposure Factor graph labeled for the lens you are using. Please notice that it makes a difference if you have the lens mounted in reverse. Read the exposure factor and apply the indicated correction.

Pupillary Magnification—If you pre-fer, you can calculate the correction for telephoto or retrofocus lenses, using a term called Pupillary Magnification (P).

To find P for any lens, remove it from the camera and set aperture a click or two smaller than wide open. Hold the lens at arms length and use a scale to measure the diameter of the pupil seen from each end of the lens.

$$P = \frac{\text{Diameter of Exit Pupil}}{\text{Diameter of Entrance Pupil}}$$

Then use either of these formulas, as appropriate:

If lens is not reversed,

$$\text{Exposure Factor} = \left(\frac{M}{P} + 1\right)^2$$

If lens is reversed,

$$\text{Exposure Factor} = \left(\frac{MP + 1}{P}\right)^2$$

P is always measured and calculated the same way. When the lens is reversed, the value of P does not change, the *formula* changes.

EFFECTIVE APERTURE

As you know, aperture size as stated by an *f*-number is used as an indication of the light-gathering ability of a lens.

Because added extension reduces light on the film, it has an effect similar to using smaller aperture. The lens may be set at *f*-4 with extension but the amount of light on the film corresponds to *f*-8 if the lens were being used with no extension. *Effective aperture* is *f*-8 because that's how much light there is. For normal lenses:

$$EA = (f\text{-stop on lens}) \times (M + 1)$$

where EA is effective aperture and M is magnification due to added extension.

The idea is to convert the effect of added extension into a fictitious but practical *f*-number for the lens, rather than use the exposure factor.

This will be handy when using flash. In some applications of flash a calculation is made to determine the *f*-number setting of the lens. This assumes no lens extension. If you are doing macro work with flash and lens extension, you need a way to convert the recommended aperture setting into the actual aperture for the lens with extension.

Suppose you are set up with extension to give a magnification of 1.75. The *f*-number setting on the lens is *f*-8 and the meter in the camera is satisfied that exposure is OK. The effective aperture of the lens:

$$EA = (f\text{-}8) \times (1.75 + 1)$$
$$= f\text{-}8 \times 2.75$$
$$= f\text{-}22$$

This says the amount of light on the film is the same with *f*-8 and extension as it would be at *f*-22 without extension.

Usually you have to work this problem the other way. The dials on your electronic flash say to set the lens at *f*-22. You have some extension behind the lens, so you know the flash unit really wants an *effective*

aperture of *f*-22. What you need to know is where to set the lens aperture control so it will have the effective aperture. To do that, change the formula around like this:

$$
\begin{aligned}
f\text{-stop on lens} &= \frac{EA}{M+1} \\
&= \frac{f\text{-}22}{1.75 + 1} \\
&= \frac{f\text{-}22}{2.75} \\
&= f\text{-}8
\end{aligned}
$$

As you can see, this is the same problem turned around. If you have enough extension for a magnification of 1.75 and you need exposure equivalent to a lens setting of *f*-22, set the lens at *f*-8. More information on EA is in my book *SLR Photographers Handbook*.

People often get carried away with the idea that photography is an exact science. Usually it isn't. One exposure step increase is a change of 100%. A half-step is sometimes hard to detect in looking at the final print. One-third of a step is the smallest amount most people recommend worrying about.

DEPTH OF FIELD LIMITATION

When you look through a lens set up for high magnification, you'll think there isn't any depth of field. In normal photography, depth of field is greatly improved by using small aperture. At higher magnifications, no matter how achieved, stopping down helps some but not nearly as much.

In normal photography, the point of best focus is about 1/3 of the way into the depth of field.

In macro photography, the point of best focus is usually about halfway into the depth of field. Because depth is so limited, most photographers put good focus near the front of the subject and let it get blurred at increasing distance from the lens.

In macro, depth of field is so small it can't cover up lens faults. If the lens isn't well corrected for flatness of field, you'll see it go out of focus around the edges when photographing flat subject matter.

It is desirable to focus at maximum aperture because the image is brighter and depth of field is minimal so you know exactly where you are placing it. Then stop down to improve depth of field when making the exposure. For some lenses, aperture-size recommendations are in the notes given earlier. You will notice that some lenses give best image quality at minimum aperture which seems to conflict with the earlier statement that best image quality is at an aperture near the middle of the range.

This is because reduced depth of field is highly visible at higher magnifications and is the most serious flaw in the image. Operating at minimum aperture does increase diffraction effects but the gain in depth of field more than offsets degradation due to diffraction.

COPY STANDS

For copying documents and most kinds of photography at high magnifications, a rigid stand to support the camera and object being photographed is nearly essential. These stands are generally called *copy stands;* Nikon calls them Repro Copy Outfits.

The PFB-2 has a rigid baseplate with a two-piece Upright Column.

For copying documents, photo prints, and photographing small subjects at high magnification, a good copy stand is nearly essential. This is the PFB-2.

Camera cradle is removable and can be used on a tripod when you need to make small and precise movements of the entire camera. Large knob moves camera; small knob is set screw. This cradle is part of PFB-2 Repro-Copy Outfit.

assembly which holds a Sliding Arm and Camera Cradle.

The PFC-2 is similar except the base is a wooden box which holds the remaining pieces of the set. The box can be used to transport the equipment and can be assembled to act as a flat baseboard and support for the vertical column.

The PFT is similar except it has a table clamp to support the vertical column and has no baseboard at all. By clamping the vertical column to any convenient table or workbench, the table or workbench acts as the baseboard.

The table clamp is available separately as PA-3 to be used with the vertical column from either the PFB-2 or PFC-2 if desired.

Except for the method of supporting the vertical column, and the type of baseboard used, these copy outfits are identical.

The sliding arm is clamped to the vertical column by a wingscrew so you can make an initial setup and clamp the arm in place.

The Camera Cradle attaches to the Sliding Arm by another wingscrew. The mounting plate on the sliding arm has two locating pins which fit into holes on the cradle. The locating holes on the cradle are spaced in a circular pattern with 45 degrees between cradle mounting positions. This allows you to mount the cradle pointing downward or anywhere in a full circle—at 45° increments.

The camera is held against a locating ridge on the face of the cradle by a Locking Screw which screws into the tripod socket on camera bottom or motor drive if you are using one. There are several holes in the cradle that can be used for the locking screw so it will fit various cameras and equipment combinations.

Built into the camera cradle is a Fine-Focusing Knob which moves the camera nearer to or farther away from the subject. As you know, the best way to find focus at higher magnifications is move the entire camera. The fine-focusing control

works very smoothly over a total range of 40mm. A small lockscrew holds the adjustment after you get it set.

The camera cradle is removable and can be used on a tripod if you are setup using a tripod for support instead of the copy-stand column.

Repro-Copy Outfit PF-3 is a new design with some added advantages. It features a coiled spring in a holder at the top of the column. The sliding *saddle* which moves up and down on the copy stand post is connected to the spring which balances the weight of camera equipment mounted on the saddle. Some equipment, such as a bellows, attaches directly to the saddle, other equipment attaches by means of a cradle. For general use, a camera cradle mounts on the saddle, or the cradle can be used separately on a tripod. For use with Nikon and Nikkormat cameras with motor drive or auto winder, a special cradle, PH-3 MD Holder, is designed to support the greater weight of the motor drive. A special two-light PL-3 Lighting Unit fits on the copy stand upright and is adjustable for height. To mount the post on a table surface, rather than on its own base, use Table Clamp PC-3. This copy stand comes with a gray card with a printed scale making it useful for exposure metering and determining magnification.

USING CLOSE-UP AND MACRO EQUIPMENT

Except when using flash, camera support is recommended. High magnification and long exposure times both make it likely that hand-holding your camera will result in a blurry picture.

When you have taken time to put the camera on a support, such as a tripod, it makes sense to follow some other simple precautions to reduce the possibility of camera motion during exposure. A good rule is: Whenever you have the camera on a tripod, use a cable release or the self-timer to trip the shutter.

Some mechanical camera supports, such as tripods, are stable unless they receive a bump or jolt. Then

they will vibrate for a while and mess up your photo. Just touching the camera to release the shutter can cause vibrations which persist during the exposure period.

Mirror motion inside the camera happens just before exposure, but it also can set up vibrations which last into the exposure interval. If your camera has a mirror lock-up control, use it whenever the camera is on a tripod or other firm support. Set all camera controls and get ready to shoot. Last thing is to lock up the mirror so that mechanical motion is all done and the vibrations over with. Then trip the shutter with a cable release or timer. If you use the timer, set it for a long run to allow the vibrations to settle down—which you caused by touching the camera.

When you are using a lot of extension, focusing the lens causes a large change in magnification in addition to a change in focused distance. Set the focus control for magnification and then move the entire camera toward or away from the subject to find best focus. Often the camera movement must be done very gradually and in very small increments so you can find focus.

Finding best focus is aided by a magnifier which fits on the viewfinder frame. You can't see the entire frame with the magnifier in place, however it is hinged so it flips out of the way quickly.

For copying documents and high-magnification photography of small objects such as stamps, coins or jewelry, a copy stand is convenient.

Depth of field is often a major problem except for flat subjects. To get reasonable depth of field requires shooting at small aperture, which in turn may complicate lighting for exposure. When the camera lens is close to the subject, it is sometimes difficult to get enough light. This is largely a matter of technique and the lighting equipment you have.

FLASH WITH MACRO

The reduction in light on the film and in the viewfinder which is caused by lens extension is sometimes troublesome and always unavoidable. If your camera can measure the light within its accuracy range, and if you consider and compensate for reciprocity failure, then the only problem is a dim image in the viewfinder.

If the light decreases to the point that the camera meter cannot measure it, then things get complicated—as you have seen in this chapter.

At high magnifications, flash is an attractive light source for several reasons: It is less expensive than good-quality tungsten lighting equipment; it's much cooler and uses less electrical power; it is easily portable and produces a lot of light from a small package.

However, with *conventional* flash, exposure complications are guaranteed. You must use the flash guide number to calculate exposure using the effective lens aperture for the amount of magnification.

The F3 camera, with certain "dedicated" flash units, greatly simplifies using flash with macro. As you saw at the end of Chapter 8, this camera measures the amount of light reaching the film and turns off the flash when enough light has been measured. It does this no matter what accessories are being used, including extension rings or bellows. No calculations are needed.

MICROPHOTOGRAPHY

This is photographing through a microscope to get magnifications larger than the 8 or 10 normally practical with extension tubes and bellows.

The camera body is installed on the microscope using Nikon Microscope Adapter 2B or Microflex PFMF. For applications where photography through a microscope is the only use of the camera, a special body is available: Camera Body M35-S for use with the PFMF unit.

Because the microscope replaces the camera lens, there is no camera *f*-stop to be concerned with. Exposure is arrived at using whatever light comes into the camera and an appropriately long exposure time. This makes lighting of the subject critical and sometimes difficult. The technique of using microscopes and illuminating the subject is beyond the scope of this book, but can be found in books on microscopes.

10
LIGHT, FILTERS & FILMS

Special-effect filter, using diffraction, separates light into its components: red, orange, yellow, green, blue, violet. Photo of this spotlight-illuminated flag made at night with a Kolor-Trix® filter.

Several characteristics of light affect equipment and technique when taking pictures.

COLOR OF LIGHT

We call direct light from the sun *white.* It is composed of all the colors in the visible spectrum. Light appears to travel in waves, similar to waves in water, which have different wavelengths. Different wavelengths appear as different colors in human vision.

The accompanying drawing of the visible spectrum shows colors of visible light and their approximate wavelengths—Figure 10-1.

Human vision does not actually respond to all colors of light. We see only three colors: Red at the long-wavelength end of the spectrum, green in the middle, and blue at the short-wavelength end. The sensation of other colors is produced in the mind by noting the relative proportion or the mix of these three *primary* colors.

Beyond the visible blues in the spectrum are shorter wavelengths called *ultraviolet,* abbreviated UV. We can't see them, *but film can* and most types of film will be exposed by UV. When you expose ordinary film, color or b&w, in your camera, some exposure results from light you can see and some from UV wavelengths you can't see. At times this is a technical problem and there are technical solutions.

Most films do not respond to wavelengths longer than visible red, called *infrared* or IR, but some special films do. You have probably seen photos taken with IR-sensitive film

Figure 10-1/Different wavelengths of light cause the sensation of color. A theory of color vision is that we respond to three primary colors: long-wavelength red, medium-wavelength green, short-wavelength blue. The unit of length used here is nanometers (nm), one-billionth of a meter.

and noticed that natural objects such as water and foliage do not photograph the same in IR as in visible light.

Even though our eyes cannot see IR, we have a sensor for it—our skin. IR waves are "heat waves" and cause the sensation of warmth. When you take a picture using IR film you are photographing reflected or radiated *heat* from the scene rather than visible light. People use IR films both for fun and science, but I don't consider it a major part of ordinary picture taking.

LIGHT SOURCES

Not all light sources produce the entire spectrum. There are two main categories: Those which produce light due to being heated are called *incandescent*. Incandescent sources include the sun, a candle or campfire, and the common household lamp which is sometimes called an *incandescent* lamp but in photography is called a *tungsten* lamp. The glowing-hot filament inside an incandescent lamp is made of tungsten.

The other category of light sources does not depend on temperature to make light. These are sources such as fluorescent lamps and the yellowish sodium-vapor lamps used to illuminate highways and streets. The quality of light from non-incandescent sources is often a problem in color photography.

COLOR TEMPERATURE

The light produced by an incandescent source—including the sun—depends on its temperature. By stating the temperature of the source, the color balance of the light is implied. When so used, the temperature of the source is called *color temperature.*

Figure 10-2 is the spectrum of several color temperatures. The main thing to observe is that low temperatures produce mainly long wavelengths of light which we see as red, orange and yellow. Candles and matches operate at low color temperatures and you don't see any blue or green in candlelight.

As color temperature increases, the amount of short-wavelength light increases. At a high color temperature, the light appears to be more blue than red. Light from the sky is a very high color temperature and it is blue.

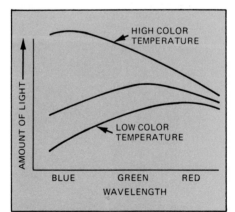

Figure 10-2/The relative proportions of red, green and blue in incandescent light are determined by the temperature of the source, called *color temperature.* Low color temperatures imply long wavelengths and reddish light. High color temperatures produce bluish light.

So far this is all technical and not very practical. However, in practical photography you worry about color temperature in one of two ways. For ordinary photography, you think of it in general terms: Is the light warm-looking and made up of red and yellow colors or is it cold-looking and bluish? Are you shooting outdoors under the blue sky, or indoors with warm tungsten illumination? In every-day photography you respond to these questions by selecting film and choosing filters to control the color of the final image.

If you do technical photography where exact color rendition is important, you worry in more detail and use color temperatures to make equipment choices. Color temperatures are disguised in the technical term *mired.* A discussion of these matters is in my book *Understanding Photography.*

Color temperatures are just labels to indicate the color quality of light, expressed in absolute temperature— degrees Kelvin (K).

You can talk about the warm color of candlelight or a color temperature of 1,800 degrees Kelvin. If you say 3,200 or 3,400 degrees, some people will know you are talking about the light produced by the two types of photoflood lamps used in photography. They have a higher color temperature than ordinary room lamps.

Sunlight alone is about 5,000 degrees but the cold-looking blue light from the sky may be around 12,000 degrees. Therefore *combinations* of sunlight, light from the blue sky and a few puffy white clouds—which we call average daylight—is between those two color temperatures. It is about 5,500 to 6,000 degrees. Light from an electronic flash simulates daylight.

A subject in the shade of a tree is illuminated only by the blue light from the sky without the "warming" benefit of direct sunlight. We think the light is cold-looking and too blue.

Much of color photography is concerned with these color effects and sometimes changing them.

Before the early-morning sun reached these mountain cabins, illumination was mainly blue light from the sky. Incandescent light in this neighborhood bar gives a warm yellow color. Your mind doesn't always realize that you are looking at a scene illuminated with colored light, but film often shows the result. Color filters over the lens are sometimes used to correct or change the color of light that exposes the film.

THE COLORS OF THINGS

A white piece of paper reflects whatever color of light falls on it. If illuminated by white light, it looks white. If illuminated by red light, it looks red.

Things which don't look white may owe their color to the light which is illuminating them, or to a property known as *selective reflection*. That means they do not reflect all wavelengths of light uniformly. A blue cloth in white light looks blue because it reflects mainly blue wavelengths. The other wavelengths of white light are absorbed by the cloth.

The color of transparent things such as glass is determined by *selective transmission*. Blue glass looks blue because it transmits mainly blue wavelengths. If illuminated by white light, blue wavelengths pass through the glass to your eye.

The other wavelengths are either absorbed by the glass or reflected from its surface—back toward the source. As far as the viewer is concerned, the glass looks blue because only blue wavelengths come through.

In general, the color of an object is determined *both* by the color of the light which illuminates it and the selective transmission or reflection of the object.

THE VISUAL COLOR OF FILTERS

If you hold a color filter between your eye and white light, you see the colors which are *transmitted* or passed by the filter. The effect of a filter on film is often more easily predicted by thinking about the colors the filter *stops* rather than those which get through.

Because human vision responds only to red, green and blue, it is only these three *primary* colors and their combinations that you have to worry about.

If a filter blocks all three primary colors completely, it looks black. If it reduces light transmission but some light at each color still comes through, the filter appears gray.

Other than that, color filters usually operate by reducing the amount of light transmitted at one or two of the three primary colors.

Color filters change the color of light by transmitting some wavelengths and blocking others.

If a filter blocks red, then it transmits both blue and green. To the eye, light coming through the filter appears bluish-green—a color photographers call *cyan*. We say cyan is the *complementary* color to red because you get cyan if you block red but transmit blue and green. Each of the three primary colors has a complement, according to this table.

PRIMARY COLORS	COMPLEMENTARY COLORS
Red	Cyan (Blue + Green)
Green	Magenta (Blue + Red)
Blue	Yellow (Red + Green)

In printing color films, laboratories use complementary-colored filters, so the words *cyan, magenta* and *yellow* are part of the language of photography and you should know what they mean.

ADAPTATIONS OF THE EYE

There are three kinds of human visual adaptations which are important in photography. One relates to the brightness of light. We can be visually comfortable in outdoor sunlight. On entering a building, we have the sensation that it is darker only for a few seconds and then we adapt to the lower level of illumination and don't notice it any more. On returning outdoors, we again adapt to the higher brightness in a short time.

The result is, people are very poor judges of the amount of light and should rely on exposure meters which don't have this adaptability problem.

We also adapt to color of light in the same way. If you are reading at night, using a tungsten reading lamp, you adapt to the yellowish color and don't even notice it. The paper in this book looks white to your mind. Go outside and look at your window. It will be obvious that you are reading in light which has a definite yellow cast.

Another adaptation results from your feeling of *participation* in a real-life situation. This turns up in several ways which often make a photo look ridiculous.

You can pose somebody in front of a tree and think it's a fine shot. When you look at the print, a tree limb seems to be growing out of your model's ear which seems absurd in the picture, even though it didn't bother you at all when it was real life.

EFFECTS OF ATMOSPHERE

The sun flings energy toward the earth over an extremely wide spectrum, part of which is visible. The atmosphere acts a a filter to block transmission of some wavelengths and allow transmission of others, including all visible wavelengths.

The atmosphere also has an effect on light rays which is called *scattering*. Instead of coming straight-arrow through the air, some light rays are diverted from the straight path and bounce around in the atmosphere. This is light from the sky as opposed to light directly from the sun.

It happens that the atmosphere scatters short wavelengths much more than long wavelengths. Therefore blue light is extracted from the direct rays of the sun and scattered all over the sky. That's why the sky is blue.

More blue light is removed from sunlight by scattering when there is more air between an observer and the sun. At noon, sunlight comes directly to the earth where you are and takes the shortest path through the air. Therefore there is minimum scattering of blue light and more of it is in the direct rays of the sun.

At morning or evening, the sun's rays come to you at an angle and therefore travel through more air. More blue light is extracted from the sun's rays, so sunlight appears to be more red-colored.

On a nice clear day, the sky is blue except near the horizon where it often looks white. This is another form of scattering caused by dust and smoke particles which are large enough to reflect most wavelengths of the visible spectrum. They scatter all of the light from the sun and the lower atmosphere appears to be white.

As sunlight travels toward the earth, atmospheric scattering takes blue light-waves out of the sunlight and scatters them all over the sky in a series of multiple reflections from air molecules. That's why the sky looks blue and why light *from* the sky is blue.

If you look from here over to that distant mountain, you are looking through a lot of lower atmosphere with both white-light scattering and blue-light scattering. The light rays coming to your eye from trees and rocks on the mountain are diverted from straight paths, details are obscured and the image looks hazy. We call that *atmospheric haze*. Fog is water droplets in the air and is worse than dust and smoke as a light scatterer and image obscurer.

The air itself scatters blue light and other particles in the air tend to scatter all colors of light. Therefore, even from point to point in the lower atmosphere, blue light is scattered more than any other wavelength.

If you take a picture without using the blue light rays to expose the film, there will be less atmospheric haze in your picture. Details of a distant scene will be more distinct. You can do that by putting a color filter over the lens which excludes blue light. It must therefore pass both green and red light. If you hold such a filter against white light it will look yellow, because the combination of red and green makes the sensation of yellow light.

It is common to use a yellow-colored filter over the lens to cut atmospheric haze. This works fine on

Blue haze between camera and distant scenery is due to atmospheric scattering of light.

b&w film, but on color film it will make a yellow-colored picture.

If your picture on b&w film is still too hazy with a yellow filter, remember that short wavelengths of light are scattered more than long wavelengths. If excluding short wavelength blue won't do the job, try also leaving out medium-wavelength greens. The filter now transmits red only, but image detail is greatly improved.

What if you exclude blue, green and also red? That will use still less scattered light to make the picture. A filter that excludes all three primary colors will look black because no visible wavelengths get through. Invisible IR wavelengths can come through a very dark-looking red or IR filter and expose IR film. That's the best haze cutter of them all.

Another effect of light scattering between your camera and the scene is reduced contrast of the image on the film. Light rays coming from bright parts of the scene are diverted by scattering so they land on the film at the wrong places. Some will land where it should be dark and that will make the dark places lighter.

View from mountain top is obscured by atmospheric haze. Haze always affects film more than your vision, so it doesn't look this bad when you take the picture.

A yellow filter cuts some of the haze by blocking short wavelengths which are scattered more than long wavelengths.

A red filter cuts haze still more because it blocks more of the shorter wavelengths. Notice that the same filters that cut haze also darken blue sky, making clouds stand out.

You can see this when outdoors on a sunny day. Notice the contrast in brightness between sunlight and shadow near where you are. Then look as far away as you can and compare the brightness of sunlight and shadowed areas over there. The shadows will appear much lighter than those nearby—due to atmospheric scattering.

Any filter which blocks scattered rays will improve contrast and sharpness of the image on the film.

COLOR-SENSITIVITY OF B&W FILM

Even black-and-white film is color sensitive. The early b&w emulsions were sensitive mainly to blue and UV light. Photos of women with red lipstick caused the lipstick to appear black because the film did not respond to red.

An improved film, called *orthochromatic* was still deficient in red-response.

Current b&w films, called *panchromatic* are said to be responsive to all visible wavelengths and as a practical matter, they are. There is still a slight deficiency in red response and too much sensitivity to blue, but it is usually not noticeable.

COLOR FILTERS WITH B&W FILM

Because the result of exposing b&w film to light of various colors is always shades of gray between black and white, we tend to think b&w film is colorblind.

It is difficult to relate the color response of b&w film to human vision which notices *both* color and brightness. Technically, they are tied together by saying that the brightness of an object in b&w, even though it is gray, should correspond to the brightness of that object in the original scene as viewed by people, never mind what color it is.

I think it is more important to recognize the fact that the major problem of b&w film is just that—it records in shades of gray. The print does not show colors which help to distinguish a red apple from green leaves or a yellow skirt from a blue sweater. If the skirt and sweater

With no filter and b&w film, a rose is about the same shade of gray as the surrounding green leaves.

A red filter lightens the rose and darkens the leaves so there is more contrast between them.

A green filter lightens the leaves and darkens the rose. Any red and green filters will have these effects, but deeper colors have a more noticeable effect.

happen to cause the same shade of gray on the film they will look the same in b&w.

Usually a b&w picture is improved if objects of different color record as different tones or shades of gray because the viewer of the print expects to see some difference between a necktie and jacket, or a rose and foliage.

You can use color filters on your camera to make a visible brightness difference between adjacent objects of different colors, as you can see in the accompanying photos.

The rule when using color filters with b&w film is: *A filter lightens its own color.* This applies to the final print, not the negative, but it is the print you are concerned about. A corollary to the rule is: *A color filter used with b&w film darkens every color except its own.*

It is common with b&w film to use filters to make clouds stand out against a blue sky. With no filter, clouds in the sky are sometimes nearly invisible and the entire sky is light-colored in the print. It is much more dramatic to have a dark sky with white clouds.

White clouds reflect all colors of light, but the sky is blue. Suppress blue with a filter and the sky darkens. The clouds darken too, but not as much. Because you are using b&w film, you can go as wild as you want with filter colors and only different shades of gray will result. The hierarchy of sky-darkening filters for b&w film runs from yellow to light red to dark red with more effect as you use darker reds.

Naturally the effect of a red filter appears on everything in the scene. If you include a model with red lipstick, the filter is an open door for red color and your model's lips will be lighter in tone.

A compromise filter often used for outdoor b&w portraits is a shade of green. This suppresses blue to darken the sky some but also holds back red so makeup and skin tones are not affected so much as with a red filter.

HOW COLOR FILMS WORK

Color film and the color-printing

process used in books and magazines is possible only because human color vision is based on the three primary colors. A color picture needs to have only these three colors mixed in proper proportions to do a very good job of presenting all colors we can see.

Color film does this with three different layers of emulsion coated on a base. The main difference between a color slide and a color print is: The base of the print is opaque white paper.

The trick of color film is to use one layer to record the amount of each primary color—at every point in the scene. When viewing a color slide by transmitted light, or a print by reflected light, each layer controls the amount of light at its own primary color. The light we see from the combination of all three layers causes our vision to see the colors of the original scene.

Naturally the colors we see when viewing a slide or print are affected by the color of the light or room illumination where we are viewing the picture.

NEGATIVE-POSITIVE COLOR

Color prints can be made from color negatives. A comparison to b&w will be useful. In b&w negatives, the shades of gray are reversed from the original scene. A white shirt appears black in the negative.

In color-negative film, after development, each layer transmits a reversed density of that particular color. If the subject is strongly red, the color-negative layer will be strongly not-red, meaning cyan-colored. A color print made from the negative reverses the color densities again with the result that a strong red in the scene becomes a strong red on the print.

You have probably noticed an overall orange color of color negatives. Even the clear parts have an orange cast. The dyes used in color films are as good as each film manufacturer can make them, but not as good as the manufacturer would like

them to be. These slight deficiencies in the color dyes are corrected by a complicated procedure called *color masking*. Evidence of masking is the orange color, which does not show in the print.

Because of color masking, the colors in a negative-positive process can be more true-to-life.

If a color print is made and the colors don't look quite right, it can be fixed by making another print. Color filters are used to change the color of the *printing* light and thereby make small corrections in the color balance of the final print.

If you miss exposure a step or two when using color-negative film, it is often possible to make a correction during printing, so the print is properly exposed and not too dark or too light.

Color-negative film allows the camera operator to make small mistakes, or be less precise about his work, and still end up with an acceptable print.

COLOR-SLIDE FILM

A color slide or transparency is the same piece of film you originally exposed in the camera. It is developed and chemically processed to make a positive image directly. This procedure is called *reversal* processing because it makes a positive out of a negative. There is no color masking because there is no opportunity to remove the orange color when making a print. The color balance of slide film is *theoretically* inferior to that of a good color negative-positive procedure but in practice it's hard to see any problem with slide-film colors.

Because there is no separate printing step to make a color slide, there is no opportunity to correct a bad exposure and no way to change the color balance of the positive. This makes exposure more critical, both in the amount of light on the film and its color.

Color-slide film will often make a perfectly good image when under- or overexposed a small amount, but it won't *look right* when projected on a screen. It will be too light or too dark

overall, particularly when viewed in succession with other slides which were properly exposed. For this reason, we say that color slides should be correctly exposed—within half a step either way.

When any color film—negative or reversal—is seriously over or underexposed, two effects may result. One is comparable to over or underexposing b&w film. Light areas become too light, or dark areas become too dark, and contrast is lost between portions of the scene in the too-light or too-dark area.

The second effect is peculiar to color film and is caused by reciprocity failure. Because the three layers are *different emulsions*, they usually don't go into reciprocity failure simultaneously and when they do, they don't react in exactly the same way.

A typical result of serious exposure error with color film is that one layer goes into reciprocity failure and needs more exposure but doesn't get it. Therefore that layer is effectively underexposed and does not properly control its color when developed. The end result is an overall color cast, such as pink or blue, which affects the entire picture.

This can be corrected in a negative-positive process if the color change is not too severe. But with color-slide film, you get what you shoot. Instructions for correcting reciprocity failure with color film usually call for both additional exposure and a color filter over the camera lens.

Making Tests—Whenever you are making tests of equipment or your skill, it's important to see what you actually put on the film. Most film laboratories will automatically make corrections when printing b&w or color negatives to compensate for apparent errors in exposure or color balance. If you are testing exposures and deliberately shoot some frames over or underexposed, you don't want the lab to correct your shots.

Color-slide film is the best way to make tests. What you get is what you shot, without any corrections by the film lab.

LIGHT SOURCES
Daylight
Tungsten, 3400K
Tungsten, 3200K
Household Tungsten below 3200K
Fluorescent

TYPES OF COLOR FILM
Daylight, 5500K
Tungsten Type A, 3400K
Tungsten Type B, 3200K

Tungsten film is manufactured so it gives acceptable colors of subjects under tungsten illumination. The film "expects" a lot of red and not much blue in the light.

FILTERS FOR COLOR FILM

First, you should know there are three types of color film. Two are made so they make a good color image with tungsten illumination.

If you use tungsten film in tungsten light, the manufacturer has already solved the problem for you and you don't have to use a filter to change the color balance of the light that gets on the film.

If there is not enough room light to shoot with, you can add light by using special photo lamps, commonly called *photofloods*. There are two types. Photofloods which are unmarked for color temperature operate at 3,400K to get more light output but with shorter life. Those marked 3,200K operate at that temperature, which is closer to normal room lighting.

Type B tungsten film is intended for use with 3,200K lights. If you use 3,400K lamps with Type B film, you should use a filter over the camera lens.

You can often "get away" with mixing 3,400K photofloods with room light from table and floor lamps, but technically this is mixed lighting with a visible color difference between the two types of light.

Type A color film is designed for use with 3,400K lighting. If you use it with 3,200K lamps or ordinary room lighting, you should use a filter over the camera lens to compensate.

A table at the end of this chapter gives recommendations for various types of films and lighting.

Daylight color film is balanced for daylight, but you may need to use a filter anyway.

Ultraviolet light is reduced by the atmosphere but present in some amount everywhere. The higher you are in altitude, the more UV there is to expose your film. You can't see it and your exposure meter probably ignores it, but the film will be exposed by UV. There are *UV filters* which reduce transmission of UV. They are clear because they don't stop any visible wavelengths.

When tungsten film is used outdoors, the light is less red and more blue than the film is designed to handle. Colors change accordingly and everything looks too blue.

A Nikon A12 filter, or equivalent, removes the unnatural blue color when tungsten film is used in daylight.

Even at sea level they are a benefit—partly because they protect the lens itself. In the mountains a UV filter should always be used. This applies equally to b&w film because it is also sensitive to UV.

If atmospheric haze is a problem, you want to exclude short wavelengths. With color film, you can't use a strongly colored filter unless you want the picture to have that color. *Haze filters* for color film cut UV and also cut some of the barely visible blue wavelengths—the shortest. A haze filter for use with color film is practically clear. If you use one, you don't need a UV filter because it will do both jobs.

A subject in shade outdoors is illuminated by skylight which has more blue in it than average daylight or direct sunlight. With color film, the effect is usually noticeable as an overall blue cast to the picture and bluish skin tones on people. *Skylight*

filters for use with color film block some of the blue light to give a more warm-looking picture. Some photographers like the effect even in daylight or direct sunlight, so they put a skylight filter on the lens and use it all the time with color film outdoors. It also blocks UV.

There are filters which allow you to use indoor film in daylight, and daylight film indoors.

To use tungsten film in daylight, the filter has to alter daylight so it looks like tungsten to the film. The filter will reduce the amount of blue and green so what comes through has a color balance similar to tungsten light. Such filters have a yellow-orange appearance when viewed in white light.

To use daylight film indoors, filtering depends on the illumination being used inside the building. If it is tungsten light, the filter must change it so it appears to be daylight as far as

the film is concerned.

The filter will block a lot of red and will look bluish or blue-green in white light.

If the indoor illumination is fluorescent lamps, it is difficult to filter. Some look bluish and some are designed to look like daylight to humans. Daylight fluorescent light sources do not look like daylight to film. Filter manufacturers offer one or more types of filters for use with fluorescent lighting and the best guide to their use is the maker's instructions.

Except for polarizing and neutral-density filters which will be discussed shortly, those are the filter types which can be used with color film without an unusual or noticeable effect on the overall color of the picture. If you shoot through a red filter, you get a red picture—including skin and snow which most people expect to be skin-colored and snow-colored.

FILTER FACTORS

Most filters reduce light at visible wavelengths. They reduce it more at some wavelengths than others, but the net result is still less light on the film. This does not apply to visually clear filters such as UV and some haze filters for color film.

Filter manufacturers normally state the amount of light loss as it affects the film exposure by a number known as the *filter factor*. This number is used to *multiply* the camera exposure that would be used *without* the filter—to get the correct exposure *with* the filter. The symbol X is included in a filter factor to remind us that it is used as a multiplier.

Some examples will clarify this. A 2X filter must be compensated by two times as much exposure which is one more exposure step. Use the next smaller *f*-number or the next slower shutter speed. A 4X filter requires two exposure steps. An 8X filter needs three exposure steps.

Nikon and Nikkormat cameras meter behind the lens and the camera exposure meter *automatically compensates* for the effect of a filter on the lens. You can ignore filter factors as long as you are using the camera's

FILTER FACTOR TO *f*-STOP CONVERSION GRAPH

FILTER FACTOR (vertical axis)

APERTURE-SIZE INCREASE (*f*-STOPS) (horizontal axis)

Filter factors are exposure multipliers. Use this graph to find *f*-stop change for any filter factor. Example shows filter factor of 2.5 is equivalent to an aperture size increase of 1.3 steps.

built-in meter, with one exception: When using a Nikon R-60 or any dark red filter with tungsten lighting, give one step more exposure than the meter indicates.

This is a great convenience. You can put on different filters and shoot quickly just by balancing the viewfinder display for exposure.

You are not getting filtering free. Even though it is simple and uncomplicated to set exposure with a filter on the lens, the correction you make *must* have the effect of increasing aperture or exposure time.

If you are shooting action in poor light and decide to pop on a red filter with a filter factor of 8X so the sky will be dramatic, you may also have a dramatic shooting problem called *you can't do it!* With action, you probably can't open up by three *f*-stops and even if you can, depth of field may disappear.

Even though behind-the-lens metering spares you the inconvenience of using filter factors to compensate every exposure, you still need to know about them because they can affect the technical solution you are using to make the picture. Filter factors are also a guide in purchasing a filter because they tell you how strong the color will be. Higher filter factors mean deeper colors and more light loss.

NEUTRAL-DENSITY FILTERS

There are circumstances when you want to get less light into the camera so you can use larger aperture for less depth of field. There are also some cases where you want less light so you can use longer shutter-open times.

Gray-colored filters, called *neutral density* (ND) reduce the amount of transmitted light uniformly across the visible spectrum, which is why they are called *neutral*.

These filters can be used with either color or b&w film because they have uniform color response. Some people say because an ND filter only has the effect of taking out white light, it does not change the colors of the image. It depends on

USING NEUTRAL-DENSITY FILTERS TO INCREASE EXPOSURE TIME OR APERTURE		
FILTER NOMENCLATURE	MULTIPLY EXPOSURE TIME BY:	OPEN LENS APERTURE BY (*f*-STOPS):
ND .1	1.25	1/3
ND .2	1.6	2/3
ND .3 or 2X	2	1
ND .4	2.5	1-1/3
ND .5	3.1	1-2/3
ND .6 or 4X	4	2
ND .8	6.25	2-2/3
ND .9 or 8X	8	3
ND 1.0	10	3-1/3
ND 2.0	100	6-2/3
ND 3.0	1000	10
ND 4.0	10,000	13-1/3

Glass screw-in ND filters with filter factors greater than 8X are hard to find. Camera dealers can supply Eastman Kodak gelatin ND filters in *densities* up to 4.

your point of view. If you look through an ND filter, all colors are different because they are less bright.

Some ND filters are rated the same way as color filters—by a filter factor. Commonly available ratings are 2X, 4X and 8X.

You may have to stack filters, meaning put one in front of another, to get the required density. When stacking filters using filter factor ratings, the combined rating is obtained by *multiplying* the individual ratings. A 2X filter and an 8X filter used together have a rating of 16X.

Some ND filters are labeled with their optical density instead of a filter factor. The two ratings can be tied together by the fact that each increase in optical density of 0.3 is equal to a filter factor of 2X.

When filters rated by optical density are stacked, the densities *add* directly. An ND 0.3 filter plus an ND 0.3 filter make an ND 0.6 filter—with a filter factor of 4X.

You can use ND filters in ordinary photography when the film in the camera is too fast for the job at hand. If you have high-speed film already in the camera and you need to make a

shot or two in bright sunlight, clip on an ND filter and effectively slow down the film.

The camera will *behave* as though the film speed is divided by the filter factor. If you have ASA 400 film in the camera and put on an ND filter with a factor of 4X, you will end up setting aperture and shutter speed as if the film had a rating of ASA 100.

Does this mean you should change the film-speed dial of the camera from 400 to 100? No, even though some instructions seem to say that.

POLARIZING FILTERS

Still another property of light wave is responsible for *polarization*, the direction of movement or vibration of the light waves. Water waves serve as a good analogy. Water particles in a water wave move up and down, so the wave is *vertically polarized*. Light can be vertically polarized, horizontally polarized, or polarized in all directions at once—called *random polarization*. Direct sunlight is randomly polarized.

Some materials have the ability to transmit waves with only a single

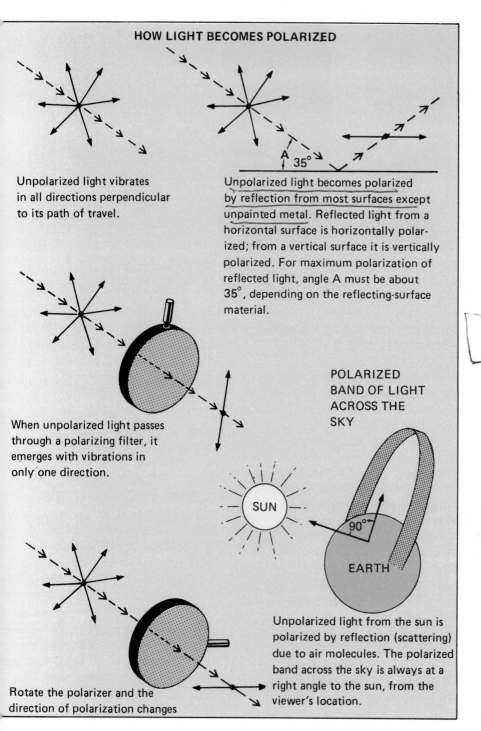

HOW LIGHT BECOMES POLARIZED

Unpolarized light vibrates in all directions perpendicular to its path of travel.

Unpolarized light becomes polarized by reflection from most surfaces except unpainted metal. Reflected light from a horizontal surface is horizontally polarized; from a vertical surface it is vertically polarized. For maximum polarization of reflected light, angle A must be about 35°, depending on the reflecting-surface material.

When unpolarized light passes through a polarizing filter, it emerges with vibrations in only one direction.

Rotate the polarizer and the direction of polarization changes

POLARIZED BAND OF LIGHT ACROSS THE SKY

Unpolarized light from the sun is polarized by reflection (scattering) due to air molecules. The polarized band across the sky is always at a right angle to the sun, from the viewer's location.

direction of polarization. These materials are made into *polarizing filters*, sometimes called *polarizing screens*. A polarizing filter that transmits vertically polarized light will not transmit horizontally polarized light, and the reverse.

If randomly polarized light arrives at a polarizing filter oriented to pass vertical polarization, the horizontally polarized component will be blocked by the filter. If the filter were perfect, this would block exactly half of the total light in a randomly polarized beam and the filter would have a filter factor of 2X or a density of 0.3. Practical filters vary from around 2.5X to 4X. They don't block all light of the wrong polarization, but the filter material is gray-colored so it absorbs some light of all polarizations just because of the gray color.

Unpolarized light becomes polarized by reflection from smooth surfaces—except unpainted metal. Where such reflections occur, we see the reflection as glare, such as in a store window or glass display case, and on the surface of varnished wood furniture. When a polarizing filter is used to block such reflections the improvement is sometimes dramatic.

When unpolarized light is reflected from a non-metallic surface, vibrations in the light which are parallel to the surface are reflected and those which are perpendicular are suppressed. For example, light reflecting from a horizontal surface will become polarized horizontally.

Polarizers are normally supplied in mounts which allow the filter to be rotated so you can change the angle of polarization while viewing the result. Meter and set the exposure controls *after* you have rotated the polarizer for the desired effect.

A polarizer is the only way to darken blue skies to make the clouds stand out, when using color film. Scattered blue light from the sky is polarized and the effect is maximum when viewed at a right-angle to the sun. When you rotate the polarizer so it suppresses the polarized blue light, the sky becomes darker and white clouds become highly visible.

Some manufacturers offer a special double polarizer which serves two purposes or you can make one by using two polarizing filters stacked so each can be rotated independently of the other. If both are set for the same angle of polarization, the effect is slightly stronger than with a single filter. If they are set so their angles of polarization are at right angles, they tend to block all of the light.

By rotating one of the two polarizers, this device acts as a variable neutral-density filter and the light passing through can be controlled over a wide range.

FILTER MOUNTING

There are about as many ways to mount filters on cameras as human ingenuity can achieve. Most Nikkor lenses use the screw-type filter which screws into the threaded accessory-mounting ring on the front of the lens. Each filter repeats the lens thread on the outer edge of the filter, so a

If you are pointing the camera at the right part of the sky, a polarizer darkens the blue sky and makes clouds stand out dramatically.

second filter can be screwed into the first. As many filters as desired can be stacked by screwing them into one another.

A problem results from lenses with different screw-thread diameters at the front. If you have a filter which fits a small-diameter lens, it will be too small for larger-diameter lenses and you may end up buying the same filter type in two diameters.

With screw-in filters, the lens-size problem can be solved by purchasing filters to fit your largest-diameter lens. Adapter rings are available at most camera shops. These are usually called *step-up rings* and *step-down rings*. The step-down type puts a smaller filter on a larger lens—which may cause vignetting of the image by blocking some of the light around the edges of the frame. Using a filter larger than the lens, installed using a step-up ring, rarely causes any problem unless several are stacked.

Another mounting system uses *series-type* filters. These drop into the cavity at the front of a lens and are held in place by a screw-in lens hood or a special retaining ring.

IMAGE DEGRADATION DUE TO FILTERS

Besides vignetting due to stacking filters, image quality may deteriorate when several filters are used together. The image will normally show no visible effect from a single filter—except the desired effect. You can normally use two without worrying.

When using three or more, test first to be sure you don't have problems with an important shot.

The light reflects back and forth between glass surfaces of a stack of filters, just the same as in a lens. All good quality modern filters are coated to reduce reflections.

Filters have least effect on image quality when they are mounted close to the front of the lens. Stacking and use of step-up rings puts some of the glass far enough from the lens to make aberrations and defects more apparent.

Dirt, scratches or fingerprints on a filter surface will scatter the light and reduce contrast of the image, the same as dirt does on the lens itself. Filters should receive the same care as lenses.

Filters may fade with age, particularly if exposed to bright light a lot of the time. This change is hard to detect because it is gradual, but it may not be important until you can detect it.

FILTER CATEGORIES

There is very little standardization in the names given to types of filters to indicate their purpose. The most common designations are those of Kodak, which have been adopted by several other major suppliers. This discussion uses Kodak terminology.

Filters are often grouped into categories that are logical but possibly misleading. A filter is a filter and it has some effect on light. Even though

one may be labeled for use in making color prints in the darkroom, it can be just as useful in front of your camera if you can find a way to hold it there.

Conversion Filters—This type of filter alters the light spectrum to make it suitable for the film you are using. It *converts* the light to your purpose. Examples are converting daylight to look like tungsten illumination and vice versa.

Light-Balancing Filters—These make smaller changes in the quality of light, such as changing from 3,200K light to 3,400K light and the reverse for Type A and Type B color film. Another example is a skylight filter to take out some of the blue when the subject is in shade.

Exposure-Control Filters—These are neutral-density filters which only alter the amount of light, not the relative amounts at each wavelength. A double polarizing filter which can be rotated to change the amount of light also fits into this class.

Contrast-Control Filters—These are color filters used with b&w film to control or alter visual contrast on the print between objects of different color in the scene. The red apple among green leaves, for example.

Haze Filters—Useful with either color film or b&w, depending on the filter. They cut haze by cutting the shorter wavelengths of light. Obviously a dark red filter used to cut haze with b&w film can also serve as a special-effect filter with color film.

Doing it wrong. This street was filled with moving automobiles, but a long exposure eliminates moving objects like magic. I stacked two glass polarizers, rotated one with respect to the other so minimum light came through, and exposed for 30 seconds. Traffic disappeared like magic. But stacked filters vignetted the image and reciprocity failure changed the colors.

Color-Compensating Filters—These are for making prints from color film but can also be used over the camera lens. They have relatively low densities in the six colors that are important in color films: Red, green, blue, cyan, magenta, and yellow.

These filters have an orderly system of nomenclature which uses the letters CC as prefix in all cases. Following the prefix is a number such as 05 which is the optical density of the filter. Following the density indicator is a letter which is the initial of the *visual* color of the filter itself. If the filter looks red when viewed against white light, it is call a red, or R filter.

A filter identified as CC30G looks green to the eye, therefore it suppresses red and blue. The density of 0.30 is to magenta light. A CC50M filter is magenta-colored.

CC filters have good optical quality and can be used in front of a camera lens and below the negative in an enlarger without noticeable degradation of the image.

SOME 35mm FILMS								
FILM TYPE	**ASA Speed/Conversion Filter**			**FILM TYPE**	**ASA Speed/Conversion Filter**			
	Daylight	Tungsten 3400K	Tungsten 3200K		Daylight	Tungsten 3400K	Tungsten 3200K	
COLOR SLIDE FILM				**COLOR NEGATIVE FILM**				
Kodachrome 25	24/none	8/80B	6/80A					
Kodachrome 64	64/none	20/80B	16/80A	Kodacolor II	100/none	32/80B	25/80A	
Kodachrome II Professional Type A	25/85	40/none	32/82A	Kodacolor 400 (CG)	400/none	125/80B	100/80A	
				Kodak Vericolor II Professional, Type S	100/none	32/80B	25/80A	
Ektachrome 64 Daylight (ER)	64/none	20/80B	16/80A					
Ektachrome 200 Daylight (ED)	200/none	64/80B	50/80A	3M Color Print Film	80/none	25/80B	20/80A	
				Fujicolor F-II	100/none		32/80A	
Ektachrome 160 Tungsten (ET)	100/85B	125/81A	160/none	Fujicolor F-II 400	400/none		125/80A	
Agfachrome 64	64/none	20/80B	16/80A	**BLACK & WHITE**				
Fujichrome R 100	100/none		32/80A	Kodak Panatomic-X	32	32	32	
				Kodak Plus-X	125	125	125	
				Kodak Tri-X	400	400	400	
				Ilford PAN F	50	50	50	
				Ilford FP4	125	125	125	
				Ilford HP4	400	400	400	

Color-Printing Filters—These have the same colors and density ranges as CC filters but are not of good optical quality. They are intended to change the color of the printing light by insertion of the filter *above* the negative in an enlarger. At that point in the optical path, the image is not yet formed, so optical quality of the filter is not important as long as the color is correct.

Special Filter Types—These include such things as star-effect filters, and soft-focus or diffusion filters.

Other Types—There are lots of other types of filters in various categories. If you have a technical interest in filters, a good book to read is Kodak Publication B-3, entitled *Kodak Filters for Scientific and Technical Uses.* It is available through your camera shop.

FILMS

I waited until after the discussion of light and filters to give you the accompanying table of available films because you should consider all aspects when choosing film. The table does not list all available films the world over, but it gives enough brands and types to be helpful in most parts of the western world.

RECIPROCITY FAILURE

So far, this book has encouraged you to believe that you can shoot at any shutter speed you choose, adjusting aperture accordingly so you get the correct exposure. That is true when photographing in daylight and in well-lit interiors. With a normal amount of light on the scene, the Reciprocity Law applies, but here is the fine print that states the exceptions:

People once thought the law applied to all values of light and time, but there are exceptions when the shooting light is either unusually bright or unusually dim. These exceptions are called reciprocity-law failure, usually known as *reciprocity failure.*

The problem lies in the nature of film, not in the camera. It is always due to light which is brighter or more dim than the design-range of the film emulsion. Even though reciprocity failure is caused by the amount of light, the best *clue* to the camera operator is shutter speed because unusually short shutter speeds mean there is a lot of light and unusually long exposure times mean the light is dim.

As a general rule for most amateur films, if you are shooting faster than 1/1000, or slower than 1/10 second, you should think about the possibility of reciprocity failure. Consult the film data sheet supplied by the film manufacturer. Some films have a more limited "normal" range of exposure times than stated above.

TYPICAL EXPOSURE INCREASE AND FILTERING TO CORRECT RECIPROCITY FAILURE IN COLOR FILMS

FILM TYPE	INDICATED EXPOSURE TIME (Seconds)										
	1/50,000	1/25,000	1/10,000	1/1000	1/10	1/2	1	2	10	64	100
Kodachrome II 5070, Type A	†		None No Filter	None No Filter	1/2 Stop No Filter		1 Stop CC10M		1-1/2 Stop CC10M		2-1/2 Stop CC10M
Ektachrome 64 (Daylight)			1/2 Stop No Filter	None No Filter	None No Filter		1/2 Stop CC15B		1 Stop CC20B		NR
Ektachrome 200 (Daylight)			1/2 Stop No Filter	None No Filter	None No Filter		None No Filter		NR		NR
Ektachrome 160 (Tungsten)				None No Filter	None No Filter		1/2 Stop CC10R		1 Stop CC15R		NR
Kodachrome 25			None No Filter	None No Filter	None No Filter		1 Stop CC10M		1-1/2 Stop CC10M		2-1/2 Stop CC10M
Kodachrome 64			None No Filter	None No Filter	None No Filter		1 Stop CC10R		NR	NR	NR
Fujichrome R-100				None No Filter		None No Filter	1/3 Stop CC5C	2/3 Stop CC5C	2/3 Stop CC10C	1-2/3 Stop CC20C	2 Stop CC20C
Kodacolor II	1 Stop CC20B	1/2 Stop CC10B	None No Filter	None No Filter	None No Filter		1/2 Stop No Filter		1-1/2 Stop CC10C		2-1/2 Stop CC10C + 10G
Kodacolor 400			None No Filter	None No Filter	None No Filter		1/2 Stop No Filter		1 Stop No Filter		2 Stop No Filter
Vericolor II Professional Type S			None No Filter	None No Filter	None No Filter		NR		NR		NR
Fujicolor F-II				None No Filter		None No Filter	1/3 Stop No Filter	2/3 Stop No Filter	1 Stop No Filter	1-1/3 Stop No Filter	1-2/3 Stop No Filter
Fujicolor F-II 400			None No Filter	None No Filter			1 Stop No Filter		2 Stop No Filter		3 Stop No Filter

NR — Not Recommended
†Blank spaces indicate data not published by manufacturer. Where blank is *between* published data estimate correction
All data subject to change by film manufacturer

The basic effect of reciprocity failure is always *less* actual exposure on the film than you expect. Therefore the basic correction is to give more exposure by using larger aperture, more time, or both. For example, if an exposure meter or an exposure calculation suggests using *f*-4 at 4 seconds, the film manufacturer may say to give one step more exposure than that to compensate for reciprocity failure. Use *f*-2.8 if it is available on the lens, or shoot at 8 seconds.

With b&w film, the film data sheet may call for more exposure and also a change in the development procedure. With color film, reciprocity failure can cause both underexposure and a color change on the film. The compensations may be more exposure, use of a color filter on the lens, and a change in development.

Nikon cameras will meter in dim light and make exposures that are well into reciprocity failure for most films. Making pictures in dim light is

Film	Filter Type or Color	Filter Desig- nation	Filter Factor (Approximate)		Use
			Daylight	Tungsten Light	
Black & White and Color	Skylight	L1B	1	1	Reduces the bluish cast of scenes taken with color film in open shade and distant landscapes to produce a more natural effect. Also cuts haze to reveal more details. Has remarkable filter stability. Leave on the lens as a lens protector. Nikon Integrated Coating (NIC) is applied to L1BC to reduce unfavorable light reflection.
		L1BC			
	Ultraviolet	L37	1	1	Cuts out ultraviolet light with no effect on visible light. Cuts haze. L37 and L37C cut wavelengths shorter than 390nm; L39 cuts shorter than 390nm. Leave L37 or L37C on lens as a lens protector for general use. Use L39 instead for a more pronounced effect in b&w. Nikon Integrated Coating (NIC) is applied to L37C.
		L37C			
		L39			
Black & White	Light Yellow	Y44	1.5	1	Absorbs moderately ultraviolet, violet and blue light for darkening skies and making clouds stand out with black-and-white film. Light yellow filters are suitable for outdoor portraits as they produce a more natural rendering of skin tones. As the filter factor increases, the color deepens and the effect becomes more pronounced.
	Medium Yellow	Y48	1.7	1.2	
	Deep Yellow	Y52	2	1.4	
	Orange	O56	3.5	2	Has a wider absorption range than yellow filters for more pronounced contrast. Accentuates any subject in which yellow, orange or red predominates. Good for accenting detail in textures of trees, stone, sculpture, etc.
	Red	R60	6	5	Creates the most striking contrast and brings out distant scenes. Red and orange are especially emphasized. Red filters are sometimes used to create a night-time effect by underexposing. Also used for infrared photography with infrared film.
	Light Green	XO	2	1.7	Absorbs ultraviolet, blue and red, either partially or completely. The color balance of the subject must be considered carefully because of the filter's tendency to cut out both blue and red simultaneously. Each color is reproduced with almost the same balance of light and shade as seen by the naked eye. Suitable for portraits and for multicolored subjects in general. The X1 filter is used under tungsten light to prevent overemphasis on red areas of the subject.
	Deep Green	X1	5	3.5	
Black & White and Color	Polarizing	Polar	2-4	2-4	Eliminates various degrees of reflected light from glass, water, tile and similar surfaces. Useful for photographing through glass windows or underwater. Not effective for metal surfaces. Darkens blue skies.
	Neutral Density	ND2X	2	2	Reduces all colors uniformly. Useful for photographing extremely bright subjects like light sources or when the lens is used at a large aperture to minimize depth of field. Can be used with either black-and-white or color films as the filter itself is colorless.
		ND4X	4	4	
		ND8X	8	8	
Color	Light Amber	A2	1.2		Used with daylight film to avoid the blue tinge which is likely to occur when a photograph is taken in the shade, in cloudy weather or indoors using light from a north window in fair weather.
	Deep Amber	A12	2		Used with color film balanced for tungsten light when shooting outdoors in fair weather. Reduces blue tinge.
	Light Blue	B2	1.2		Used with daylight film to prevent the red-yellow cast which is characteristic of shots taken three hours or so before sunset or after sunrise.
	Medium Blue	B8	1.6		Used with daylight film and clear flash bulbs to eliminate excessive red-yellow cast.
	Deep Blue	B12	2.2		Used with daylight film to avoid the red-yellow cast caused by using a photoflood lamp indoors.

Nikon FILTERS

challenging and enjoyable provided you *remember* to compensate for reciprocity failure.

There are four ways: Best is to use the film manufacturer's data. If you don't have data, you can make tests to find the best correction. If you don't have time to make tests, you can shoot several different exposures such as 4, 8 and 16 seconds, hoping one will be right. The poorest way is to guess at it, but even that is better than making no correction at all.

SOFT FOCUS FILTERS

In addition to the filters listed on the preceding page, Nikon offers two soft focus filters. They give a misty overall appearance to a photo but preserve the impression of sharp focus. They are often used in portraiture to "erase" wrinkles and skin blemishes. Soft focus filter 2 has more effect than Soft 1 and they can be stacked for maximum effect. They are available to fit 52mm filter threads.

TYPICAL EXPOSURE INCREASE FOR RECIPROCITY FAILURE OF KODAK BLACK & WHITE FILMS				
	IF INDICATED EXPOSURE TIME IS (SECONDS)	USE ONE OF THESE CORRECTIONS (NOT BOTH)		AND CHANGE DEVELOPING TIME:
		Increase Aperture	Exposure Time	
Panatomic-X Plus-X Tri-X	1/100,000	1 stop	Use Aperture Change	20% more
	1/10,000	1/2 stop	Use Aperture Change	15% more
	1/1,000	None	None	10% more
	1/100	None	None	None
	1/10	None	None	None
	1	1 stop	2 seconds	10% less
	10	2 stops	50 seconds	20% less
	100	3 stops	1200 seconds	30% less

AVAILABLE NIKON FILTER SIZES																						
Attachment Size	SOFT FOCUS	L1B	L1BC	L37	L37C	L39	Y44	Y48	Y52	O56	R60	X0	X1	Polar	ND2X	ND4X	ND8X	A2	A12	B2	B8	B12
39mm		•		•	•				•	•	•			•	•	•	•	•	•	•	•	•
52mm	•		•			•	•	•	•	•	•	•	•	•		•	•	•	•	•	•	•
72mm			•	•			•		•		•				•			•				
95mm							•		•	•	•											
122mm						•	•		•	•	•											
Series IX						•	•	•	•	•	•											

FILTER SIZE OF NIKON SERIES E LENSES
ALL SERIES E LENSES USE 52mm FILTERS

FILTER SIZE OF NIKKOR LENSES			
Lens	Filter	Lens	Filter
6mm f-2.8	Built-in (Skylight, Y48, Y52, O56, R60	105mm f-2.5	52mm
		105mm f-4 Micro	52mm
6mm f-5.6	Built-in (Skylight, Y48, Y52, O56, R60, X0)	135mm f-2	72mm
		135mm f-2.8, 135mm f-3.5	52mm
8mm f-2.8	Built-in (Skylight, Y48, Y52, O56, R60)	180mm f-2.8	72mm
		200mm f-2 ED IF	122mm
10mm f-5.6	Built-in (Skylight, Y48, Y52, O56, R60, X0)	200mm f-4	52mm
		300mm f-2.8 ED	122mm
15mm f-5.6	Built-in (Skylight, Y48, O56, R60)	300mm f-4.5	72mm
		400mm f-5.6	72mm
16mm f-3.5	Built-in (Y48, O56, R60, Clear)	500mm f-8	39mm (supplied with R60, Y52, O56, ND4X, L37)
18mm f-4	86mm screw-in or series 9	1000mm f-11	39mm (supplied with ND-4, L37C, O56, A2, B2)
20mm f-3.5	72mm		
20mm f-4	52mm	2000mm f-11	Built-in (62mm L39, Y48, O56, R60)
24mm f-2.8	52mm		
28mm f-2, 20mm f-2.8, 28mm f-3.5	52mm	28-45mm f-4.5 Zoom	72mm
		35-70mm f-3.5 Zoom	72mm
28mm f-4 PC	72mm	43-86mm f-3.5 Zoom	52mm
35mm f-1.4, 35mm f-2 35mm f-2.8	52mm	50-300mm f-4.5 Zoom	95mm
		80-200mm f-4.5 Zoom	52mm
35mm f-2.8 PC	52mm	180-600mm f-8 Zoom	95mm
45mm f-2.8 GN	52mm	200-600mm f-9.5 Zoom	82mm screw-in or series 9
50mm f-2, 50mm f-1.8 50mm f-1.4, 55mm f-1.2	52mm	360-1200mm f-11 Zoom	122mm
		400mm, 600mm, 800mm, 1200mm	122mm
55mm f-3.5 Micro	52mm		
85mm f-1.8	52mm	600mm ED, 800mm ED, 1200mm ED	122mm
85mm f-2	52mm	200mm f-5.6 Medical	38mm

11
HOW TO USE FLASH

Because flash is a very brief exposure, sometimes it happens when your subject blinks and his eyes are closed.

Insurance against catching your subject with his eyes closed is to make more than one shot. When flash is aimed directly at subject, photo usually shows reflections of flash in subject's eyes. My noble dog, Goodo, likes to have his picture taken.

In addition to natural light and unusual sources such as candles and campfires, photographers commonly use artificial light sources of three general types: bulb-type flash, electronic flash, and continuous light sources such as incandescent lamps.

Flash bulbs superseded the old-fashioned pile of flash powder that the photographer held aloft and burned to make a bright light. In the same way, electronic flash units have replaced flash bulbs among most photographers using SLR cameras.

FLASH MOUNTING METHODS

Whatever kind of flash you use, if it is portable there is usually some way to attach it to your camera. This combines flash and camera into one unit that is easy to carry and handle,

but flash-on-camera is not often the best way to use flash. Nevertheless it is common because of its convenience.

Accessory Shoes—The first flash-holding gadgets used on cameras were simple metal brackets called *accessory shoes*. To install a flash unit, you just slide the mounting foot of the flash into the accessory shoe. No electrical connection is made between camera and flash—it's just a simple and convenient way to attach the flash unit to the camera.

Some accessory shoes have been built as part of the camera; others are separate items that you mount on the camera body when you need them.

Hot Shoes—Later in the course of flash-unit development, accessory shoes were equipped with an electrical contact which mated with a con-

tact in the mounting foot of the flash unit. This allows the camera to fire the flash at the proper time without any other electrical connections between flash and camera. This type of flash mount is called a *hot shoe*.

Flash Brackets—Another way to combine flash and camera into one unit is an accessory bracket that holds both. One arm of the L-shaped bracket extends under the camera body and uses the camera's tripod socket to mount the camera on the bracket. The vertical arm of the bracket serves as a handle and mounts a flash unit in an accessory shoe—often on top of the handle portion, but there are other methods.

Flash mounted in a bracket usually requires a separate electrical cord to make the electrical connection between camera body and flash unit.

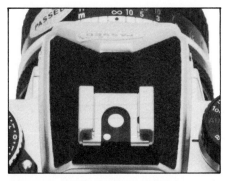

Hot-shoe on FE camera accepts standard ISO flash units which are fired by center contact in shoe. Also accepts special SB-10 flash unit which uses both contacts in shoe as described later in this chapter.

A conventional flash-mounting foot slides into the ISO hot shoe from the rear. Knurled plastic knob tightens the mount so the flash doesn't wobble or come loose. Metal contact in center of flash foot touches metal contact in camera hot shoe to make the electrical connection between camera and flash.

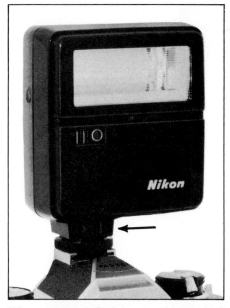

When mounted, flash is securely attached and needs no other electrical connection to the camera. For use when not mounted in a hot shoe, Nikon flash units have provision to use flash cords to interconnect flash and camera. Flash cord plugs into special two-prong socket (arrow) just above flash-mounting foot. This is Nikon Speedlight SB-4.

Sync Cords—Common names for electrical cords to connect flash to camera are *PC cord, sync cord* and *synch cord.* One type of electrical connector on camera bodies is called a *PC socket,* whence the name, *PC cord.* *Sync* and *synch* are both intended to be abbreviations of the word *synchronization.* The electronics industry generally uses *sync,* and I prefer it.

The purpose of sync cords is to allow the camera to control the flash, so the flash fires at the correct time.

PC sockets and common PC cords fit together by pushing the connector on the cord into the socket on the camera. It remains connected only because of friction. Sometimes PC cords become disconnected when you don't know it and you lose a picture because the flash didn't flash.

It's common to see PC cords held into cameras and flash units with strips of gray duct tape to prevent the PC cord from pulling loose. One photographer I know says it's to guard against "PC"—poor connections!

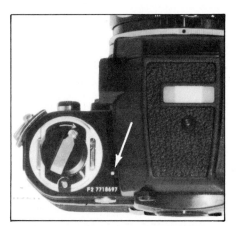

Nikon F and F2-series cameras use this special Nikon hot shoe that surrounds the camera rewind knob. Grooves on each side and spring-loaded rails below grooves hold flash foot securely in place. Electrical contact at back is used to fire flash. Small electrical contact on side of viewfinder housing (arrow) also makes contact with flash foot and is used to operate flash ready-light in viewfinder eyepiece.

MOUNTING FLASH ON CAMERA
Types of flash:
Standard ISO flash foot
Special F2 flash foot that fits directly on F and F2 cameras.
Special F3 flash foot that fits directly on F3 cameras.
Types of Adapters:
AS-1 mounts flash with ISO foot on F and F2 cameras.
AS-2 mounts flash with F2 foot on cameras with ISO hot shoe.
AS-3 mounts flash with F2 foot on F3 cameras.
AS-4 mounts flash with ISO foot on F3 cameras.

This table identifies three types of electronic flash and adapters that can be used to mount them on various camera models.

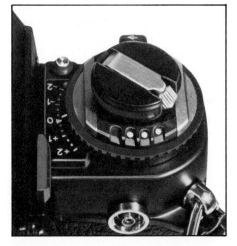

The special hot shoe on the F3 is similar to the F2. The Nikon flash foot slides on from the front and fits into grooves on each side of the rewind knob. The F3 hot shoe has three contacts to make electrical connections to the flash, as shown here. Nikon flash units designed for the F3 fit directly on this shoe. Other flash units may be mounted with an adapter.

Nikon and Nikkormat camera-body sockets have a threaded collar surrounding the center electrical part of the socket. Some Nikon flash cords have a connector that makes electrical contact with the center part of the socket and is held securely in place by a threaded ring which screws into the outer part of the socket on the camera body. Nikon threaded sync sockets will also accept push-in PC-type connectors but without the security of the threaded mechanical connection.

To mount a flash unit with the ISO foot onto an F or F2 camera, use AS-1 Flash Unit Coupler.

To mount a flash with the special F-2 foot onto a camera with an ISO hot shoe, use AS-2 Flash Unit Coupler.

FLASH BULBS

Flash bulbs come in various sizes and types. All work by burning metal foil in an oxygen atmosphere within the glass bulb. Because the light is caused by combustion inside the glass envelope, light intensity increases from zero as combustion begins. It reaches a peak value and then falls off as combustion ends.

The flash unit is fired or triggered by the shutter mechanism in the camera. For some flash-bulb types in some cameras, the shutter mechanism fires the flash and then waits for a specified time delay before it actually opens the shutter. This delay is to allow the flash bulb to get up to full brightness.

Flash bulbs are plugged into a holder with a reflector behind the bulb so most of the light is directed toward the subject. One type has a connector cord which is plugged into the flash sync connector on the camera body.

Another type of flash-bulb holder mounts directly on the camera hot shoe. Flash-bulb holders intended for use in a hot shoe require no other electrical connection except the one in the hot shoe. Some also have a sync cord so they can be mounted in an accessory shoe and cord-connected to the camera flash sync socket—also called *flash sync terminal*.

NIKON FLASH UNIT BC-7

This is a holder for flash bulbs, designed to mount directly on the special hot shoe of F and F2 camera

bodies. This shoe surrounds the film-rewind knob on the left side of the camera top plate. A special adapter, the Nikkormat Accessory Shoe, can be used to attach the BC-7 to other cameras with a conventional hot shoe or accessory shoe. The BC-7 can be connected to the camera with a special Nikon sync cord if necessary. The cord is 20cm long so the flash holder can be hand-held away from the camera if desired, remaining connected electrically through the sync cord.

A collapsible fan-type circular metal reflector can be unfolded behind the flashbulb to reflect more light toward the subject. Or, the fan can be left folded and the unit used as a *bare-bulb* flash. Indoors, bare-bulb flash gives softer and more diffused illumination because light from the flash-bulb travels in all directions and much of it reflects off room walls before illuminating your subject. Light from several directions at once makes shadows that are less dark and less distinct.

The flashbulb socket and the reflector can be pivoted upward so all or part of the light bounces off the ceiling before illuminating the subject. *Bounce flash* also gives softer shadows and more even illumination. Try it for portraits, either with flash bulbs or electronic flash.

ELECTRONIC FLASH

Electronic flash requires a high voltage, usually obtained from batteries through a voltage-multiplying circuit.

Electronic flash produces a color temperature of around 6,000 degrees Kelvin. They are generally considered to have the same photographic effect as daylight. Filters on the camera or over the flash unit can be used to alter the color if necessary.

Electronic flash units fire virtually instantaneously and reach full brightness immediately. Therefore no time delay is required. In fact, if there is a time delay, the electronic flash may be all over before the shutter gets open. To fire electronic flash with a focal-plane shutter, the switch in the camera is closed at the instant the *first* curtain of the focal-plane shutter reaches fully open—called *X synchronization*.

Electronic flash units are available which mount on the hot shoe and are triggered by the electrical contact in the shoe. Other types use a sync cord which connects to the sync terminal on the camera.

FLASH WITH A FOCAL-PLANE SHUTTER

When shooting with flash, a focal-plane shutter is at a disadvantage.

Exposure time with a focal-plane

shutter is measured from the instant the first curtain is *released,* to begin its travel across the frame, until the instant the second curtain is *released,* to begin its travel across the frame. When the first curtain reaches the end of its travel, the film frame is uncovered *as far as the first curtain is concerned,* so it closes the electrical contacts for X sync and fires the flash instantly.

If the second curtain is following too closely behind the first, at 1/500 second for example, part of the frame will already have been covered by the second curtain at the instant of the flash. The only part of the frame which could be exposed is the narrow slit between the two curtains.

To use electronic flash with a focal-plane shutter, a shutter speed must be selected so the first curtain reaches the end of its travel and then a brief moment passes before the second curtain *begins* its journey across the frame. During that brief moment, all of the frame is open to light and the flash occurs.

This means the exposure time selected on the shutter-speed dial must be slightly longer than the time required for the first curtain to travel across the frame. Horizontally moving shutters travel across the wide dimension of the frame—36mm. Vertical shutters travel across the narrow dimension of the frame—24mm.

Therefore vertically moving focal-plane shutters synchronize with electronic flash at faster shutter speeds than horizontal shutters. Depending on camera model, X-sync speed is 1/125, 1/80, or 1/60. These are the fastest shutter speeds at which the film frame is fully open to light from an electronic flash. You can use slower shutter speeds if you have reason to. At slower speeds, the second curtain waits even longer before starting across the frame, so electronic flash works OK.

GHOST IMAGES

Focal-plane shutters require exposures for electronic flash of 1/125 or longer, but the actual time of exposure due to the bright light of the

A ghost image can sometimes add drama to a photo made with flash. Short-duration electronic flash stopped motion of these volleyball players. Because shutter remains open after flash fires, moving ball made a blurred image due to room light. Photo by Josh Young.

flash is very much shorter—1/500 second down to as little as 1/50,000 second or less in some cases. If there is enough illumination on the scene from sources other than the flash to cause some exposure during the full time the shutter is open, then there are *two* exposures. One short-time exposure due to the flash and another longer-time exposure due to the ambient light on the scene. If the subject moves during the time the shutter is open, or if the camera moves, the image due to ambient light will not be in register with the image due to flash. This can cause a blur or a faint "echo" of the subject on the film.

With a motionless subject, the cure is to hold the camera still during the entire period of exposure. With a moving subject, there isn't much you can do about it except try to shoot so the flash is the dominant light and the other light on the subject is too dim to make a visible image on the print. Or else pan with the subject. *Pan* means follow motion by moving the camera.

SYNCHRONIZING WITH FLASH

Nikon and Nikkormat cameras have a hot shoe and a threaded flash sync terminal on the camera body. The hot shoe is switched on by insertion of a flash unit and is otherwise "cold." The camera-body sync terminal is always "hot."

When the camera closes the internal contacts to fire a flash, the circuit to the hot shoe and the circuit to the camera-body terminal are both closed simultaneously. If you have an electronic flash mounted in the hot shoe, it may be possible to get a mild electrical shock from the camera-body terminal if it is uncovered and you manage to get your finger on or near the center contact of the terminal. For this reason, Nikon and Nikkormat cameras are factory equipped with a threaded plastic cover for the camera-body flash terminal. You should keep the terminal covered except when it is in use.

Firing Two Flashes Simultaneously—Because both flash terminals are energized simultaneously, you can fire one flash in the camera hot shoe and another that is cord-connected to the camera-body terminal. This doubles the electrical load on the internal contacts. Firing more than two flash units simultaneously, by making multiple connections with flash cords, is not recommended.

Accessory flash "slave" units are

available to fire multiple flash units without multiple electrical connections to the camera. These units sense the light output of the first flash, which is mounted in the camera hot shoe, or cord-connected to the camera. When the light output is sensed, the slave unit triggers a second flash unit that is connected only to the slave. Additional slaves and flash units can be used, if needed.

Sync Delay—All electronic flash units require X sync, but flashbulbs require a time delay between firing the flash and opening the camera shutter. The optimum delay varies among flashbulb types, but you will get much of the flashbulb light through the shutter and onto the film even if delay is not exactly correct. Firing delay for flashbulbs is indicated by code letters:

> F—fast
> M—medium
> MF—medium fast
> S—slow

Nikon and Nikkormat cameras operate with X sync on both hot shoe and camera-body sync terminal when the shutter-speed dial is set to the correct speed for electronic flash. At other shutter speeds, the flash sync may be either X or M, depending on camera model. A table is published for each model showing which shutter speeds can be used with electronic flash and various flashbulbs.

Flash Synchronization tables are given for all cameras discussed in Chapter 13.

FP Flashbulbs—A special flashbulb that can be used at certain shutter speeds is called *FP* where the initials stand for *Focal Plane*. Designed for use with focal-plane shutters these bulbs make a nearly uniform amount of light for a relatively long time. The idea is to turn on the light before the focal-plane shutter starts to open and keep the light on until the shutter is completely closed. Therefore the focal-plane shutter doesn't even "know" you are using flash. As far as the shutter is concerned, you are using a continuous light source. The main advantage is to allow use of flash at high shutter

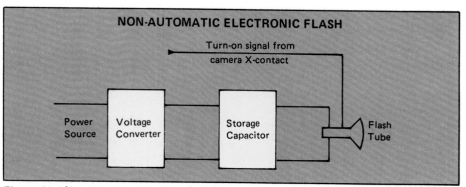

Figure 11-1/A non-automatic electronic flash is turned on by a signal from the camera. It makes light until the storage capacitor discharges to the point where the flash tube extinguishes.

speeds with a focal-plane shutter. Generally, FP flashbulbs can be used with any shutter speed and any firing delay except X sync. The FP bulb will extinguish during exposure intervals longer than 1/60 second but enough light will have reached the film to make the exposure.

HOW A NON-AUTOMATIC ELECTRONIC FLASH WORKS

You don't have to be an electronic whiz to understand the basic operation of an electronic flash. Figure 11-1 shows a power source feeding a voltage converter. The power source is usually batteries, but for some equipment it is AC power from a wall socket.

Either way, the electrical voltage needed to operate the flash tube is higher than the supply or source voltage so a special circuit converts it to a higher voltage. This high voltage is accumulated in a storage *capacitor*.

An electrical capacitor behaves very much like a rechargeable battery. The capacitor charges up to the high voltage from the voltage converter, then suddenly dumps its charge into the flash tube to make the bright light.

A signal is required to tell the capacitor to dump its charge and cause the flash. This signal comes from the X-sync contacts in the camera. The signal wire in the drawing is shown connected to the flash tube itself, and you can think of it as turning on the flash. The flash turns itself off when the storage capacitor

has discharged.

Once the flash has been fired, it cannot be operated again for a period of time needed to charge up the capacitor again, called the *recycle* time. It can vary from a short time such as one second up to a relatively long period such as 30 seconds. When batteries are the source of electricity for the capacitor, recycle time depends on the battery condition. If it is fully charged, recycle time is short. As it approaches discharge, recycle time takes longer.

With rechargeable batteries, longer recycle time tells you the batteries need charging. The flash may have an external charging adapter and an AC line cord for battery charging, or the adapter may be built into the unit. The specs on most accessory flash units give you an idea of the time needed to put enough charge back into the batteries to expose another roll of film. If you use flashlight-type non-rechargeable batteries, consider alkaline cells. They give many more flashes than the common variety, before recycle time becomes excessively long or the unit won't recycle at all.

The type of capacitor used in electronic flash units may deteriorate if left a long time without an electrical charge. Just before you put the flash away after shooting, it's a good idea to let it recycle so it is ready to shoot, but don't fire the flash. That allows you to store it in a charged condition. In long storage it is beneficial to turn on the flash unit and recharge the capacitor about once a

month, returning it to storage in a charged conditon.

Most electronic flash units have a signal light, or ready-light, which glows when the capacitor has enough charge to operate the flash. If you operate the flash as soon as the signal light turns on, light from the flash will be less than if you wait a while longer and allow the capacitor to accumulate more charge. You may get approximately double the amount of light from the flash if you wait an additional length of time equal to the recycle interval. In other words, if it takes 2 seconds for the ready-light to come on, wait another 2 seconds and get about one step more light—if the batteries are in good condition. If they are nearly discharged, the additional light after waiting may be only a small amount more.

Non-automatic electronic flash and flash bulbs are similar in one important way. Each time you pop a flash bulb, you expect it to make the same amount of light as any other flash bulb of the same type—the amount of light is constant and repeatable. Similarly, each time you fire a non-automatic electronic flash unit, you expect it to make the same amount of light as it does every other time you flash it. Generally it will do that if the batteries are in good condition and if you wait long enough for the capacitor to be fully charged. *Automatic* electronic-flash units, discussed later, *do not* make the same amount of light each time they flash. That's why we must be careful to distinguish between auto and non-auto electronic flash units in this discussion.

GUIDE NUMBERS

Guide numbers help you set camera exposure controls properly when using flash bulbs or non-automatic electronic flash units. Higher guide numbers indicate more light from the flash.

Suppose a non-automatic flash or flash bulb makes enough light to expose a subject at a certain distance from the camera. This implies a certain film speed, aperture and shutter speed.

Starting with that situation, the light source could be moved farther from the subject and proper exposure could still be made by opening the aperture to compensate for the reduced amount of light.

Variation of light on the subject due to a changed distance between flash and subject is assumed to follow the inverse-square law. Doubling the distance between light source and subject should reduce the amount of light by a factor of 4.

The aperture change to get the same exposure as before should be opening up two steps.

Now let's use some numbers to illustrate that. Suppose the light is 5 feet from the subject and a suitable aperture is f-16. Please notice that the distance in feet multiplied by the f-number is: 5 x 16 = 80.

Double the distance to 10 feet and open up the aperture two stops to f-8. The product of distance times f-number is still 80.

All combinations of distance and f-number which produce the same exposure with that flash will have the same product—80 or whatever the number turns out to be. That number is called a *guide number*.

Obviously, guide numbers will be different for different film speeds because with faster film, you need less light on the subject. Shutter speed may be important. With bulb flash, which happens over a fairly long interval of time, shorter shutter speeds admit less of the total light produced by the flashbulb. Therefore guide numbers for flashbulbs are specified for a certain film speed *and* a certain shutter speed.

With electronic flash, film speed is important but shutter speed is not because the entire flash happens in a time interval much shorter than the shutter speed you are allowed to use with a focal-plane shutter.

A non-automatic electronic flash may have a guide number of 60 feet for ASA 25. Here's how to use guide number (GN) to find the f-stop you should use:

Tom Monroe used flash to balance inside and outside light. Without flash or other additional light, there were two choices: Expose for the cat and the background would be washed out. Expose for the background and the cat would appear in silhouette.

$$f\text{-number} = \frac{GN}{Distance}$$

If the guide number is 60 feet, and you are shooting at a distance of 15 feet from the subject, the f-number you should use is $60/15 = f$-4.

If you move closer, say 7.5 feet to keep the arithmetic simple, the new aperture is $60/7.5 = f$-8.

Notice that a guide number includes distance between light source and subject. If the distance is measured in feet, a certain guide number results. If measured in meters, a different guide number results. Unless you know if the number is based on feet or meters, you can miss exposure by working at the wrong f-stop.

Sometimes guide number is specified only for one film speed. If you decide to shoot with film of a different speed, you should know how to convert the guide number. Let's use the terms *New GN* and *New ASA* to mean the GN and film speed you intend to use. *Old GN* and *Old ASA* mean the published guide number.

$$New\ GN = Old\ GN \times \sqrt{\frac{New\ ASA}{Old\ ASA}}$$

Sometimes the film speeds make the calculation easy. Suppose the guide number as stated in the specs is 60 feet with ASA 100 film. You intend to shoot with ASA 400 film.

$$\text{New GN} = 60 \text{ feet} \times \sqrt{\frac{400}{100}}$$

$$= 60 \text{ feet} \times \sqrt{4}$$

$$= 60 \text{ feet} \times 2$$

$$= 120 \text{ feet}$$

If you switch to ASA 400 film instead of ASA 100 film, the guide number doubles. You can place the flash at double the distance *or* close down the aperture by two steps.

Guide numbers for electronic flash units are quoted at ASA 25 or ASA 100 or some other film speed. The flash unit "looks better" when a higher film speed is used as the base—because the guide number is higher. If you are shopping for an electronic flash, compare guide numbers based on the same film speed.

Guide numbers are just that—a guide. They are based on photographing people indoors because more flash is used for that purpose than any other. Some of the light from the flash bounces off ceiling and walls and then illuminates the subject while the shutter is still open. If you use flash outdoors, you will lose the light that would otherwise bounce off ceiling and walls and the picture may be underexposed. Try figuring *f*-stop with the guide number and then opening up one-half stop or more for outdoor locations.

ESTABLISHING YOUR OWN GUIDE NUMBERS

Because guide numbers are based on average conditions, the published guide number for your flash may not work well under your shooting conditions—such as a room with a high dark ceiling.

You can figure and assign your own guide number to your equipment and shooting environment by testing—remember that a guide number is just the product of distance and *f*-stop which gives a good exposure at a specified shutter speed.

A handy shooting distance for the test is 10 feet from the subject. Use several different *f*-stops above and below the one suggested by the published guide number. Make notes or have the subject hold a card showing the *f*-stop for each exposure. After processing, pick the one you like best. The guide number for that situation is the *f*-stop multiplied by the best distance used. If you like *f*-8 best, and you are testing at 10 feet, the guide number is 80 feet. Use color slide film for the test.

LIGHTING RATIO

A thing to worry about with artificial lighting, and sometimes outdoors, is the difference in the amount of light on the best-lit areas of the subject and the amount in the worst-lit areas.

Direct sunlight from above or the side can spoil a portrait by casting deep and well-defined shadows of facial features. This effect can be reduced by using reflectors to cast some light into the shadows, or using flash to *fill* some of the shadowed areas with more light—called *fill lighting*.

If you are using more than one source of light, you can usually control some or all of them to adjust both the amount of light and the directions of illumination on the subject. In portraiture and other kinds of photography, arrangement of lighting is important for artistic effect.

For a portrait, suppose there are two light sources such as flood lamps or flash. With the subject looking straight ahead, one light source is to the left at an angle of 45 degrees. Let's say this source puts 4 units of light on the subject.

Another source, at a 45-degree angle on the opposite side only puts one unit of light on the subject. This gives a *lighting ratio* of 4 to 1— which is simply the ratio of the two amounts of light.

On the subject, there are *three* values of light. Where illumination is only from the brighter source, the amount of light is 4 units. Where it is only from the less-bright source, which will be in the shadows cast by the brighter source, the illumination is one unit. Where both lights overlap

and both illuminate the subject, the total light is 5 units. The *brightness ratio* of 5 to 1 is only a fraction more than two steps, usually no problem for b&w film. It is often recommended as the upper limit for brightness variation in color photography because of the nature of color film.

Color film has two jobs to do. It must record differences in scene brightness, just as b&w film records the different brightnesses along the gray scale. In addition, it has to record color information.

A simple way to think about that is to remember that brightness gets on the film first. After that color is introduced by chemical processing. When there is conflict between brightness and color, color loses.

There are no firm rules, but by restricting the brightness ratio with color films as shown in the table above, you can be pretty sure of recording details in both shadows and highlights. These ratios allow "room" on the film for both brightness and color variations. Very bold and vivid colors may require even smaller brightness ratios.

With color, the colors themselves produce visual differences between objects, so we don't have to rely as much on brightness differences.

HOW TO CONTROL LIGHTING RATIO

If the lights are floods or flash, you can control the brightness of each source by selecting sources of different light output and you can control the amount of light from any source by adjusting the distance from source to scene. Sometimes this is more difficult in the real world than on paper.

With floodlights, you can confirm lighting ratio by measuring at the scene with a hand-held meter, or by moving your camera up close so it only "sees" parts of the scene. Measure the brightest part and the darkest part of interest.

With lights of the same intensity, control lighting ratio by moving one farther back. If they are located so they put the same amount of light on the scene, and then one is moved back to double the distance, the light from that one drops to one-fourth its former value due to the inverse-square law.

Using Flash for Fill Lighting— When using flash, you have to *predict* the amount of light on the scene when the flash happens. The simplest way is to use the guide number to figure *f*-stop and then consider the *f*-stop as an indicator of the amount of light. If you are using two flash units to make a portrait; one is located so it requires *f*-4 and the other requires *f*-8 to produce full exposure; you will get a 4-to-1 lighting ratio by setting the camera at *f*-8.

Remembering that *f*-8 is 2 steps away from *f*-4, and each step doubles the amount of light, settings of *f*-4 and *f*-8 represent a lighting ratio of 4 to 1. The usual rule is, set camera exposure controls for the brightest light. The flash unit which needs *f*-8 for proper exposure is obviously brighter than one which can use *f*-4. Therefore you set to *f*-8 to avoid overexposure by the brighter source.

This is generally true of fill lighting whether continuous light or flash.

USING FLASH IN SUNLIGHT

A special case of fill lighting with flash is when the main light is the sun.

With the shutter at the speed required for flash, and sunlight on the subject *at an angle which makes shadows,* the camera exposure setting should be for the main light source—the sun. Then locate the flash at the right distance from the subject so it gives the desired lighting ratio.

Here's a procedure for using flash fill lighting in sunlight.

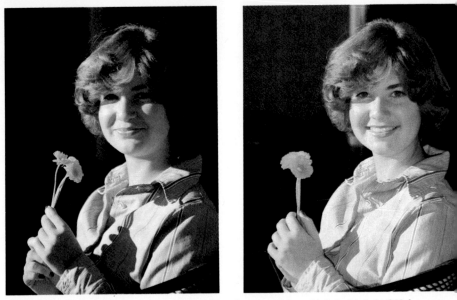

Afternoon sunlight casts strong shadows in photo at left, which I think is OK for some pictures. You can use flash to *fill* the shadows, as shown at right, so they are not as dark. Fill flash should not eliminate shadows entirely. If it does, you have made a photo with flash rather than a photo combining sunlight and flash.

1. Set the camera shutter speed as required for use with flash—1/60, 1/80, or 1/125 depending on camera model.

2. Focus, meter the subject and set aperture for normal exposure using sunlight. Notice the distance from the camera location to the subject, either by reading the distance scale on the lens or actual measurement. If the film speed is too fast to allow using the slow shutter speed required for flash sync, then you'll have to use a neutral-density filter or switch to a slower-speed film.

3. With the guide number of the flash for the film speed you are using, calculate flash *f*-stop for the distance between camera and subject. For a 4-to-1 lighting ratio, that *f*-stop as calculated should be two stops larger than the camera setting.

4. If it is not 2 stops larger, use the guide number to figure distance between flash and subject which will give the desired aperture.

5. Put the flash at that distance. Remember about flash outdoors being less effective than flash indoors where ceiling and wall reflections help. Fudge the flash forward a little ways to compensate. That's not scientific but it's practical.

6. Shoot at the camera setting you made for sunlight, *not* the larger aperture you calculated for normal exposure with the flash.

If you have the type of flash which connects to the camera by a sync cord, you can locate the flash away from the camera by using a long cord.

If you cannot remove the flash from the camera because it is a direct-connected hot-shoe type, then you can't use a different distance for flash and camera. It is always possible to find some distance that will give the lighting ratio you want, but that may not give good composition of the picture.

When your calculation indicates that the flash should be moved back to reduce its light, but you can't move it back independent of the camera, you can reduce the amount of light coming from the flash.

With electronic flash which doesn't get hot, you can cover about half of the window that lets light out and about half of the light will come out—a reduction of one step.

A practical rule is, one thickness of pocket hankerchief or facial tissue over an electronic flash cuts the light by one step. Two thicknesses—two steps. Don't do this with flash bulbs.

Some electronic flash units come with neutral-density filters which fit over the flash lens.

PROBLEMS WITH FLASH

Flash on camera very close to the

for Polarizer - or flleptender

axis of the lens can cause "red eye" when using color film. Light rays from the flash enter the subject's eyes and reflect back to the lens from the retina of the eye. The light will be colored red from the blood vessels in the eye. To avoid this, pocket cameras come with an extension which raises the flash bulb a few inches above the lens. Most SLR cameras mount a flash high enough to avoid this problem, but it can happen.

To avoid red-eye problems: Brighten the room to reduce the size of the pupils in your subject's eyes. Ask the subject not to look directly into the lens. Don't mount the flash on the camera—locate it away from the camera and use a flash sync cord.

Flash on camera produces "flat" lighting because it is usually aimed straight at the face, eliminating all shadows. The exception of course is when the flash is used for fill lighting.

When people stand close to a wall while being photographed with flash on camera, there are often sharp shadows of the people visible on the wall behind them.

If the flash connects to the camera with a sync cord, and the cord is long enough, it is preferable to hold the flash high and to one side. This casts shadows similar to those caused by normal overhead lighting and the effect is more realistic.

Also, a flash held high tends to move shadows downward on the wall and they may not be visible in close "head shots" of people.

The light from a single flash unit falls off drastically with increasing distance. If you photograph a group of people at different distances from the flash, and make a guide-number calculation for the middle of the group, people nearest the camera will be overexposed, those in the center will be OK and those in the background will be underexposed.

Using guide numbers to find f-stop is a bother, particularly when you are shooting in a hurry. The bother can be eliminated by using an *automatic electronic flash.*

BOUNCE FLASH

A technique used to avoid flat lighting and harsh shadows from a single flash is to aim it at the ceiling. With a flash detached from the camera, just point it at an angle toward the ceiling so the bounced light will illuminate your subject. Some flash units intended for hot-shoe mounting have a swivel head so the light can be bounced.

This has all the advantages of holding the flash unit high plus the added diffusion of the light from a broad area of the ceiling. If the ceiling is colored, it will also color the reflected light and change skin tones in a color photograph.

To bounce with non-automatic flash, the distance to use in the guide-number calculation is from flash to ceiling and then ceiling to subject. You must also allow for light absorption by the ceiling which can require opening up one or two steps larger than the guide-number calculation suggests. A flash must be more powerful—meaning make more light—to be used this way but it is a much-improved method of taking flash pictures indoors.

OPEN FLASH

A technique that is sometimes useful could be called "open the shutter and then pop the flash," but that long name is shortened to *open flash.* Most electronic flash units have a button on the case that will fire the flash whether or not the flash is connected to a camera. The technique is to put the camera on B; open the shutter and hold it open; fire the flash using the Open Flash Button; and then close the shutter. If there isn't much light on the scene, exposure depends primarily on light from the flash. If is dark enough, you can leave the shutter open quite a while and use the flash more than once—to illuminate different parts of the scene or just to get more light.

AUTOMATIC ELECTRONIC FLASH

Automatic electronic flash uses a light sensor to measure light reflected from the subject and turn off the flash when enough light has been measured for correct exposure. Nikon offers two types: Conventional automatic electronic flash uses a light sensor built into the flash to measure light from the scene. The light being measured goes directly to the flash and the *flash turns itself off* when enough light has been measured. In this book, I will refer to this type as self-regulated automatic flash.

You already know about the other type. With certain dedicated flash units and an F3 camera, light from the scene is measured inside the camera at the surface of the film. When exposure is correct, the *camera turns off the flash.* The camera uses the same light-measuring system for ordinary photography without flash and to control exposure with certain flash units. A common name for the built-in metering system in SLR camera is Through-The-Lens metering (TTL) because the meter measures light after it has come through the lens. When the camera meter is used to control light output of a flash, it's the TTL meter that does it, so Nikon refers to this as TTL flash control.

Both types of automatic flash units have constant brightness when turned on, but vary the time duration of the flash to produce a desired amount of *exposure* on the film.

How Self-Regulated Automatic Flash Works—The light-measuring sensor of most self-regulated flash units is mounted in the housing, so it faces the scene being illuminated by the flash.

A turn-on signal comes to the flash tube from the camera, as shown in Figure 11-2. The flash tube is turned on and starts making light. The light sensor measures exposure and generates a turn-off signal.

Specifications for different distance ranges, camera f-stops and film speeds seem complicated because there are many different combinations of those three variables. The data is usually presented to the user by rotating calculator dials on the automatic flash.

You set film speed into your camera and also into the calculator on the automatic flash. Then the calculator

on the flash unit displays an f-stop for the camera along with a maximum shooting distance and sometimes a minimum distance even if not shown on the dials. Check the flash instruction booklet. Some say the minimum distance is 10% of the maximum distance.

If you set the camera lens for the f-stop recommended by the flash-unit calculator dial, you can shoot automatically anywhere within the specified distance range without changing f-stop of the lens.

Suppose the distance range shown by the calculator is from 2 to 20 feet, and the f-stop is f-4. If the subject is at the maximum distance in the range, the automatic flash will operate as long as it can. If you shoot at a shorter distance, the sensor on the flash receives more reflected light from the subject and decides that exposure is correct with a shorter time duration of the flash. It turns off sooner. At the shortest range—2 feet—the unit turns back off again as fast as possible. The exposure time will be extremely short, such as 1/30,000 second.

Some automatic flash units allow you to choose from two or more f-stops at the camera and make an adjustment to the sensor of the flash so it will give correct exposure. Choice of f-stop gives you some control over depth of field.

These additional f-stops don't come free, even though it seems so at first. Each smaller aperture size allowed by the flash calculator dial is accompanied by a shorter maximum working distance of the automatic flash.

A choice of f-stops expands the versatility of the electronic flash but complicates the display of information on the calculator.

Some self-regulating flash units are built with swivel heads to allow bouncing off the ceiling. The sensor does not swivel but continues to look where the camera does—assuming the flash is mounted on the camera. Thus the flash compensates automatically for light loss due to bouncing and will not shut off until the proper amount of exposure is received by the sensor looking at the scene.

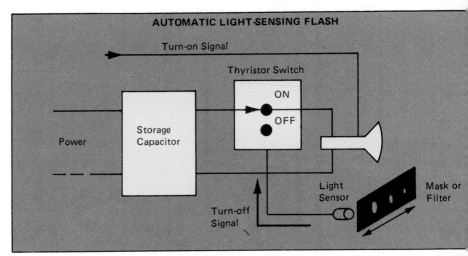

Figure 11-2/A light-sensing automatic flash is turned on by the camera, then turns itself off when it has measured what it "thinks" is the right amount of light reflected from the scene.

Some flashes are detachable from the camera but have a separate sensor unit that mounts on the camera. This allows you to point the flash in any direction and hold it anywhere. Meanwhile the sensor mounted on the camera still does its job of keeping the flash on until it thinks the film got enough exposure.

Automatic flash units normally have one position of the control to turn off all light from the sensor. This allows the flash to run for maximum time duration at every firing. It puts the flash on non-automatic or manual operation. Then you use it with its guide number just like any other non-auto flash.

TTL AUTOMATIC FLASH

With a conventional self-regulating flash, the light sensor in the flash usually does not view the same amount of scene that the lens is photographing, because cameras use lenses with different angles of view.

Figure 11-3 is a reminder. It shows light from an SB-12 flash reflecting off the subject and entering the F3 lens. The light falls on the film and some is reflected toward the SPD sensor in the bottom of the camera. When the sensor measures enough light for correct exposure, it generates an electrical signal that turns off the flash.

Nikon TTL flash control automatically adjusts the viewing angle because the sensor controlling the flash receives light through the picture taking lens. Another ambiguity with conventional self-regulating flash is the sensor measuring pattern which may not be the same as the camera. With the TTL system, there is only one pattern.

A major advantage of metering flash behind the camera lens is that the range of aperture settings is not restricted. You can use any aperture setting on the lens! The maximum working range of the flash is reduced at smaller apertures, but that's true even with manual flash.

Nikon flash units that can be used with TTL control by the F3 camera are the SB-11 and SB-12. Both are discussed later in this chapter.

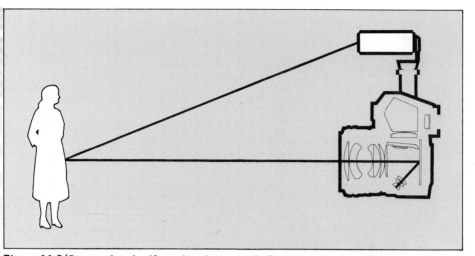

Figure 11-3/Conventional self-regulated automatic flash units use a sensor on the flash to measure flash light returned from the scene. The Nikon F3 uses a different method. As shown in this drawing, light from the flash is reflected by the subject, enters the lens and exposes the film. The light sensor in the F3 is in the bottom of the camera body, facing backwards toward the film. This sensor measures light on the film and shuts off the flash when the measurement indicates correct exposure.

Q∆RAE. What is effect of this operation if flash is used outdoors in free flash situation, in automatic mode, with subject in Zone of distances for aperture set but not at maximum distance in the Zone (which is the correct distance for free flash in manual mode)? Must test. See p 142

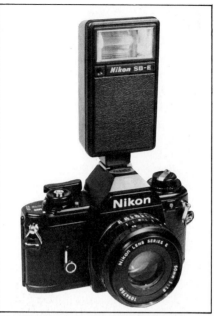

The SB-E has special features with the EM and FE. It can be used as a conventional self-regulated electronic flash with any camera that provides X-sync to a conventional ISO hot shoe.

ENERGY-SAVING AUTO FLASH

The first automatic flash units on the market switched off the flash tube to control exposure time but did it in such a way that the entire electrical charge in the capacitor was used up no matter how short the time duration of the flash. This had the advantage of controlling flash duration but wasted electrical energy.

Recent developments in auto flash use a switching circuit which does two things: It shuts off the flash at the desired instant and also "turns off" current flow from the capacitor so any electrical energy not used to make light is saved for the next flash. The word *thyristor* and the phrase *energy saving* are sometimes used to identify this type of flash. An energy-saving flash unit is preferred because the battery charge lasts longer and makes more flashes. Also, when all of the charge is not taken out of the capacitor by one flash, recycle time is shorter because only the energy used must be replaced.

Nikon also uses the words *Silicon*

Control Rectifier and *series wiring* to identify energy-saving automatic flash units.

NIKON ELECTRONIC FLASH UNITS

Other names for electronic flash include *strobe lights* and *speedlights. Nikon uses speedlight* and offers several models, all energy-saving automatic types, but with different light-power and different operating features. See the table at the end of this chapter for a comparison of specifications.

Speedlight SB-E—Introduced with the Nikon EM camera, this flash is a special "dedicated" unit which means it is primarily intended for use with certain models and has special features when so used. It is a self-regulating automatic energy-saving flash with no manual non-auto setting.

Maximum capability of the SB-E is when mounted in the hot shoe of the EM. In that application, with the EM camera set to AUTO, the flash sets the correct flash sync speed in the camera, 1/90 second, and controls

an LED in the viewfinder which serves as a ready-light or a warning light either to help you select correct aperture or to warn you of improper procedures. In this mode, you can select one of three different lens apertures, depending on film speed.

Because these special features of the SB-E are closely tied to the operational features of the EM camera, this application of the flash is discussed in detail in Chapter 13 with the EM.

There is only one control on the SB-E: a three-position switch labeled FE-FM, OFF, and EM. The center position is off—which is equivalent to removing the flash. The camera operates just as though the flash were not mounted in the hot shoe.

To set up for operation with the EM, move the switch to EM. For use with the FM or FE, move the switch to FE-FM.

SB-E with FE—With the camera set to AUTO the camera is automatically set to a shutter speed of 1/90 for electronic flash synchronization when the flash ready-light is lit. Set lens aperture for the film speed you

are using, according to the table on the back of the SB-E. When the ready-light on the flash and in the viewfinder glow, the flash is charged and ready to fire. Exposure control is automatic, by the light sensor in the flash.

With the FE set for manual shutter-speed control, exposure control is automatic using the sensor in the flash. However you must select a shutter speed of 1/125 or slower for electronic flash sync. If the camera is set for a shutter speed faster than 1/125, the LED lamp in the camera viewfinder will blink as a warning.

When set to M90 or B, the camera viewfinder LED serves as a ready-light only, with no warning function.

SB-E with FM and Other Cameras—The flash works as a conventional light-sensing automatic. You select 1/125 second or slower and set aperture according to the table on the back of the flash.

SB-E Operating Distance Range—In all modes of operation, the range is 0.6 to 3 meters (2 to 10 feet).

SB-4 Speedlight—The SB-4 is designed to mount in a conventional ISO hot shoe.

It's self-regulating energy-saving, with one auto and one manual setting. A special Sync Cord SC-8 is supplied with the flash and is used to connect the flash to a sync terminal on the camera body if the flash is not mounted in a hot shoe. In the auto position, only one f-stop is available for each film speed.

A calculator disc on the back of the

The SB-4 is a conventional self-regulated automatic flash with a manual setting.

flash unit is used during both auto and non-auto operation. If the flash is set to automatic, the calculator shows which f-stop to use for each film speed, with maximum shooting range constant at 4 meters.

A ready-light on the back of the unit lights up when the capacitor is charged and ready to fire. A Test Firing Button will fire the flash when you press the button, even if the flash is not connected to a camera. This button is also called an Open Flash Button because you can also use it for that purpose.

SB-5 Speedlight—This is a larger, more powerful unit of the type commonly called *handle-mount*. In some

Nikon literature, it's called *side-mount*. The flash head is on top of a round handle which holds the batteries. Guide number with ASA 100 film and manual operation is 32 meters at FULL power setting. When used on manual, you can choose full power or two other power settings: 1/4 gives you a guide number of 16 meters and MD (Motor Drive) gives you a guide number of 11 meters with ASA 100. These guide numbers change with different film speeds, but the calculator dial on the back of the flash shows them in both feet and meters.

For self-regulating automatic operation, a remote light sensor, Sensor Unit SU-1, is required. This sensor mounts on the camera end of a special connecting cord, Extension Cord SC-9, which in turn attaches directly to an F2-type hot shoe or to a conventional hot shoe through adapter AS-2. The extension cord acts as a sync cord between flash and hot shoe.

When used, the remote sensor controls the flash and has a switch position to select manual or automatic operation. If the remote sensor is not used, the flash is always on manual operation. With the sensor, three f-stops are available for each film speed.

The SB-5 attaches to a camera by a mounting bracket which attaches to the tripod socket in the camera baseplate. Because the bracket does not make a hot-shoe connection, a sync cord is required.

SB-10 is designed for the FE but will work on any camera with an ISO hot shoe.

The flash bracket has a quick-disconnect feature so you can remove the flash to hand-hold it at a distance from the camera, or use it for bounce flash. The bracket also allows bounce flash without removing the flash unit. By partially operating the quick-disconnect controls on the bracket, you can rotate the flash unit so it points up or down as desired. Rotation is in steps of 30°, with secure mechanical locking at those intervals.

A special feature of the SB-5 is the ability to fire flashes repeatedly, in synchronization with a motor drive. It will operate up to one frame per second at FULL power. At the fastest motor-drive speed, when set either to 1/4 power or the MD setting, it will operate up to 3.8 frames per second.

Speedlight SB-9 is automatic only. Scales on back show two *f*-number settings for each film speed from ASA 25 to ASA 400. Lower scale is an extension of upper scale. Example: If you use ASA 100 film, you can choose *f*-2.8 or *f*-4. Distance ranges are color-coded and shown below the scales.

The unit can be operated with a dry-cell battery pack in the handle, or a NiCad battery which is recharged by Quick Charger SH-2. Also available is an external Battery Pack SD-4 which plugs into a connector on the flash unit.

The SB-5 uses Ready-Light Adapter SC-4 to operate the flash ready-light in the Photomic viewfinder eyepiece. For other cameras, an eyepiece ready-light can be provided by Eyepiece Pilot Lamp SF-1. There is a built-in ready-light on the back of the flash head, and a separate Open Flash Button.

SB-5 is a powerful bracket-mounted flash unit that attaches to the camera through a quick-disconnect bracket. For non-automatic operation, it uses a sync cord connected to the camera sync terminal. For automatic operation, use sensor SU-1.

Making Connections—When using a sync cord, connect it first to the flash, then to the camera. When inserting a flash unit into a hot shoe, sometimes the flash will fire. This is normal and should cause no concern. When the flash charges up again, it will operate normally. Never install a hot-shoe type flash unit into an accessory shoe with a metal surface that may make electrical contact in the flash-mounting foot. This can short out the flash and cause internal damage. When the electronic flash unit is first turned on, and after each flash, you should hear a faint humming sound that rises in pitch as the unit recycles. If you don't hear the sound, the batteries are discharged and should be replaced or recharged.

SB-9 Speedlight—Small and light enough to carry in a shirt pocket, the SB-9 is self-regulating automatic only, with two operating ranges: 0.6 to 5 meters and 0.6 to 3.5 meters. These ranges are color-coded on the calculator. For each film speed, you have a choice of two aperture settings, depending on where you have set the sensitivity control. For example, at ASA 25, you can shoot at *f*-1.4 with a maximum range of 5 meters, or at *f*-2 with a range of 3.5 meters. With higher film speeds, the max ranges stay the same but you can use smaller apertures. At ASA 400, for example, you can use either *f*-5.6 or *f*-8. Beam angle is 56° x 40°, which covers the field of view of a 35mm lens.

The SB-9 is equipped with an ISO mounting foot; a ready-light and a separate Open Flash Button. A special sync cord, SC-10, adapts the flash for use on cameras with an accessory shoe that does not have a hot-shoe electrical contact to fire the flash.

SU-1 is a light sensor that makes the SB-5 automatic. It can be mounted on the side of the flash head or on the camera hot shoe using accessory Extension Cord SC-9 which also supplies sync to the flash unit, so no other sync cord is required. With the SU-1 mounted on the camera, bounce flash is automatic as long as you stay within automatic operating range.

SB-10 Speedlight—A self-regulating energy-saving flash with a sensitivity control that gives two *f*-stops for each film speed on auto and a manual non-auto setting with a guide number of 25 meters at ASA 100. The setting is shown by a moving pointer on the side, adjacent to the calculator dial.

On manual, the calculator dial gives pairs of *f*-numbers and shutter speeds for different film speeds. On automatic, the dial shows a maximum shooting range for each of the two *f*-stops.

At higher film speeds, maximum shooting distances remain the same but you can use smaller aperture at each distance. Minimum shooting distance on automatic is 0.6 meter at all film speeds.

With the FE and EM, some special features of the SB-10 come into use.

When the SB-10 is turned on and ready to fire, it turns on a ready-light on the back of the flash unit which also serves as an open-flash button. In addition, the flash turns on a ready-light built into the viewing eyepiece of the FE or EM cameras.

When the SB-10 is mounted in the camera hot-shoe and both are turned on with the camera set for automatic, the FE or EM is automatically switched to the mechanical shutter speed of 1/90. Thus you can flash without switching the camera to non-auto. If you turn the flash off, the camera reverts to normal operation even if you leave the flash on the camera.

If the FE is set for non-auto, you must select a shutter speed suitable for electronic flash—1/125 or slower. If you select a faster speed, the ready-light will blink until you choose an allowable shutter speed.

If the EM is set for non-auto, it must be on M90 using a mechanical shutter speed of 1/90 second, or on B with the operator controlling the shutter. Either way, the flash ready-light will glow when the flash is ready to fire; it will not blink; and the flash sensor will control exposure by the flash.

Sync cords SC-5 (15cm), SC-7 (25cm), and Coiled Sync Cord SC-6

(1m) can be used to connect the SB-10 to camera-body sync terminals. Wide-Flash Adapter SW-2 changes the flash angle from the normal 40° X 56° which covers the angle-of-view of a 28mm lens. Use of SW-2 reduces the non-auto flash guide number to 18 meters at ASA 100.

SB-12

The SB-12 is dedicated to the F3 camera. It has a special mounting foot with three electrical contacts and fits only on the F3 hot shoe. It's an automatic energy-saving flash using TTL control by the F3. It also has a manual setting with guide number which you use the same as any other manual flash.

Guide number is 25 meters at ASA 100. Beam angle is 56° x 40° which covers the field of view of a 35mm lens. An accessory SW-4 Adapter widens the beam to 67° x 48° which covers the field of view of a 28mm lens. Using SW-4 reduces the ASA 100 guide number to 18 meters.

On the back panel is an On-Off switch, Auto-Manual switch, ready-light, open flash button, and sync connector for a PC cord.

With the F3 shutter-speed control on AUTO, turning on the SB-12 automatically sets the F3 to the X-sync shutter speed of 1/80 second, whether the flash ready-light is lit or not. If the F3 is set for manual with the shutter-speed dial on a *numbered* speed of 1/125 or faster, the flash switches the camera to 1/80. If the shutter speed is 1/60 or slower, the flash allows that speed to be used. At the B and T settings, the flash does not control shutter speed. This paragraph applies whether the SB-12 is set to automatic or manual operation.

The F3 has a flash ready-light visible in the viewfinder which duplicates the action of the ready-light on the flash. If the flash is mounted incorrectly or if the camera film-speed dial is set out of range, the ready-lights blink asking for correction. The ASA range for automatic flash operation is 25 to 400. When set to manual the flash can be used with any film speed set on the camera.

The ready-lights glow steadily when the flash is charged and ready to fire.

If the flash is set to automatic, the ready-lights also serve to indicate incorrect exposure due to insufficient light by blinking for a few seconds im-

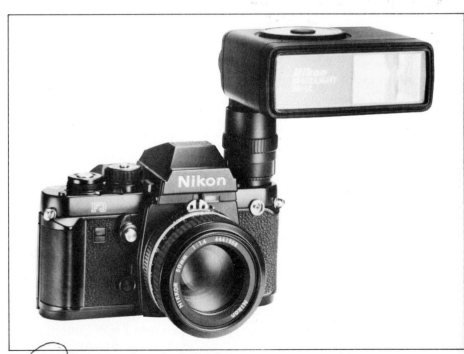

The SB-12 flash is "dedicated" to the F3 camera—which means it has special operating features with the F3.

mediately after the flash. (With the flash set for manual, the ready-lights do not have this function.)

With the flash on automatic, you can test before shooting to see if there will be enough light. Turn on the camera LCD display by partially depressing the camera shutter button. Then depress the open flash button on the flash. The flash will fire and the ready-lights will blink if there was not enough light.

You can use any lens aperture you choose, but operating range depends on aperture and film speed. A calculator on the flash shows maximum and minimum automatic operating ranges for film speeds from ASA 25 to ASA 400 and apertures from f-2 to f-22. For example, at ASA 100 and f-4, automatic operating range is from 1 meter to 6 meters. On manual, the operating distance at each aperture is the same as maximum range on automatic. In other words, at ASA 100 and f-4 on manual flash, your subject should be at 6 meters.

The SB-12 is powered by four AA Alkaline cells which produce approximately 160 flashes on manual or at full output on automatic.

SB-11 SPEEDLIGHT

The SB-11 is a more powerful handle-mount flash, similar in appearance to the SB-5. It can be hand held or bracket-mounted to the camera. It has three modes of operation: TTL control with the F3, self-regulated automatic with any other camera, and manual with any camera. ASA 100 guide number is 36 meters. The normal beam width is 56° x 40° which covers the angle of view of a 35mm lens. Adapter SW-3 widens the beam to 67° x 48° which covers the angle of view of a 28mm lens. Guide number with the SW-3 is 25 meters.

For TTL control, a special SC-12 Sensor Cord is used between flash and camera. At the camera end of this cord is a special connector that fits into the hot shoe and makes all necessary electrical connections including X-sync. With this cord, operation of the SB-11 is similar to the SB-12.

The SB-11 does not automatically set shutter speed. Set the F3 shutter-speed control to X or a numbered speed of 1/60 or slower.

For self-regulated automatic flash with cameras other than the F3, the SB-11 measures light with an SU-2 Sensor Unit which is normally plug-

ged into the front of the flash. In this mode, a standard sync cord is used between the sync terminal on the camera body and the sync socket on the flash. The SU-2 measures the light and turns off the flash. Lens aperture settings are limited to three at each film speed, selected by a control on the SU-2.

For bounce flash, the SU-2 sensor can be removed from the flash and mounted in the camera hot shoe. Extension Cord SC-13 is required to connect the SU-2 to the flash unit.

Manual flash operation is selected by the control on the SU-2.

Power is supplied by four AA-size alkaline cells in the handle of the flash. These provide approximately 170 flashes on manual or at full output on automatic.

RINGLIGHTS

Two special ring-shaped flash units are available to mount on the forward end of the lens. The ringlights use either an AC power supply, LA-1, which can be switched to operate from 100V AC, 117V AC, 220 V AC or 240V AC, or a battery pack LD-1. These power supplies are also used with the Medical Nikkor lens.

No specific reference to use of SB-12 in automatic mode in free flash situation. See p142. Method must be tested. Select aperture on camera based on ambient light, which will call for shutter speed of no more than 1/60 sec. Turn flash on — it will fall 1 to 1, set on automatic. To fill 1 stop darker than ambient light set calculator dial to twice the ASA speed of film in use

The SB-11 can be used as a dedicated flash with the F3 and also as a conventional self-regulating automatic or manual flash with any camera.

Ringlight SR-2 mounts on the front of a non-reversed lens. A similar ringlight, SM-2, mounts on the front of a reversed lens.

NIKON ELECTRONIC FLASH UNITS					
	SB-E	SB-4	SB-5	SB-11	SB-12
Type	Energy-Saving Automatic	Energy-saving Auto or Manual	Energy-saving Auto or Manual	Energy-saving Auto, TTL Auto or Manual	Energy-saving TTL Auto or Manual
Mount	ISO Hot Shoe	ISO Hot Shoe	Side-Mount on Bracket	Side-Mount on Bracket	F3 Hot Shoe
Auto Ranges	1	1	3 with SU-1	Note 1 and 2	Note 1
Manual Light Control	Auto only	Full output only	FULL, 1/4 & MD	Full output only	Full output only
ASA 100 Guide No. Manual, meters (ft.)	17 (56)	16 (52)	32, 16, 11 (105), (52), (36)	36 (118)	(25) 83
f-stop choices on auto with ASA 100	3 with EM 1 with FE-FM	f-4	f-4, f-5.6, f-8	Note 1. On conventional Auto: f-4, f-5.6, F-8	Note 1
Max. shooting distance on auto. meters (ft.) ASA 100	3 (10)	4 (13)	8, 5.5, 4 (26), (18), (13)	25.5 (84)	17.5 (58)
Angle of Coverage (H x V)	56° x 40°	56° x 40°	67° x 48°	56° x 40° 67° x 48° with SW-3	56° x 40° 67° x 48° with SW-4
Power Source	4-AAA Alkaline Batteries	2-AA Alkaline Batteries	SN-2 Nicad SD-4 480V	8-AA Alkaline Batteries	4-AA Alkaline Batteries
Approx. Number of Flashes per Battery or Recharge at around 20°C (68°F)	80+	Manual: 140 Auto: 1000	Manual: SN-2: 75-4000 SD-4: 250-4000 Auto: SN-2: 230-420 SD-4: 1500-3000	Manual: 170	Manual:160
Approx. Recycle Time (seconds) with Flash Batteries	9	Manual: 9 to 13 Auto: Less than 1 up to 9-13	Manual: SN-2: 0.25-2.6 SD-4: 0.25-1.5 Auto: SN-2: 0.25-2.6 SD-4: 0.25-0.5	Manual:8 Auto: Less than 1 up to 8	Manual: 8 Auto: Less than 1 up to 8
Ready-Light	Yes plus LED in EM and FE	Yes	Yes	Yes, plus Viewfinder LED in F3	Yes, plus Viewfinder LED in F3
Open-Flash Button (Test-Firing Button)	No	Yes	Yes	Yes	Yes

Note: 1 TTL Auto has one range for each aperture setting on the lens. Note 2: SB-12 has three ranges on conventional self-regulated Auto

	SB-9	SB-10	SR-2	SM-2
Type	Non-Energy-Saving Auto only	Energy-Saving Auto or Manual	Ringlight Manual only	Ringlight Manual only
Mount	ISO Hot Shoe	ISO Hot Shoe and special FE	Screws into lens filter threads	Attaches to bayonet end of reversed lens
Auto Ranges	2	2	Manual only	Manual only
Manual Light Control	Full output only	Full output only	FULL or 1/4	FULL or 1/4
ASA 100 Guide No. Manual, meters (ft.)	Auto only	25, 18 with SW-2 (83), (59) with SW-2	16 on FULL; 8 on 1/4 (53) on FULL; (26) on 1/4	Guide numbers not applicable at Macro ranges
f-stop choices on auto with ASA 100	f-2.8, f-4	f-4, f-8	—	—
Max. shooting distance on auto. meters (ft.) Minimum is 2' (0.6m)	5, 3.5 (16.5), (11.5)	6, 3 (20), (10)	—	—
Angle of Coverage (H x V)	56° x 40°	56° x 40° 67° X 48° with SW-2	—	—
Power Source	2-AA Alkaline Batteries	4-AA Alkaline Batteries	LD-1 DC Power Unit LA-1 AC Power Unit	LD-1 DC Power Unit LA-1 AC Power Unit
Approx. Number of Flashes per Battery or Recharge	Auto: 200	Manual: 160 Auto: 1000	Manual: 600-1400	Manual: 600-1400
Approx. Recycle Time (seconds)	Auto: 9	Yes, combined with Open-Flash Button	Manual: 12	Manual: 12
Ready-Light	Yes	Yes, combined with Open-Flash Button	Yes	Yes
Open-Flash Button (Test-Firing Button)	Yes	Yes	Yes	Yes

12
HOW TO CARE FOR YOUR CAMERA

Camera care requires a few essentials: One brush for camera and lens bodies, another for glass surfaces; some way to make squirts of air; lens tissue and lens-cleaning fluid; cotton swabs.

With proper care, Nikon equipment will give you many years of good service and great photographs. The best care you can give any piece of equipment is to use it properly so you don't cause problems to develop.

If your camera is new, or if you haven't used it lately, read the instructions to be sure you are familiar with the controls and what they do.

CHECK OUT YOUR CAMERA

You will not harm your camera by operating it without film. You can get acquainted with its operation and practice using the controls by firing "blank shots" as much as you wish.

Open the back and trip the shutter a few times at different shutter speeds while looking into the camera. You'll see the shutter open and close. While the shutter is open, you'll see the rear pupil of the lens. At different aperture settings, the pupil should be different sizes.

Don't touch the shutter or interfere in any way with its motion. It's fast, precise and vulnerable.

If the battery is more than 6-months old it's good insurance to replace it before leaving on a trip. If the battery is more than a year old, it's living on borrowed time.

If the camera is new, or you haven't used it in a long time, test by exposing a roll of film. Particularly if you are going on a trip or planning to make some very important photos, check out the camera first by testing with film in the camera.

For any kind of testing with film which you will send out for processing, color slide film is best because "what you see is what you get."

When you load film, be sure the leader is caught in the slot in the take-up spool. After closing the camera back, watch the rewind knob to be sure it rotates as film is being advanced.

Make your test shots under a variety of lighting situations. This gives you the opportunity to check the camera's built-in exposure meter, shutter-speed timer and aperture settings over a wide range of operating conditions.

Send the film in for developing through your local dealer. Carefully inspect the finished slides. If you see something that doesn't look right, it could be your shooting technique, improper use of the camera controls, a fault in the camera, or a problem resulting from improper processing. If you can't figure out which, your dealer will be glad to look over the slides and help you.

THINGS THAT CAN HARM YOUR CAMERA

Camera mechanisms can be damaged due to improper storage and improper use. Here are some of the camera's "natural enemies" and what you should do about them.

Dirt—Cameras and lenses are not dustproof. Under normal conditions of use and storage, dirt, dust and grit are not a problem. When you use a camera at the beach, in the desert when sand is blowing, at dirt race tracks, cement plants, and all such

places where dirt is in the air, protect your camera by keeping it enclosed except while using it. Use a camera case, or a plastic bag, or even an article of clothing wrapped around the camera. You can shoot with the camera inside a plastic bag if you cut an opening for the lens. Use lens caps both front and rear on lenses not mounted on a camera. Use body caps for your spare camera bodies.

Water—Cameras are not waterproof. There are several places where water can get inside and do a lot of damage. Protect both body and lenses from rain or splashing water. If the camera exterior gets wet, dry it immediately with a clean soft cloth.

If a camera is thoroughly wet due to being submerged or left for a long time in rainfall, it may be damaged beyond repair. Get it to an authorized Nikon service facility as soon as possible.

Condensation—When exposed to sudden temperature changes or high humidity, condensation may form on lenses, on the inside glass surfaces of lenses, and inside the camera. If you store camera and lens in such a way that they can't dry out properly, problems may result.

You can't take camera and lens apart to dry them out, but proper storage after condensation forms will do it. Leave camera and lens uncovered at room temperature for two or three days.

Amateur Repairs—Well-meaning amateur camera servicing and repairs can cause more damage than they cure. Never take a camera body or lens apart. Never attempt to lubricate camera parts yourself. If the camera seems to have mechanical damage, visible or invisible, take it to your authorized Nikon dealer for repair.

Lengthy Storage—Like people, cameras need regular exercise. If you are not using a camera, it will survive the inactivity better if you exercise it every 2 or 3 months. Fire some blank shots at various shutter speeds. Operate the film-advance lever and other camera controls to free them up and redistribute lubricants. If you know you won't be using a camera for several months, it's a good idea to remove the old battery and replace it with a new one when you start using the camera again.

Never store a camera with the shutter cocked. Make a point of depressing the shutter button just before you put it away, just to be sure the internal springs are unwound and relaxed.

Storage Conditions—Improper storage is an enemy. Store camera and lenses in a cool dry place. A shelf or drawer in a room occupied by people is much better than a basement or attic where the camera may be attacked by humidity or temperature extremes. Store the equipment in

cases, wrappings or bags. It's a good idea to package it with small cloth bags of dessicant to hold down humidity. New camera equipment usually has these dessicant bags in the packaging—don't throw them away.

Shooting Conditions—Be careful not to bang your camera against walls or drop it. A short neckstrap, used around your neck instead of over your shoulder is very good insurance against inadvertent bangs and knocks that can damage your camera. A good rule is: Whenever you are using the camera, have the strap around your neck, except when using a tripod.

When carrying a camera in a vehicle such as a car or airplane, keep it in the passenger compartment and pad it some way so it does not receive steady vibrations from contact with the frame of the vehicle. Vibration can loosen screws and possibly damage the precision mechanism.

When you're using the camera, always have the proper lens hood on the lens. Not only will it improve image quality but also it will help protect the front of the lens. A dented or cracked lens hood is a lot cheaper and easier to replace than a camera or lens.

If you're going outdoors in very cold weather, keep the camera under your coat when you're not actually shooting. This will help keep the battery functioning and when you

When you are not actually using the camera, keep a front lens cap in place. When a lens is not installed on a camera, always keep both front and rear lens caps in place. Store and carry lenses in a container that protects them from dirt, bumps and extreme temperature changes.

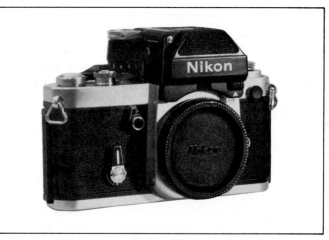

To store or carry a camera body without a lens in place, always use a body cap to keep dirt out of the body mechanism.

return to the warmer area, you'll have less worry about condensation forming on or inside the camera.

If you've been out long enough so the camera has gotten cold, wrap it in your jacket, or better yet place it inside a plastic bag before going into a warm room. Allow it to return to room temperature slowly, and don't take it out of the bag until it is the same temperature as the surrounding air. Otherwise, condensation will form both inside and outside the camera and cause problems later on. This is especially important if you are going to go back outside, into the cold again. Condensation inside a camera may quickly freeze when you go outside, jamming the camera.

In hot weather, protect the camera from the direct heat of the sun. High temperature may affect the camera and the film. Color film is especially sensitive to high temperatures. Don't leave your camera in the open sun. Don't leave it in the trunk of a car, the glove compartment, on the car's dash or back window ledge, especially in cars with lots of glass.

Caution: Catalytic converters are mounted under the floor of a car and get extremely hot. Keep your camera away from this heat source.

If you must leave it in a closed car, make sure the camera is in a case and place it on a cool portion of the floor, or under the seat. Drop a jacket or blanket over it. This serves two purposes, it protects it from the sun and camouflages it from would-be thieves.

ASSEMBLE A CLEANING KIT

Put together a small cleaning kit and keep it with you whenever you're using your camera. Include a spare battery or batteries if your camera uses more than one. Also camera lens-cleaning tissue, lens-cleaning fluid, a brush for lens barrel and camera body, a soft lens-cleaning brush for glass surfaces, cotton swabs, and a can of pressurized air. The can of air can be left at home because it is a bit bulky to carry in your camera bag.

Practical portable substitutes for a can of pressurized air are: A puff of air from your mouth delivered without any bonus of liquid or other matter, a rubber squeeze bulb such as an ear syringe or a combined squeeze bulb and brush of the type sold at camera shops.

Don't use any other kind of tissue such as nose-blowing or bathroom, and don't use the tissues sold for cleaning eyeglasses because they are often impregnated with silicone—fine for your glasses but not for your camera lens.

How To Clean a Lens—With lens cap in place, or both caps if the lens is removed from the camera, use a blast of air and brush to clean dust from the lens barrel and the crevices around the controls. Be careful to use this brush only on metal surfaces. Use the lens-cleaning brush only on glass surfaces.

Then remove the front lens cap and blow the loose dust off the front glass element. With the lens brush, gently stroke any remaining dirt particles off the front surface.

Apply a drop or two of lens-cleaning fluid to a piece of lens-cleaning tissue and lightly wipe the len starting at the center and spiraling outward.

Don't rub hard and don't use more than a drop or two of lens-cleaning fluid. Never apply fluid directly to the lens as it may seep into the lens, dissolving the lubricant and possibly getting between lens elements. The rear lens element can be cleaned in the same way. It should not require frequent cleaning because it is protected by a rear lens cap or the camera camera body.

Clean a lens only when it actually needs it—when it's covered with dust or has finger smudges.

How To Clean The Camera Body—Use a brush to clean loose dust off the body and out of crevices. Work around all controls to remove dirt.

Then open the back of your camera. Use the brush to clean out any dust or film particles. You can also use a puff of air to do the job. Be very careful not to spray the air directly on the shutter curtains and don't touch them with anything.

Using a small piece of lens-cleaning tissue dampened with cleaning fluid, clean the pressure plate and guide rails in the camera body.

Never attempt to clean the camera mirror. It is surfaced on the front rather than on the back of the glass and is easy to scratch. Never apply a piece of lens cleaning tissue or even try to brush it. This is the place to use your can of air or squeeze bulb to clear away loose dirt.

How To Clean The Viewfinder Eyepiece—This will get dirtier and greasier than your lenses. A cotton

1/To clean a lens, first use a squirt of air to blow off dust particles. Then, using a good quality lens brush, gently *lift off* remaining dust particles.

2/If the lens has smears or fingerprints that the brush didn't remove, use lens-cleaning fluid and lens-cleaning tissue to complete the job. Apply a drop or two of fluid to the tissue; use the tissue gently to sweep particles to outside of lens; then lift dirt up and off.

Use one brush for lens body and camera body. Use a *different* brush for glass surfaces.

swab such as a Q-Tip can be used. Blow out the dust first, then use a slightly dampened swab to lift off any remaining dirt or smears.

IF YOU HAVE A PROBLEM

Through use, even the best camera may develop problems, but many are not serious.

What if the film stops advancing? There's a good chance you've simply reached the end of a roll of film. It may be a 20 exposure when you thought it was a 36, or maybe you advanced the film a little farther than normal before closing the camera back. Never use unusual force to advance the film—or on any other camera control. Rewind the film, operate the camera without film and it may check out OK. If so, try another roll of film.

If the meter quits, put in a new battery. This will frequently solve exposure or meter problems instantly. You should replace the camera battery once a year, even if it tests OK.

While using your camera, be aware of how the controls feel. The film-advance and lens controls should be smooth with no grinding, crunching or scraping. Generally, if something does go wrong, you'll know it almost immediately because the smooth feel will be gone.

How To Test Exposure Accuracy—If you are getting some bad exposures, check the simple things first. Try a new battery. Is your metering technique causing the problem—such

as shooting a subject against a bright background without making any compensation? If you get bad exposure on prints, it may be the lab—not likely but possible.

Exposure errors due to a fault in the camera metering system will usually occur at all shutter-speed settings and all apertures. One check is to compare the settings read from the camera meter to those of a separate accessory meter. A hand-held meter will normally measure a much wider area than your camera, and the readings may vary depending on the scene being measured. Another SLR camera can be used for comparison. They should agree within about one-half step. Check at different scene brightnesses. If you get fairly good agreement, the meter in your camera is probably OK—if the comparison camera is making good exposures.

Find a brick wall or other uniform textured surface. Put the camera on a tripod and focus carefully on the wall. Then make a series of exposures starting at the widest aperture and going down to the smallest. Use the exposure meter in the camera to measure the light and set the exposure controls for each frame you shoot. Record the settings for each frame.

Send the film out for processing. It will be easier to check results if you enclose a note to the film lab asking that the slides not be mounted. You'll get back a continuous roll of film, so each frame has to be in proper order, as shot. Hold the film strip against a light source such as a window pane and examine each frame. Use a magnifying glass so you'll be sure to spot any problems.

All should be reasonable exposures of the scene. All exposures should look the same. If some are lighter or darker, look for a pattern or some clue as to what is wrong.

How to Test Focus—It may be your vision or technique instead of the camera. When your vision is getting fuzzy images from everything, it's hard to tell good focus from bad.

With the camera on a tripod and at large aperture so depth of field is

A cotton swab, slightly moistened with lens-cleaning fluid is handy to clean the viewing eyepiece. Don't clean any glass surface more often than necessary.

minimum, ask somebody with good vision to focus your camera sharply. Then you do it. If you had to refocus, somebody did it wrong because there is only one camera setting that gives best focus.

To test the camera, use a tripod and focus on a wall as before. Move the camera to at least four different distances from the wall, focusing carefully each time. Make notes. Use slide film and ask that it not be mounted. Check the returned film with a magnifying glass. Every frame should be in good focus. If some or all are not, it's either your eyesight or the camera. Have one or both checked. A simple Eyepiece Correction Lens will often solve this problem.

HOW TO GET IT FIXED

If you can tell by feel of the controls or the pictures you get that the camera needs repair, have it fixed by an authorized Nikon service agency. Save your receipts when you purchase camera gear, so you will have a record of the purchase date. Read the warranty card that comes with new equipment—it is different in different parts of the world. Save the warranty card with your receipt so you will later be able to double check warranty provisions and also check to see if your equipment is still in warranty.

3 NIKON CAMERAS & ACCESSORIES

NIKON AND NIKKORMAT CAMERA SPECIFICATIONS				
	NIKON EM	NIKON F2	NIKKORMAT FT3	F3
METERING SYSTEM AND INDICATOR (Center-Weighted)	Silicon Photo Diode Moving Needle	None	CdS Needle Centering	Silicon Photo Diode LCD
METERING RANGE (ASA 100, with f-1.4 lens)	EV 2 to EV 18 (With f-1.8)	Not Applicable	EV 3 to EV 17	EV1 to EV 18
FILM-SPEED RANGE	ÁSA 25 to 1600	Not Applicable	ASA 12 to 1600	ASA 12 to 6400
SHUTTER-SPEED RANGE (seconds)	1 to 1/1000 on AUTO. plus M90 and B	1 to 1/2000 and B 2-10 by Self-Timer	1 to 1/1000 and B	8 to 1/2000, B, T, and X
SHUTTER TYPE	Metal, Vertical	Titanium, Horizontal	Metal, Vertical	Titanium, Horizontal
STANDARD FOCUSING SCREEN	Type K	Type K	Split-Image and Microprism Ring	Type K
INTERCHANGEABLE VIEWFINDERS	No	Yes	No	Yes
INTERCHANGEABLE FOCUSING SCREENS	No	Yes	No	Yes
VIEWFINDER DISPLAY (with Standard lens)	Shutter Speed, LED for SB-E, plus SB-10	None	Exposure, Shutter Speed	Exposure, Aperture, Shutter Speed, Flash Ready
VIEWFINDER FRAME COVERAGE (approx.)	92%	100%	92%	100%
ELECTRONIC FLASH SYNC SPEED	1/90	Up to 1/80	Up to 1/125	Up to 1/80
AUTO. EXPOSURE CAPABILITY	Yes, auto only	No	No	Yes
AUTO. FULL-APERTURE INDEXING	Yes	Not Applicable	Yes	Yes
MIRROR LOCKUP CONTROL	No	Yes	Yes	Yes
MULTIPLE EXPOSURE METHOD	Unofficial procedure using rewind button; frame counter advances	With rewind button; frame counter does not advance	Unofficial procedure using rewind button; frame counter advances	With Multiple-Exposure Lever; frame counter does not advance
FILM-ADVANCE LEVER	Single or multiple stroke, 50° stand-off, 144° winding stroke	Single or multiple stroke, 20° stand-off, 120° winding stroke	Single stroke, 20° stand-off, 135° winding stroke	Single or multiple stroke, 30° standoff, 140° winding stroke
DEPTH-OF-FIELD PREVIEW CONTROL	No	Yes	Yes	Yes
SELF-TIMER RANGE	8 to 11	2 to 10	2 to 10	10 spc.
CANCEL SELF-TIMER	Yes	Yes	No	Yes
MOTOR DRIVE OR AUTO WINDER	MD-E	Motor Drive MD-3, MD-2, MD-1	None	MD-4
BATTERY	2 Silver-Oxide 1.5V No. 76 or equivalent	2 Silver-Oxide 6V No. 76 or equivalent	1 Silver-Oxide 1.5V No. 76 or equivalent	2 Silver-Oxide 1.5V No. 76 or equivalent
MEMO HOLDER	Yes	Yes	No	Yes
WEIGHT & DIMENSIONS (without lens)	460g 134.5x 85.9x54mm	732g 152x99x56mm	750g 148x96x54mm	700g 148.5x96.5x65.5

NIKON CAMERA SPECIFICATIONS				
	NIKON FE	**NIKON FM**	**NIKON F2A**	**NIKON F2AS**
METERING SYSTEM AND INDICATOR (Center-Weighted)	Silicon Photo Diodes Match-Needle	Gallium Photo Diode 3 LED Indicators	CdS Needle Centering	Silicon Photo Diodes 3 LED Indicators
METERING RANGE (ASA 100, with ƒ-1.4 lens)	EV 1 to EV 18	EV 1 to EV 18	EV 1 to EV 17	EV −2 to EV 17
FILM-SPEED RANGE	ASA 12 to 4000	ASA 12 to 3200	ASA 6 to 6400	ASA 12 to 6400
SHUTTER-SPEED RANGE (seconds)	8 to 1/1000 and B	1 to 1/1000 and B	1 to 1/2000 and B 2 to 10 by Self-Timer	1 to 1/2000 and B 2 to 10 by Self-Timer
SHUTTER TYPE	Metal, Vertical	Metal, Vertical	Titanium, Horizontal	Titanium, Horizontal
STANDARD FOCUSING SCREEN	Type K	Split-Image and Microprism Ring	Type K	Type K
INTERCHANGEABLE VIEWFINDERS	No	No	Yes	Yes
INTERCHANGEABLE FOCUSING SCREENS	Yes	No	Yes	Yes
VIEWFINDER DISPLAY (with Standard lens)	Exposure, Shutter Speed, ƒ-stop	Exposure, Shutter Speed, ƒ-stop	Exposure, Shutter Speed, ƒ-stop	Exposure, Shutter Speed, ƒ-stop
VIEWFINDER FRAME COVERAGE (approx.)	93%	93%	100%	100%
ELECTRONIC FLASH SYNC SPEED	Up to 1/125 (SB-10 selects 1/90)	Up to 1/125	Up to 1/80	Up to 1/80
AUTO. EXPOSURE CAPABILITY	Yes	No	No	Yes, with EE Aperture Control DS-12
AUTO. FULL-APERTURE INDEXING	Yes	Yes	Yes	Yes
MIRROR LOCKUP CONTROL	By Self-timer	By Self-timer	Yes	Yes
MULTIPLE EXPOSURE METHOD	Control on body; frame counter does not advance	Control on body; frame counter does not advance	With rewind button; frame counter does not advance	With rewind button; frame counter does not advance
FILM-ADVANCE LEVER	Single stroke, 30° stand-off, 135° winding stroke	Single stroke, 30° stand-off, 135° winding stroke	Single or multiple stroke, 20° stand-off, 120° winding stroke	Single or multiple stroke, 20° stand-off, 120° winding stroke
DEPTH-OF-FIELD PREVIEW CONTROL	Yes	Yes	Yes	Yes
SELF-TIMER RANGE	2 to 10	2 to 10	2 to 10	2 to 10
CANCEL SELF-TIMER	Yes	Yes	Yes	Yes
MOTOR DRIVE OR AUTO WINDER	Motor Drive MD-11	Motor Drive MD-11	Motor Drive MD-3, MD-2, MD-1	Motor Drive MD-3, MD-2, MD-1
BATTERY	2 Silver-Oxide, 1.5V No. 76 or equivalent	2 Silver-Oxide, 1.5V No. 76 or equivalent	2 Silver-Oxide, 1.5V No. 76 or equivalent	2 Silver-Oxide, 1.5V No. 76 or equivalent
MEMO HOLDER	Yes	Yes	Yes	Yes
WEIGHT & DIMENSIONS (without lens)	590g 142x 89.5x57.5mm	590g 142x89.5x60.5mm	830g 152.5x102x65mm	840g 152.5x102x65mm

This chapter includes descriptions and specs on Nikon cameras along with descriptions of some major accessories not covered earlier. At the end of the chapter are lens tables and equipment lists.

Rather than give specs individually for each camera model, they are grouped in the preceding table. This allows quick reference and easy comparison of features.

For brevity in the camera descrip-tions that follow, I have made references to earlier discussions or illustrations.

FE

Introduced in 1978, the FE is a compact automatic with aperture priority and manual operation. It uses Motor Drive MD-12. A new electronic flash, the SB-10, provides special features when used with the FE. The flash will set shutter speed automatically, operate a viewfinder ready-light, and flash the ready-light if an incorrect shutter speed is selected when you are operating the camera on manual.

The FE uses interchangeable focusing screens, accessible through the lens mount. A type K screen is standard. Other screens for the FE are packaged with a special tweezers used to interchange screens.

The FE is designed for full-aperture metering with AI lenses and stop-down metering with non-AI lenses.

SWITCHING TO AUTOMATIC

Rotate the Shutter-Speed Dial to AUTO. Then, when you select aperture size, the camera will automatically select a suitable shutter speed between 1/1000 and 8 seconds—or it will show under- or overexposure.

SWITCHING TO NON-AUTOMATIC

The shutter-speed dial locks in the auto setting. To release, depress the Shutter-Speed Dial Lock and turn the control to the desired shutter speed.

MECHANICAL SHUTTER SPEEDS

The focal-plane shutter is controlled electronically during automatic operation and at all non-auto shutter speeds except M90 (1/90) and B. Both of these are mechanical and do not use battery power.

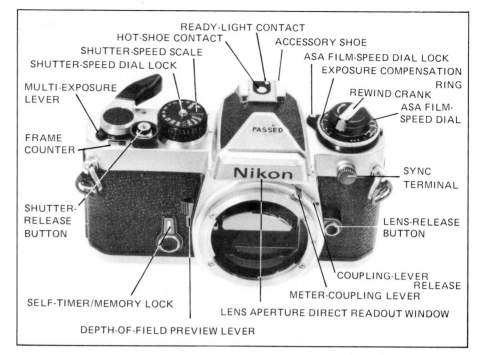

READY-LIGHT CONTACT
HOT-SHOE CONTACT
SHUTTER-SPEED SCALE
SHUTTER-SPEED DIAL LOCK
ACCESSORY SHOE
ASA FILM-SPEED DIAL LOCK
EXPOSURE COMPENSATION RING
MULTI-EXPOSURE LEVER
REWIND CRANK
ASA FILM-SPEED DIAL
FRAME COUNTER
PASSED
Nikon
SYNC TERMINAL
SHUTTER-RELEASE BUTTON
LENS-RELEASE BUTTON
COUPLING-LEVER RELEASE
METER-COUPLING LEVER
LENS APERTURE DIRECT READOUT WINDOW
SELF-TIMER/MEMORY LOCK
DEPTH-OF-FIELD PREVIEW LEVER

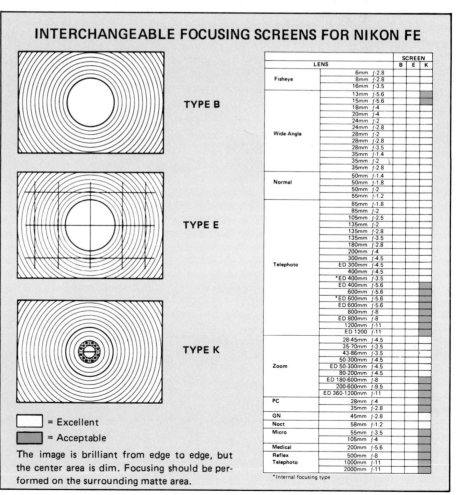

INTERCHANGEABLE FOCUSING SCREENS FOR NIKON FE

TYPE B

TYPE E

TYPE K

☐ = Excellent
▨ = Acceptable

The image is brilliant from edge to edge, but the center area is dim. Focusing should be performed on the surrounding matte area.

LENS		SCREEN B	E	K
Fisheye	6mm f·2.8			
	8mm f·2.8			
	16mm f·3.5			
Wide-Angle	13mm f·5.6			▨
	15mm f·5.6			▨
	18mm f·4			
	20mm f·4			
	24mm f·2			
	24mm f·2.8			
	28mm f·2			
	28mm f·2.8			
	28mm f·3.5			
	35mm f·1.4			
	35mm f·2			
	35mm f·2.8			
Normal	50mm f·1.4			
	50mm f·1.8			
	50mm f·2			
	55mm f·1.2			
Telephoto	85mm f·1.8			
	85mm f·2			
	105mm f·2.5			
	135mm f·2			
	135mm f·2.8			
	135mm f·3.5			
	180mm f·2.8			
	200mm f·4			
	300mm f·4.5			
	ED 300mm f·4.5			
	400mm f·4.5			
	*ED 400mm f·3.5			
	ED 400mm f·5.6			▨
	600mm f·5.6			
	*ED 600mm f·5.6			
	ED 600mm f·5.6			▨
	800mm f·8			
	ED 800mm f·8			▨
	1200mm f·11			
	ED 1200 f·11			▨
Zoom	28-45mm f·4.5			
	35-70mm f·3.5			
	43-86mm f·3.5			
	50-300mm f·4.5			
	ED 50-300mm f·4.5			
	80-200mm f·4.5			
	ED 180-600mm f·8			▨
	200-600mm f·9.5			▨
	ED 360-1200mm f·11			▨
PC	28mm f·4			
	35mm f·2.8			
GN	45mm f·2.8			
Noct	58mm f·1.2			
Micro	55mm f·3.5			▨
	105mm f·4			▨
Medical	200mm f·5.6			
Reflex Telephoto	500mm f·8			
	1000mm f·11			▨
	2000mm f·11			▨

*Internal focusing type

METERING

A silicon photo-diode system is used with center-weighting. Metering range is EV 1 to EV 18 with f-1.4 and ASA 100.

VIEWFINDER DISPLAY

Automatic Operation—When set for automatic, the green needle moves to the top of the display at the symbol A—for Automatic. The black needle then moves along the scale of shutter speeds to show what speed the camera has selected.

If the black needle enters the red band at the top of the display, it is signaling overexposure. The red band at the bottom indicates underexposure.

Non-Automatic Operation—When you are manually selecting shutter speed, the green needle indicates the shutter speed you have selected and the black needle indicates the shutter speed the camera exposure meter "thinks" you should use. If you are

FE exposure is match-needle on non-automatic. When switched to auto, green needle points to A, black needle shows shutter speed to be used. Red zones indicate over- or underexposure.

metering an average scene, match the needles so they both indicate the same shutter speed and you should get a satisfactory exposure.

If the black needle enters the red zones at top or bottom of the display,

change lens aperture setting, film speed, or scene illumination if possible, until the black needle indicates a suitable shutter speed between 8 seconds and 1/1000 second.

When you use the shutter-speed dial to select M90 or B, the green needle moves to the appropriate symbol and the black needle has no significance—disregard it.

DISPLAY ILLUMINATION

Lens aperture is displayed by the ADR method, using ambient light falling on the ADR scale on the lens. Shutter-speed display illumination is by light coming through the lens.

EXPOSURE COMPENSATION ON AUTOMATIC

Lift the Exposure Compensation Ring. Turn the ring until the desired amount of compensation is shown opposite the red index mark on the ring. The range of compensation is from −2 to +2, in steps of 1/2 unit.

ASA FILM SPEED

Depress the Film-Speed-Dial Lock while turning the Film-Speed Dial until the desired ASA film speed is set opposite the red index mark.

SELF-TIMER

Delays from about 2 to 10 seconds are available, depending on how far you rotate the Self-Timer Lever. No scale is provided to show time delay.

To start timer countdown, depress the Shutter-Release Button. You can use the Self-Timer with any shutter speed except B. If the camera is on automatic and your eye is not at the viewfinder, cover the eyepiece with something opaque.

Canceling the Self-Timer—If you set the timer and then decide not to use it, just rotate the lever back to its normal position.

MEMORY LOCK

A second function of the Self-Timer is to serve as a Memory Lock when the camera is set for automatic. To perform substitute metering, point the camera to the substitute metering

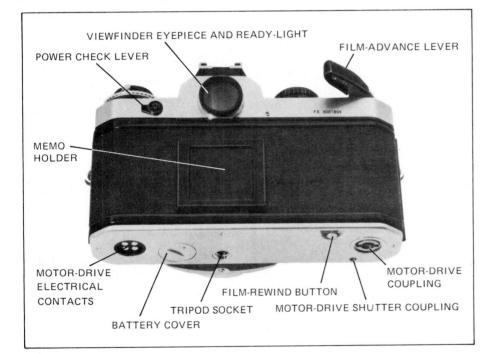

VIEWFINDER EYEPIECE AND READY-LIGHT

POWER CHECK LEVER

FILM-ADVANCE LEVER

MEMO HOLDER

MOTOR-DRIVE ELECTRICAL CONTACTS

BATTERY COVER

TRIPOD SOCKET

FILM-REWIND BUTTON

MOTOR-DRIVE SHUTTER COUPLING

MOTOR-DRIVE COUPLING

FE FLASH SYNCHRONIZATION																
	Shutter speed (sec.)															
	1/1000	1/500	1/250	1/125	1/60	1/30	1/15	1/8	1/4	1/2	1	2	4	8	M90	B
X	▓	▓	▓	▓												
FP		▓	▓	▓	▓										▓	
M		▓	▓												▓	
MF		▓													▓	

☐ Synchronized ▓ Cannot be used

SLOWEST SHUTTER SPEED AT FULL APERTURE WITH f-1.4 LENS	
ASA Speed	Slowest Shutter Speed (sec.)
3200	1/30
1600	1/15
800	1/8
400	1/4
200 (160)	1/2
100 (80)	1
50 (64)	2
25	4
12	8

Lower limit of metering accuracy with an f-1.4 lens. See page 88.

surface and push the Self-Timer Lever toward the lens. While holding in the Memory Lock, point the camera at the scene you wish to shoot and operate the shutter. Shutter speed is locked even though the black needle continues to move with light changes.

VIEWING DEPTH OF FIELD

When metering stopped-down, observe depth of field while metering. When metering at full aperture, depress the Depth-of-Field Preview Lever on the camera body.

STOP-DOWN METERING

First, set the camera for stop-down metering by flipping up the Meter-Coupling Lever as shown on page 23. Then mount the lens or lens and accessory combination.

For Bellows, Non-Automatic Extension Rings, Preset Lenses, and all Lenses Requiring Manual Aperture Control—Select either auto or non-auto. Adjust aperture manually until the needles match if set for non-auto, or until a satisfactory shutter speed is indicated if set for auto. Make the exposure using the shutter button.

For Fixed-Aperture Reflex-Nikkor Lenses—Select either auto or non-auto. On auto, the black needle should indicate a satisfactory shutter speed. On non-auto, you should be able to match the needles at some shutter speed. In either case, if you can't find a working shutter speed, use ND filters or change film speed as appropriate.

For non-AI Auto-Nikkors Mounted on the Camera or on Automatic Extension Rings and Lenses with Automatic Diaphragm but Not Meter-Coupled—Some AI lenses have auto diaphragm but are not meter-coupled for full-aperture metering. These can be identified in the lens table by noting lenses that offer automatic diaphragm but require stop-down metering, such as the 400mm f-4.5 Nikkor. In addition, all non-AI lenses with automatic diaphragm are not meter-coupled when mounted on an AI camera. For all lenses in these categories, you can use auto or non-auto.

With automatic camera operation: Depress the Depth-of-Field Preview Lever and hold it depressed while changing lens aperture until a satisfactory shutter speed is indicated. Continuing to hold in the Depth-of-Field Preview Lever, operate the shutter button.

With non-auto camera operation: Depress the Depth-of-Field Preview Lever and hold it depressed while matching the needles. Then use shutter button to make exposure. Releasing the preview lever before making the exposure is optional.

MIRROR LOCKUP

Use the Self-Timer to make the exposure. As timer countdown begins, the mirror moves up and the lens is stopped down to shooting aperture.

Lenses that require mirror lockup cannot be used. There are only two such lenses in current production: the 6mm f-5.6 Fisheye and the 10mm f-5.6 OP Fisheye.

SHUTTER-BUTTON LOCK

When the Film-Advance Lever is fully against the camera body, the shutter button is locked so a motor drive can be used.

HOLDING THE SHUTTER OPEN

For long time exposures, use a locking cable release.

MULTIPLE EXPOSURES

See page 85.

INTERMEDIATE DIAL SETTINGS

See page 84.

BATTERY CHECK

Move Power Check Lever downward and observe adjacent LED indicator. If the light glows, batteries are OK.

IF THE BATTERIES FAIL

Exposure meter and automatic exposure system will not work. Shutter operates mechanically at 1/90 no matter where camera controls are set, except B. When set to B, shutter remains open as long as you hold shutter button depressed.

FLASH

The hot shoe has two electrical contacts. The second contact works only with the special SB-10 flash. When an SB-10 flash is installed, switched on, and ready to operate, a ready-light glows in the SB-10. Another ready-light glows in the top of the FE viewfinder eyepiece.

SB-10 with the FE on Auto—If the FE is set for automatic, the camera shutter is automatically switched to 1/90. You can use the flash without switching the camera to non-auto. When the SB-10 is switched off, the camera reverts to automatic exposure and selects a shutter speed appropriate for the ambient scene illumination.

SB-10 with the FE on Non-Auto—If the FE is set for non-auto, the shutter will operate at whatever speed you have selected. You can use 1/125 or any slower shutter speed, including M90 and B. If you have selected a speed faster than 1/125, the ready-light will blink repeatedly when it comes on. Change to 1/125 or slower before making the exposure.

MAJOR ACCESSORIES

Nikkor lenses, bellows, extension tubes, motor drive, viewing eyepiece attachments, flash—including the special SB-10.

FM

A compact manual AI camera, the FM uses AI lenses with full-aperture metering and non-AI lenses with stop-down metering.

METERING

A gallium photo-diode system is used with center-weighting. Range is EV 1 to EV 18 with f-1.4 and ASA 100.

VIEWFINDER DISPLAYS

Exposure Indicator—Three LED indicators provide five levels of indication, as shown in the accompanying table. When only the center O is illuminated, exposure is correct within 1/5 of an exposure step.

Aperture and Shutter-Speed Displays—Aperture is displayed by the ADR method whereby an image of the ADR scale on AI lenses appears at the top of the viewfinder display. With non-AI lenses, there is no aperture display. Shutter speed is displayed on the left side of the frame. The shutter-speed display encroaches slightly on the image area.

DISPLAY ILLUMINATION

The aperture-size display is illuminated by outside light falling on the lens ADR scale. Shutter-speed and the symbols +, O and − for the exposure display are illuminated by light coming through the lens. The LEDs are self-illuminated.

SELF-TIMER

Delays from about 2 to 10 seconds are available, depending on how far you rotate the Self-Timer Lever. No scale is provided to show time delay.

Be sure film has been advanced and the camera is set to make the next exposure. To start timer countdown, depress the Shutter-Release Button. You can use the Self-Timer with any shutter speed except B. If used on B, the timer will count down; the shutter will operate; but exposure time will be uncertain.

Canceling the Self-Timer—If you have set the timer and then decide not to use it, rotate the Self-Timer Lever back to its normal position and

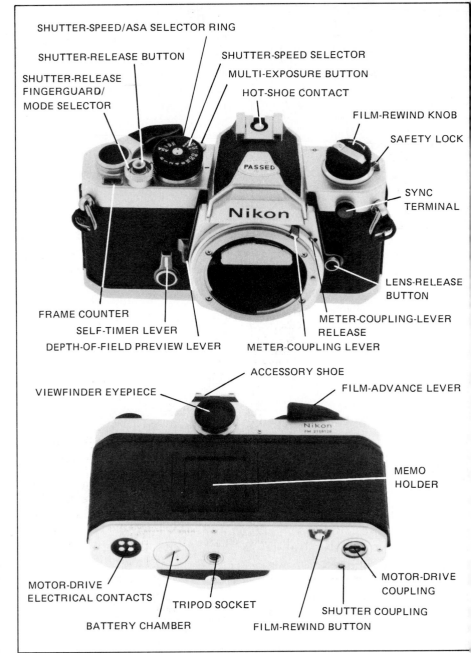

then use the camera normally, just as though the timer had not been set. The internal clock mechanism will wind itself down, with no effect on camera operation.

STOP-DOWN METERING

Stop-down metering must be done with non-AI lenses; when accessories that do not preserve lens automation are installed between any lens and camera; with lenses that have auto-diaphragms but are not meter-coupled for full-aperture metering such as the 400mm f-4.5 Nikkor; and with all lenses not designed for full aperture metering such as preset and

Reflex-Nikkor lenses.

First, prepare the camera body for stop-down metering as shown on page 23. Then mount the lens or lens and accessory combination that you plan to use.

For Non-AI Auto-Nikkors Mounted Directly on the Camera or on Auto Extension Rings, and for Lenses with Auto-Diaphragm but no Meter-Coupling for Full-Aperture Metering—Depress Depth-of-Field Preview lever and hold depressed while setting exposure controls. Release Depth-of-Field Preview Lever Operate shutter button.

For Bellows, Non-Auto Extension Rings, Preset Lenses and all Lenses Requiring Manual Aperture Control—Adjust aperture size and shutter speed for correct exposure. Operate shutter button.

For Reflex-Nikkors—Adjust shutter speed until correct exposure is indicated. If not possible, use ND filters or film with a different film speed.

MIRROR LOCKUP

No special mirror lockup control is provided. A practical way to reduce the vibration of mirror operation for many shooting situations is to use the Self-Timer to make the exposure. As the timer-countdown begins, the mirror moves up and the lens aperture is stopped down to shooting aperture.

Because the mirror on the FM cannot be permanently locked up, lenses that require mirror lockup cannot be mounted. There are only two such lenses: the 6mm f-5.6 Fisheye-Nikkor and the 10mm f-5.6 OP Fisheye-Nikkor.

SHUTTER-BUTTON LOCK

When the Film-Advance Lever is fully against the camera body, the shutter button is locked—a motor drive can be used.

Older Models—Earlier models of the FM have a ring around the shutter button called the Shutter-Release Fingerguard/Mode Selector. When the red line on the ring is aligned with the index mark on the camera, the shutter button is locked—a motor drive can be used.

When the black line on the ring is aligned with the index mark, the shutter button can be operated. This is the normal setting when you don't have a motor drive unit installed on the camera.

Because this control does more than just lock or unlock the shutter button, it is called the Shutter-Release Fingerguard/Mode Selector.

HOLDING THE SHUTTER OPEN

For long time exposures, use a locking cable release.

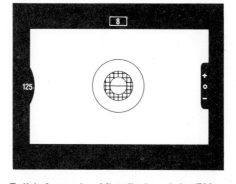

Full-Information Viewfinder of the FM uses LED indicators for exposure display.

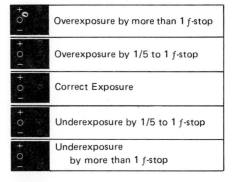

	
+ o⚬ −	Overexposure by more than 1 f-stop
+ o⚬ −	Overexposure by 1/5 to 1 f-stop
+ ⚬o −	Correct Exposure
+ ⚬o −	Underexposure by 1/5 to 1 f-stop
+ ⚬o −	Underexposure by more than 1 f-stop

Three LED indicators give five levels of exposure indication as shown.

MULTIPLE EXPOSURES

See page 85.

INTERMEDIATE DIAL SETTINGS

See page 84.

BATTERY CHECK

Turn on camera. If any LED in the exposure display glows steadily, the batteries are OK. Reduced temperature near or below freezing will reduce battery output and good batteries may not pass the test. They may recover at normal temperature.

IF THE BATTERIES FAIL

The exposure meter will not work but the camera functions normally otherwise. All shutter speeds are available.

TO REPLACE BATTERIES

Unscrew cover on camera bottom. Batteries are held in a clip which is attached to the cover. Remove old batteries, noticing how they were installed. Clean new battery surfaces by rubbing with a clean cloth. Don't touch battery surfaces with your fingers as you load them. Place new batteries into battery clip, observing correct polarity. Replace cover. Follow battery check procedure.

FLASH

The hot shoe is a conventional ISO type. To attach a flash with the special Nikon mounting foot, use adapter AS-2. The hot shoe electrical contact is switched on by insertion of a flash unit or adapter. The sync terminal on the camera body is always turned on, therefore it is provided with a threaded cover which should be in place except when a sync cord is connected. Two flashes can be fired simultaneously: one in the hot shoe and another connected to the sync terminal.

MAJOR ACCESSORIES

Nikkor lenses, bellows, extension tubes, motor drive, viewing eyepiece attachments, flash. Because of the smaller size of the FM camera, viewfinder eyepiece attachments designed for larger Nikon and Nikkormat cameras may interfere with opening the camera back cover. A new series of eyepiece attachments is being designed to fit all Nikon and Nikkormat cameras without interfering with back cover operation of the FM. Check with your dealer when buying eyepiece attachments and be sure to specify that they are to be used on an FM camera.

FM FLASH SYNCHRONIZATION												
	Shutter speed (sec.)											
	1/1000	1/500	1/250	1/125	1/60	1/30	1/15	1/8	1/4	1/2	1	B
FP												
M												
MF												

☐ Synchronized ■ Cannot be used

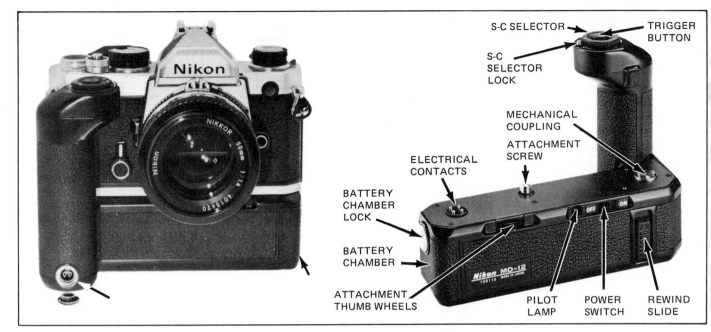

MOTOR DRIVE MD-12

The MD-12 Motor Drive replaces the earlier MD-11.

Designed as a companion to the FE and FM cameras, the MD-12 will fire single shots or continuously, depending on the setting of the S-C Selector Ring on the motor drive. To select S or C, depress the S-C Selector Lock and turn the ring.

When set to S, so it fires single shots, it works at shutter speeds of 1 to 1/1000 second, but not B. It advances film automatically when you release the Trigger Button, but always waits for the camera to complete the exposure before advancing.

When set to C, for continuous shooting, it makes exposures in rapid sequence for as long as you hold down the Trigger Button. At shutter speeds faster than 1/125 second, maximum frame rate is about 3.5 frames per second. At slower shutter speeds, the motor drive waits for the camera to complete each exposure so the frame rate is slower. The shutter-speed range on C is in the specifications. Do not use B. If you have a quick trigger finger, it's easy to fire single shots when set for continuous operation.

To install—The MD-12 can be attached or removed anytime. Be sure the motor drive is turned off. Place it on the bottom of the camera, correctly oriented, and guide it carefully into position as you turn the Attachment Thumb Wheels on front and back of the case. The attachment screw fits into the camera tripod socket. The MD-12 has its own tripod socket so the camera and MD-12 combination can still be tripod mounted.

Turn the FM Shutter-Release Fingerguard/Mode Selector to lock the camera shutter button. The FE doesn't have a Mode Selector—just install the motor drive. Push the camera Film-Advance Lever fully against the camera body. Then use the Trigger Button on the MD-12 to control the camera.

The Power Switch on the MD-12 must be turned on to operate the motor drive. When you depress the MD-12 Trigger Button partway, the camera meter and viewfinder display are turned on for about 50 seconds. After each exposure, the meter and display remain on for 50 seconds. This saves the camera batteries and is the major difference between the MD-12 and its predecessor.

If the motor drive does not advance film properly, the probable cause is failure to engage the couplings. Turn the motor drive off and turn the Mode Selector on the camera to unlock the shutter button. Use the camera Film-Advance Lever to complete the film advance, if the motor drive did not. Then expose one frame manually. Return to motor-drive operation and it should function normally.

If this doesn't clear the problem, don't force the Film-Advance Lever. Remove the motor drive. Expose one frame manually and advance the film manually. Reattach the motor drive and it should work OK.

End of Roll—When you have exposed the last frame, the motor drive will stop and the pilot lamp will remain on. Turn off the motor drive to stop battery drain. Push the Rewind Slide on the MD-12 upward to prepare the camera for rewinding. Then use the camera Rewind Crank to rewind film normally and proceed as though the motor drive were not installed.

Manual Operation—You can operate the camera normally, with manual film advance, just by turning off the motor drive and setting the camera to unlock the camera Shutter-Release Button.

Multiple Exposures—When the motor drive is set for single shots, operate the Multi-Exposure control on the FE or FM during each exposure and hold the button until you have released the motor drive Trigger Button. You can make as many exposures as desired on the same frame. During the last multiple exposure, do not operate the Multi-Exposure con-

MD-12 SPECIFICATIONS	
Camera:	Nikon FM or FE
Shooting Speed:	3.5 frames per second approx. maximum (at shutter speeds faster than 1/125 sec.)
Shooting Modes:	Single frame (S) Continuous (C)
Usable Shutter Speeds:	(S) 1 to 1/1000, FM; 8 to 1/1000, FE (C) 1/2 to 1/1000, FM; 8 to 1/1000, FE
Pilot Lamp:	LED lights up when in operation
Trigger Button:	Also acts as camera meter On/Off switch
Remote Control:	Possible; uses standard Nikon 3-pin connector.
Power Source:	Eight 1.5V penlight batteries (AA size, in integral battery chamber)
Weight: (approx.)	410g (without batteries)
Dimensions: (approx.)	144 x 36 x 42mm; or 144 x 68.5 x 109.5mm including the grip.

trol on the camera. At the end of that exposure, the motor drive will move an unexposed frame of film in place for the next exposure.

When the motor is set for continuous shooting, operate and hold the Multi-Exposure control while making multiple exposures. Release the Multi-Exposure control just before the last exposure so the motor drive will advance the next frame. If you fail to release the control in time, make one more multiple exposure with the lens cap on and without using the Multi-Exposure control. After that, the motor drive will advance the next frame.

Power—Power is supplied by 8 AA-size 1.5V penlight batteries, housed in the motor-drive case.

Remote Control—A Remote Control Socket on the front of the MD-12 allows use of several remote control devices.

MR-2 Terminal Release is a small housing that fits into the MD-12 Remote Control Socket. The MR-2 is equipped with a pushbutton that can be used to control the motor drive and camera metering circuit instead of using the Trigger Button on top of the motor drive grip. This is convenient when you rotate the camera to make a shot with vertical format.

The Nikon AR-2 cable release can be attached to the MR-2 for remote control. From the far end of the cable release, using the pushbutton on the cable, you can control the motor drive and the camera metering system as already described.

Two or more MD-12 units can be fired simultaneously using MC-4 cords plugged into the Remote Control Sockets and connected to a user-furnished switch. Pistol Grip Model 2 can be attached to the MD-12, with control by the trigger on the pistol grip. Use Connecting Cord MC-3 to connect the grip to the MD-12.

For time-lapse photography, use MT-1 Intervalometer. For wireless remote control, you can use ML-1 Modulite Remote Control Set which triggers by a light beam, or MW-1 Radio Control Set which uses a radio signal.

Using Nikon remote control units is generally straightforward, however there are some precautions and special instructions. You should read the MD-12 instruction booklet and the instructions for the remote control unit before making connections.

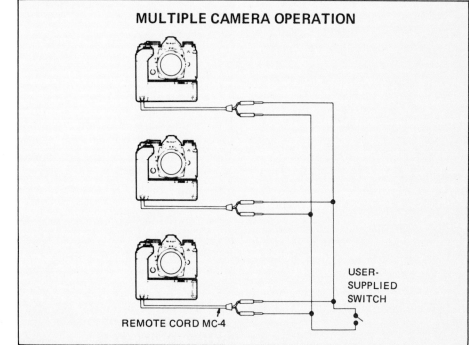

MULTIPLE CAMERA OPERATION

USER-SUPPLIED SWITCH

REMOTE CORD MC-4

Nikon motor drives with a remote control socket can be controlled in parallel, as shown here.

EM

Introduced in 1979, the EM is a compact, lightweight camera that is basically automatic-only using aperture priority. You set aperture; the camera chooses any shutter speed between 1 second and 1/1000. There is no manual control for shutter speeds except two special non-automatic modes of operation—M90 and B, discussed later.

A new group of lenses, Nikon Series E, was introduced with the EM. These lenses are smaller, lighter and less expensive than Nikkor lenses. Series E lenses are AI type and work with all AI cameras.

Other new items introduced with the EM are Motor Drive MD-E which fits only the EM camera and is described later in this chapter. Another companion to the EM is a new compact flash, Speedlight SB-E. The SB-E is a light-sensing automatic flash with special operating features when used with the EM. It can be used on other cameras but without some or all of the special features—see Chapter 11.

The EM is intended for users who prefer the simplicity of automatic exposure control. Camera and accessories are simpler to operate and lower in price than earlier models. A novel feature is a "beeper" in the camera body with makes an audible intermittent tone to warn of overexposure and slow shutter speeds.

In addition to the audible warning, a moving needle in the viewfinder also warns of overexposure and slow shutter speeds. This combination of features is advertised using the word *SONIC* which is an acronym for *Sound Optical Nikon Indicator Circuits.*

LENS CHOICES

Nikon Series E, AI Nikkor lenses, and non-meter-coupled Nikkors such as reflex and PC lenses work with the EM. *Do not attempt to install non-AI Auto Nikkor lenses. Damage to the camera will result.* Nikkor lenses modified to the AI configuration may be mounted and will work except that some automatic features of the SB-E flash are inoperative.

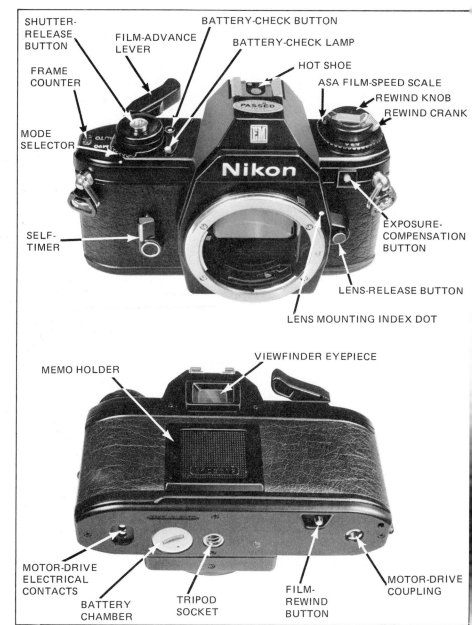

ON-OFF CONTROL

The metering system, automatic exposure system, viewfinder display and electronic "cooperation" with the SB-E flash are all turned on by depressing the shutter button halfway with the camera set for the normal AUTO mode of operation. After removing your finger from the Shutter-Release Button, these systems remain on for about 20 to 30 seconds and then switch off automatically to conserve battery power.

SHUTTER OPERATION MODE SELECTOR

Referred to here as the Mode Selector, this switch has three settings: AUTO is the usual setting. The camera operates with aperture-priority automatic exposure. M90 selects a mechanical shutter speed of 1/90 second which is also X-sync speed for electronic flash. At B, the shutter will remain open as long as you hold the shutter button depressed. Both M90 and B are mechanical and will operate without battery power.

METERING

A silicon photo-diode system is used with center-weighting. Metering range is EV 2 to EV 18 with ASA 100 and f-1.8. The primary area of light measurement is the 12mm circle visible in the viewfinder.

VIEWFINDER DISPLAY

A moving needle travels along a scale of shutter speeds in the image area at the left side of the frame. The needle indicates the camera-selected shutter speed to be used for the next exposure—when the camera is set to AUTO.

Red bands at top and bottom of the shutter-speed scale indicate over-exposure and underexposure. When the meter is off, the needle moves to the top and remains in the overexposure warning band.

An opaque flash index is visible adjacent to the scale with a notch or bracket in the index at a shutter speed of 1/90. When the SB-E or SB-10 flash is being used, a red LED indicator which is part of the flash index becomes visible.

The camera meter and the moving-needle exposure display are turned on by depressing the shutter button halfway with the Mode Selector set to AUTO. If set to M90 or B, touching the shutter button will not turn on the display. If you have the display turned on with the Mode Selector at AUTO, and then switch to M90 or B, the display will remain on for a short time and then automatically switch off. During that brief period when the display is on at the M90 or B settings, the meter needle position has no significance.

Shutter speeds below 1/60 are colored red as a warning to take precautions against camera movement during exposure. Use a tripod or other firm support for the camera.

AUDIBLE SIGNAL

The built-in "beeper" makes an intermittent tone when the meter needle indicates overexposure and when it indicates shutter speeds below 1/30. Beeping at slow shutter speeds is another way of suggesting use of firm camera support. In a noisy environment, you may have to listen closely to hear the sound, however the meter needle gives you the same information.

The audible warning signal works only while you are depressing the shutter button, so you can control whether it beeps or not.

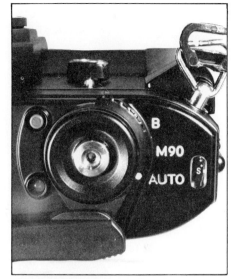

The EM Mode Selector has three settings. AUTO is the normal setting.

FOCUSING SCREEN

Similar to Nikon type K, the screen has a center biprism surrounded by a microprism, all in a matte field which can also be used for focusing. The screen is not interchangeable.

VIEWFINDER ACCESSORIES

A separate Eyepiece Adapter slides over the eyepiece to adapt the EM to use Nikon viewfinder accessories such as eyepiece correction lenses, a rubber eyecup or a right-angle viewing attachment. These are described in Chapter 7.

EXPOSURE COMPENSATION

Pushing the Exposure Compensation Button in gives about two exposure steps more exposure for backlit subjects. The button must be held in while you operate the shutter. The change in exposure is visible in the viewfinder—shutter speed becomes about two steps slower.

ASA FILM SPEED

Lift up on the outer rim of the ASA Film-Speed Selector Ring and turn until the index mark on the rim is opposite the desired film-speed number. Release the outer rim and turn slightly if necessary so it drops down to its normal position.

SELF-TIMER

Turn the Self-Timer lever counter-clockwise until it latches and does not move clockwise when you release it. Delay will be about 7 to 11 seconds, depending on how far you rotate the lever.

Start the self-timer by depressing the camera shutter button—after advancing film and preparing the camera for the next exposure. Caution—Light entering the viewfinder eyepiece will cause incorrect exposure on AUTO. If you do not have your eye at the eyepiece at the moment you depress the shutter button with the self-timer set to operate, cover the eyepiece with your hand or a piece of black tape.

At the instant you depress the shutter button to start the self-timer, the mirror moves up and lens aperture closes to the selected value. Exposure is locked at that instant and will not change. Once the self-timer is operating, you don't have to block light from the viewfinder eyepiece.

You can cancel self-timer operation *before you start it* by rotating the lever back to its normal position. Once started, it cannot be canceled.

In the normal position, the lever fits over a metal button on the camera body. It takes a small amount of force to rotate the lever off the button to start the timer. When timer operation is complete, use your finger to move the lever over the button again, again using a small amount of force.

The camera doesn't have a mirror lockup control. If you have the EM on a tripod, copy stand or other firm support, you can use the self-timer to lock up the mirror and stop down the lens as just described. After composing, focusing and preparing the camera to make the exposure, set the self-timer. Then depress the shutter button. Once the mirror is up, you

can no longer view through the camera, which is why support is required.

MIRROR LOCKUP DUE TO DIM LIGHT

If the EM is operated on AUTO with the lens cap on or in light so dim that satisfactory exposure is impossible, the mirror will lock up and the film-advance lever will be locked so you cannot advance film. To bring the mirror down again, rotate the Mode Selector to M90 or B and then back to AUTO. Then advance film to the next frame and use the camera normally. If long exposures are necessary, switch to B.

DEPTH OF FIELD

There is no depth-of-field preview button, therefore you cannot view depth of field through the lens. Both AI Nikkor and Nikon Series E lenses have depth-of-field indicators on the lens body which can be used as described in Chapter 4.

STOP-DOWN METERING

When using non-meter-coupled lenses or lenses with non-meter-coupled accessories between lens and camera, stop-down metering is automatic without any special control settings on the camera.

MULTIPLE EXPOSURES

Use the "three-finger method" described on page 85.

INTERMEDIATE CONTROL SETTINGS

The Mode Selector must be set exactly on a marked position. The lens aperture control can be set anywhere within its range.

LOADING FILM

The loading procedure is standard but there is an electrical interlock between the frame counter and the camera electronics that you should know about.

It's good practice to load film with the lens cap on. If you were to do that with the EM meter operating, it would lock up the mirror due to dim light when you advanced film during the procedure. To prevent that problem, the camera electronics cannot be turned on and the dim-light mirror

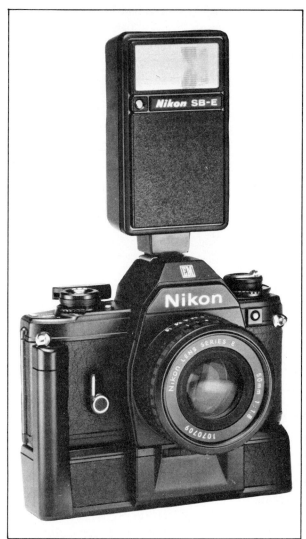

The EM was introduced with the SB-E flash which can also be used on other cameras; Motor Drive MD-E which is used only with the EM; and Nikon Series E lenses which can be used on any AI camera.

lockup system does not operate until you have advanced film to frame 1. This can be confusing if you are examining or demonstrating the camera without film.

This feature provides an advantage, compared to some other aperture-priority cameras. With other cameras, if you load and then advance film with the lens cap on, the camera will try to get a good exposure on each frame and hold the shutter open a long time when you actually want to advance film rapidly from S to 1.

With the EM, shutter speed is a mechanical 1/1500 during this procedure so there is no delay.

BATTERY CHECK

Depress the Battery Check Button. If the LED Battery-Check Lamp glows steadily and with normal brightness, batteries are OK. If not, replace both batteries.

IF THE BATTERIES FAIL

The exposure meter and automatic exposure system will not work. The shutter operates mechanically at 1/90 second on M90. B works normally.

FLASH WITH THE SB-E

The SB-E flash and the EM together provide unusual operating simplicity and capabilities—*when the lens is a Nikon Series E or an AI Nikkor manufactured to the AI configuration.* Both of these types have a special Aperture-Indexing Post on the back of the lens which works only with the EM and the SB-E.

Nikkor lenses modified to the AI configuration don't have the special post—actually a tab—and don't give the camera and flash combination the same features as explained later.

The SB-E has only one control: a three-position Power Switch with OFF in the center. Moving the switch

to the EM position sets up the unit for use with the EM. Moving it to the FE-FM setting prepares the flash for those cameras and for special use on the EM. The flash has a built-in light sensor that controls exposure as explained in Chapter 11.

Selecting either position, not OFF, turns the flash on. The flash ready-light in the EM viewfinder shows when the flash is charged and ready to fire and also provides some warnings of improper operation. A ready-light on the back of the flash glows steadily when the flash is charged and doesn't have any warning functions.

To use the flash with the EM, install it in the hot shoe and move the Power Switch to the EM setting. When the flash is charged and ready, the LED lamp in the camera viewfinder will start to function. If the camera electronics have not been turned on, the LED will flash to indicate that something is wrong. This is because the camera *must be turned* on by depressing the shutter button halfway before camera and flash can function properly together.

Recognizing the warning, suppose you touch the shutter button to turn on the camera but the Mode Selector is at M90 or B. The electronics will not turn on and the LED continues to flash.

Switch to AUTO, touch the shutter button, and the camera is turned on. You know this because the meter needle moves downward and responds to light changes. At that point, the LED will no longer flash to tell you to turn on the camera, but it may still be flashing for another reason.

When the camera is turned on, the LED flashes to warn you of *underexposure* if you have the lens set to an aperture that is too small. When you turn the camera on, if the LED continues to flash, you must change lens aperture to larger openings until you find a setting that causes the ready-light to glow steadily. That aperture size *and two larger sizes,* will give correct exposure. Intermediate settings between allowable apertures are also OK.

The three aperture settings that give correct exposure change when you change film speed. For example, with ASA 50 you can use *f*-2, *f*-2.8 and *f*-4. With ASA 100 you can use *f*-2.8, *f*-4 and *f*-5.6. Exception—At ASA 40 and below, less than three aperture steps are allowed.

The automatic operating range of the SB-E is 0.6 to 3 meters (2 to 10 feet).

In practice, operation up to about 17 feet is possible at the largest aperture.

There is no ASA film-speed dial on the flash. That information is handled electronically between camera and flash so you can't make a mistake or forget to set the flash unit correctly.

There are two ways to decide on a lens aperture setting. You can consult a table on the back of the flash unit, or the larger table of usable aperture settings in this chapter. Or, you can rely on the LED in the viewfinder to help you find a setting that will give correct exposure.

If you use the viewfinder LED, remember that it warns you *only* of underexposure due to an aperture that is too small. Start at the smallest aperture setting of the lens and increase aperture until you reach the first setting that causes the ready-light to glow steadily. For most film speeds, that aperture and the next larger two will be OK. However, if you use an aperture that is too large, the LED will not flash to warn you of overexposure—it will continue glowing steadily. Don't go beyond the largest permissible setting.

With the ready-light glowing steadily and an allowable aperture setting on the lens, you are ready to take a picture. If you spend too much time composing and focusing, the camera electronics will turn themselves off automatically and you are back where this discussion started. The LED begins flashing again, asking you to turn on the camera. To avoid this problem, always keep the

ASA FILM SPEED	f-2	+1/3	+2/3	f-2.8	+1/3	+2/3	f-4	+1/3	+2/3	f-5.6	+1/3	+2/3	f-8	+1/3	+2/3	f-11
USABLE LENS APERTURES WITH SB-E AND EM ON AUTOMATIC																
25	O	O	O	O												
32	O	O	O	O	O											
40	O	O	O	O	O	O										
50	O	O	O	O	O	O	O									
64		O	O	O	O	O	O	O								
80			O	O	O	O	O	O	O							
100				O	O	O	O	O	O	O						
125					O	O	O	O	O	O	O					
160						O	O	O	O	O	O	O				
200							O	O	O	O	O	O	O			
250								O	O	O	O	O	O	O		
320									O	O	O	O	O	O	O	
400										O	O	O	O	O	O	O

O means OK to use.

The SB-E has only one operating control: the three-position Power Switch.

camera meter turned on when using the SB-E. Hold the shutter button halfway down or touch it occasionally to keep the meter on.

The camera and flash will warn you if aperture is too small. That means the flash "knows" what lens aperture you are using. That's the function of the special post or tab on AI lenses that were manufactured to be AI.

Lenses that were modified to AI do not have the post. Modified AI lenses will work with the SB-E and EM but you don't get a warning signal if aperture is too small and you don't get a choice of apertures. Set the Power Switch on the SB-E to the FE-FM position and consult the lower table on the back of the flash for for the allowable aperture for the film speed you are using.

The FE-FM Setting—Moving the Power Switch to the FE-FM position disables the warning feature. The LED in the viewfinder will glow steadily when the flash is charged

and ready to fire. It also removes the choice of apertures—you can use only one.

SB-E with EM on M90 or B—If you have the SB-E Power Switch set to EM but the camera is set to M90 or B, the viewfinder LED flashes, asking you to turn the camera on. But you can't turn the camera electronics on at M90 or B. That combination won't work.

If you set the SB-E to the FE-FM position, the light sensor in the flash controls exposure automatically and you should get a good exposure provided you set the lens to the correct aperture from the FE-FM table on the back of the flash. The LED in the viewfinder serves as a flash ready-light only.

With the SB-E Ready-Light Off— When the ready-light is off on the flash and in the viewfinder, because the flash is not charged or because the unit is turned off, the camera operates just as though the flash were removed from the hot shoe.

FLASH WITH THE SB-10

With the EM set to AUTO, the SB-10 works the same way as with the FE. It automatically selects a shutter speed of 1/90. You choose one of two aperture settings on the flash and set the same aperture on the lens. The LED ready-light glows when the flash is ready to fire and has no warning functions. The flash sensor controls exposure.

With the EM set to M90, operation is the same. At B, the flash fires and controls its own exposure. You control exposure due to ambient light.

USING OTHER BRANDS AND TYPES OF FLASH

The EM camera produces X-sync on the center terminal of the hot shoe. Any flash with a standard ISO mounting foot that uses X-sync can be installed and operated. Set the camera Mode Selector to M90. Follow instructions for the flash.

The EM does not have a camera body sync socket.

MOTOR DRIVE MD-E

MD-E SPECIFICATIONS

Shooting Modes: Single frame or continuous
Shutter-Speed Range: 1 second to 1/1000
Frame Rate: Approximately 2 frames/second at shutter speeds from 1/90 to 1/1000.
Indicator: LED glows during film advance; remains lit at end of roll.
Power Source: Six 1.5V AAA batteries
Number of Rolls: More than 50 cartridges of 36-exposures per set of alkaline batteries at room temperature.
Dimensions: 133 x 32 x 46mm. Grip height: 82mm
Weight: 185g (without batteries)

Designed for the EM, the MD-E attaches using the tripod socket. The motor drive has its own tripod socket and a Film Rewind Button so you don't have to remove the unit to rewind film.

The only control is the On-Off switch. When turned on, you can control the motor with the camera shutter button. Depress the shutter button and remove your finger quickly

to shoot single frames. Hold the button down for continuous operation at a rate up to about two frames per second. depending on shutter speed.

The motor drive operates at any shutter speed, but it will wait for each exposure to end before advancing film for the next. When the MD-E is turned off, you can operate the camera normally as though the MD-

E were not attached.

Be sure the MD-E is turned off while attaching the unit to the camera. Then turn it on. You can use the MD-E to advance film to frame 1 after loading, if you wish. A red LED indicator glows during each film advance and glows continuously at the end of a roll when the motor stops. Turn the switch off, rewind and reload.

3

Introduced in 1980, the F3 uses a wide range of accessories and has some important new capabilities. A companion motor drive, the MD-4, and the SB-11 and SB-12 flash units were introduced with the camera.

The F3 is an aperture-priority automatic camera that can also be used with manual exposure control. It meters in both modes, and both are very convenient to use.

LENS CHOICES

The F3 is primarily intended for use with AI Nikkor lenses. It can be used with Series E lenses without losing any operational capabilities. It can be used with non-AI Nikkors using stop-down metering and with all earlier Nikkor lenses.

FILM LOADING

This procedure is similar to other Nikons with a couple of exceptions. To open the back cover, first move the Camera-Back Lock lever toward the viewfinder and then lift up the Rewind Knob.

After loading film and closing the camera back, it is necessary to have the camera turned on to operate the shutter button to advance film to frame 1. If you have the camera set to automatic, shutter speed is automatically switched to 1/80 until the frame counter reaches 1. This prevents long waits between film advances while the shutter opens and closes.

If the camera is set on manual, shutter speed is switched to 1/80 second when the shutter-speed dial is set at 1/125 or higher. At lower dial settings, the shutter operates at the speed you have set. To avoid long waits between film advances, choose a manual shutter speed setting of 125 or higher.

An alternate method in either automatic or manual can be done with the camera turned off. Operate the shutter with the Backup Mechanical Release Lever. This works at a shutter speed of 1/60 second, no matter where the shutter-speed dial is set—except T.

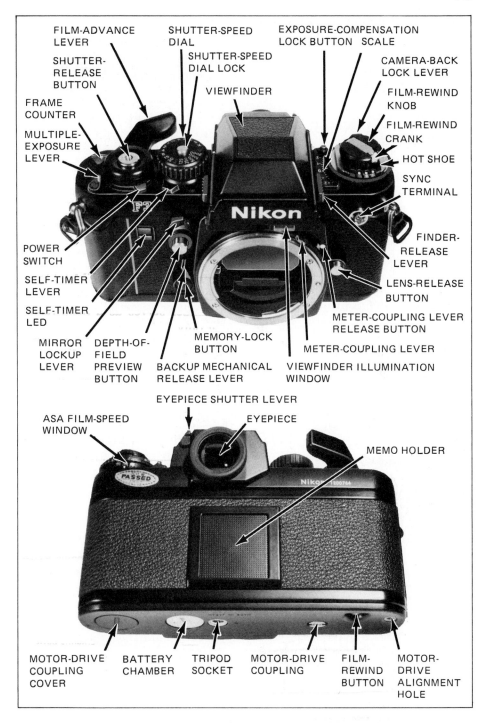

It is necessary to remove the Motor-Drive Coupling Cover on the bottom of the camera to install the MD-4 Motor Drive. When this cover is removed, light can enter the opening unless the motor drive is installed. Never load film with the cover off and the motor drive not installed. Never remove the motor drive when there is film in the camera.

ON-OFF CONTROL

To turn the camera on, move the Power Switch lever to the right, which exposes a red dot on the camera top. The camera cannot be operated normally with the Power Switch turned off. It can be operated with the Backup Mechanical Release Lever.

TO SELECT AUTOMATIC

The two operating modes are selected by the Shutter-Speed Dial. To choose aperture-priority automatic, set the dial to A. In this mode, shutter speeds from 8 to 1/2000 second can

be selected steplessly by the camera. That means the shutter speed can be any value, such as 1/423 second, rather than one of the standard values on the shutter-speed control.

TO SELECT MANUAL

Choose any numbered shutter-speed setting from 8 to 1/2000 second. The camera will operate at that speed. Other settings on the dial are B, T, and X. At B, the shutter remains open as long as you hold down the shutter button. At T, the shutter opens when you depress the shutter button. You can remove your finger and it will remain open. To close the shutter, turn the Shutter-Speed Dial away from the T setting. At X, the shutter operates at the X-sync speed of 1/80 second. Shutter speeds are timed by a built-in quartz oscillator and are very accurate.

INTERCHANGEABLE VIEWFINDERS

Four interchangeable finders are available. To remove, slide the Finder-Release Levers toward the back of the camera and lift off the finder. To install, place the finder carefully on the camera and press downward.

Because metering is in the camera body, it works with any finder and the exposure displays are visible.

The DE-2 Eye-Level Finder is standard. DW-3 Waist-Level Finder is a folding hood which allows you to look downward into the camera to view the focusing screen and displays. DA-2 Action Finder works well when you can't place your eye close to the finder eyepiece—for example, if you are wearing a racing helmet and goggles, or if the camera is in an underwater housing. DW-4 6X Magnification Finder is used for critical focusing at high magnifications.

EXPOSURE DISPLAY

To turn on the display, depress the shutter button partway. If you don't make an exposure within about 16 seconds, the display turns off. After each exposure, it remains on for 16 seconds and then turns off.

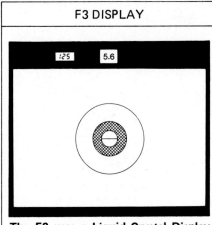

F3 DISPLAY

The F3 uses a Liquid Crystal Display (LCD) which is not self-illuminated. They are opaque numerals which must be illuminated by another source of light. The light source is either ambient light or a lamp in the viewfinder that you can turn on.

At top center, lens aperture setting is shown using the ADR method. At left, shutter speed is shown by an LCD display. At top right is a red LED which is used with some Nikon flash units.

Automatic operation is selected by turning the shutter-speed dial to A. The LCD display then shows shutter speed selected by the camera for correct exposure of an average scene. If the light is brighter or dimmer than the metering range of the camera, the display shows a + or − symbol.

M 500	Underexposure
M 125	Overexposure
M 250	Correct exposure

On manual operation, the LCD shows the setting of the shutter-speed dial and an M with + and − symbols. These indicate overexposure, underexposure or correct exposure of an average scene as shown in this table. To give more or less exposure than the meter recommends, adjust aperture or shutter speed as you choose.

The display has three parts. Shutter speed and an exposure indication are shown by an LCD display at top left. This display is interpreted as shown in the accompanying illustration. Lens aperture setting is shown by the ADR method, in a window at top center. A red LED at top right is used with the SB-12 flash or the SB-11 flash when connected to the cam-

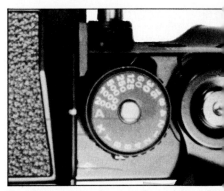

To select automatic operation with an F3, turn the Shutter-Speed Dial to the A setting.

era with the SC-12 TTL Sensor Cord. See Chapter 11.

VIEWFINDER ILLUMINATION

The LED display used with flash is self-illuminated. Both the LCD display and the ADR aperture display are normally illuminated by ambient light. A window in the front of the DE-2 viewfinder brings in ambient light to illuminate the LCD display. The ADR scale on the lens is also illuminated by ambient light.

In dim light, a lamp in the finder can be used to illuminate both the LCD display and the ADR scale on the lens. This is controlled by the Viewfinder Illuminator Button on the side of the finder housing.

EXPOSURE METERING

The metering pattern is center weighted, using a Silicon Photo Diode located in the bottom of the camera body as shown in Chapter 8. Metering range is EV 1 to EV 18 at ASA 100 with an f-1.4 lens. In ordinary operation, the meter reading is memorized by the camera just before the mirror moves up and metering stops when the mirror is up.

With the SB-12 flash and the SB-11 using the TTL sensor cord, metering begins when the first shutter curtain is fully open. The SPD light sensor measures light on the film surface and the camera meter turns off the flash when correct exposure has been reached. This is discussed in Chapter 11.

3 focusing screens are very easy to change. Remove the viewfinder, lift out the screen using the tab at the rear. Drop in the new screen and replace finder.

With the F3 back cover open and the focal-plane shutter held open on T, you can see the light sensor in the bottom of the camera.

To open the back cover, first move the Camera-Back Lock Lever to the right as shown by the arrow. Then pull up the Film-Rewind Knob.

INTERCHANGEABLE FOCUSING SCREENS

Twenty interchangeable screens are available for the F3, as shown in the accompanying table. These adapt the camera for a wide variety of photographic applications, taking into account both the application and the lens in use.

To interchange screens, first remove the viewfinder. Remove the screen by carefully grasping the tab at the rear and lifting out the screen. Install by tipping the screen downward into its recess so the forward edge is in place. Then lower the rear edge and release the tab. Install the viewfinder.

EYEPIECE SHUTTER

With the camera on automatic, if your eye is not at the eyepiece, close the eyepiece shutter to prevent stray light from entering the camera and causing incorrect exposure. To close the shutter, move the Eyepiece Shutter Lever to the left. The shutter is colored red to remind you that it is closed and you are looking at it.

MEMORY LOCK BUTTON

For substitute metering, point the

lens at the surface you wish to meter. While metering on the substitute surface, depress the Memory Lock Button and hold it depressed. Then point the lens at the scene you intend to shoot and make the exposure while continuing to hold down the Memory Lock Button.

ASA FILM SPEED

Film speed and exposure compensation are set using the same control, which surrounds the rewind knob. To set film speed, lift up on the outer rim of the control and turn until the desired speed number is in the window at the back of the control. ASA film-speed range is 12 to 6400.

EXPOSURE COMPENSATION

When the camera is on automatic, you can cause it to give more or less exposure than it normally would be using the Exposure Compensation Dial. To set in exposure compensation, depress the adjacent Exposure Compensation Lock Button while turning the outer rim of the control to place the white index mark opposite the amount of compensation desired. Range is plus or minus 2 EV, in incre-

ments of 1/3 step. This control also functions with the camera set for manual control but normally there is little reason to use it. When you don't want exposure compensation, be sure to set the control to 0. (No WARNING IN VIEWFINDER THAT COMPENSATION IS IN USE)

SELF-TIMER

The self-timer is electronically controlled with the run-down time of 10 seconds. To set the timer, move the Self-Timer Lever to the right, which exposes a red dot on the camera top. To start the timer, operate the camera shutter button. Indication of self-timer operation is a flashing LED on the front of the camera. The LED flashes at one rate for the first 8 seconds and at a visibly faster rate for the last 2 seconds.

To cancel the self-timer while it is counting down, move the Self-Timer Lever to its off position. Make the next exposure by depressing the camera shutter button.

To interrupt self-timing and start the timer over, move the Self-Timer Lever to its off position. When ready to resume, depress the camera shutter button again. The counter is reset to 10 seconds.

MULTIPLE EXPOSURES

The Multiple-Exposure Lever is on top of the camera, at the right front corner. To make multiple exposures: Make the first shot in the normal way, adjusting exposure as discussed in Chapter 8. Flip the Multiple-Exposure Lever counterclockwise. Then operate the Film-Advance Lever

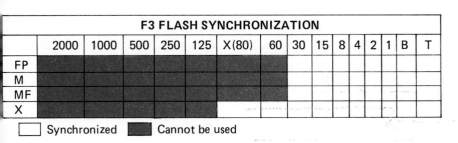

F3 FLASH SYNCHRONIZATION															
	2000	1000	500	250	125	X(80)	60	30	15	8	4	2	1	B	T
FP															
M															
MF															
X															

☐ Synchronized ■ Cannot be used

through one full stroke. This prepares the camera to make another exposure but does not advance film. While the film-advance lever is moving, the Multiple-Exposure Lever returns to its normal setting. Make the next exposure. For additional exposures on the same frame, repeat the procedure.

Motor-driven multiple exposures can be made by holding the Multiple-Exposure Lever fully counterclockwise while shooting this sequence. When the motor-driven sequence is completed, make one exposure with the lens cap on. Then advance the film using the Film-Advance Lever. This brings the next frame into shooting position.

DEPTH-OF-FIELD PREVIEW

The Depth-of-Field Preview Button is on the front of the camera where you can conveniently operate it with your right forefinger. When depressed, the lens aperture closes to the value set on the aperture ring and you can see depth of field at that aperture size. This button is also used for some stop-down metering procedures described later.

MIRROR LOCK

When shooting with the camera supported on a tripod or stand, it is sometimes desirable to lock up the mirror before the exposure to minimize the possibility of image blur due to vibrations caused by mirror movement. This may be desirable when using lenses with very long focal lengths or when using high magnification. When it is desirable to lock up the mirror for this reason, it is equally desirable to stop down the lens in advance so the lens aperture mechanism does not move during the instant before exposure.

The mirror-lock procedure does both. To lock up the mirror, first depress the Depth-of-Field Preview Button and hold it depressed. Then rotate the Mirror Lock Lever fully counterclockwise. The lens will remain stopped down and the mirror will remain up until you move the Mirror Lock Lever back to its normal position.

Two Nikkor lenses require locking

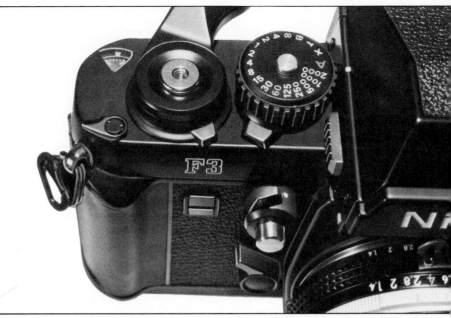

From left to right in this photo, along the top front of the camera: Multiple-Exposure Lever shown flipped out to make a multiple exposure; Power Switch lever extending forward from the shutter button; Self-Timer Lever extending forward from Shutter-Speed Dial. Red Self-Timer LED lamp just below F3 symbol blinks on and off to show timer countdown. Other controls are in a vertical row just beside the lens mount, where you can reach them easily with your right forefinger. From top to bottom: Mirror Lockup Lever, which surrounds the Depth-of-Field Preview Button; Backup Mechanical Release Lever shown tipped out ready for use. This lever surrounds the Memory-Lock Button. On the side of the viewfinder, you can see one of the two Finder-Release Levers. Viewfinder Illuminator Button is on the lower front corner of the finder housing.

up the mirror before mounting the lens: the Fisheye-Nikkor 6mm f-5.6 and the OP-Nikkor 10mm f-5.6.

When shooting with any continuous light source, do not use the camera on automatic with the mirror locked up. The exposure-measuring system will not work properly. With the SB-12 flash, you can operate with the mirror locked up. With any light source, you can use manual with the mirror locked up.

INTERMEDIATE CONTROL SETTINGS

The lens aperture can be set between marked f-numbers. The shutter-speed dial and ASA film-speed dial should always be set exactly on a marked setting.

FLASH

X-sync for electronic flash is 1/80 second. This can be selected by the X setting of the shutter-speed dial and it is automatically selected by the SB-12 when the SB-12 is installed and turned on.

The F3 is primarily intended for

use with the SB-12 and SB-11 as described in Chapter 11 and with these flash units you get the benefit of TTL flash control. Any other flash can be used on the F3 with the correct adapter: AS-3 mounts a Nikon speed-light with an F2-type foot onto the F3 hot shoe. AS-4 mounts any flash with an ISO-type foot onto the FE hot shoe.

No flash mounted with either of these adapters can operate any of the special features of the camera. The flash units will receive an X-sync pulse from the camera and will operate on the F3 the same as any other camera with a single-contact hot shoe.

MOTOR DRIVE

The F3 is designed to use MD-4 Motor Drive, described later in this chapter.

POWER SOURCE

The F3 uses two 1.5V silver-oxide batteries, EPX76, D 76, or equivalent. When Motor Drive MD-4 is attached, camera power is drawn from the batteries in the motor drive

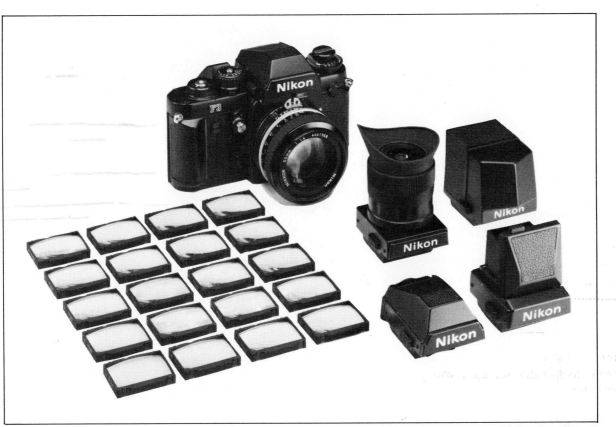

The large variety of focusing screens, viewfinders and other accessories allow you to set up an F3 for virtually any photographic purpose. Clockwise from top left, finders are: DW-4 6X Magnification Finder, DA-2 Action Finder, DW-3 Waist-Level-Finder and DE-2 Eye-Level Finder.

BATTERY CHECK

If the LCD display is visible, the batteries are OK.

OPERATION WITHOUT BATTERIES

If the camera batteries are dead or missing, and the MD-4 is not supplying power, the camera can still be operated in a special mode. You can advance film with the Film-Advance Lever and operate the shutter with the Backup Mechanical Release Lever which surrounds the Memory Lock Button. The shutter will operate mechanically, at a speed of 1/60 second no matter where the shutter-speed control is set, except T. The meter doesn't work and the automatic-exposure system doesn't work.

You can also make time exposures by setting the shutter-speed control to T and using the backup lever to release the shutter.

If you advance film while holding down the backup lever, the shutter will open immediately when film-advance is complete. If you fail to advance the film completely and

open the shutter with the backup lever, the mirror will lock up and remain up until you complete the full stroke of the Film-Advance Lever.

STOP-DOWN METERING

Depress the Meter-Coupling Release Button and move the Meter-Coupling Lever to the up position as shown on Page 23.

For non-AI Nikkor lenses with automatic diaphragms:

On automatic: Push in and hold the Depth-of-Field Preview lever while making the exposure.

On manual: Set shutter speed. Push in and hold the Depth-of-Field Preview Button while setting lens aperture for a correct exposure indication in the viewfinder. Release the preview button before making the exposure.

For non-AI lenses or accessories without automatic diaphragm:

On automatic: Adjust lens aperture for the shutter speed you wish to use. If there is no over- or underexposure indication in the viewfinder, make the exposure.

On manual: Adjust shutter speed or aperture until the viewfinder display indicates correct exposure. Make the shot.

For fixed-aperture reflex lenses, photomicrography and shooting through telescopes:

On automatic: No procedure is necessary. The camera will select a suitable shutter speed if possible. If not, the camera will display an over- or underexposure indication.

On manual: Adjust the shutter-speed control for an indication of correct exposure. Make the shot.

MAJOR ACCESSORIES

Interchangeable lenses, interchangeable viewfinders, interchangeable focusing screens, MD-4 Motor Drive, SB-11 and SB-12 Speedlights, Eyepiece Correction Lenses, camera cases, bellows, extension tubes, Pistol Grip Model II, Auto Rewind-Stop Back MF-6 for use with MD-4.

FOCUSING SCREEN SELECTION GUIDE FOR F3 & F2-TYPE CAMERAS

TYPE A

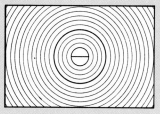

Matte Fresnel field with 3mm split-image rangefinder spot and 12mm reference circle. For general photography with lenses to 400mm telephoto, ƒ-4.5 or faster.

TYPE B

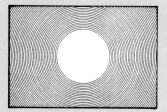

Matte Fresnel field and 12mm fine groundglass center. For general photography; especially suited for use with long-focus lenses and lenses of small maximum aperture (ƒ-5.6-ƒ-11).

TYPE C

Fine-ground matte field with 4mm clear spot and cross-hair reticle. It is especially suitable for photomicrography and other uses involving high magnification where aerial image and parallax focusing can be used with 6X magnifying finder DW-2 or 2X eyepiece magnifier.

TYPE D

All-matte, fine-ground surface. For use with long focal-length lenses.

TYPE E

Matte Fresnel field with multiple vertical and horizontal reference lines, 12mm reference circle, and fine-ground matte spot. For architectural photography and other applications requiring accurate image placement or alignment.

TYPE G SERIES

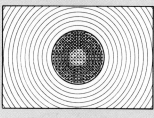

Clear Fresnel field with 12mm diameter microprism focusing spot. Provides extremely brilliant image for viewing and focusing in poor light. Available in 4 models with individual Fresnel patterns to match specific lenses, as shown on selector chart.

TYPE H SERIES

Clear Fresnel field with microprism pattern over entire screen area. Permits rapid focusing on any part of screen image, with optimum edge-to-edge brightness. Excellent for use in poor light and with moving subjects. Available in 4 models for specific Nikkor lens types. See selector chart.

TYPE J

Matte Fresnel field with 4mm microprism focusing spot and 12mm reference circle. For general photography with any Nikkor lens.

TYPE K

Matte Fresnel field with 3mm central split-image rangefinder spot surrounded by 1mm-wide microprism ring and 12mm reference circle. For general photography with any lens, supplied as standard with all Nikon and Nikkormat cameras.

TYPE L

Similar to Type A but with split-image spot set at 45° angle. Facilitates focusing on horizontal line.

TYPE M

Clear field with double cross-hair reticle and scales in 1mm increments. For aerial-image focusing in photomicrography and other high-magnification work with 6X focusing finder or 2X magnifier.

TYPE R

Combines features of Types A and E. 3mm-diameter rangefinder spot works best with lenses having maximum apertures ƒ-3.5 to ƒ-5.6. Excellent for architectural and multi-exposure photography where precise image placement is vital.

TYPE P

Matte Fresnel field with split-image spot at 45° angle surrounded by 1mm-wide microprism ring plus vertical and horizontal lines and 12mm reference circle. For general photography with all Nikkor lenses.

TV-FORMAT SCREEN

Has central 3mm split-image rangefinder and overall matte Fresnel field. Special, engraved lines show standard TV frame plus 'safe action' areas, ensure that entire image recorded will be visible in commercial or closed-circuit TV broadcasts.

FOCUSING SCREEN SELECTOR CHART

LENS		A/L	B	C	D	E	G1	G2	G3	G4	H1	H2	H3	H4	J	K/P	M	R
Fisheye	6mm ƒ-2.8																	
	8mm ƒ-2.8																	
	16mm ƒ-3.5																	
Wide-Angle	13mm ƒ-5.6																	
	15mm ƒ-5.6																	
	18mm ƒ-4																	
	20mm ƒ-4																	
	24mm ƒ-2																	
	24mm ƒ-2.8																	
	28mm ƒ-2																	
	28mm ƒ-2.8																	
	28mm ƒ-3.5																	
	35mm ƒ-1.4																	
	35mm ƒ-2																	
	35mm ƒ-2.8																	
Normal	50mm ƒ-1.4																	
	50mm ƒ-1.8																	
	50mm ƒ-2																	
	55mm ƒ-1.2																	
Telephoto	85mm ƒ-1.8																	
	85mm ƒ-2																	
	105mm ƒ-2.5																	
	135mm ƒ-2																	
	135mm ƒ-2.8																	
	135mm ƒ-3.5																	
	180mm ƒ-2.8																	
	200mm ƒ-4																	
	300mm ƒ-4.5																	
	ED 300mm ƒ-4.5																	
	400mm ƒ-4.5																	
	*ED 400mm ƒ-3.5																	
	ED 400mm ƒ-5.6																	
	600mm ƒ-5.6																	
	*ED 600mm ƒ-5.6																	
	ED 600mm ƒ-5.6																	
	800mm ƒ-8																	
	ED 800mm ƒ-8																	
	1200mm ƒ-11																	
	ED 1200mm ƒ-11																	
Zoom	28-45mm ƒ-4.5																	
	35-70mm ƒ-3.5																	
	43-86mm ƒ-3.5																	
	50-300mm ƒ-4.5																	
	ED 50-300mm ƒ-4.5																	
	80-200mm ƒ-4.5																	
	ED 180-600mm ƒ-8																	
	200-600mm ƒ-9.5																	
	ED 360-1200mm ƒ-11																	
PC	28mm ƒ-4																	
	35mm ƒ-2.8																	
GN	45mm ƒ-2.8																	
Noct	58mm ƒ-1.2																	
Micro	55mm ƒ-3.5																	
	105mm ƒ-4																	
Medical	200mm ƒ-5.6																	
Reflex	500mm ƒ-8																	
Telephoto	1000mm ƒ-11																	
	2000mm ƒ-11																	

*Internal focusing type

■ = Excellent

▨ = Acceptable

The image is brilliant from edge to edge, but the central rangefinder, microprism or cross-hair area is dim. Focus on the surrounding matte area.

□ = Acceptable

Slight vignetting or moire affects the screen image, but the image on film shows no trace of this.

■ = Acceptable

Incompatible with any lens having a maximum aperture larger than ƒ-2.8. The in-focus image in the central spot may prove to be slightly out of focus on film. Focus on the surrounding matte area.

Caution: The rear surface of the screen is made of acrylic resin. Special care should be taken to protect it from scratching or excessive pressure.

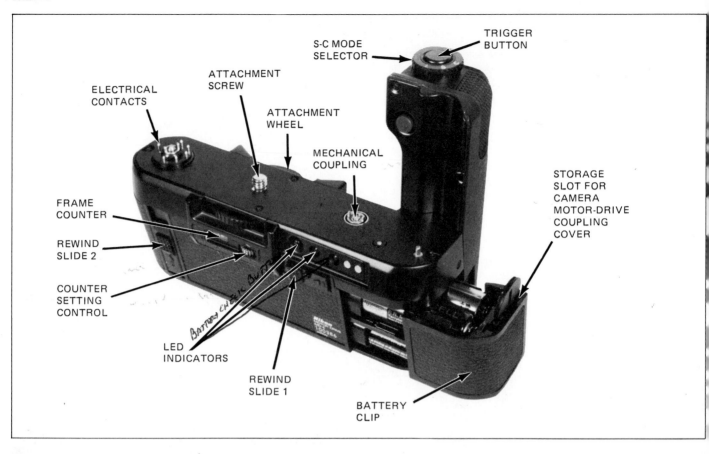

ELECTRICAL CONTACTS

ATTACHMENT SCREW

S-C MODE SELECTOR

TRIGGER BUTTON

ATTACHMENT WHEEL

MECHANICAL COUPLING

STORAGE SLOT FOR CAMERA MOTOR-DRIVE COUPLING COVER

FRAME COUNTER

REWIND SLIDE 2

COUNTER SETTING CONTROL

BATTERY CHECK BUTTON

LED INDICATORS

REWIND SLIDE 1

BATTERY CLIP

MOTOR DRIVE MD-4

Loaded with features, yet simple to operate, this motor drive fits the F3. It advances frames one at a time when the S-C Mode Selector is set to S, and continuously at C. At L, the unit is turned off and the Trigger Button is locked.

There are three ways to operate with the MD-4. The normal way is with the camera set to A, a numbered shutter speed, or X, and F3 Power Switch turned off so the shutter button on the camera is inoperative. You can make single or continuous exposures using the Trigger Button on the motor drive.

With the motor drive turned off and the camera turned on, operate the camera normally, just as though the motor drive were not attached.

With both MD-4 and F3 turned on, you can use either pushbutton. The shutter button on the camera will make motor-driven single shots with the MD-4 set either to C or S. The Trigger Button on the MD-4 will operate in the single-shot mode at S or the continuous mode at C. If you set the MD-4 at C with the camera turned on, you can make single shots using the shutter button on the camera or continuous exposures using the Trigger Button on the motor drive.

The motor drive Trigger Button turns on the camera meter and display when partially depressed and the camera stays on for 16 seconds. After each exposure, the camera stays on for 16 seconds.

If the camera shutter-speed control is set to B, the shutter will open and remain open as long as you hold the Trigger Button or the camera shutter button depressed. At T, the shutter will open and remain open until you turn the shutter-speed control away from the T setting.

To Install—First remove the Motor-Drive Coupling Cover on the bottom of the F3. This will allow light to enter the camera, so don't do it with film loaded.

Place the MD-4 on the bottom of the F3 and turn the knurled Attachment Wheels on both sides. This screws the motor drive unit onto the base of the camera, using the tripod socket. Another tripod socket is on the MD-4 so you can tripod-mount the combination.

To Make An Exposure—Turn on camera or motor-drive or both, as already discussed. Depress the camera shutter button or motor-drive Trigger Button. The motor drive will wait while the shutter opens and closes, then immediately advance the next frame.

Because the motor-drive waits for each exposure to be completed, maximum continuous frame rate depends on shutter speed. At shutter speeds of 1/125 or faster, maximum frame rate is 3.8 frames per second with 8 AA batteries in the clip or 5.5 frames per second with the optional NiCd Battery Unit MN-2. With the accessory AC power supply MA-4, maximum frame rate is 5 per second.

You can get faster speeds by locking up the mirror, but of course you can't see through the viewfinder while shooting. Max frames per second are: 4 with AA batteries; 6 with MN-2; and 5.5 with MA-4.

Battery Check—On the back is a

Battery-Check Button and two LED indicators. With the button depressed, if both LEDs glow, the batteries are correctly installed and have sufficient power. If only one glows, it's time to replace the batteries or recharge the MN-2. If none glows, the batteries are incorrectly installed or they are completely dead, or none are installed. If the batteries discharge during operation, the motor will stop and one LED will glow.

Motor-Drive Frame Counter—The frame counter on the MD-4 can be preset to expose a desired number of frames in one continuous burst and stop. Turn the Counter Setting Control to place the desired number of frames on the scale in the center of the adjacent window. This counter counts down to zero and stops the motor. One LED, at the right, will glow briefly during each film advance and continuously when the counter reaches zero. To turn it off, move the S-C Mode Selector to L and reset the counter or rewind the film as described later.

You can disable the counter by setting it to the orange dot. With the dot visible in the window, the counter does not count and it does not turn off the motor at zero.

End of Roll—If you have set the motor-drive frame counter to 36 at the beginning of a 36-exposure roll, or counted down in bursts, when the counter reaches zero the motor will stop and one LED glows. You can always tell how many frames have been exposed by checking the frame counter on the camera.

If the counter is disabled with the orange dot visible, the motor will run until it can no longer pull film out of the cartridge and the LED will glow. This is normally OK. The safest way to operate is to set the counter to the number of frames in the cartridge, immediately after loading the cartridge. Or do the same thing by counting down in bursts.

Rewind—At the end of each roll, an LED will glow. Setting the MD-4 to L will turn it off. Rewinding the film turns it off until the next roll ends.

To rewind manually, depress the small pushbutton on Rewind Slide 1,

MD-4 SPECIFICATIONS	
Camera:	Nikon F3
Shooting Modes:	Single Frame (S) Continuous (C)
Shooting Speed:	Up to 6 frames per second with Ni-Cd MN-2. Up to 4 frames per second with AA batteries. (at shutter speed of 1/125 or faster)
Frame Counter:	Preset type to count desired number of frames and stop.
Usable Shutter Speeds:	8 to 1/2000 second and X.
Remote Control:	Connector provided.
Automatic Film Rewind:	4.5 seconds for 36-exposure roll with MN-2; 8 seconds with AA batteries. Auto rewind stop with MF-6 camera back.
Weight:	(1LB) 480g without batteries + 8 - AA Batteries
Dimensions:	146.4mm x 114.7mm x 70.7mm

move it to the left and release it. This depresses the Rewind Button on the bottom of the camera body so you can rewind film. Use the Rewind Crank to rewind normally, remove the exposed cartridge and load the next. Set the Frame Counter on the MD-4.

To rewind with the motor, move Rewind Slide 1 to the left and hold it there while moving Rewind Slide 2 upward. This locks Rewind 1 so you can release it. Use Rewind 2 to control the motor. When the sound indicates that the film is rewound, release Rewind Slide 2. This will release slide 1 automatically and set the counter to the orange dot. Load the next cartridge and set the Frame Counter to the number of frames loaded, if you wish. This method winds the film end all the way into the cartridge.

With accessory camera back MF-6 installed instead of the standard camera back, power rewind stops with the film end extending from the cartridge. An extension of the special camera back extends downward to make a connection with the two metal contacts to the right of the LEDs. Through this connection, the MF-6 stops the motor at the right time.

In very low humidity, power rewinding may cause static electricity discharges inside the camera which can cause visible "lightning tracks" on the film. Slow manual rewinding will prevent this.

Remote Control—MR-2 Terminal Release attaches to the Remote Terminal on the front and provides a second pushbutton to make exposures. Nikon Cable Release AR-2 can be attached to the MR-2 and used to control operation. MC-10 Remote Cord attaches at the same location. It is an electrical cord, three meters long, with an on-off switch at the far end to control operation. MW-1 Radio Control Set, ML-1 Modulite Remote Control Set, and MT-1 Intervalometer can also be used.

Other Accessories—Optional accessories include the MF-6 Auto Rewind-Stop Back, MN-2 NiCd Battery Unit with its MH-2 Quick Charger, MA-4 AC/DC Converter to draw power from AC, Pistol Grip Model 2 and MC-3 Connecting Cord and AH-2 Tripod Adapter. The existing tripod socket in the bottom of the MD-4 is at one side. The tripod adapter provides a socket near the middle of the base.

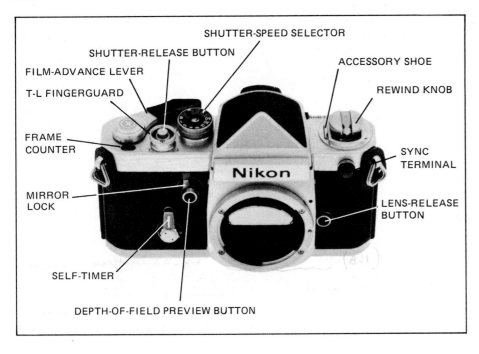

SHUTTER-SPEED SELECTOR

SHUTTER-RELEASE BUTTON

FILM-ADVANCE LEVER

ACCESSORY SHOE

T-L FINGERGUARD

REWIND KNOB

FRAME COUNTER

SYNC TERMINAL

MIRROR LOCK

LENS-RELEASE BUTTON

SELF-TIMER

DEPTH-OF-FIELD PREVIEW BUTTON

F2

This is the basic F2 body equipped with the DE-1 non-metering eye-level viewfinder.

FLASH READY-LIGHT

Nikon electronic flash units designed for F2-type cameras operate a small flash ready-light in the top of the viewfinder eyepiece.

SELF-TIMER

The Self-Timer can be set for any delay between 2 and 10 seconds by reference to a scale on the timer.

Be sure film has been advanced and the camera is set to make the next exposure. To start timer countdown, depress the small timer-start button on the camera body. This button is concealed under the timer lever except when the lever is rotated to select a time delay.

You can use the self-timer with any shutter speed except B. If used on B, the timer counts down; the shutter will operate; but exposure time will be uncertain.

If you depress the camera Shutter-Release Button with the Self-Timer set, the shutter operates immediately with no time delay. Shutter speed will be correct, as selected.

Canceling the Self-Timer—If you set the timer and then decide not to use it, make the next exposure with the Shutter-Release Button on top of the camera. After the exposure is made, the Self-Timer runs through its cycle with no effect on the camera.

MIRROR LOCKUP

The Mirror Lockup Lever is concentric with the preview button. Before the lever can be rotated to lock up the mirror, it must be pushed toward the camera body. Depress the Depth-of-Field Preview Button fully, so your finger *also* pushes the Mirror Lockup Lever against the camera body. Then use another finger to rotate the lockup lever away from the lens until the white dot on the base of the lever aligns with the white line on the camera.

The mirror will move up and lock in that position until the lockup lever is returned to its normal setting. Also, the lens will be stopped down to the aperture size selected by the lens aperture control ring.

HOW TO TIME LONG EXPOSURES WITH THE F2 SELF-TIMER

Lift up the T-L Fingerguard surrounding the shutter button and set it to T. Rotate the Self-Timer Lever until it indicates the desired exposure interval—anything between 2 seconds and 10 seconds. Be sure the camera shutter-speed dial is set to B.

Use the camera shutter button to start the operation, *not* the Self-Timer Start Button on the camera body. The shutter will open when you operate the Shutter-Release Button on top of the camera and it will close when the Self-Timer completes its cycle.

SHUTTER-BUTTON LOCK

Lift and turn the T-L Ring to L.

HOLDING THE SHUTTER OPEN

For long time exposures you can use a locking cable release, or the T-L Ring. To use the T-L ring, lift and turn to the T setting. Set shutter speed to B. Then depress the shutter button. The shutter will open and remain open. At the end of the desired exposure time, carefully lift and turn the T-L Ring back to its center position. The shutter will close.

MULTIPLE EXPOSURES

1. After making the first exposure, depress the film-rewind button

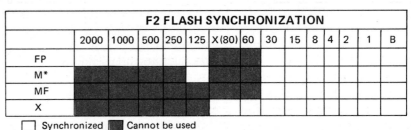

F2 FLASH SYNCHRONIZATION														
	2000	1000	500	250	125	X (80)	60	30	15	8	4	2	1	B
FP						■	■							
M*	■	■	■	■			■							
MF	■	■	■	■	■		■							
X	■	■	■	■	■									

☐ Synchronized ■ Cannot be used

*Some M-class bulbs have longer flash duration covering all shutter speeds up to 1/2000 sec., except for 1/60 and 1/80 (X) sec.

on the bottom of the camera. Hold it in.

2. While holding in the rewind button, move the film-advance lever through one full stroke.

3. Make the next exposure on the same frame.

To make additional exposures on the same frame, repeat the procedure. When the multiple-exposure is completed, operate the film-advance lever one more time, but *do not* depress the rewind button. This is required to cause the rewind button to drop out of its "locked in" position. This movement of the film-advance lever *does not* advance the film, so you have the same frame still in place behind the lens. Install a lens cap and make another exposure on top of the multiple exposures already made. Because the lens cap is in place, this exposure doesn't affect the film.

Then use the film-advance lever in the normal way to advance the film. Film will actually move, as you can see by observing the rewind knob. Because film registration is very good when using this procedure with F2 cameras, a blank frame following a multiple exposure is not necessary.

FLASH

The hot shoe is the special Nikon type. To attach a flash with a conventional ISO mounting foot, use adapter AS-1.

The hot shoe electrical contact is switched on by insertion of a flash unit or adapter AS-1. The sync terminal on the camera body is always turned on, therefore it is provided with a threaded cover which should be in place except when a sync cord is connected. Two flashes can be fired simultaneously: one in the hot shoe and another connected to the sync terminal.

MAJOR ACCESSORIES

Nikkor lenses, bellows, extension tubes, interchangeable viewfinders, interchangeable viewing screens, motor drives, magazine backs with extra film capacity, viewing eyepiece attachments, flash.

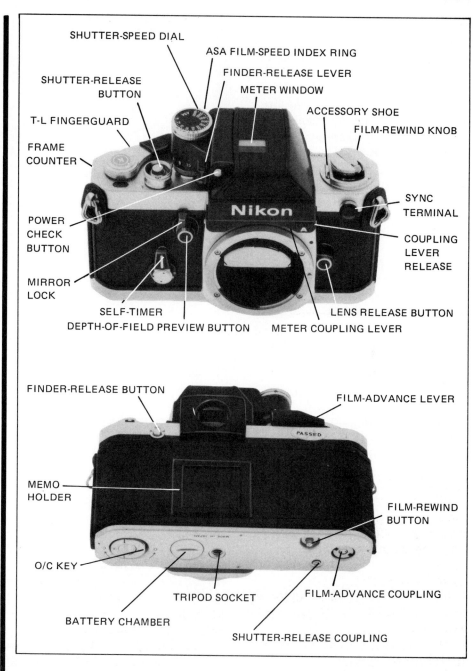

F2A PHOTOMIC

This is an F2 body with Photomic Finder DP-11 installed.

An AI camera with moving-needle exposure indicator. Uses AI lenses and lenses converted to AI configuration. Also uses non-AI lenses but only with stop-down metering.

METERING

A CdS metering system is used with center-weighting. Range is EV 1 to EV 17 with f-1.4 and ASA 100.

VIEWFINDER DISPLAYS

Exposure Indicator—Correct exposure is indicated when the moving needle is centered between the + and − symbols. The meter needle is also visible in a window on top of the viewfinder housing.

Aperture and Shutter-Speed Displays—Numerals showing selected aperture and shutter speed appear adjacent to the moving-needle display. All displays are out of the image area of the focusing screen. The aperture display is by the Aperture Direct Readout method, whereby numerals on the lens ADR scale are imaged in the viewfinder. With a non-AI lens, aperture is not displayed. Shutter-speed numerals for the display are mechanically produced inside the camera viewfinder.

STOP-DOWN METERING

Full-aperture metering can be performed with AI lenses and lenses converted to AI configuration. Stop-down metering must be done with non-AI lenses; when accessories that do not preserve lens automation are installed between any lens and camera; with lenses that have auto-diaphragms but are not meter-coupled for full-aperture metering such as the 400mm f-4.5 Nikkor; and with all lenses not designed for full-aperture metering such as preset and Reflex-Nikkor lenses.

First, prepare the camera for stop-down metering as shown on page 23. Then mount the lens or lens and accessory combination that you plan to use.

For Non-AI Auto-Nikkors Mounted Directly on the Camnera or Auto Extension Rings, and for Lenses with Auto-Diaphragm but no Meter-Coupling for Full-Aperture Metering—Depress Depth-of-Field Preview Lever and hold depressed while setting exposure controls. Release Depth-of-Field Preview Lever. Operate shutter button to make exposure.

For Bellows, Non-Auto Extension Rings, Preset Lenses and all Lenses Requiring Manual Aperture Control—Adjust aperture size and shutter speed for correct exposure. Operate shutter button.

For Reflex-Nikkors—Adjust shutter speed to center the needle. If not possible, use ND filters or film with a different film speed.

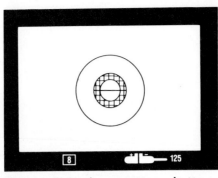

F2A viewfinder shows aperture, shutter speed, and a moving needle exposure display.

EXPOSURE CORRECTION FOR CERTAIN COMBINATIONS OF LENS AND FOCUSING SCREEN

Some combinations of screen and lens require an adjustment to the light-measuring system so it reads correct exposure.

BATTERY CHECK

Turn on camera. Depress Battery Check Button on viewfinder housing. Meter needle should move to right side of "notch" in exposure display, or farther. Reduced temperature near or below freezing will reduce battery output and good batteries may not pass the test. They may recover at normal temperatures.

IF THE BATTERIES FAIL

The exposure meter will not work but the camera will function normally otherwise. All shutter speeds are available.

MAJOR ACCESSORIES

Nikkor lenses, bellows, extension tubes, interchangeable viewfinders, interchangeable viewing screens, motor drives, magazine backs with extra film capacity, viewing eyepiece attachments, flash.

F2AS PHOTOMIC

This is an F2 body with Photomic Finder DP-12 installed.

An AI camera with LED exposure indicator. Uses AI lenses and lenses converted to AI configuration. Also uses non-AI lenses but only with stop-down metering.

METERING

A silicon photo-diode system is used with center-weighting. Metering range is EV -2 to EV 17 f-1.4 and ASA 100.

VIEWFINDER DISPLAYS

Exposure Indicator—Three LED indicators provide five levels of indication, as shown in the accompanying table. When only the center O is illuminated in the viewfinder display, exposure is correct within 1/5 of an exposure step.

The external exposure display on top of the viewfinder housing is a single LED indicator which lights up to indicate correct exposure.

Aperture and Shutter-Speed Displays—Aperture is displayed by the ADR method whereby an image of the ADR scale on AI lenses appears in the viewfinder display. With non-AI lenses, aperture is not displayed. Shutter-speed numerals are internally generated in the viewfinder.

DISPLAY ILLUMINATION

The LED exposure indicators are self-illuminated. Aperture display is illuminated by external light falling on the ADR scale of the lens in use. Shutter-speed numerals are illuminated by overhead light through a window on top of the viewfinder housing. A built-in illuminator, controlled by the Illuminator Switch on the viewfinder, can be used to increase brightness of the shutter-speed display only.

FLASH READY-LIGHT

Nikon electronic flash units designed for F2-type cameras operate a small flash ready-light in the top of the viewfinder eyepiece.

F2AS EXTREME LOW-LIGHT METERING

F2AS cameras have a special metering procedure for use in dim light that requires exposure times between 2 and 10 seconds. The F2AS has a metering limit of EV -2 with ASA 100 film and an f-1.4 lens.

The special metering procedure *does not* extend the dim-light limit of the exposure meter—it merely allows you to use it.

For example, EV -2 is f-1.4 at 8 seconds. Suppose you are metering in light so dim as to require EV -2 settings on the camera. First you open the lens as much as possible and leave it at f-1.4 with the exposure display still showing underexposure. Then you rotate the shutter-speed dial to longer exposure times, still looking for correct exposure. At a shutter speed of 1 second, you run out of shutter-speed settings on the control but the display still shows underexposure.

On F2AS cameras, the next shutter-speed setting is B. If you continue rotating the shutter-speed dial toward long exposures, you'll end up on B with the display still indicating underexposure. You haven't received full benefit of the camera's metering range yet.

Use the Special Metering Procedure—At that point, depress the small button in the center of the ASA scale on the finder. Continue rotating the outer ring on the finder dial in the same direction you have been turning it—counterclockwise. The shutter-speed dial remains set at B because you can't turn it beyond B in that direction. Another scale just above the shutter-speed scale on the finder starts turning.

This scale is called the Extra-long Exposure Scale. It is marked in seconds: 2, 4, 8, and •, where the dot means 10 seconds. The scale is read against a white dot on the finder body, just above the numbers.

While rotating the outer ring of the ASA dial, observe the exposure display in the finder. If it shows correct exposure, stop turning the outer ring. Notice the time indicated by the Extra-Long Exposure Scale. That is

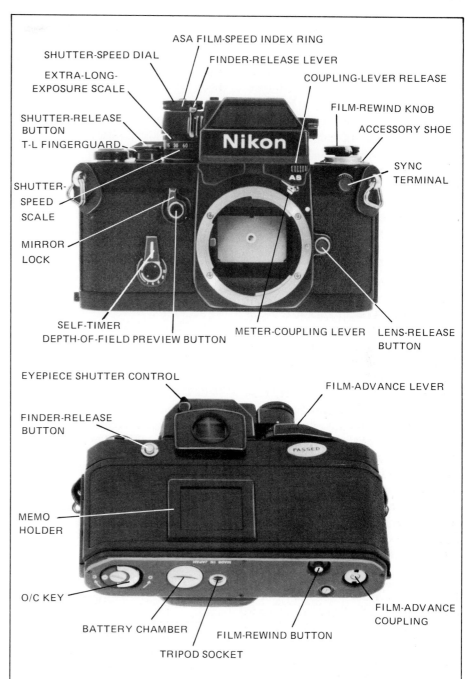

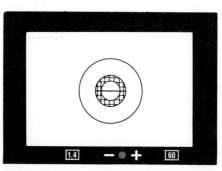

F2AS viewfinder shows aperture, shutter speed, and an LED exposure display.

Three LEDs in the exposure display show five levels of exposure.

– ● +		Overexposure by more than 1 f-stop
– ● +		Overexposure by 1/5 to 1 f-stop
– ● +		Correct Exposure
– ● +		Underexposure by 1/5 to 1 f-stop
– ● +		Underexposure by more than 1 f-stop

F2AS

the correct exposure time—except for reciprocity failure as discussed in Chapter 10.

Notice the reading on the scale, then correct it for reciprocity failure if you need to. This gives you the total exposure time needed. If this amount of time is between 2 and 10 seconds, you can make the exposure using the Self-Timer on the camera body. If the time is longer than 10 seconds, use a locking cable release to hold down the shutter button for the desired length of time.

Whichever way you do it, you need the camera shutter-speed dial set at B. It is convenient to leave the Extra-long Exposure Scale just the way it was at the end of the exposure measurement while you make the shot. It serves as a reminder of the exposure time you need and the shutter-speed dial remains at B.

After making the exposure, turn the outer ring on the finder control clockwise so the Extra-Long Exposure Dial returns to B. At that point, the control re-engages the camera shutter-speed dial. Further clockwise rotation moves the shutter-speed dial to 1 second and then on to faster shutter speeds, in the normal way.

BATTERY CHECK

Turn on camera. If any LED in the exposure display lights up and glows steadily, the batteries are OK. Reduced temperature near or below freezing will reduce battery output and good batteries may not pass the test. They may recover at normal temperatures.

IF THE BATTERIES FAIL

The exposure meter will not work but the camera will function normally otherwise. All shutter speeds are available.

STOP-DOWN METERING

Full-aperture metering can be performed with AI lenses and lenses converted to AI configuration. Stop-down metering must be done with non-AI lenses; when accessories that do not preserve lens automation are installed between any lens and camera; with lenses that have auto-dia-

phragms but are not meter-coupled for full-aperture metering such as the 400mm f-4.5 Nikkor; and with all lenses not designed for full aperture metering such as preset and Reflex-Nikkor lenses.

First, prepare the camera for stop-down metering as shown on page 23. Then mount the lens or lens and accessory combination that you plan to use.

For Non-AI Auto-Nikkors Mounted Directly on the Camera or on Auto Extension Rings, and for Lenses with Auto-Diaphragm but no Meter-Coupling for Full-Aperture Metering—Depress Depth-of-Field Preview Lever and hold depressed while setting exposure controls. Release Depth-of-Field Preview Lever. Operate shutter button to make exposure.

For Bellows, Non-Auto Extension Rings, Preset Lenses and all Lenses Requiring Manual Aperture Control—Adjust aperture size and shutter speed for correct exposure. Operate shutter button.

For Reflex-Nikkors—Adjust shutter speed for correct exposure indication. If not possible, use ND filters or film with a different film speed.

FLASH

The hot shoe is the special Nikon type. To attach a flash with a conventional ISO mounting foot, use adapter AS-1.

The hot shoe electrical contact is switched on by insertion of a flash unit or adapter AS-1. The sync terminal on the camera body is always turned on, therefore it is provided with a threaded cover which should be in place except when a sync cord is connected. Two flashes can be fired simultaneously: one in the hot shoe and another connected to the sync terminal.

EXPOSURE CORRECTION FOR CERTAIN COMBINATIONS OF LENS AND FOCUSING SCREEN

Some combinations of screen and lens require an adjustment to the light-measuring system so it reads correct exposure.

MAJOR ACCESSORIES

Nikkor lenses, bellows, extension tubes, interchangeable viewfinder, interchangeable viewing screens, motor drives, magazine backs with extra film capacity, viewing eyepiece attachments, flash.

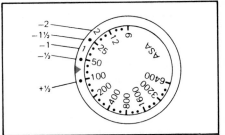

Exposure compensation on Photomic Finders used with F2 bodies is by changing the film-speed setting. An exposure-compensation scale on the control helps you do this without arithmetic. For normal exposures, set the ASA film-speed number opposite the red triangular index mark. For exposure compensation, use the desired compensation figure as the index mark. In this drawing, film speed is ASA 25 but the control is set for under-exposure of 1½ steps. Therefore the number 25 is set opposite the symbol −1½ rather than opposite the triangular index.

182

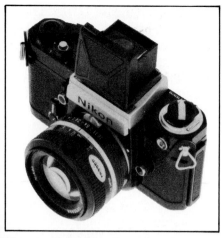

Waist-Level Finder DW-1 allows you to view the focusing screen directly by looking downward into the camera, or view a magnified part of the screen through the flip-up magnifier. In this photo, magnifier is flipped up for viewing.

6X Focusing Finder DW-2 fits any F2 body and gives you a magnified view of the entire focusing screen.

F2 EXPOSURE COMPENSATION FOR FOCUSING SCREENS

LENS		A/L	B	C	D	E	G1	G2	G3	G4	H1	H2	H3	H4	J	K/P	M	R
Fisheye	6mm f-2.8	0	0	-½	-½	0	0	0			0	0			0	0		0
	8mm f-2.8	0	0	-½	-½	0	0	0			0	0	0		0	0		0
	16mm f-3.5	0	0			0	-½				0				0	0		0
Wide-Angle	13mm f-5.6	0	0			0		-1				-½			0	0		0
	15mm f-5.6	0	0			0		-1½				-½			0	0		0
	18mm f-4	0	0			0	-1				-1				0	0		0
	20mm f-4	0	0			0	-1				-½				0	0		0
	24mm f-2	0	0			0		0			+½	0			0	0		0
	21mm f-2.8	0	0			0		0			+½	0			0	0		0
	28mm f-2	0	0			0	+½	+½			+½	+½			0	0		0
	28mm f-2.8	0	0			0	-½				0				0	0		0
	28mm f-3.5	0	0			0	-½	-½			0	0			0	0		0
	35mm f-1.4	0	0			0		+½			+½	+½			0	0		0
	35mm f-2	0	0			0	+½	0			+½	0			0	0		0
	35mm f-2.8	0	0			0	0	0			0	0			0	0		0
Normal	50mm f-1.4	0	0			0		+½				+½			0	0		0
	50mm f-1.8	0	0			0	0	+½			0	+½			0	0		0
	50mm f-2	0	0			0	+½	+½			+½	+½			0	0		0
	55mm f-1.2	0	0			0		0				0			0	0		0
Telephoto	85mm f-1.8	0	0			0		+½			+½	+½			0	0		0
	85mm f-2	0	0			0		+½			+½	+½			0	0		0
	105mm f-2.5	0	0			0		0			+½	+½			0	0		0
	135mm f-2	0	0	0	0	0		+½				+½			0	0		0
	135mm f-2.8	0	0	0	0	0		0				+½			0	0		0
	135mm f-3.5	0	0			0		-½				+½			0	0		0
	180mm f-2.8	0	0	0	0	0			0			0	0	0	0	0		0
	200mm f-4	0	0	0	0	0		-1½				-1			0	0		0
	300mm f-4.5	0	0	0	0	0			-1½			-1½	-1	-1½	0	0		0
	ED 300mm f-4.5	0	0	0	0	0			-1½			-1½	-1	-1½	0	0		0
	400mm f-4.5	0	0	0	0	0												
	*ED 400mm f-3.5	0	0	0	0	0			-1	-½		0		-½	0	0		0
	ED 400mm f-5.6	0	0	0	0	0									0	0		0
	600mm f-5.6	0	0	0	0	0												
	*ED 600mm f-5.6	0	0	0	0	0									0	0		0
	ED 600mm f-5.6	0	0	0	0	0									0	0		0
	800mm f-8	0	0	0	0	0												
	ED 800mm f-8	0	0	0	0	0									0	0		0
	1200mm f-11	0	0	0	0	0												
	ED 1200mm f-11	0	0	0	0	0									0	0		0
Zoom	28-48mm	0	0			0					0				0	0		0
	37-70mm f-3.5	0	0			0		0				0			0	0		0
	43-86mm f-3.5	0	0			0		-½				-½			0	0		0
	50-300mm f-4.5	0	0			0			-2				-1½		0	0		0
	ED 50-300mm f-4.5	0	0			0			-1			-1½	-½		0	0		0
	80-200mm f-4.5	0	0			0			-1			-1½	-½		0	0		0
	ED 180-600mm f-8	0	0	0	0	0									0	0		0
	200-600mm f-9.5	0	0	0	0	0									0	0		0
	ED 360-1200mm f-11	0	0	0	0	0									0	0		0
PC	28mm f-4	0	0			0									0	0		0
	35mm f-2.8	0	0			0									0	0		0
GN	45mm f-2.8	0	0		0	0					0				0	0		0
Noct	58mm f-1.2	0	0			0		0	0						0	0		0
Micro	55mm f-3.5	0	0			0									0	0		0
	105mm f-4	0	0			0									0	0		0
Medical	200mm f-5.6	0	0			0									0	0		0
Reflex Telephoto	500mm f-8	0	0	0	0	0									0	0		0
	1000mm f-11	0	0	0	0	0									0	0		0
	2000mm f-11	0	0	0	0	0									0	0		0

*Internal focusing type

☐ = Exposure measurement via full-aperture method.

▨ = Exposure measurement via stop-down method.

■ = Exposure measurement not possible; lens/screen combination permits only focusing operation.

Blank space indicates lens/screen combination cannot be used.

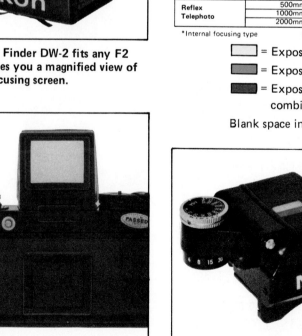

Sports Finder DA-1 shows you the full focusing screen with your eye as far as 60cm away from the eyepiece.

F2A Photomic Finder DP-11 has a moving-needle exposure display

Finder DP-12 is the LED-indicator finder for AI lenses—standard finder for the F2AS camera.

MOTOR DRIVE MD-2

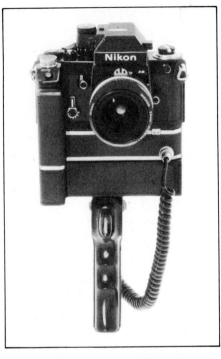

Two motor drives are available to fit any F2-series camera: MD-2 and MD-3. The MD-2 is a deluxe unit with more features and a faster operating speed. It is also a little more complicated. This discussion covers the main operating features of the MD-2.

Operating speed varies according to the setting of the Firing-Speed-Selector Knob and the power source used. Maximum speed is about 5 frames per second as you can see in the accompanying table. For each setting of the Firing-Speed-Selector-Knob, a shutter speed setting is also shown on the dial. This is the *slowest* shutter speed you can use at that setting. It is necessary to set shutter manually, for each setting of the Firing-Speed-Selector Knob. If you set the firing-speed selector between dial markings, use the next higher indicated shutter speed. In addition, if you set the knob to H, you must also lock up the mirror. This gives the fastest operating speed.

The MD-2 operates continuously or single-shot, as selected by the S-C Knob on top of the handle. This knob also has a lock position to prevent accidental operation of the Trigger Button. To set the S-C Knob, lift the knurled outer ring and turn. An LED indicator on the back of the motor drive flashes during film advance.

To Install—Remove the camera O/C Key by unscrewing the center slotted portion of the key. For safe keeping, install the O/C Key in a threaded receptacle on the back of the motor drive grip. Place the motor drive on the camera bottom, in proper alignment, and carefully tighten the Locking Screw until the motor drive fits snugly against the camera. The MD-2 has its own tripod socket so you can still mount camera and motor drive on a tripod.

To Operate—Choose a setting of the Firing Speed Selector Knob and make the indicated shutter-speed setting on the camera, locking the mirror up if you have selected H.

Load film only *after* you have installed the MD-2 because removing the O/C Key allows light to enter the camera until you have installed the motor drive. To open the camera

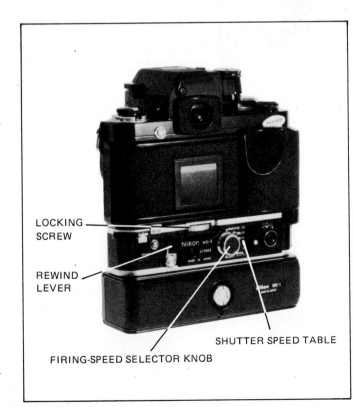

LOCKING SCREW

REWIND LEVER

SHUTTER SPEED TABLE

FIRING-SPEED SELECTOR KNOB

Special camera back MF-3 stops motor-driven rewind automatically when film pulls off take-up spool. MB-1 holds 10 AA batteries or 2 MN-1 NiCad Batteries.

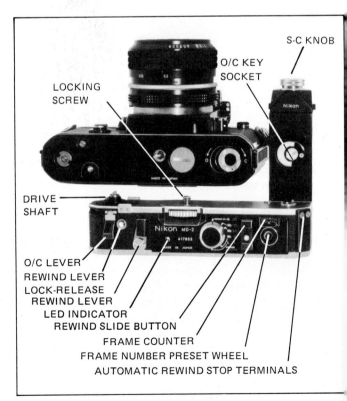

S-C KNOB

O/C KEY SOCKET

LOCKING SCREW

DRIVE SHAFT

O/C LEVER
REWIND LEVER
LOCK-RELEASE REWIND LEVER
LED INDICATOR
REWIND SLIDE BUTTON
FRAME COUNTER
FRAME NUMBER PRESET WHEEL
AUTOMATIC REWIND STOP TERMINALS

Before attaching MD-2, remove O/C Key from camera bottom and store it in holder on MD-2 handle.

back, lift the O/C Lever on the MD-2 and move it toward the left. The camera back will pop open. Leave the O/C lever in that position or you won't be able to insert the cartridge.

MD-2 OPERATING SPEED (frames per second)					
	Firing-Speed Selector Setting				
	H	M3	M2	M1	L
With 10 AA cells	4	3.5	3	2	1
With 2 NiCad MN-1	5	4.3	3.8	2.5	1.3

With film loaded and the camera back closed, the frame counter on the camera will indicate S, but the frame counter on the MD-2 may not. Push the Rewind Slide Button upwards on the MD-2 and the motor-drive frame counter will change its reading and also show S.

Choose C or S, using the S-C Knob, and fire three blank shots manually or with the motor drive. This advances film in the camera to the first usable frame. The frame counter on the camera will show 1, the frame counter on the motor drive will show 36. From there, the camera frame counter counts up; the MD-2 counter counts down.

When set to C, the Firing-Speed Selector Knob adjusts motor-drive speed so there is enough time for shutter operation between film advances. When set to S, you must hold down the motor drive Trigger Button long enough to complete each exposure before releasing the button.

When set to C, with the Trigger Button held down, the motor drive will always expose in one continuous burst the number of frames in the motor-drive frame counter—if there is that much film loaded or remaining unexposed. If you want the capability of shooting the whole roll in one burst, set the counter to agree with the number of frames in the cartridge—36, for example.

You can preset the motor-drive frame counter to expose any desired number of frames in one burst, such as 17 or 3. To do this, push inward on the Frame Number Preset Wheel, which is just below the motor-drive frame counter, and turn it clockwise until the counter shows the desired number of frames. When you hold down the Trigger Button, the motor drive will expose that number of frames and stop. If you don't have that much film in the camera, the motor drive may pull the end out of

the cartridge or tear out sprocket holes. To avoid this, monitor the number of frames remaining by watching the frame counter on the camera. Don't set the motor drive to use more frames than you have left.

If you set the motor drive to expose 6 frames, for example, and then you want to reset it to another number for the next sequence, start by pushing up on the Rewind Slide Button. This resets the motor-drive frame counter to S but does not advance the film. Then put on a lens cap and trigger the shutter one time. This is actually double exposure on the last frame of the preceeding sequence, but no image is formed because of the lens cap. At the end of the shot with the lens cap installed, the motor drive will advance film to an unexposed frame. Then use the Frame-Number Preset Wheel to select the desired number of frames for the burst.

If the motor drive fails to operate properly and the batteries are good, it is probably because the couplings did not mate. Advance the film using the camera Film-Advance Lever and the problem should disappear.

End of Roll—Be sure the frame counter of the motor drive agrees with the actual number of frames left to expose. If so, the motor drive will shut off at the end of the roll. If not, it may tear the film or pull it out of the cartridge.

To rewind, push upward on the Rewind Slide Button on the motor drive. The motor drive frame counter should reset to S. Then you can rewind manually, using the Rewind

Crank on the camera, or you can use the MD-2 to power rewind a 36-exposure roll in about seven seconds.

For power rewind, depress the Rewind Lever Lock-Release button and simultaneously push the motor drive Rewind Lever to the right until it locks. Look at the Rewind Knob on the camera to be sure it is turning. When you hear the motor speed up, rewind is complete. Push the motor drive Rewind Lever back to the left to turn off the motor.

Or, you can install the special MF-3 camera back. Depress the locking catch on the camera-back hinge and remove the standard back. Install the MF-3. This has special rollers to sense when the film end is pulled off the takeup spool during rewind. When that happens, the MF-3 turns off the motor drive. MF-3 can be used only with MD-2. Some film cartridges cannot be rewound by the MD-2 because they don't have a rewind key on the bottom side of the cartridge.

Manual Operation—With the motor drive installed, you can use the camera normally, with Film-Advance Lever and Shutter-Release Button, any time you choose. There is no on-off control on the motor drive—it is turned on by the Trigger Button.

Multiple Exposures—The S setting is recommended for precise registration of images, but you can also use C. Before beginning any of the following procedures, note and remember the frame count on the motor-drive counter.

Double exposures at S:

MD-2 SPECIFICATIONS	
Camera:	Any Nikon F2-series
Shooting Speed:	Single Frame (S) or Continuous from 1 to 5 frames per second
Usable Shutter Speeds:	Single Frame: Any speed Continuous: 1/4 to 1/2000 second
Frame Counter:	Automatic-reset subtractive, can be used to preset number of frames in one burst.
Rewind Time:	Approx. 7 seconds with motor drive Manual rewind also possible
Remote Control:	Built-in relay for control by wire, radio or Modulite.
Power Source:	Battery Pack MB-1, Converters MA-2 or MA-4. MB-1 uses 10AA batteries or 2 NiCad MN-1 units.
Weight (approx.)	470g (without batteries)
Dimensions (approx.)	147 x 110 x 77mm

MOTOR DRIVE MD-3

The MD-3 is basically a simplified and less expensive version of the MD-2. It has a maximum frame rate of 4 frames per second; it does not power rewind the film; but otherwise it has the same capability as the MD-2, including single-shot and continuous operation. To save reading time, I will just discuss the differences between the two units.

To Install—The MD-3 can be installed anytime because removing the camera O/C Key is not required. Just flip the O/C operating handle out and install the motor drive so the handle fits into the Key Groove on the top of the motor-drive O/C Knob.

To Operate—There is no motor-drive speed control and shutter-speed limits are more flexible. As indicated on the S-C Ring surrounding the Trigger Button, single-shot operation at the S setting can be done at any shutter speed from B to 1/2000. When set to C for continuous operation, you can use any shutter speed from 1/80 (X-sync speed) to 1/2000. The control also has an L position to lock the Trigger Button. To turn the S-C Ring, depress the Locking Button on the front of the grip.

The camera back is opened for loading and reloading by depressing the O/C Knob Lock-Release button and then moving the O/C Knob to the left until the camera back pops open.

The Rewind Slide button on the MD-3 prepares the camera for manual rewind but does not affect the setting of the motor-drive Frame Counter. The motor-drive Frame Counter is set manually by rotating the Frame Counter Preset Wheel in any direction, to any setting you choose. It is used to preset the number of exposures that can be made in a continuous burst and also to shut off the motor drive when the last frame is exposed. As with the MD-2, if you set the frame counter for more frames than there are left, the motor drive may pull the film end out of the cartridge or tear the film.

1. Push Rewind Slide up as far as it will go. Release slide.

2. Make first exposure by depressing and releasing Trigger Button. On release, the motor drive will cock the shutter but it does not advance the film.

3. Make second exposure using Trigger Button. On release, film will be advanced to the next frame.

4. Reset motor-drive frame counter to read one less than the reading before the double exposure.

Multiple exposures at C or S:

1. Push Rewind Slide up and hold it up for all exposures.

2. Make the desired number of exposures. Release Rewind Slide.

3. Install lens cap and make two exposures. This resets film-advance mechanism and advances the next frame.

4. Reset motor-drive frame counter to read one less than the reading before the multiple exposure.

Use with Repeating Flash—Nikon Speedlight SB-5 can be synchronized to flash with each exposure at shutter speeds up to 1/80 (X-sync speed) and frame rates up to 3.8 frames per second.

Power Sources—Cordless Battery Pack MB-1 can be attached directly to the bottom of MD-2. This uses 10 AA dry cells or two rechargeable NiCad battery units, rechargeable in Quick Charger MH-1.

AC/DC Converter MA-4, is used to convert AC power to DC for use by the motor drive. Connecting Cord MC-2 is used between the motor drive unit and the converter.

Remote Control—Pistol Grip model 2 and MC-3 Cord may be used to control the motor drive from the pistol grip. Two or more motor drives may be operated simultaneously using an MC-4 Remote Cord connected to the Remote Terminal socket on each motor drive. The cables all connect to a user-furnished switch.

The trigger portion and S-C switch of the MD-2 grip is removable for use as a remote control, connected to the MD-2 by SC Remote Cord MC-1 which is 10 feet long.

For time-lapse photography, use MT-1 Intervalometer. For Wireless remote control, you can use ML-1 Modulite Remote Control Set which triggers by a light beam, or MW-1 Radio Control Set which uses a radio signal.

A special trigger button, Shutter Release MR-2, screws into the Remote Terminal to give you a choice of trigger-button locations. You can use the one on the motor-drive grip, or the MR-2. Also, the MR-2 accepts Nikon Cable Release AR-2 in case that method of remote control is useful to you.

Using Nikon remote control units is generally straightforward, however there are some precautions and special instructions. You should read the motor-drive instruction booklet and the instructions for the remote control unit.

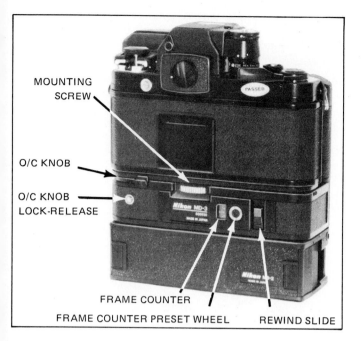

MOUNTING SCREW

O/C KNOB

O/C KNOB LOCK-RELEASE

FRAME COUNTER
FRAME COUNTER PRESET WHEEL
REWIND SLIDE

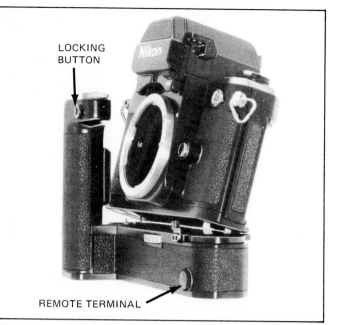

LOCKING BUTTON

REMOTE TERMINAL

MD-3 does not require removing O/C Key from F2 body. Merely extend key as shown; capture key in slot on motor drive.

End of Roll—Push upward on Rewind Slide, then release. Rewind film manually. Use motor-drive O/C Knob to open camera back. After reloading film, reset motor-drive Frame Counter to the number of exposures in the cartridge, or as desired for a continuous burst.

Power Sources—The MD-3 can use either of two Cordless Battery Packs—the MB-1 or MB-2. The MB-1 is the standard pack for use with the motor drive MD-2 and contains either 10 AA dry cells or two MN-1 rechargeable NiCad cells. MB-2 contains only 8 AA dry cells and has less shooting capacity and operates the motor drive at slower speeds.

All other power sources for the MD-2 can be used on the MD-3. All remote-control methods for the MD-2, except SC cords, can also be used on the MD-3.

MD-3 SPECIFICATIONS	
Camera:	Any Nikon F2-series camera
Shooting Modes:	Single-frame or continuous (max. 36 frames)
Shooting Speed:	4 frames per second, maximum (using NiCad battery unit)
Frame Counter:	Subtractive type Possible to preset the desired number of exposures. Automatic motor stop when the frame counter reaches zero.
Usable Shutter Speeds:	1/80–1/2000 sec. (continuous) 1–1/2000 sec. plus B (single-frame)
Power Sources:	DC supply between 12 and 15 volts Cordless Battery Pack MB-1 Cordless Battery Pack MB-2 AC/DC Converter MA-4
Remote Control:	Built-in relay for control by wire, radio or Modulite.
Dimensions:	Approx. 147 X 106 X 62 mm (excluding the grip)
Weight:	Approx. 355g

TRIGGER BUTTON

S-C RING

MD-3 OPERATING SPEED		
	frames per sec.	Usable shutter speed (sec.)
Cordless Battery Pack MB-1		
• Zinc-carbon	3.5	
• Alkaline-manganese	3.5	
• NC battery unit MN-1	4	
Cordless Battery Pack MB-2		1/80 – 1/2000
• Zinc-carbon	2.5	
• Alkaline-manganese	2.5	
AC/DC Converter MA-4	4	

EE APERTURE CONTROL

BATTERY POWER CHECK LAMP
LOCK KNOB
ON/OFF BUTTON
LENS-MOUNTING INDEX
LOOP ARM
DRIVE GEAR
BATTERY HOUSING
SYNC TERMINAL
LENS-RELEASE BUTTON
A-M SWITCH LEVER

EE Aperture Control Attachment DS-12 fits F2AS camera with AI lens. DS-2 is similar, but for non-AI cameras and lenses.

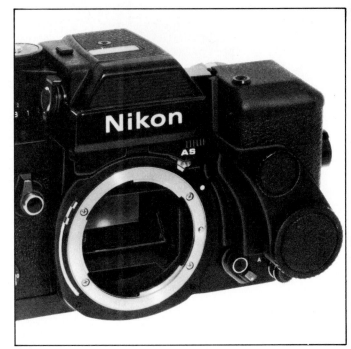

Remove lens and viewfinder. Install EE attachment; reinstall viewfinder.

EE APERTURE CONTROL ATTACHMENTS

Use of an EE Aperture Control Attachment on certain F2-series cameras converts the camera to automatic with shutter priority. The aperture control attachments work only with Photomic finders that have LED indicators. In use, the Photomic finder measures the light and controls the EE attachment which, in turn, mechanically rotates the lens aperture ring to select an aperture size that will give good exposure.

The DS-2 EE Aperture Control Attachment fits F2S or F2SB cameras, or any F2 camera with the DP-2 or DP-3 finders installed. The DS-12 is the AI version—it fits the F2AS camera or any F2 body with the DP-12 Photomic Finder installed. The main difference between the two units is the mechanical connection to the lens aperture ring. The DS-2 turns the lens aperture ring using the meter-coupling prong. The DS-12 connects to a lug on the lens aperture ring, called EE Servo Coupling Post.

This discussion covers the princi-

pal features of the DS-12 and the photos are of that unit. This discussion also applies to the DS-1, except for the method of turning lens aperture ring as already mentioned. Additional information will be found in the instructions that are packaged with each EE Aperture Control.

To Install—Remove lens and viewfinder from the F2AS and pull up the camera Rewind Knob as far as it will go. Set the A-M lever on the DS-12 to the M position. Slide the attachment into place with the Fork fitting over the accessory shoe and the Loop Arm around the camera lens mount. Turn the Lock Knob clockwise until you feel resistance. The locking screw threads into the sync socket on the camera body for two purposes: It locks the EE unit onto the camera. It connects into the flash sync circuit and transfers flash sync to the Sync Terminal on the EE unit so you can still use flash sync cords.

Mount the DP-12 Photomic Finder onto the camera in the normal way. Electrical contacts on the side of the finder will mate with contacts on the EE unit.

Turn the Drive Gear (actually a slot) on the EE Loop Arm so it is

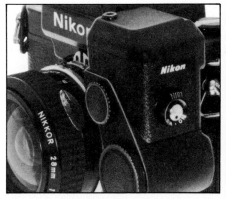

Then install lens. ON/OFF button is on side of EE Attachment.

fully clockwise. Turn the aperture ring on the AI lens to minimum aperture. This positions the EE Servo Coupling Post (lug) on the lens aperture ring so it will be captured in the Drive Gear on the EE unit when you install the lens. Mount the lens in the normal way, checking to be sure the EE Servo Coupling Post drops into the Drive Gear slot.

Because bellows units and extension rings do not have the EE Servo Coupling Post, they cannot be used with the DS-12.

To Use—The A-M Switch Lever selects automatic or manual. It will

188

lock in the A position and can be released by depressing the Lens Release Button on the EE unit. This allows selecting M for manual operation. The Lens Release Button also serves to release the lens for disassembly.

If you choose A for automatic, you can then set the EE unit so it works continuously or only when switched on. Select shutter speed. Depress the ON-OFF button and the EE unit will set aperture. When you hear the motor stop, aperture is set. Release the ON-OFF button to reduce battery drain. The exposure display in the viewfinder should indicate correct exposure.

If the camera is unattended or on remote control, or if you are shooting rapidly and following a subject through changing light, you may want the EE unit to be on all the time so it can change aperture if the light changes. If so, depress the ON-OFF button and turn the surrounding lever *clockwise* to lock the button in the ON position. This lever is called the Run-Control/Power Check Switch because if you push the lever *counterclockwise* it checks the battery and turns on the Battery Power Check Lamp if OK.

Manual Operation—Flip the A-M Lever to M, after depressing the button in the center, and you can operate the camera manually, just as though the EE unit were not attached.

Flash—Flash can be used only with the A-M Lever set to M. Flash sync is derived from the Sync Terminal on the EE unit.

Power—For maximum portability and convenience, use NiCad rechargeable battery DN-1 installed in the battery housing of the EE unit. DN-1 is recharged with Nikon Quick Charger DH-1. For more exposures with portable battery power, use Battery Pack DB-1 which is a case holding four 1.5V C-type batteries supplied with a connecting cord which plugs into the battery housing of the EE unit. If AC power is available, both the DS-12 EE unit and motor drive MD-2 or MD-3 can be powered by AC/DC Converter MA-4.

F2 NIKON DATA CAMERA SETS

Two data-recording camera systems are available from Nikon, both based on slightly modified F2 bodies. These record time, date and a small amount of handwritten information on the side of each frame as it is exposed. Because of their specialized nature, they are only mentioned here. Additional information is available through any Nikon dealer.

Both use a special camera back, a special focusing screen and a special removable mask at the film plane to keep light from the lens off the area where data is recorded. Both bodies can be converted back to standard F2 units by switching to a standard camera back, installing any standard focusing screen and removing the special mask at the film plane.

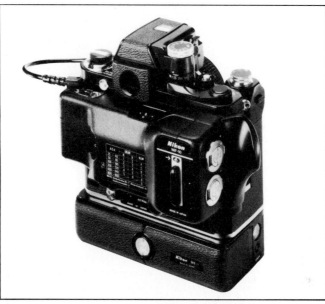

36-Exposure F2 Nikon Data Camera Set uses standard 36-exposure film cartridges. Motor drive and EE Aperture Control Attachments can be used but are optional.

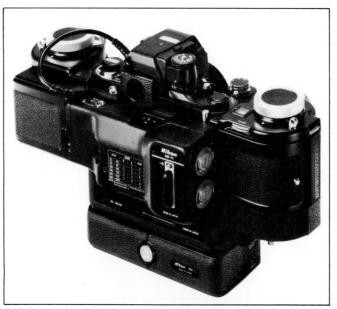

250-Exposure F2 Nikon Data Camera Set uses MF-1 250-Exposure Film Magazine with a special magazine back. Motor Drive MD-2 is required. EE Aperture Control Attachment is optional.

MAGAZINE BACKS FOR F2-SERIES CAMERAS

Any of the motor drives will zip through a 36-exposure roll of film in a hurry. If you need more frames per roll, you can use either of two special Magazine Backs. The MF-1 holds 250 frames and the MF-2 holds 750 frames.

Each magazine replaces the camera back, which is removed by depressing the locking catch on the camera-back hinge and removing the standard camera back. Then the camera, with Motor Drive MD-2 already attached, is installed into the special Magazine Back. Then Battery Pack MB-1 is attached. Motor Drive MD-3 and Battery Pack MB-2 cannot be used with the special magazine backs.

Each magazine uses reloadable Film Cassettes holding 250 or 750 frames, as appropriate. The cassettes are loaded in the darkroom, using a Nikon Bulk Film Loader to spool off film from bulk rolls. The film cassettes can be closed so they are light-tight, therefore you can load several before beginning the shooting assignment.

When the loaded film cassette is placed in the feed side of the magazine, pull the film across and thread it into the takeup cassette. Close the magazine back. The cassettes are then opened by knobs at each end of the magazine, labeled OPEN-CLOSE. The trick in understanding their function is to remember that setting to OPEN prepares the magazine so you can open it, therefore it *closes* the film cassettes so the film can not become light-struck. Setting the control to CLOSE means the magazine is closed so the cassettes are open.

Assembling camera, magazine back, cassettes, motor drive and battery case may seem difficult the first time you do it, but it all goes together quicky and simply when you have learned how. Read the instructions with the magazine back and proceed carefully until you see how it works.

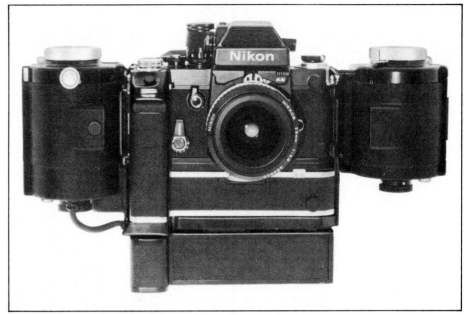

MF-1 250-frame Magazine Back used with F2AS and Motor Drive MD-2. A 750-frame Magazine Back MF-2 is also available.

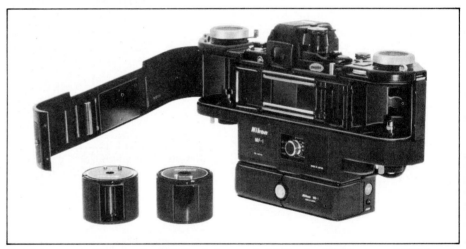

Special cassettes that you load in the darkroom hold film for 250-frame and 750-frame magazines. These are 250-frame cassettes.

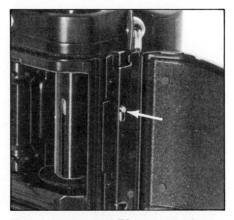

To remove standard F2 camera back, push down on pin (arrow). Then you can install any of the special backs or magazines.

Use Nikon Bulk Film Loader to spool film into reloadable cassettes.

SPECIAL F2 CAMERAS

Two special versions of the F2 are available through your dealer.

High-Speed Nikon F2H—This titanium-bodied camera with special MD-100 motor drive and power supply is capable of motor-driven frame rates up to ten frames per second and also provides motor-driven film rewind. It uses a special non-moving mirror that reflects part of the light up through the viewing system and transmits part of the light on to the film. Focusing screen is an interchangeable type B. The camera is supplied with a non-metering DE-1 pentaprism finder but any other F2-type finder can be installed. All Nikon bayonet-mount lenses can be used, except those that require mirror lockup.

Nikon F2T—For maximum strength and durability, the F2T uses titanium in some areas: pentaprism housing, top and bottom of the body, rear cover and lens-mount panel. The camera has a durable finish and is interchangeable in every way with the standard F2 body. Although supplied with the non-metering pentaprism, any F2-type viewfinder can be installed. It uses all Nikon lenses and accessories.

SPECIAL F2 CAMERAS

The High-Speed Nikon F2H has a fixed mirror and other modifications.

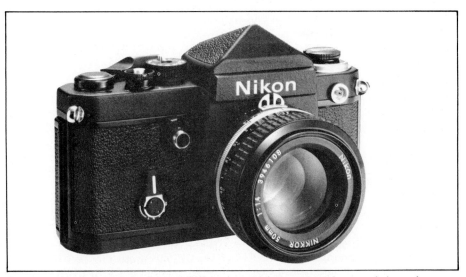

For rugged service, use the special F2T body, which is stronger because it is made with titanium.

MISCELLANEOUS EQUIPMENT

Wireless Remote Control Set MW-1 uses radio signal to control up to 3 cameras with motor drive.

Modulite Remote Control System ML-1 uses a light beam to control one or two cameras with motor drive at distances up to 200 feet. Receiver portion of ML-1 connects to Remote Control Socket of motor drive unit.

Intervalometer MT-1 is an interval timer for single frames or multiple-frame bursts at intervals up to 8 minutes. MT-1 can itself be controlled by ML-1, MW-1, or switch.

The unique Speed Magny replaces an F2 camera back and "bends" light around corners to expose Polaroid Land 3-1/4" x 4-1/4" film packets (Model 100-2).

AC/DC Converter MA-4, connected to AC power source, supplies operating power for Nikon motor drive unit *and* EE Aperture Control Unit. AC/DC Converter MA-2 is similar but supplies power for motor drive only.

Quick Charger DH-1 is one of several Nikon chargers for NiCad Batteries. The DH-1 recharges the DN-1 NiCad battery used in all EE Aperture Control Attachments.

Model & Description	NIKON F2 WITH			NIKON			With Lenses 16mm to 55mm[1] and:
	DE-1 Finder	Photomic Finder (All)	Action Finder	FM & FE	EM	F3	
CH-4 Hard Eveready Case	●	●					85mm
CH-5 Hard Eveready Case	●	●					85mm, 105mm, 43-86mm
CF-1 Semi-Soft Eveready Case	●	●					85mm
CF-2 Semi-Soft Eveready Case	●	●	●				85mm
CS-12 Soft Pouch Case	●	●					85mm
CS-8 Soft Pouch Case	●	●					
CS-9 Soft Pouch Case	●	●					85mm, 105mm, 135mm
CS-10 Soft Pouch Case	●	●					85mm, 105mm, 135mm, 200mm, 43-86mm, 80-200mm
CF-6 Semi-Soft Utility Case	●	●				●	85mm, 105mm, 135mm, 200mm, 43-86mm, 80-200mm, + extra lens, filters
CH-3 Hard Eveready Case							85mm
CH-8 Hard Eveready Case							85mm, 105mm, 43-86mm
CS-7 Soft Pouch Case						●	
CH-11 Hard Eveready Case		●[3]					85mm, 105mm, 43-86mm
CF-7 Semi-Soft Eveready Case				●			85mm
CF-8 Semi-Soft Eveready Case				●			
CF-11 Eveready Case					●		
CF-20 Semi-Soft Eveready Case						●	85mm
CB-1 Custom Shoulder Case (Blue)						●	85mm
CB-2 Custom Shoulder Case (Green)						●	85mm
CB-3 Custom Shoulder Case (Beige)						●	85mm

[1] Includes 16mm f-3.5; 20mm f-4; 24mm f-2.8; 28mm f-2, 2.8, & 3.5; 35mm f-1.4, 2, & 2.8 (except PC) 45mm f-2.8; 50mm f-1.4 & 2; 55mm f-1.2 & 3.5 (without PK or M-Ring).

Soft Pouch Cases (CS-series) require accessory Neckstrap with Shoulder Pad, Models AN-1, Leather, or AN-3, Leatherette

[3] With EE Aperture Control Attachment

REFERENCE TABLES

BATTERY SELECTOR		
	Quantity	Battery
Cameras		
Nikon F2, F2S, F2SB, F2A	2	1.5V Silver Oxide #76
F2AS Photomic, FE, FM, EM, F3	2	1.5V Silver Oxide #76
Motor Drives		
MB-1 Battery Pack	10	AA Alkaline 1.5V
		MN-1 NiCad Battery
MB-2 Battery Pack	8	AA Alkaline 1.5V
MD-12 Motor	8	AA Alkaline 1.5V
MD-E	6	AAA Alkaline 1.5V
MD-4	8	AA Alkaline 1.5V or MN-2
Auto-Winder		
Auto-Winder AW-1	6	AA Alkaline 1.5V
EE Control		
EE Aperture Control	1	NiCad Battery DN-1
DB-1 Battery Pack	4	C Cell 1.5V
Flash Units		
Medical Nikkor II Battery Pack	8	D Alkaline 1.5V
BC-7 Flash	1	15V Battery #504
SB-E Speedlight	4	AAA Alkaline 1.5V
SB-5 Speedlight	1	NiCad SN-2
SB-5 Battery Pack, SD4	1	480V Battery #0160W
	or 2	240V Batteries #0160
SB-9 Speedlight	2	AA Alkaline 1.5V
SB-10 Speedlight	4	AA Alkaline 1.5V
SB-11 Speedlight	4	AA Alkaline 1.5V
SB-12 Speedlight	4	AA Alkaline 1.5V

LENS AND BODY CAPS

SCREW-IN LENS CAPS

Filter-Thread Size	Product Number
38mm Medical Nikkor I	2741
38mm Medical Nikkor II	2740
52mm	581
72mm	583
79mm	573
86mm	588
88mm	620
95mm	626
110mm	629
122mm	621

SLIP-ON LENS CAPS

Lens Outer Diameter	Product Number
64mm	586
90mm	585
93mm	625
110mm	617
115mm	627
133mm	622

REAR LENS CAPS

Lens	Product Number
F-mount Nikkors	607
6mm f-5.6 & 10mm f-5.6	608
2-part Tele	599

BODY CAP

Camera	Product Number
All Nikon & Nikkormat SLR cameras	587

Nikkor lenses use three kinds of front lens caps; screw-on, snap-on and slip-on.